In memory of Justin K. Thannhauser
and Hilde Thannhauser

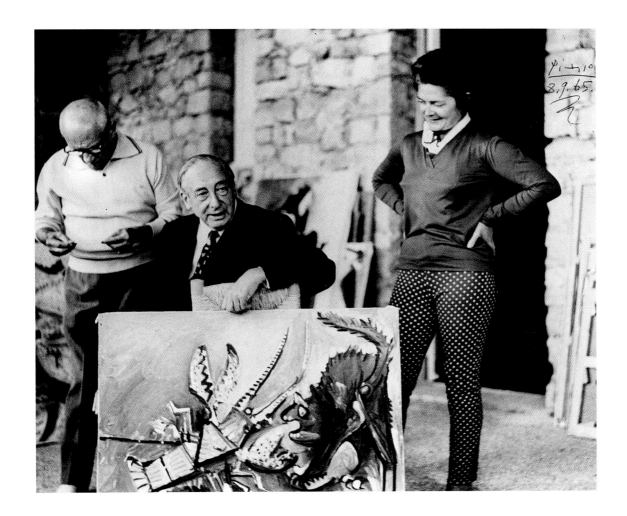

Georges Braque
Landscape near Antwerp, 1906
Oil on canvas, 60 x 81 cm (23 ⅝ x 31 ⅞ inches)

The last to join—and the youngest of—the informally linked Fauve group, Braque worked in the style of these painters in 1906 and 1907, adapting their use of bright colors and leaving areas of canvas exposed. Braque's familiarity with Georges Seurat's Pointillism is seen in his use of distinct brushstrokes rather than solid areas of color.

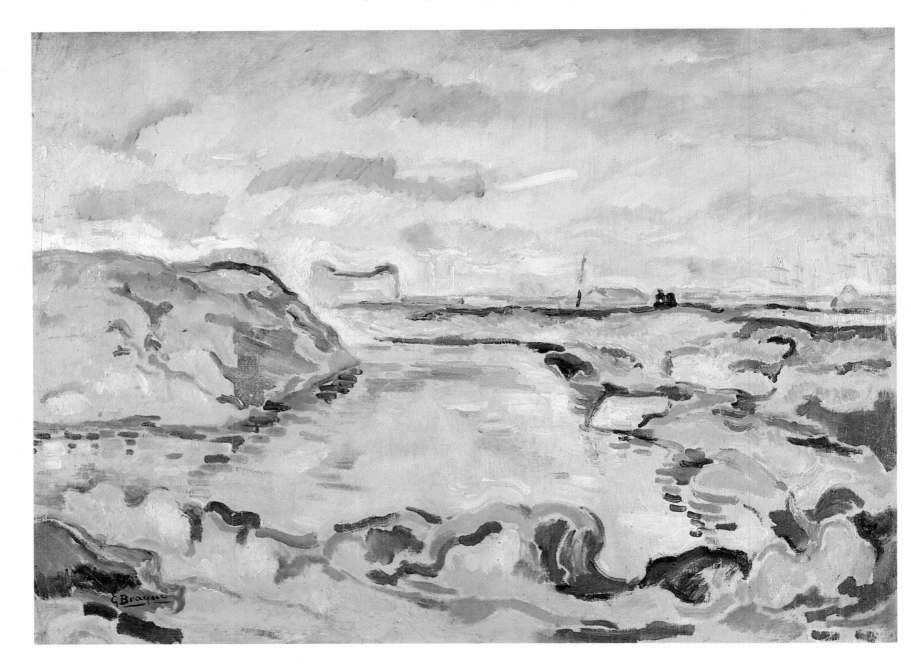

Guggenheim Museum *Thannhauser Collection*

Revised and expanded edition

Foreword by Thomas Krens

Essays by Vivian Endicott Barnett,
Fred Licht, and Paul Tucker

Catalogue entries by Vivian
Endicott Barnett

©The Solomon R. Guggenheim
Foundation, New York, 1992

ISBN: 0–89207–074–9 (clothbound)
ISBN: 0–89207–075–7 (paperbound)

Published by the Guggenheim Museum
1071 Fifth Avenue
New York, New York 10128

Distributed by Rizzoli
International Publications, Inc.
300 Park Avenue South
New York, New York 10010

Color separations by Color Control, Inc.,
Redmond, Wash.

Printed in Italy by Arti Grafiche Motta

Cover: Pablo Picasso, *Woman with Yellow
Hair*, December 1931. Oil on canvas,
100 x 81 cm (39 ³/₈ x 31 ⁷/₈ inches).

Dedication page: Pablo Picasso and the
Thannhausers on September 8, 1965.

Paul Cézanne
Environs du Jas de Bouffan, 1885–87
Oil on canvas, 65 x 81 cm (25 9/16 x
31 7/8 inches)

One of ten art works in Hilde Thannhauser's
bequest to the Guggenheim Museum. Environs
du Jas de Bouffan is among Cézanne's
numerous paintings of his family's estate in
Aix-en-Provence, where he lived with his

mother and sister. Cézanne's repeated observation
of the familiar setting helped him to achieve the
timeless quality evident in the landscape.

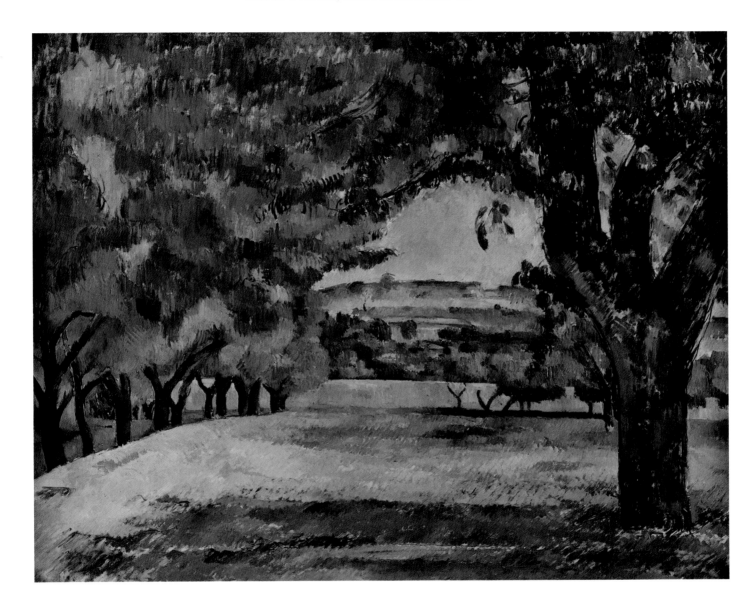

Vincent van Gogh
The Zouave, *late July–early August 1888*
Ink on wove paper, 31.9 x 24.3 cm (12 9/16 x 9 9/16 inches)

Van Gogh employed a variety of pen-and-ink lines and stipples in this copy of his painting of a Zouave, a member of a division of the French army that wore exotic uniforms. It is one of twelve drawings that van Gogh drew from his own paintings and sent to the artist John Peter Russell during a productive summer in the South of France.

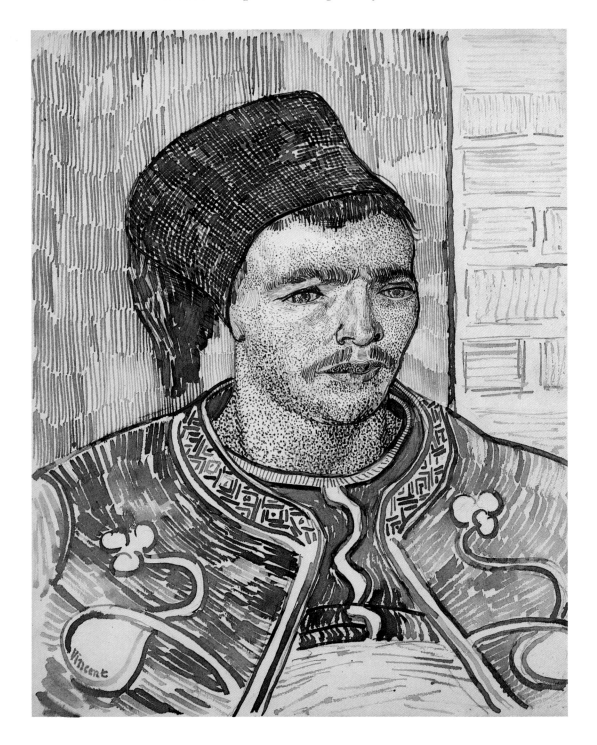

Contents

Foreword and Acknowledgments
Thomas Krens

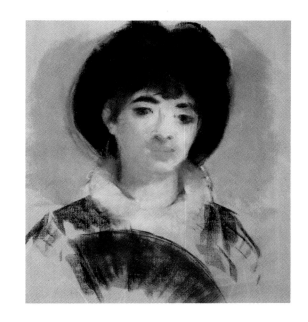

This book, a revised and greatly expanded edition devoted to the Thannhauser Collection, is published on the occasion of the reopening of the Guggenheim Museum after the restoration of its landmark Frank Lloyd Wright building and the construction of new galleries. It also coincides with two major events specific to the Thannhauser donation: the installation of this remarkable collection of Impressionist, Post-Impressionist, and early Modern art in a building that has recently been named in eternal appreciation of the Thannhausers' achievement and generosity; and the first showing in New York City of ten works bequeathed to the Guggenheim by Hilde Thannhauser, who, sadly, died last year in Bern.

Justin K. Thannhauser was an important figure in the development and dissemination of Modern art in Europe. His father, the renowned art dealer Heinrich Thannhauser, founded the Moderne Galerie Thannhauser in Munich, which presented celebrated exhibitions of Impressionism and Post-Impressionism as well as the first exhibition of Der Blaue Reiter (The Blue Rider) and the first large retrospective of Pablo Picasso's work. Justin succeeded him, expanding the gallery to include branches in Lucerne and Berlin. In 1937, he fled Nazi Germany and settled in Paris, where he reopened his gallery. However, when the war broke out in 1939, Justin, his wife Kate, and their two sons found themselves in Switzerland, and from there were able to make their way to Lisbon, where they departed for New York on the last ship to leave. Unfortunately, Justin later lost one son to the war and his other son and wife to illness.

In the United States, Justin was able to continue to build his business and collection, which had in part been confiscated by the Nazis. He felt strongly that an important core of his collection should reside in the United States, out of reach of future European conflicts. He met Hilde in 1961, when she came to New York to assist in the supervision of his home and collection, and they were wed a year later. They lived happily in New York until the end of the 1960s, when they returned to Switzerland.

The Thannhausers enjoyed close relationships with many avant-garde artists, especially Picasso. In fact, the Spanish master dedicated his 1965 painting *Le Homard et le chat* to Justin in appreciation of their long-standing friendship. It is to Justin and Hilde and their vigorous commitment to art that this book is also dedicated.

The process by which great art works reach museums involves many people, including artists, private collectors, and the staff of the museum to which the works are ultimately entrusted. At the Guggenheim Museum, it was Thomas M. Messer, Director for twenty-seven years, who knew Justin and Hilde Thannhauser and first won their interest and devotion to the museum.

After Justin Thannhauser's death in 1976, the ongoing dedication and generosity of Hilde Thannhauser led to three important new acquisitions in the 1980s. Her bequest of ten additional works considerably enriched the Thannhauser Collection, firmly establishing it as one of the finest private gifts of late-nineteenth- and early twentieth-century European art to any museum.

Both during the last decade of Hilde Thannhauser's life and at this very important

moment, the presentation of this collection at the Guggenheim was and is also due to the careful attention, understanding, and precise counsel of Mrs. Thannhauser's advisor, Max B. Ludwig, Esq., now executor of her estate. As a communicator and guardian of Mrs. Thannhauser's interests, Max has been an essential part of this process, contributing both his substantial professional talents and his firm belief in the importance of these works of art.

This book includes individual catalogue entries meticulously researched by Vivian Endicott Barnett and first published in 1978. Research has already commenced on the ten works in Hilde Thannhauser's bequest and will be published in the next edition.

In an effort to extend this book into a more interpretive realm, we have invited two noted scholars, Paul Tucker and Fred Licht, to write essays bringing out two critical aspects of the collection: its reflection of the historical role played by Impressionism and Post-Impressionism as Modernism was being invented in Paris at the end of the last century; and the extraordinary range of Picasso's work, represented in the collection with thirty-two works spanning a sixty-seven-year period.

Guggenheim Museum: Thannhauser Collection represents the efforts of many skilled and dedicated staff members of the Guggenheim Museum. It was edited and produced under the direction of Anthony Calnek, Managing Editor. Laura Morris, Assistant Editor, undertook a great deal of editorial work and wrote the captions that accompany each color illustration using a wide range of sources, including the essays and documentation found in this volume. Cara Galowitz, Designer, brought a fresh approach to the layout, and the reproductions reflect the care and precision of David Heald, Photographer. Pamela Myers, Administrator for Exhibitions and Programming, also contributed to the creative and technical processes that went into the making of this book. Katharina Katz, Research Assistant, compiled information on the works in the Hilde Thannhauser bequest, and Andrea Feeser, Collections Curatorial Assistant, contributed her knowledge and help on many occasions.

Many talented individuals from outside the museum contributed to this book as well. Additional research on the exhibition and publication histories of the works in the collection was provided by Vrinda Khanna and Ingrid Schaffner. Stephen Frankel edited the essays by Paul Tucker and Fred Licht. Peter Lauri photographed the ten works in Hilde Thannhauser's bequest while they were still in Switzerland.

Judith Cox, the Guggenheim's General Counsel, provided expert assistance in facilitating the transfer of the new gift to the museum. Ann Kraft, Executive Associate, has been the museum's liaison to the Thannhauser family since 1985.

In Geneva, Janet Briner has, for several years, served as the curator of Mrs. Thannhauser's collection. As such, she has worked closely with Lisa Dennison, the Guggenheim's Collections Curator, who oversees every aspect of the presentation of the works. The proper care of the collection is of the highest importance. Paul Schwartzbaum, Chief Conservator and Assistant Director for Technical Services, and Gillian MacMillan, Associate Conservator, have painstakingly attended to the physical condition of the works. Elizabeth Carpenter, Registrar, and Laura Latman, Associate Registrar, Collections, insure their care-

ful handling. The Guggenheim's highly trained team of preparators and exhibition techni-
cians are essential to the display of the works in the galleries.

A mark of the importance of the Thannhauser Collection is the amount of scholarship
and research that has already been done to document each work. There is still a great deal to
be done, particularly in light of the recent discovery of a portion of Justin Thannhauser's
gallery records, heretofore thought to be lost. Many of the works in the collection may be
classified as true masterpieces. As such, they will never fail to reward new interpretations,
nor will they disappoint the hundreds of thousands of visitors who each year will see them
in the elegantly restored Frank Lloyd Wright galleries in which they will be on view in per-
petuity.

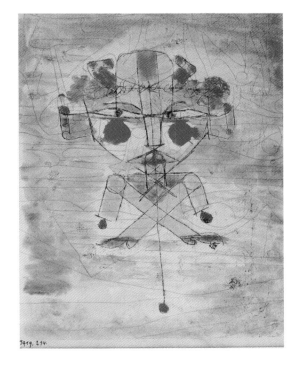

Edouard Manet
Woman in Evening Dress, 1877–80
Oil on canvas, 174.3 x 83.5 cm (68⅜ x
32⅞ inches)

The unidentified woman depicted in loose brush-work is probably an acquaintance of Manet. At this time in his career, the artist tended to paint people in their natural settings—rather than posing studio models—in order to further his attempts at portraying modern life. At one time, Manet considered cutting this painting down considerably, a practice not uncommon to him as part of a continuing reevaluation of his work.

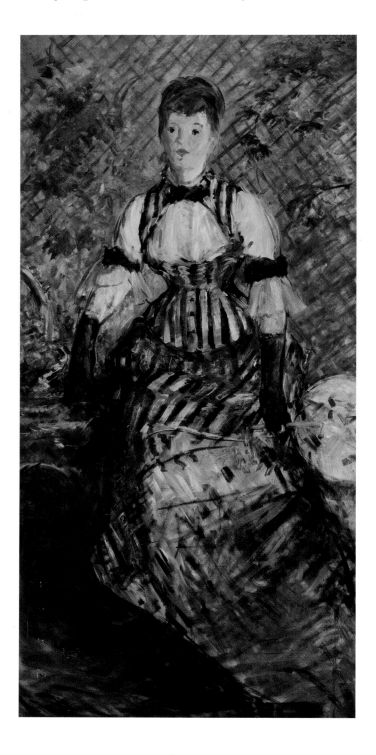

The Thannhauser Collection
Vivian Endicott Barnett

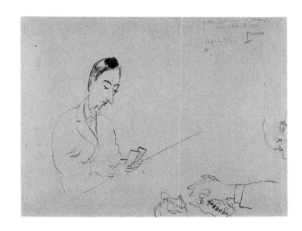

The Thannhauser Collection has become closely tied to the identity of the Solomon R. Guggenheim Museum. The objects in the original donation were placed on permanent view in the Thannhauser Wing of the Museum in 1965 and formally entered the Museum's collection in 1978, two years after Justin K. Thannhauser's death. More recently, several paintings have been added to the Thannhauser Collection through exchanges and through gifts and a bequest from Hilde Thannhauser, his widow. Since the works of art are always on exhibition in the specially designated Thannhauser building of the Museum, they are familiar to more than a generation of visitors to the Guggenheim in New York. The generosity of the Thannhausers is reflected in the masterpieces given both in Justin's original bequest and in the significant additional gifts made by Mrs. Thannhauser. Both donors have presented to the Guggenheim essential masterpieces and outstanding works of art from the late nineteenth and early twentieth centuries.

Their gifts of Impressionist and Post-Impressionist pictures and rare early works by Picasso expand the historical parameters of the Guggenheim's collection. Camille Pissarro's monumental landscape *The Hermitage at Pontoise* (ca. 1867), which belonged to the Thannhausers for more than seventy years, is, in fact, the earliest picture in the Guggenheim Museum's holdings.

The history of the Thannhauser collection began around the turn of the century.[1] Justin K. Thannhauser was born on May 7, 1892, in Munich. His father, the prominent art dealer Heinrich Thannhauser (1859–1935), was well known and respected as early as 1904, when he was first associated with F. J. Brakl in Munich. On November 1, 1909, he opened his own gallery, the Moderne Galerie in the Arco-Palais at Theatinerstrasse 7 in the center of Munich, with an exhibition of Impressionist paintings.[2] It was at about this time that Justin began to assist his father with exhibitions.

The younger Thannhauser studied art history, philosophy, and psychology in Paris, Munich, Berlin, and Florence. Years later he particularly recalled his studies with Henri Bergson, Adolf Goldschmidt, and Heinrich Wölfflin.[3] During his stay in Paris around 1911, Justin Thannhauser became acquainted with leading Parisian dealers Wilhelm Uhde and Daniel-Henry Kahnweiler as well as the circle of Henri Matisse, which included painters Rudolf Levy and Jules Pascin. An extraordinary drawing by Pascin portraying Thannhauser and Levy in the Café du Dôme on Christmas Eve 1911 is included in Hilde Thannhauser's recent bequest to the Guggenheim Museum.

From the beginning, the Moderne Galerie Thannhauser presented innovative exhibitions of French as well as German art. The first exhibition of the Neue Künstlervereinigung München (New Artists' Association Munich) was held at the Moderne Galerie from December 1 to 15, 1909. Organized by Vasily Kandinsky, it included thirteen of his own paintings and prints, twenty-one works by Gabriele Münter, eleven by Alexej Jawlensky, as well as several by Adolf Erbslöh, Alexander Kanoldt, Alfred Kubin, Vladimir von Bechtejeff, and Marianne von Werefkin. The second exhibition of the Neue Künstlervereinigung was held at the gallery from September 1 to 14, 1910, at which time paintings by Georges Braque, David and Vladimir Burliuk, André Derain, Henri Le Fauconnier,

Pablo Picasso, Georges Rouault, Kees van Dongen, and Maurice Vlaminck as well as Jawlensky, Kandinsky, Kubin, Münter, and Werefkin were shown. In May 1910, the Moderne Galerie mounted an exhibition of forty paintings by Edouard Manet from the famous Auguste Pellerin collection. More than twenty pictures by Paul Gauguin were shown in August and paintings by Camille Pissarro and Alfred Sisley were exhibited in November of the same year. In January 1911, the art of Giovanni Giacometti and Cuno Amiet was presented at the gallery. One of the first exhibitions of Franz Marc's work was held there in May 1911. In June of the same year, Thannhauser showed thirty drawings by Paul Klee, and that December one hundred works by Ferdinand Hodler were exhibited.

It was Heinrich Thannhauser who hosted the first exhibition of Der Blaue Reiter (The Blue Rider), the innovative group that created a new style of German painting. *Die erste Ausstellung der Redaktion der blaue Reiter* took place at the Moderne Galerie at the same time as the third Neue Künstlervereinigung exhibition, from December 18, 1911, until January 1, 1912.[4] The Blue Rider was founded by Kandinsky and Marc; this first show included their work as well as that of Robert Delaunay, Auguste Macke, Münter, Henri Rousseau, Arnold Schönberg, and others. The group's publication, *Der Blaue Reiter Almanach*, and their exhibitions in Munich became the nucleus of new artistic directions.

However, Thannhauser's gallery continued to show Impressionist as well as avant-garde art. A presentation of forty works by Pierre Auguste Renoir in January 1912 was followed by a large Edvard Munch exhibition in February. A Futurist show opened on October 27, 1912, and in December fifteen paintings by Paul Cézanne were displayed. In 1912, when Walt Kuhn was in Europe locating works of art for the *International Exhibition of Modern Art* to be held in New York, he contacted Heinrich Thannhauser. When the famous Armory Show opened in New York in February 1913, it included two Hodlers and a Vlaminck lent by Thannhauser.

In February 1913, the Moderne Galerie Thannhauser in Munich organized the first large retrospective of Picasso's work with the assistance of Kahnweiler. Justin Thannhauser contributed a foreword to the exhibition catalogue. Picasso's *Woman Ironing* (1904) was one of the seventy-six paintings and thirty-eight works on paper that were presented. In the late 1930s, Thannhauser was able to buy this canvas from Karl Adler, who had owned it since 1916.

During World War I, the Moderne Galerie was forced to curtail its activities considerably. Justin Thannhauser was called to do military service and left Munich. Three illustrated catalogues, *Nachtragswerke*, which appeared between September 1916 and the spring of 1918, document the pictures that were available. The gallery's stock was predominantly nineteenth-century German and French art, and included Post-Impressionist works by Cézanne, Gauguin, and Vincent van Gogh as well as twentieth-century pictures by Munch and Picasso. Since the German public was resistant to the French art that the Moderne Galerie handled,[5] Justin moved to Switzerland around 1918 and explored the possibility of expanding the gallery outside Munich. By this time, he was married to his first wife, Kate (1894–1960); their two sons, Heinz and Michel, were born in 1918 and 1920, respectively.

Kate Thannhauser was greatly supportive of her husband in all his many activities, particularly in building up his collection.

Following the war, Justin K. Thannhauser assumed the dominant role in the Moderne Galerie. In 1919, the gallery added a branch in Lucerne, which remained active until 1928. January 1927 marked the opening of the Galerien Thannhauser at Bellevuestrasse 13 in Berlin, and a large exhibition to commemorate the occasion was held at the Künstlerhaus. The *Erste Sonderausstellung in Berlin* included several pictures now at the Guggenheim: van Gogh's *Mountains at Saint-Rémy* (1889), Manet's *Before the Mirror* (1876), Pissarro's *The Hermitage at Pontoise*, and Renoir's *Woman with Parrot* (1871) and *Still Life: Flowers* (1885). The Berlin gallery closed in 1937. The original Moderne Galerie in Munich continued to do business until 1928. A Picasso exhibition took place there in June 1922, followed by a Kandinsky show in July and a presentation of works by Henri de Toulouse-Lautrec in December. In 1926, an exhibition of Degas bronzes organized by the Galerie Flechtheim in Berlin traveled to the Galerie Thannhauser in Munich. During the late 1920s, Justin Thannhauser expanded the activities of the gallery and acquired many works of art. He purchased Cézanne's *Still Life: Plate of Peaches* (1879–80), which had formerly belonged to Egisto Fabbri in Florence, from Paul Rosenberg in Paris in 1929. In November 1929, Thannhauser bought Cézanne's landscape of *Bibémus* (ca. 1894–95) from Ambroise Vollard in Paris. Significantly, the focus of activity shifted to Berlin at this time. A large memorial exhibition honoring Claude Monet, organized with the assistance of Georges Clemenceau, took place at the Berlin gallery in February and March 1928. Other historic events were the influential Gauguin show in October 1928 and the successful Matisse show in February and March 1930. Gauguin's canvas *In the Vanilla Grove, Man and Horse* (1891), although it did not belong to Thannhauser at the time, was included in the famous 1928 exhibition.

Moreover, Justin Thannhauser played a prominent role in the organization of the 1932 Picasso exhibition at the Kunsthaus Zürich. He had been in contact with Picasso since the artist's first retrospective in 1913 and he maintained the friendship throughout Picasso's lifetime. Thannhauser's warm relations with Picasso also explain why there are so many works by the artist in the collection. By 1930, Thannhauser had acquired *Bird on a Tree* (1928) from the artist, and in 1932 the drawings *Au Café* (1901) and *Woman and Child* (1903) entered the collection. A few years later, around 1937, he acquired from Picasso the *Still Life: Flowers in a Vase* (1906) as well as the superb *Woman with Yellow Hair* (1931). After World War II, Thannhauser continued to visit Picasso in the south of France. David Douglas Duncan photographed the artist signing his painting *Two Doves with Wings Spread* (1960) when Thannhauser received the canvas from Picasso at La Californie in September 1960.

Although Justin Thannhauser's contacts with artists and his friendships continued, his life was disrupted by the political events of the 1930s. In 1937 he left Germany for France, where he reestablished the gallery at 35, rue de Miromesnil in Paris. However, in 1939 he had to flee the Nazis again. On Christmas Eve 1940, Justin and Kate Thannhauser left Europe on the last ship departing from Lisbon for New York. During World War II,

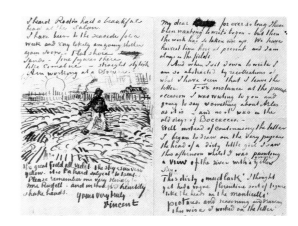

Pablo Picasso
Bird on a Tree, *August 1928*
*Oil on canvas, 34.9 x 24.1 cm (13 ⁵/₄ x
9 ¹/₂ inches)*

Picasso told Justin Thannhauser that during the summer of 1928 in Dinard, where he had gone for some peace and quiet, a loud bird woke him very early. One morning he got up during sunrise and painted a picture of the source of his *annoyance. After that, he reported, he was able to sleep. The time—midway between night and day—is indicated by the stars in the blue sky and the bright yellows and reds of the sunrise.*

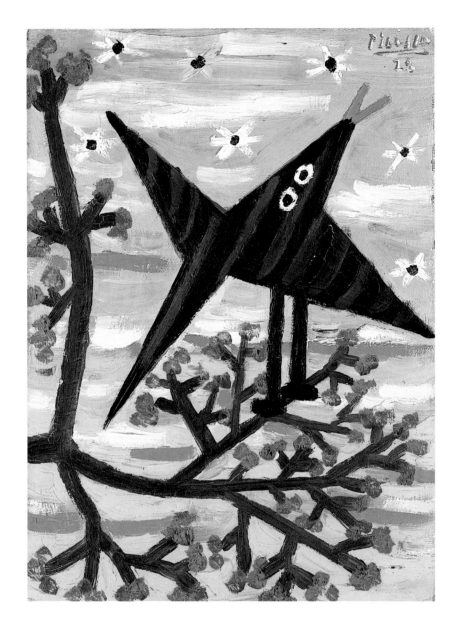

Thannhauser lost countless works of art and other valuable possessions in both Germany and France. His home in Paris was raided by German troops who stole or destroyed antique furnishings, musical instruments, numerous works of art, and the rare books and papers in his library. Also lost were a large portion of the gallery archives and correspondence with artists, including that between Marc and Heinrich Thannhauser regarding the founding of the Blue Rider.[6]

It is impossible to reconstruct what no longer exists, and difficult to trace all works that survived. We do know that certain masterpieces were acquired during the 1930s: Gauguin's *Haere Mai* (1891) was purchased from Ambroise Vollard in Paris in 1934, and Picasso's *Le Moulin de la Galette* (1900), which the Moderne Galerie had sold to Paul von Mendelssohn Bartholdy about 1910, was bought back around 1935. Van Gogh's canvas *Landscape with Snow* (1888) was acquired by 1937, and the drawings that van Gogh sent to the Australian artist John Russell were purchased from his daughter in Paris in 1938–39. In addition, Thannhauser had obtained Picasso's *The Fourteenth of July* (1901), *Woman Ironing, Young Acrobat and Child* (1905), and *Vase of Flowers* (1905–06) by 1939.

In 1939, the fear of impending war provoked the French government to organize traveling exhibitions of paintings that belonged to museums, galleries, and private collectors. Gauguin's *Haere Mai*, Pissarro's *The Hermitage at Pontoise*, and Renoir's *Woman with Parrot* went to South America for an exhibition called *La pintura francesa de David a nuestros días*, which was presented in Buenos Aires (1939), Montevideo (1940), and Rio de Janeiro (1940). The three pictures were exhibited subsequently in the United States at the M. H. De Young Museum in San Francisco (1940–41), The Art Institute of Chicago, the Los Angeles County Museum of Art, and the Portland Art Museum in Oregon (1941). Likewise, Cézanne's *Bibémus* was sent with an *Exhibition of French and British Contemporary Painting* organized by the Association française d'action artistique to Adelaide, Melbourne, and Sydney in Australia during 1939. Van Gogh's painting *Mountains at Saint-Rémy*, which was on loan to the Museum of Modern Art in New York when the war broke out, was kept there until Mr. Thannhauser moved into his new home at 165 East Sixty-Second Street in April 1941.

In 1944, Justin Thannhauser's elder son, Heinz, who was fighting against the Nazis, was killed in combat on the day the South of France was liberated. The young man, who had studied art history and published important articles on van Gogh's drawings, was to have continued the family tradition by taking over the gallery.[7] Justin Thannhauser, grieving the death of Heinz and the illness of Michel, decided not to open a gallery on Fifty-Seventh Street in New York as he had previously planned and, instead, sold many works at auction in April 1945 at the Parke-Bernet Galleries.[8]

From 1946 to 1971, Justin Thannhauser's home and private gallery was located at 12 East Sixty-Seventh Street in New York. Friends, colleagues, and clients remember visiting the townhouse and speak fondly of musical evenings with the Thannhausers. In America he continued to acquire additional works by the artists the gallery had always handled. Cézanne's *Still Life: Flask, Glass, and Jug* (ca. 1877) and the portrait of Madame Cézanne

Pablo Picasso
Dinard, *summer 1922*
*Pencil on wove paper, 42.2 x 29.4 cm (16 ⁵/₈ x
11 ⁹/₁₆ inches)*

*Picasso customarily summered near the seaside.
In 1922, he went to Dinard, a popular resort
town in Brittany. During that summer Picasso
made many line drawings of views of the town
and water and also painted still lifes before
hastily departing to take his wife Olga, who
had become ill, to Paris.*

(1885–87) as well as Picasso's *The End of the Road* (1898–99) were all obtained in the mid-1950s.

Justin Thannhauser's relationship with the Guggenheim Museum began in the early 1960s. In 1963, an agreement was made whereby works from his collection would be bequeathed to the museum, and from 1965 until the temporary closing of the Guggenheim Museum in 1990 these were on view in their own galleries in the Monitor Building. Over the years, Thannhauser gave works to museums in several countries, most recently to the Kunstmuseum Bern in 1973. In 1971, Justin Thannhauser and his second wife Hilde (1919–1991), whom he had married in 1962, moved to Switzerland, and resided primarily in Bern. On May 7, 1972, Justin's eightieth birthday was celebrated at the Guggenheim Museum with a concert by his friend Rudolf Serkin. On December 26, 1976, Justin K. Thannhauser died in Gstaad, Switzerland.

The legacy of Justin Thannhauser to the Guggenheim Museum has been perpetuated by the exhibition and continuing documentation of his renowned collection. Moreover, through the generosity and support of his widow Hilde Thannhauser, the collection was augmented by the acquisition in 1981 of Braque's still life *Guitar, Glass, and Fruit Dish on Sideboard* (1919) as well as by the gift of van Gogh's *Landscape with Snow* and Picasso's *Still Life: Fruits and Pitcher* (1939). In 1985, at the time of Mrs. Thannhauser's presentation of the van Gogh and the Picasso, it was announced that she had promised to bequeath ten additional works to the Guggenheim Museum. She died in Bern on July 25, 1991, and those ten works were transferred to the Solomon R. Guggenheim Foundation. To commemorate the critical role the Thannhausers played in the development of the Guggenheim Museum, the Monitor Building was named for them in 1989. The newly refurbished Thannhauser galleries, with the ten new works installed, were unveiled to the public in June 1992, upon the reopening of the Guggenheim Museum.

Pablo Picasso
Garden in Vallauris. *June 10. 1953*
Oil on canvas. 18.7 x 26.7 cm (7 ⅜ x 10 ½ inches)

Picasso. always experimenting. made his first ceramics in Vallauris. a center of pottery manufacturing. in the late 1940s. This new interest and his collaboration with local potters drew him to the town for several years. He also produced sculptures and paintings during this time. including thirteen pictures of a transformer station. of which Garden in Vallauris *is one.*

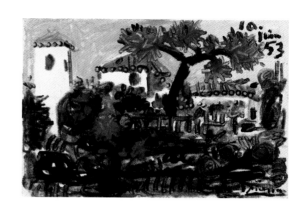

Notes

This essay was originally published in *From van Gogh to Picasso, From Kandinsky to Pollock: Masterpieces of Modern Art* (Milan, Bompiani, 1990) and has been reprinted in slightly modified form with the author's permission.

1. V. E. Barnett, *Guggenheim Museum: Justin K. Thannhauser Collection* (New York, The Solomon R. Guggenheim Foundation, 1978), pp. 13–15.

2. For photographs and information about the Moderne Galerie, see K.-H. Meissner, "Der Handel mit Kunst in München 1500–1945," *Ohne Auftrag: Zur Geschichte des Kunsthandels*, vol. I (Munich, 1989), pp. 44–57.

3. Notes by J. K. Thannhauser, December 1972.

4. M.-A. von Lüttichau, "Die Moderne Galerie Heinrich Thannhauser vor dem Ersten Weltkrieg und der Blaue Reiter," *Ohne Auftrag: Zur Geschichte des Kunsthandels*, vol. I (Munich, 1989), pp. 116–29; M.-A. von Lüttichau, "Der Blaue Reiter," *Stationen der Moderne*, exh. cat. (Berlin, 1988), pp. 108–18; and *Der Blaue Reiter*, ed. Christoph von Tavel, exh. cat. (Kunstmuseum Bern, 1986).

5. E. W. Kornfeld, "Die Galerie Thannhauser und Justin K. Thannhauser als Sammler" in *Sammlung Justin Thannhauser*, exh. cat. (Kunstmuseum Bern, 1978), pp. 13–14.

6. Notes by J. K. Thannhauser, ca. 1972.

7. H. Thannhauser, "Documents inédits: Vincent van Gogh et John Russell," *L'Amour de l'Art*, XIXe année, September 1938, pp. 285–86; and H. Thannhauser, "Van Gogh and John Russell: Some Unknown Letters and Drawings," *The Burlington Magazine*, vol. LXXIII, September 1938, pp. 96–97.

8. New York, Parke-Bernet Galleries, Inc., *French & Other Paintings*, April 12, 1945.

Vincent van Gogh
Mountains at Saint-Rémy, *July* 1889
Oil on canvas, 71.8 x 90.8 *cm (*28 ¹/₄ *x* 35 ³/₄ *inches)*

Van Gogh stayed voluntarily at the asylum in Saint-Rémy, near Arles, from May 1889 *to May* 1890. *He continued to paint, most often outdoors, in between periods of illness. Gauguin, when staying with him at Arles the year before,*

had tried to convince him to paint from his imagination but he remained most comfortable working from nature, as evidenced by this scene of the Alpilles mountains and olive trees visible from the grounds of the asylum.

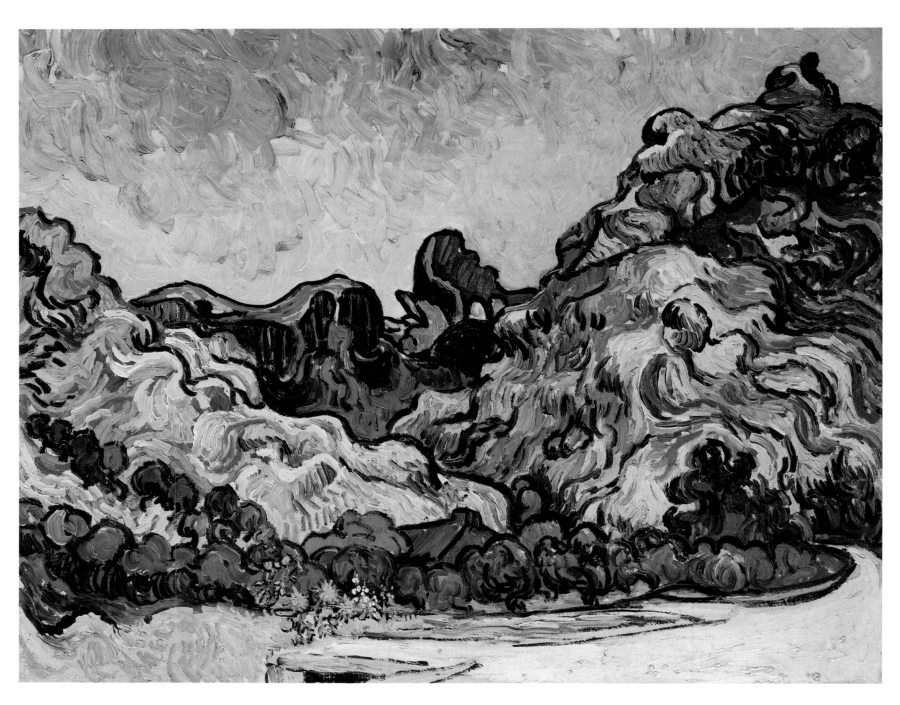

The Makings and Remakings of Modernist Art in France, 1860–1900

Paul Tucker

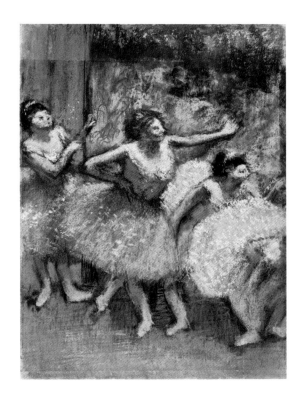

In 1926, by which time Justin Thannhauser had acquired Edgar Degas's *Dancers in Green and Yellow* (ca. 1903), one of the first works by a modern French artist of the late nineteenth century to enter his collection, he never could have envisioned the status that Degas and his contemporaries would achieve over the course of the twentieth century. No one could have predicted it. Yet today, this art, popularly known as Impressionism and Post-Impressionism, has captured the imagination of a public that spans the globe.

The ironies of this abound. First and foremost, the heralded position that these French movements have come to enjoy is not only different from their status during Thannhauser's early years as a collector; it is far from what they were awarded at the outset. Indeed, the very paintings that are now revered as icons of the West's artistic patrimony—such as Degas's brilliant pastel or the many other late-nineteenth- and early twentieth-century masterpieces in the Thannhauser Collection—were frequently the victims of public satire and outright condemnation when they were initially exhibited. The tales of the vituperative reactions to the first Impressionist exhibition held in Paris in 1874, for example, are almost legendary, as are those concerning Vincent van Gogh's plight, particularly his inability to sell more than one or two paintings to the public during the course of his short and tragic life. All of these now-celebrated artists experienced economic hardship at certain points in their careers. Some, like Camille Pissarro, were forced to sell paintings for as little as fifty francs—several hundred dollars in today's currency—a paltry sum considering the fortunes Impressionist paintings have come to command. What is also ironic is that this art was intended by its makers to be controversial if not actually adversarial, which is one of the reasons it provoked such negative responses when it first appeared. Now it is accepted as the norm and endowed with special privileges. No other movement in the history of art can claim such a shift in status and none can assert such evident power.[1]

Why this reversal occurred is not easy to explain. It probably has something to do with the way time softens the impact of the unfamiliar. It is also related to developments in the history of art subsequent to the Impressionists' revolution, specifically to the even-more-forceful assault artists waged on traditions and public taste from the first decade of the twentieth century onward. This attack, initially mounted by Fauve and Cubist artists and pursued by a succession of Modern movements that lead up to those of our own day, resulted in works that made Impressionist and Post-Impressionist art look increasingly attractive. The broken brushwork and heightened color of Claude Monet and his contemporaries, for example, may have upset conservative viewers in the 1860s and 1870s, but those formal departures from accepted practice were tame in comparison to what Henri Matisse and his fellow Fauves inflicted upon their public in 1905 and thereafter. Similarly, the flattened forms and "primitive," often non-Western subjects of Paul Gauguin and his followers, so radical for the 1880s and 1890s, were soon regarded as far more palatable than what Pablo Picasso and the Cubists or Piet Mondrian and other abstract artists served up two and three decades later.

The change in status of late-nineteenth- and early twentieth-century French painting also has something to do with national economies and shifting world relations. It is not

coincidental, for example, that Americans began actively collecting Impressionist art in the 1890s, a time when they started to dominate international trade and enjoy enormous prosperity, just as it is no surprise that Arab collectors became important figures in the market in the 1970s, when oil became so precious or that Japanese buyers assumed a significant position in the 1980s, when their economy was one of the strongest in the world. The Americans who initiated this interest found a variety of attractive values in Impressionist and Post-Impressionist art—boldness, brashness, novelty, and conviction—all of which seemed to coincide with those held dear in "the land of the Yankees," as Monet referred to the United States in the 1880s.[2] Americans had also been nurtured from the 1850s onward on Barbizon art and were prepared to graduate to the next level of Modernist production by the end of the century, especially when the story of the Impressionists' struggles so paralleled their own as laissez-faire capitalists competing against established monopolies. In addition, they held in high esteem France's ability to maintain her position at the forefront of world culture and coveted that leading role for themselves and their country. They soon staked their claims to it by amassing impressive collections of Western art and building museums across the nation to house them. Once Americans focused their attention on these prizes, particularly Impressionist and Post-Impressionist painting and sculpture, collectors from around the world followed suit.

All of this came at the expense of the nation that had been the home to these late-nineteenth-century artists, France. Today, French visitors to museums outside their country, especially museums in America, often feel a sense of loss when they see Impressionist and Post-Impressionist art hanging so far from its place of origin, as if part of the country's patrimony had been sacrificed. Traditionally, it has been said that this was the fault of Parisian collectors and museum curators who were so appalled at what these Modern artists were producing in the last forty years of the nineteenth century that they obscured its merits, to the detriment of future generations. There is much evidence to support this contention; one need only glance at the press of the period and note the barrage of negative reactions to Impressionist and Post-Impressionist exhibitions. Indeed, the critical acclaim of people interested in the arts at the time was bestowed on the technically proficient but often rather unadventurous work produced by mainstream academic artists who exhibited at the annual Salon in Paris and who for the most part are now all but forgotten. Some of these artists were cultural standard-bearers of their day, such as Ernest Meissonier, Henri Regnault, Albert Besnard, and Jean-Léon Gérôme, and most commanded huge sums for their work.

It is therefore not surprising that the story of later nineteenth-century French art has usually been written along the lines of this broad division between the Impressionist/Post-Impressionist avant-garde and the academic artists and their supportive public. There are several problems with this story, however, not the least of which is its simplistic analysis, reducing a complex interplay of forces to the age-old struggle of the "good guys" of the avant-garde against the "bad guys" of the entrenched system. In the 1970s, the tale was opened up and revised slightly by a reconsideration of the so-called Salon artists, who produced what the public in the nineteenth century had so warmly welcomed. The emphasis

shifted from the combat of fringe groups against the mainstream to a more nuanced appreciation of what these more conservative artists and their followers had both defended and achieved. It also entailed a deeper awareness that the Impressionists and Post-Impressionists had actually been dealing with some of the same formal issues that they had been said to have scorned and foresaken and that their academic contemporaries had so ardently advocated. All of a sudden, the bad guys did not seem as bad, and the good guys, while still the victors, were not as shining in their success as they once had been; nor were they as removed from what other less-heralded artists of the time could now be said to have accomplished. More recently, the story has been made even richer and more complex by considerations of the context in which the Impressionist and Post-Impressionist works were produced, bringing to bear social and political issues that once seemed alien to the world of the arts but which actually reveal the multiple levels on which these cultural expressions operate. The expansion of the story has also been greatly aided by scholarly inquiries into questions about gender and psychology, science and biography, which in the last few decades have likewise yielded pertinent results.

Another problem with the tale is that these avant-garde artists were not as uniformly rejected by their countrymen and women as we have been led to believe. Otherwise, they truly would have starved or taken up other jobs, which they did not. Although they experienced real difficulties, particularly the Impressionists in the 1860s, they were able to survive by selling their paintings (in van Gogh's case, only to his saintly dealer-brother Theo). By the early 1870s, however, the thirty-year-old Monet, for example, was making more than 10,000 francs a year, which exceeded what doctors and lawyers earned in Paris. By the 1890s, that had increased twentyfold to 200,000 francs, a sum that allowed him to live extremely well on his Giverny estate. Pierre Auguste Renoir was nearly as successful by then, receiving a commission from the French government in 1891 and buying his house in Essoyes in 1897 for an impressive sum while maintaining an apartment and two studios in Paris. In addition, the influence of Impressionism as a style was so prevalent by the middle of the 1890s that there were those who believed it had become something of a national style, a point underscored at the end of the decade by Monet's elevation to the status of one of the country's great national artists and Renoir's nomination to chevalier in the French Legion of Honor. Thus, while based in part on certain verifiable instances, the notion of the Impressionists' lifelong plight is largely the creation of twentieth-century observers who wanted to assert the superiority of their tastes over those of their predecessors.

A final problem with this tale is the implication that the Impressionists and Post-Impressionists were two solidly united groups of artists who steadfastly maintained their cohesiveness in order to preserve their avant-garde identity, articulate their commitment to controversial principles, buoy their spirits, and defray the cost of mounting group shows. This too is only partly true. Aside from agreeing to practical matters related to their joint exhibitions, the Impressionists and Post-Impressionists were not stalwart bands of inseparable rebels. Each of these groups was a diverse collection of distinctive individuals whose interests, strengths, and opinions were as varied as their biographies, oeuvres, and legacies.

Some, such as Pissarro, were strong family men; others, like Gauguin, ardent male chauvinists. Some, such as Paul Cézanne, enjoyed independent means and did not exhibit on a regular basis. Others, such as Monet, were deft marketers of their own work. Some were interested in plein-air painting, others in creating works from memory in the quiet of their studios. They also did not always get along. Monet and Pissarro, for example, had a painful falling out in the mid-1880s that lasted until the early 1890s. Neither of them liked Gauguin's work and both at various times made every effort to avoid contact with Renoir. Degas developed a profound disdain for Pissarro, had few good things to say about Monet's series paintings of the 1890s, and could not stomach Renoir's work after 1880. Edouard Manet had reservations about Renoir's achievements prior to 1880, just as he had about the independent exhibitions that the Impressionists mounted beginning in 1874. Indeed, he refused to participate in any of their shows, preferring instead to follow the more traditional route of negotiating his work into the annual Salon.

If the cohesiveness of these groups is a problem with this story, so too is pinning down an accurate definition of "Impressionist" or "Post-Impressionist," as Manet's lack of cooperation suggests. Clearly, he did not want to be listed on anyone's roster as one of the former, although his innovations of the 1860s were essential to the group's orientation; and his work of the 1870s was strongly influenced by the Impressionists' heightened color and leisure subjects, which is why he was placed in their camp during his own lifetime. Even the terms "Impressionist" and "Impressionism" are problematic. They are often said to have been derived from Monet's painting *Impression: Sunrise*, which a critic lambasted in a review of the first Impressionist exhibition in 1874 in which the canvas appeared. This explanation is not entirely true, as the term "Impression" had been in use long before that show. In addition, the show itself was not called the First Impressionist Exhibition but rather the first exhibition presented by a "Société Anonyme des artistes, peintres, sculpteurs, graveurs, etc.," suggesting the organizers' much more neutral stance. In fact, we know there was little interest on the part of any of the original participants to be called "Impressionists" in 1874 and that it was not until two years later, during their second exhibition, that they employed the name—although not for the catalogue or the announcements for the show, a restraint they followed for all eight of their gatherings and accompanying publications. The catalogues of those shows also reveal that the people we now consider to be the essential Impressionists (which would include Monet, Renoir, Alfred Sisley, Gustave Caillebotte, Berthe Morisot, Degas, and Pissarro) did not participate in all eight of the independent exhibitions; indeed, only Pissarro could claim that honor. Degas joined in seven, as did Morisot; but Monet and Caillebotte showed in only five, while Sisley and Renoir participated in just four. Those shows themselves are also unfaithful guides to a definition of the group because they included dozens of artists who had little to do with the novel strategies of the core members and who had been invited to participate because they were friends of certain Impressionists or because they were useful to the group's cause—people such as the Ottins, Henri Rouart, Victor Vignon, Léopold Levert, and Charles Tillot, among the many who have long fallen into obscurity.

Claude Monet
Le Palais Ducal vu de Saint-Georges
Majeur, *1908*
Oil on canvas, 65 x 100.5 cm (25 9/16 x
39 9/16 inches)

Monet is probably the best known among the so-called Impressionist painters. That designation is inaccurate in that these painters frequently dwelled upon their subjects rather than making quick summations. For example, Monet

reworked the canvases made in 1908 in Venice—which he visited on the invitation of John Singer Sargent—back in his studio in Giverny from 1909 into 1912.

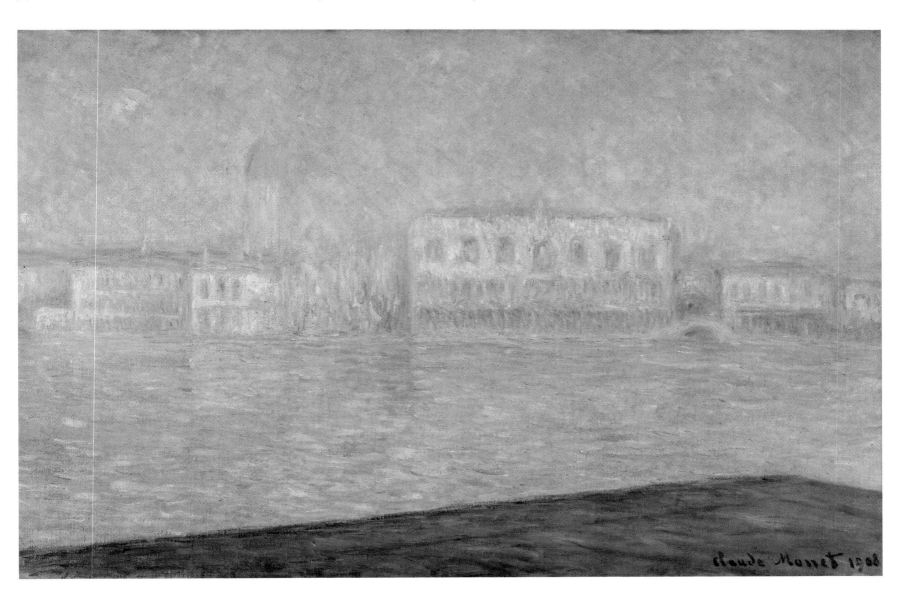

The designation "Post-Impressionist" is even more perplexing, primarily because it is so amorphous. Today it is generally understood to refer to the four major figures in French art who succeeded the Impressionists—Georges Seurat, van Gogh, Gauguin, and Cézanne— but these four artists and their followers could hardly be considered a homogeneous group. Besides being widely different in terms of styles and aesthetics, they never exhibited together and had little to do with each other (except for the brief and ill-fated association between van Gogh and Gauguin in the South of France, which was riddled with argument and which ended with Gauguin's hasty departure and van Gogh's infamous severing of his ear-lobe). In addition, the term was never used by any of the artists who now fall under its banner, and indeed was never even employed during any of their lifetimes. It entered the lexicon only in 1910, when renowned early twentieth-century English critic Roger Fry organized an exhibition that included their work and called them "Post-Impressionists" rather than "Expressionists" or "Synthetists" because it was less specific. Unfortunately, it stuck.

Where does all of this leave us? It should be evident that what had appeared to be relatively accessible art produced by clearly defined groups of uniform practitioners, operating with simple agendas under straightforward circumstances, turns out to be something quite the opposite. We are dealing instead with highly individualistic, multileveled cultural productions that are replete with ironies and inconsistencies, the former suggesting significant trends or idiosyncracies, the latter revealing almost unresolvable problems. Thus, we should be cautious when approaching the history of late-nineteenth- and early twentieth-century French painting and sculpture as so richly represented by the Thannhauser Collection. It is not necessarily what it seems to be.

Nowhere is this clearer than when considering the ways those works generally seduce their audience—with brilliant color, bold brushwork, and enviable moments in time seemingly snipped haphazardly from a broad array of contemporary events, mostly involved with the pursuit of pleasure. As we look at the paintings, these formal factors often coalesce to suggest that the works are the product of naive, though highly sensitive, artists operating in uncomplicated worlds in which freedom and experience are cherished and beauty and harmony reign. Understood as such, it is little wonder that these works are some of the most popular of our time; they are the perfect antidote to the complexities and contradictions that our increasingly dislocated age has experienced. Yet here too there is more than what meets the eye. First, these paintings are not spontaneous. Instead, they are carefully planned and artfully executed; they merely create the illusion of the momentary to make us believe that they are products of pure inspiration during single working sessions, even though nothing usually could be further from the truth. These paintings also depict subjects that are a part of a time that seems quite removed from our own. But those subjects too were carefully chosen for the meanings they carried and the ways they revealed the artist's attitudes about art and life. In addition, they are not so removed from realities we know all too well, for more often than not they suggest a world that is fractured and groping like our own, a world that was filled with confidence but that was equally fragile and constantly haunted by doubt. Thus, the harmony these artists appear to achieve spontaneously was

actually wrought from struggle, just as the beauty they suggest was selective and the bliss they propagate fugitive.

What is most striking, perhaps, is that many of these subjects hardly seem to have merited being elevated into art in the first place—the group of gawking and unceremoniously posed ballerinas behind the stage curtain in Degas's pastel, for example, or the substantial, semidressed woman adjusting her bodice in Manet's *Before the Mirror* (1876), or the relatively undistinguished woman feeding a parrot in Renoir's *Woman with Parrot* (1871). What could be less appropriate for aesthetic wonder or edification than the swine in Gauguin's *Haere Mai* (1891) or less interesting than van Gogh's view of an unassuming tunnel under a roadway we do not see in the middle of an unprepossessing place? Yet all of these subjects, together with those depicted in the other superb paintings in the Thannhauser Collection, tell us much about the artists who painted them and the worlds from which they were drawn. And it is to those works and their stories that we can now turn.

Advanced artists of the late nineteenth and early twentieth centuries, for all of their diversity and contentiousness, their contradictions and compromises, as well as their frequent attempts to manipulate their own histories, concentrated above all on producing works that would appeal to a public whose thinking about art was as advanced as their own and that would be considered modern by contemporary standards or by any that might follow. What "advanced" and "modern" actually meant varied from artist to artist and from decade to decade, just as the standards that would be used to judge the works they produced changed over time. But for those artists who were born in the 1830s and 1840s and who would enter the ranks of what we now refer to as the avant-garde—artists such as Manet, Pissarro, Degas, and Renoir, all well represented in the Thannhauser Collection—one clarion call dominated the others. And that was the era's imperative "Il faut être de son temps" (It is necessary to be of one's time). Uttered by Romantic artists and writers earlier in the century, this demand became the rallying cry of the so-called Realist painters and sculptors of the 1840s and 1850s, the predecessors to Manet and his cohorts.[3] It was they who enthusiastically turned to quotidian events as subject matter and produced an outpouring of works that depicted peasants, farm animals, shopkeepers and factory workers, middle- and lower-class urban dwellers engaged in daily activities, tavern scenes, church ceremonies, small-town festivals, and sympathetic views of rural menial labor. Realists who were historically inclined and fortunate enough to receive commissions from the state turned out paintings of contemporary events that government ministers deemed sufficiently important to immortalize: Napoleon III's conquests on the battlefields, the emperor's visits to sites around the country (often to aid victims of natural disasters), state occasions, even the pope blessing a railroad. With the exception perhaps of Gustave Courbet, all of these artists followed the prescribed aesthetic decorum for painting by consistently favoring relatively smooth surfaces, clearly rendered forms, restrained color, and balanced compositions. Their concentration on lowly aspects of contemporary life came at the expense of subjects that had traditionally preoccupied artists who aspired to the heights of their profession—historical

events drawn from the past, religious scenes taken from the Bible, mythological stories based on the classics, or literary subjects derived from the accepted canon of eminent Western authors. These subjects had been at the top of the Academy's hierarchy over a period of centuries for obvious reasons: they were thought to represent the most significant moments or ideas in history and thus were the very foundations on which civilization stood. Paintings of everyday life were deemed trivial and thus occupied the lowest rung of the Academy's order. But beginning with the French Revolution of 1789, when it was felt that art should speak more directly to its public, that hierarchy came under fierce attack. By the middle of the nineteenth century, it had essentially been leveled.

Claiming the everyday to be equal to the greatest achievements of human history had grave implications in France, where art had long been accorded an important role in the life of the nation. Considered to be one of the most refined products of the human spirit, art carried a heavy responsibility as the very embodiment of everything the nation cherished. Not surprisingly, therefore, the upending of the country's time-honored traditions by the Realists did not meet with universal approval. Many observers and practicing artists bemoaned the turn of events and pleaded against "that deplorable tendency to put art at the service of fashion or the caprices of the day." But they were often seen to be unnecessarily worried or overly conservative. Even the minister of state who made the above complaint in 1857 could claim, "At no time has France furnished more ample material for the chisel and brush of her artists."[4] Although his interest was in contemporary history, not in subjects randomly selected from mundane existence, he was clearly trying to direct, rather than stem, a tide whose force was much more powerful than he or his administration.

Ironically, his remarks echoed those issued about a decade earlier by the much more liberal poet and critic Charles Baudelaire, who had written his now-famous Salon review of 1846, one section of which was entitled "On the Heroism of Modern Life." In this essay, revised and reprinted in 1863 under the title "The Painter of Modern Life," Baudelaire stated "that our age is no less fertile in sublime themes than past ages," and argued for an artist who could show how "the pageant of fashionable life and the thousands of floating existences . . . all prove to us that we have only to open our eyes to recognize our heroism."[5] Baudelaire was not interested in preserving history painting or the old hierarchy of genres. Instead, he wanted artists "to distill the eternal from the transitory" and to seek "the distinguishing character of that quality . . . we have called 'modernity,'" which meant focusing on subjects that would reveal "the amazing harmony of life in the capital cities, a harmony so providentially maintained amid the turmoil of human freedom."[6] For Baudelaire, that required training one's eyes on the multiple perspectives of the burgeoning city of Paris.

Paris and its surrounding suburbs most fully embodied the mysterious novelty of modern existence, primarily because they had undergone extraordinary change in the first half of the nineteenth century, doubling in population between 1830 and 1850 and then increasing again by another thirty percent over the next twenty years. This unprecedented growth caused by rural workers streaming into the capital region in search of better jobs created innumerable housing, health, and security problems. For people like Baudelaire, however, it

also offered a wonderfully diversified and endlessly fascinating spectacle, one that became both clearer and more confusing beginning in 1853. It was in that year that Napoleon III and his prefect of the Seine, Baron Georges Haussmann, initiated the largest urban renovation project of their time—the massive rebuilding of the French capital. Over the course of the next seventeen years, until the outbreak of the Franco-Prussian War in 1870, construction crews demolished more than 24,000 old buildings to erect 100,000 new ones, laid over three hundred miles of new water and sewer pipes, built more than fifty-seven miles of new streets, installed more than 15,000 new street lights, and planted thousands and thousands of new trees. The stinking, filthy, medieval ghetto that had been Paris for centuries was transformed, overnight it seemed, into the "city of light" as we know it today, earning this sobriquet at the end of the 1860s as it turned into the crowning jewel of Europe.[7]

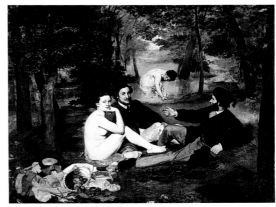

Edouard Manet. Le Déjeuner sur l'herbe. 1863. Oil on canvas. 208 x 264.5 cm (81 ⅛ x 104 ⅛ inches). Musée d'Orsay. © Photo R.M.N.

The new Paris, with its broad boulevards, captivating street life, and abundance of leisure attractions, became the focus of the generation of artists who had been born in the 1830s and 1840s and who had been nurtured on the Realists' responses to the contemporary world. Maturing during the very years the capital was being transformed—Renoir's apartment building was one of the thousands that were knocked down during the renovations—these younger artists substituted the city and its new intrigues for the Realists' concentration on less up-to-date matters. And beginning in the 1860s, they set out to alter the course of French art in ways that even Baudelaire could not have predicted, and which we are still trying to understand today.

The first manifestations of this new art came from the hand of Manet, who was singled out for his efforts in his Salon debut in 1861 as an artist to be reckoned with, for better or worse. Some hailed him as a talented individual who could breathe new life into his country's moribund art; others condemned him as a daubing provocateur, incapable of rational judgment and unable to follow prescribed norms—a polarity of opinion that would be repeated nearly every time Manet put his work in front of the public. What was upsetting to conservative critics was the way Manet flaunted his virtuosity while consistently refusing to make evident his knowledge, training, or personal discipline. "The fine brush strokes, . . . caked and plastered on, are like mortar on top of mortar," complained one writer in 1861. "He begins and does not finish; as soon as his paintings have reached a certain point, he leaves them incomplete," decried another critic almost fifteen years later. "Neither drawing nor modeling count for him."[8] Many felt his talent was being squandered, others that he was establishing "dangerous" precedents. If fellow artists followed his deviant example, what would become of the practice of painting? Conservatives shuddered to think.

It was not that Manet's shorthand was totally novel. There were plenty of prior examples in Spanish art, particularly in Diego Velázquez and Francisco de Goya (whom Manet copied), precedents that contemporary observers often noted. Courbet was also cited as one of Manet's touchstones, for Courbet, unlike most of his fellow Realists, had consciously allowed his paintings to bear evident witness to the materials from which they were made, just as he consistently drew attention to the formal strategies he employed and to the coarse and challenging subjects he selected. In addition, all of these critics knew that even Salon

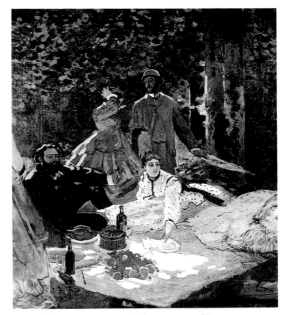

Claude Monet. central fragment of Le Déjeuner sur l'herbe. 1865–66. Oil on canvas. 248 x 217 cm (97 ⅛ x 85 ⁷⁄₁₆ inches). Musée d'Orsay. © Photo R.M.N.

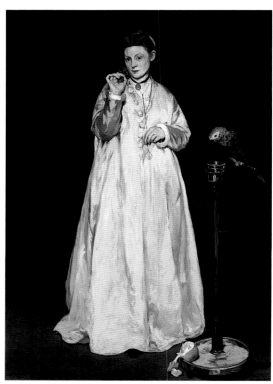

Edouard Manet, Woman with a Parrot,
*1866. Oil on canvas, 185.1 x 128.6 cm
(72 ⁷/₈ x 50 ⁵/₈ inches). The Metropolitan
Museum of Art, Gift of Erwin Davis, 1889
(89.21.3).*

artists painted pictures with similar freedom, and that such a technique was actually taught in the classrooms of the Academy. But in the eyes of conservative viewers, Manet made the technique his entire art, thus taking those precedents and pushing them to an extreme. However much some of the paintings done by Salon artists may have looked like Manet's in their disregard for detail and control, they were never considered finished; they were merely sketches, dashed off to capture a particular effect or to examine a specific visual problem. Finished paintings or true art had to be more refined, studied, and labored. They had to reveal a mastery of the conventions of painting and an inventiveness that would still abide by the rules governing that practice. Everything else was slapdash, mere child's play, hardly worth serious attention (unless, of course, a work was going to be judged according to the tenets applicable to sketching, which were decidedly less rigorous and less elevated than those for the more revered task of producing completed pictures). It was the contention of Manet and his followers that freer works brought one closer to the very nexus of creativity, that they required equal patience and care to produce, and that they underscored the continuing vitality of the tradition in which they were engaged. Paintings that were finished in accord with academic principles, in their opinion, were sapped of spontaneity and thus ended up too predictable and lifeless.

Another problem conservative critics had with Manet's work was their inability to fit his paintings neatly into established categories—history, mythology, religion, everyday life, portrait, still life, landscape, or figure study. This was particularly true when they were confronted with works such as Manet's *Le Déjeuner sur l'herbe* (1863), whose original title of *Le Bain* made it difficult to identify the roles of the various figures in the scene and to determine what kind of painting it was supposed to be. Was it a genre picture or a landscape, a group portrait or a modern mythological scene? What were these people doing and why was the woman stark naked and staring at us so defiantly? In addition, like Courbet before him, Manet often reversed the normal code of using certain sizes of canvases for particular kinds of subjects—larger ones for history, religion, or mythology, and smaller ones for all others. *Le Déjeuner sur l'herbe*, like most of his paintings of the 1860s, was on a canvas that was considered much too big for the subject it supported and thus contributed to its apparent pretentiousness and impropriety.

Despite drawing fire on these counts, Manet soon saw other young artists adopt his subversive strategies. In 1865, the twenty-five-year-old Monet, after receiving high praise for two seascapes in his promising Salon debut that year, set out to renovate Manet's *Le Déjeuner sur l'herbe*. In his even more modern version of the same subject, the upstart younger artist removed Manet's references to past precedents and set a more unified group of properly dressed men and women in a more legible, light-filled environment. Rooting his work more in the realities of experience and less in the artifices of art, Monet heightened the impact of his scene of consummate leisure by choosing a canvas that was twice the size of Manet's and employing brushstrokes that likewise far exceeded those the older artist used.

The equally youthful Renoir followed suit. His painting *Woman with Parrot* (1871), while somewhat reminiscent of genre pictures by more accepted artists at the time, such as

Pierre Auguste Renoir
Woman with Parrot, *1871*
Oil on canvas, 92.1 x 65.1 cm (36 ¼ x
25 ⅝ inches).

The subject of a woman with a parrot was used by various nineteenth-century artists, including Gustave Courbet, Edgar Degas, and Edouard Manet. For his version, Renoir updated the theme by placing a model, his mistress Lise

Tréhot, in a fashionable dress and in a contemporary room. He may have been making an analogy between the woman—with her ruffled dress and plant-filled setting—and the parrot.

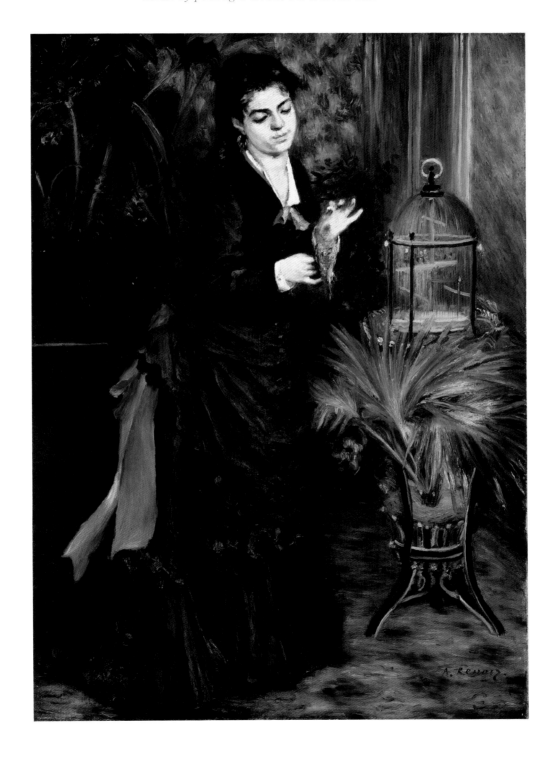

Camille Pissarro
The Hermitage at Pontoise, *ca. 1867*
Oil on canvas, 151.4 x 200.6 cm (59 ⅝ x 79 inches)

Pissarro spent considerable time outside Paris living and painting in Pontoise, a town just northwest of the capital. The Hermitage at Pontoise *reflects Pissarro's longstanding interest in landscape, strengthened in the 1850s by his discovery of plein-air (outdoor) painting, his study of the works of J. M. W. Turner and John Constable, and his meeting of Jean-Baptiste-Camille Corot.*

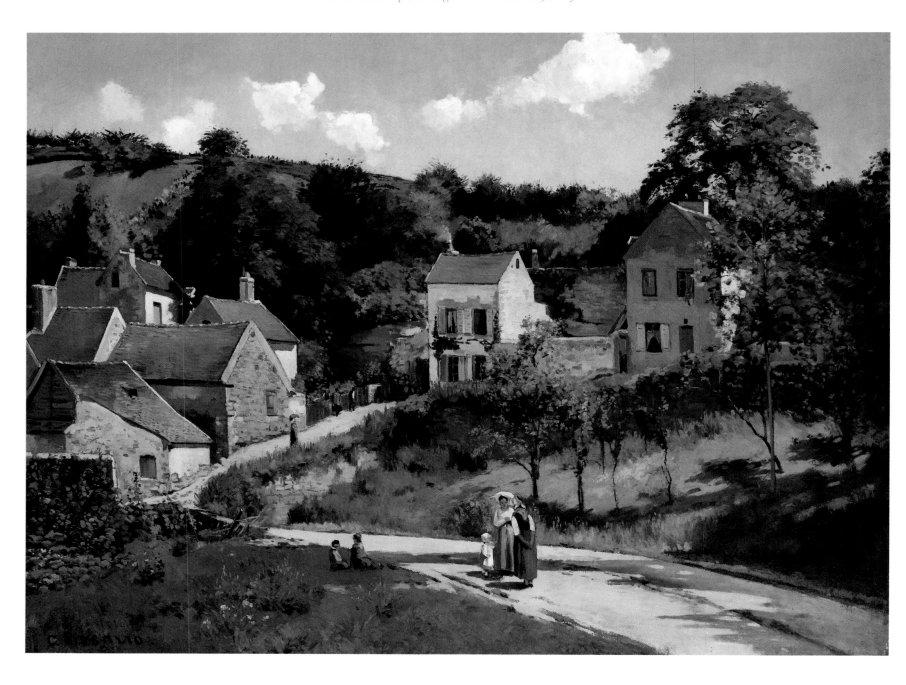

the Belgian society painter Alfred Stevens, is in many ways an updated version of Manet's canvas of five years earlier, *Woman with a Parrot* (1866). Renoir too has given Manet's treatment of the subject a more contemporary look. He has placed his fashionably dressed woman in a room complete with wall-to-wall carpeting, floral wall covering, and well-tended plants. Like Monet's transcription, there seems to be a consistency to this setting and a plausibility about its parts that contrast with the ill-defined, stagelike space in which Manet's more enigmatic figure stands. There also appears to be little question about the identity of this person; initially at least, she seems to be the woman of the house. The figure in Manet's painting is not given a specific role. Indeed, we do not know what she is doing besides holding a flower to her nose, twirling a monocle, and staring straight at us with an inquisitive but ambiguous look. Renoir's woman appears quite innocent by comparison, engaged as she is with the pet that is perched on her gently extended index finger and nibbling a treat. The common nature of Renoir's subject is echoed in the unpretentiousness of his model who, while à la mode in terms of costume, is rather plain in terms of looks, something Renoir underscores by applying his paint in multiple layers to her pallid face and hands and making them contrast radically with the darker dress and room. She does not seem to be endowed with mystery or airs, unlike Manet's actress, just as the room appears to be her own, not one that was snipped from Velázquez or Bartolomé Esteban Murillo.

The contrast may not be quite as clear-cut as that, but the apparent allegiance to direct observation advocated by Manet and his followers appealed to more liberal critics who in the 1860s and 1870s defended these artists against conservative bombast—critics such as Emile Zola, Théodore Duret, Arsène Houssaye, Zacharie Astruc, Théophile Thoré, Jules Antoine Castagnary, Edmond Duranty, and Stéphane Mallarmé, to name but a few. Their support is often given less attention than the meaner remarks made by more conservative writers, which tends to make our picture of the struggling artists bleaker and to confirm our appreciation of their heroic efforts. But their support was significant and strongly stated. For in contrast to their more conservative colleagues, these men of letters appreciated the audacity Manet and his followers exhibited, not only in their choice of subjects but also in their handling, claiming, as Thoré did in 1864, that Manet in particular "has the qualities of a magician, luminous effects, flamboyant hues, copied from Velasquez and Goya, his favorite masters."[9] Zola likewise trumpeted Manet's cause while supporting Monet and Renoir, who in his opinion formed a group he labeled "Les Actualistes," who "try above all to penetrate the exact sense of things" and whose "works are alive because they have taken them from life and because they have painted them with all of the love that they feel for modern subjects."[10]

The enthusiasm of these more open-minded observers was whetted by almost everything these young artists produced, including the seemingly less contemporary scenes of country life that formed the core of Pissarro's output during the 1860s and 1870s, such as the Thannhauser Collection's *The Hermitage at Pontoise* (ca. 1867). Their interest was more than justified, given this painting's extraordinary qualities, from its rich color scheme, simplicity, and directness to its evocative light, seductive touch, and surprisingly complex internal

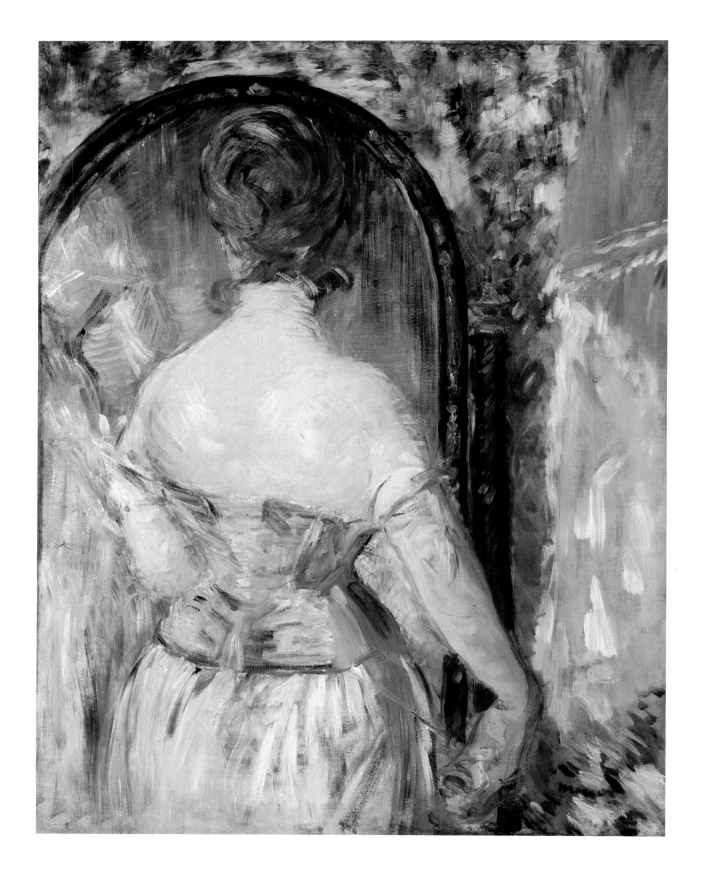

Edouard Manet
Before the Mirror, 1876
Oil on canvas, 92.1 x 71.4 cm (36 ¹/₄ x
28 ¹/₈ inches)

The subject of Before the Mirror was not new. Scenes of women at their toilette, some including male figures and many with erotic implications, were common in the eighteenth and early nineteenth centuries. But Manet's loosely applied, unblended brushstrokes, the undefined setting and drapery, and the unclear relationship between viewer and model set his version apart from predecessors.

relations. Note the subtle way the land rises and falls, for example, or how the path leads from the quiet and uncluttered right-hand corner to the more forceful planes of the houses on the left, which it then skirts as it turns to climb to the two more-isolated white houses on the right. Note as well how the hill in the background on the left leads down to those two houses on the right, only to be stopped by the foliage of a tree that breaks the horizon behind the darker structure on the far right, a vertical gesture that also appears to push the stream of clouds up and out of the scene. Pissarro's love of contrasting forms is evident here as well—the stone wall on the left, for example, which he plays off against the eroded bank to the right, and above that wall the darker roofs that stand out against the lighter facades below, or the three large wedges of land that head right, left, and then right again as they move from foreground to middle ground to background. Filled with the freshness of a summer's day and all of the empathy Pissarro felt for the humble aspects of rural France, paintings like this rightfully inspired Zola to exclaim, "What vibrant earth, what greenery full of vitality, what a vast horizon! After studying it for several minutes, I thought I saw the very countryside open up before me."[11] Like contemporaneous paintings by Manet, Monet, and Renoir, this picture unites the empiricism of Courbet and his Realist contemporaries with a love for natural light and for clear, resonating color, all set down with conviction and bravura. Little wonder that Zola asserted that these artists "are at the forefront of the modern movement and that one day we will have to reckon with them."[12]

Although Manet set the pace among his colleagues for the changes that occurred in French art in the 1860s, he increasingly adopted the strategies of his friends and associates in the 1870s. After the disastrous defeat of the French at the hands of the Prussians and the bloody repression of the Commune insurrection in 1870 and 1871, Manet essentially abandoned his more historically oriented work for subjects that were taken directly from the contemporary social fabric, much as Monet, Renoir, and Pissarro had been doing in the previous decade. He also began to render these more consistently modern subjects with the heightened palette of his friends, although he still maintained his interest in motifs that were riddled with ambiguity and could be read on various levels. Few paintings demonstrate this better than the Thannhauser Collection's *Before the Mirror*, a work that Manet included in his last solo exhibition (held in the offices of the Parisian newspaper *La Vie moderne* in 1880) and which remained in Manet's possession until his death in 1883.

It is perhaps not surprising that it did not find a buyer given the challenges it poses, beginning with its apparent subject—a woman in her undergarments seen from the rear, standing in front of a mirror in what is presumably her private dressing or bedroom space. It is not the subject per se that is so striking; such scenes were common in earlier art, particularly in the French Rococo of the eighteenth century, when the boudoir became the standard setting for much steamier encounters. What is remarkable is Manet's treatment of the motif. Most of his predecessors, for example, provided some storytelling elements and insisted on some distance between the viewer and the action. Here, there is only a single figure whose features are obscured despite the presence of the mirror. Her actions are also extremely limited if they are definable at all. Besides looking at herself (as we would like to

believe she is), she simply appears to be adjusting her bodice, although it is impossible to say whether she is loosening it or tightening it. Her reflection in the mirror is of little help; indeed, it only contributes to our confusion, as it hardly appears to be a reflection at all. The smeared array of hues vaguely recalls those of her shoulders and garments, but they tell us nothing about this woman. They also seem to be too far to the left, if she is supposed to be standing in front of the mirror and if the mirror is supposed to be parallel to the floral-covered wall behind it. But perhaps these too are false assumptions, something the cropping of the mirror frame on the left suggests together with the larger amount of the frame that we see as it emerges from the left and curves up to the top.

Apparently, nothing is for certain here. For example, what is the blue-and-white form on the right—a window curtain restrained by a cord, or a section of a sheer canopy hanging from an unseen bedpost? Why is it two different colors (the same two as the woman's garment), and why do the colors change just where the cord disappears, which is where the finial of the mirror ends as well? There are no sure answers to any of these questions, just as there are no indications as to what our role is supposed to be in the scene. Are we related to this woman? If so, is it by blood, marriage, or temporary consent? Are we even in the room with her? If we are, we are sitting or lying down or else very short. Because of our low vantage point, we could actually be voyeurs outside her space and peering in at her through some kind of keyholelike opening, although once again the painting does not permit us to draw firm conclusions. It is even difficult to determine whether she knows we are looking at her. She makes no concessions to us and seems completely self-absorbed; even her body is contained within the boundaries of the mirror, whose rounded top gently arcs over her similarly colored hair while imitating the outline of her rising hips below. Yet there is a hint—in her slightly turned head, cocked ear, and frozen action—that she is aware of us, something her right arm implies as well, as it breaks out of the confines of the mirror, permitting her wrist to touch the boldly lit material on the right and her hand to attract or dispel the staccato strokes in the lower corner on that side.

Those strokes are deftly applied, like all of the touches that cover this canvas. They are also surprisingly varied, from the blocklike, opaque highlights on the material at the right and the whisper-thin, almost combed, sections of blue-gray in the mirror to the flurry of strokes in the background and the pasty buildup of paint on the woman's shoulders and back. In most areas, the strokes are distinct and separate, both individually and as groups. While describing the image and increasing its immediacy, they are often so self-evident as touches of paint that they constantly call attention to themselves as a rich, thick impasto, thus reaffirming Manet's working method as part of the aesthetic of the image instead of convincing us of the veracity of the scene they evoke.

It is the extraordinary alliance of all of those marks, however, together with the ambiguity of the forms they barely describe that make this painting at once so forceful and fragile, so convincing and unnerving, an effect that can be underscored by comparing the painting to works that it ultimately leads to, such as Matisse's two drawings from ca. 1900 and 1939 in the Thannhauser Collection, *Male Model* and *Woman Before Mirror*.

These drawings are radically different from each other. One is energized by fierce crosshatching and a rough play of light and shade; the other is airy, lyrical, and evanescent. But they are both the product of a man who has learned his lessons well, informed as they are by a host of precedents, from Greek vase painting of the fifth century B.C. (as in the case of *Woman Before Mirror*) to Michelangelo, J. A. D. Ingres, Auguste Rodin, and Picasso, as well as to Matisse's own earlier work. But in many ways, neither would have been possible without Manet's example, as it is Manet's freedom of handling, his obsession with form, and his keen interest in the elements of his craft that allow him to stake out a position between description and abstraction, knowledge and naiveté. But neither of these drawings possesses the ambiguity and tentativeness that seem to haunt Manet's painting. They are only draw-ings, of course, and thus less labored and plastic. But Matisse's basic urge to extract harmo-ny from whatever he encountered, so evident in both of these drawings, seems remarkably absent from Manet's painting, despite the concordance of forms, the synchronized strokes, and the pleasing coordination of related colors. Every element in this painting seems to be part of a deliberate strategy to only *approximate* clarity and resolution, as if such goals were unachievable or perhaps not even desired.

One could make much of this, for it does not appear to be simply the result of Manet's interest in capturing a particular moment in time. Nor is it due to oversight or lack of tal-ent, as conservative critics in the 1870s might have claimed. It is also not because the pic-ture was a sketch. Manet seems to have considered it to be finished, having reworked the woman's right hand, signed the canvas, and included it in his 1880 exhibition without any qualifying additions to the title, as artists often did if the work were not actually complete.

Clues to resolving this quandary are suggested by critics who praised the paintings of Manet and his friends, for many of these critics found something more there than mere aes-thetic novelty or technical brilliance, something that spoke to them about life itself, as Zola and Baudelaire had suggested in their writings in the 1860s. These connections were made more frequently beginning in 1874 with the first Impressionist exhibition, when the par-ticipants were generally called the "Intransigeants." This was a label critics appropriated from the political sphere, where it referred to Spanish anarchists who in 1873 had initiated a civil war in their country in an attempt to topple their Bourbon monarch. Although the coup had been crushed, their goals were familiar to most French citizens. The name Intransigeants, therefore, would have been quite pungent when applied to the "indepen-dent" society of artists who staged their first public show the year after the rebellion col-lapsed. It suggested the group's adversarial position in relation to the artistic establishment while implying that the Impressionists had a revolutionary if not a lawless bent. Some of the Impressionists would not have appreciated this association, but it seemed appropriate to most early reviewers whether they supported the show or not, since so many used it.[13]

The boldly painted works the Impressionists produced in the 1870s were linked specifi-cally to conditions in France by Mallarmé, who in 1876 went so far as to assert that the art of Manet and his followers would be a beacon for the disenfranchised classes in the country. This startling assertion was predicated on the poet's acute sensitivity to the simplicity, hon-

Henri Matisse
Woman Before Mirror, *November 1939*
India ink on wove paper, 38.1 x 28.3 cm
(15 x 11 ¹/₈ inches)

The simplicity of Woman Before Mirror *is a continuation of the linear style Matisse used in drawings and prints of the 1920s. The subject is one he had explored repeatedly, particularly in 1936 and 1937. The harmony and clarity* *for which Matisse usually strove is reflected in this drawing, which was made in a hotel room in Cimiez, near Nice.*

esty, and directness of the Impressionists' work, which he claimed were parallel to the principles governing popular art. He also saw the artists' interest in casting off the shackles of the Academy and starting anew as equivalent to the political aspirations of all workers in France. Even the lack of traditional finish in the Impressionists' paintings was a sign of their independence and their quest for truth, which he felt was similar to the way the multitude demanded "to see with its own eyes."[14] Although members of the group would not necessarily have agreed with Mallarmé, his reading was one more example of how their work was wedded to their times whether they liked it or not.

One of the most succinct and revealing connections between this new art and its particular historical moment was made by Frédéric Chevalier when he reviewed the third Impressionist exhibition of 1877. "The disturbing ensemble of contradictory qualities . . . which distinguish . . . the Impressionists," he observed, "the crude application of paint, the down to earth subjects . . . the appearance of spontaneity . . . the conscious incoherence, the bold colors, the contempt for form, the childish naïveté that they mix heedlessly with exquisite refinements . . . all of this is not without analogy to the chaos of contradictory forces that trouble our era."[15] Although we will never know precisely what Chevalier meant by this remarkable bit of criticism, his enumeration of the Impressionists' formal innovations indicates his familiarity with their strategies and the ways that those innovations suggested salient characteristics of contemporary life.

Chevalier's observations about that life were reiterated by innumerable other commentators, for by the 1870s Baudelaire's magical city of Paris had long been haunted by contradictions. The broad new boulevards, imposing new structures, and swirling public life, while novel and exhilarating, were also alienating and disconcerting. Most residents, although they could understand the changes as the effects of progress, were profoundly affected by the radical transformation of the city. What had once been a collection of virtually independent, self-sustaining neighborhoods had been forced into a new configuration, one that had obvious advantages—access was much easier, for example—but which was strained beyond the tolerable to many who lived there. Bonds that had been established with neighbors and places, for instance, now seemed compromised by the hordes of new people who moved into the townhouses and apartment buildings that were dutifully aligned along the sidewalks in the recently devised order of the renovated areas. While everyone could welcome the light, air, and running water, there were plenty of people who felt they had lost their past, that the city no longer belonged to them. Through forces much larger than themselves—government power and private capital—all under the name of progress, Paris had been snatched from their grasp, seemingly forever. Many people thus felt estranged in their once familiar surroundings, adrift and yet an intimate part of this newly constituted body, isolated even though they were surrounded by thousands like themselves. Those who felt this most poignantly were the thousands who were actually forced out of their dwellings either by increased rents or by losing their homes to the demolition. They were obliged to relocate, generally in different neighborhoods if they stayed in the city at all. Many left the capital for cheaper housing in the suburbs.

*Braque concentrated on still life from 1917.
"In a still life, space is tactile, even manual,
while the space of a landscape is a visual space,"
he said.* Guitar, Glass, and Fruit Dish on
Sideboard, *with its composition built up of*
*overlapping planes and a patterned surface,
demonstrates this preference for an art that
plays with the flatness of a canvas rather than
one that attempts to re-create the three-
dimensionality of the real world.*

But Paris continued to grow as an arena for amusement and spectacle. Indeed, with a swollen population and an increased need for leisure distractions, the spectacle spilled out from its more confined spaces into the broader public arena—the huge new outdoor cafés, for example, and the numerous new parks, particularly the Bois de Boulogne, which was annexed to the city in 1848 and entirely reconfigured between 1852 and 1858. It also stretched out into the surrounding countryside, primarily because more and more people moved there, transforming those once agrarian areas into modern suburbs complete with new streets and sewer systems, recently built single-family houses on individual plots of land, and leisure activities such as gardening and pleasure boating. While the suburbs and their offerings could seem some distance from Paris, they were actually linked to the city by social customs, work, and the recently constructed railroad, thus making one space merely an extension of the other.

It was this spectacle—in city and suburb—that the Impressionists rendered over and over again in the 1860s and 1870s, immortalizing places where the social swirl occurred—the cafés, restaurants, racecourses, and circuses in the city, for example, and the outdoor pleasure spots, backyards, and boat-filled stretches of the Seine in the suburbs. When people gathered in those places they bore witness to their time, as they generally were men and women who seemed both carefree and wary, self-sufficient and dependent, people who out of necessity put a premium on posturing—such as the nude in Manet's *Le Déjeuner sur l'herbe*, or his semidressed female in front of her mirror. They were people whom the Impressionists would catch unawares in private moments of reflection, like Renoir's woman with her parrot, people whose identities could shift if placed in a different context or painted in a different style, just as the places themselves could be understood to be quite different if the larger environment was revealed.

Renoir's painting *Woman with Parrot* is a case in point, for it is actually not as straightforward as it initially appears. The room is an unlikely combination of a conservatory and a living room that is spatially peculiar, particularly in the area behind the figure. Renoir reinforces this spatial ambiguity by consciously disrupting the perspective lines on the right, where the edge of the plant stand breaks the wainscoting and wall pattern. The stand is also impossibly rendered, with its turned legs seemingly unconnected to its distorted top. And the woman herself may be less innocent than one assumes, judging from such details as the brilliant red plumage of her sash, the charged extension of the potted plant's foliage, and the dark lushness of the arcing plants behind her. Perhaps most significant are certain analogies between the woman and the parrot, particularly the way that Renoir has her gazing at the bird just as we look at her in the painting. Even the folds in the middle of her dress imitate the parrot's layers of feathers, while the pleats at the bottom of her gown echo those at the feet of the plant stand supporting the cage, and the gold of her earring is the same color that highlights the parrot, the stand, and the cage. Thus, the figure who had appeared to be a typical middle-class woman in her own well-cared-for house could instead be someone imitating that societal type. All of a sudden, she becomes less an independent creature and more a kind of tropical species who has alighted in this hothouse environment

either for her passing pleasure or for someone else's. As in Manet's painting, Renoir seems to be suggesting that nothing is ultimately secure in this late-nineteenth-century world, a world in which values are as fluid as the paint on the canvas, just as personal facades are as interchangeable as the categories of painting that this work could occupy. Such ambiguity was a constant issue in these Impressionist paintings, whether they critiqued, embraced, or disguised it.

While evident most often in Manet's work, this sense of a fractured, contradictory world at once fascinating and unnerving is suggested even in paintings that are seemingly free of such concerns, such as the still lifes in the Thannhauser Collection that Cézanne produced at the very same time as Manet's *Before the Mirror*. Although these canvases could hardly have been realized without the example of someone such as Jean Baptiste Siméon Chardin, whose achievements in the genre in the eighteenth century were touchstones for all who followed, Chardin could never have conceived of arrangements like these, for his preindustrial world was too hierarchical and forthright. The world Cézanne appears to be rendering is filled with tensions—of folds pulling against tabletops, of fruits competing for positions, of objects appearing to be on different levels even though they are supposed to be sitting on continuous flat surfaces, of one reality (the still-life arrangements) set off against another (the artfully composed wall coverings in the backgrounds). Unlike in Chardin's paintings, ambiguities abound in these works. Is the brown triangle in the lower right of *Still Life: Flask, Glass, and Jug* (ca. 1877) the dropped leaf of the table or part of the wall behind it? Why does the edge of the table in this picture change several times, and how does the cloth extend out so rigidly on the right? Why do we see so far into the glass in the center, and why is the reflection in that glass a blue-white stripe? Why do the vase and jug cast no shadows while seeming to float on green touches of paint? In *Still Life: Plate of Peaches*, (1879–80) how can the tablecloth stick out so sharply on the left? Why does the background wall change between the bottom-left quadrant and the area under the table? And why does the dark form in the center of this still life appear to be trying to maintain a hold on the blue plate by means of the extended green stem? Everything is as tentative and perplexing as it is stable and tangible, a contradiction that is underscored in *Still Life: Plate of Peaches* by the way forms appear to be going in different directions or contained in distinctly separate spheres, all held together by the sheer force of Cézanne's aesthetic will.

Those contradictions would be taken to their logical extreme in the first two decades of the twentieth century when Georges Braque and Picasso systematically dismantled and then reconstructed pictorial reality in the form of Analytic and Synthetic Cubism, resulting in works such as Braque's *Guitar, Glass, and Fruit Dish on Sideboard* (1919), also in the Thannhauser Collection. The crisp, clear-cut forms in this picture are far from Cézanne's painterly ensemble; but Braque's arbitrary lighting, multiple perspectives, and cropped and flattened shapes rigorously integrated to suggest a tentative but believable structure all ultimately derive from Cézanne's initiatives. In addition, Braque's architectonics, so artfully concocted by setting up a counterpoint of shapes and colors using his keen sense of a form's weight and measure, is the product of a similar urge to negotiate a truce between opposing

Paul Cézanne
Still Life: Flask, Glass, and Jug, *ca. 1877*
*Oil on canvas, 45.7 x 55.3 cm (18 x
21 ³/₄ inches)*

To Cézanne, still life was as appropriate a vehicle for making art as any other genre. He once declared that he wanted to astonish Paris with an apple. The simple objects he chose were appropriate to his analysis of form and color. He used the wallpaper pattern in Still Life: Flask, Glass, and Jug *in other paintings, altering the placement of the lozenges for each composition.*

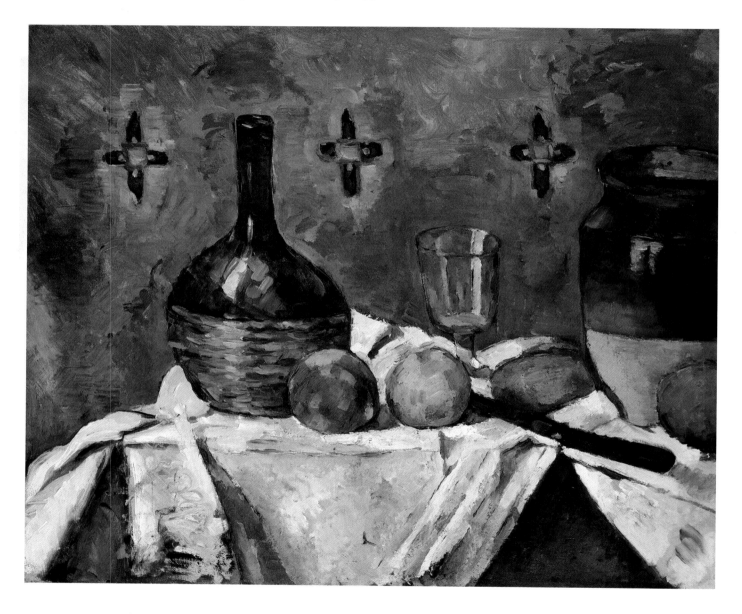

Paul Cézanne
Still Life: Plate of Peaches. 1879–80
Oil on canvas. 59.7 x 73.3 cm (23 ¹/₂ x
28 ⁷/₈ inches)

Exhibiting with the Impressionists for the last time in 1877, Cézanne rejected Impressionism's interests in temporal light effects as perceived by the artist. He worked meticulously to obtain what he believed was a less subjective and more lasting art. In Still Life: Plate of Peaches *the flower and leaves on the wallpaper become active elements rather than part of a passive background. Likewise, the fabric under his objects carries as much weight as the fruit.*

Edgar Degas
Dancer Moving Forward, Arms Raised,
1882–95
Bronze, height 35 cm (13 ¾ inches)

factions and to find order and meaning in an apparently disorderly world.

One senses this same struggle in much of the work of these Impressionist artists, despite the accessibility of their subjects or the apparent beauty they seem to describe. It is even evident in Degas's sculptures, such as the three in the Thannhauser Collection, for these works too are studies in contrast. In *Dancer Moving Forward, Arms Raised* (1882–95), note her ascending upper torso but also the weightiness of the figure, the gracefulness of her gestures but the roughness of her form, and the classical prototypes she suggests along with her inevitable roots in the late nineteenth century (down to her "primitive"-looking face and her distorted cranium). The figure in *Spanish Dance* (1896–1911) is thinner and more elongated than her mate, but she is endowed with even-more-perplexing features. She confidently assumes the classical fourth position, but her equilibrium appears threatened by the arc of her body and her exaggerated contrapposto. Her right leg strains to achieve full extension, while her left struggles to maintain its rigid position with the foot flat on the ground. Her two arms, tightly held in opposing planes, echo her taut legs. The arms appear to define counterbalancing spaces that she stretches to possess in order to accentuate the tensions in the work between masses and voids, tentativeness and resolution. *Seated Woman Wiping Her Left Side* (1896–1911) carries these contrasts and rhythms to their logical extreme. How awkwardly posed this poor woman is and how unfairly she is caught in such a private moment. Yet how remarkable she is to be able to remain as a whole. For although her feet are firmly planted and her thighs and buttocks rest on a stump for support, she seems to be trying to extricate herself from the mass of material behind her as much as she is drying herself off. One senses this in the diagonal thrust of her torso, the triangle of her bent left arm, and her turned and lowered head. It is also evident in the rough texture of the towel and the stump, which are the opposite of her smoother, rounder form. Voids compete with masses here. Certain elements defy reason, such as the extension of the towel off the base, an artful ploy that recalls the tablecloth in Cézanne's still lifes, just as Degas's manipulated surface and sense of ambiguity hark back to Manet's *Before the Mirror*. The latter qualities are even more evident in Degas's *Dancers in Green and Yellow*.

In this magisterial pastel, Degas permits all of his powers to flourish, from his masterful draftsmanship and sensitivity to color to his painterly inclinations and jarring compositional strategies, all of which both support and compete with each other, just as Manet had allowed in his earlier painting. The figures of the four dancers are evoked by a raw chiaroscuro and by boldly applied outlines of murky gray-browns, blacks, and blues. But how ill-defined their forms and facial features are, how pasty and unattractive is their skin, and how awkward and ungainly are their stances, especially the positions of the two dancers on the right. The latter squats so low she is barely discernible; her tutu is quite separate from the front of her slumped body, her head unmercifully cut off by the edge of the paper. The curtain behind them is an aesthetic tour de force. Its blotchy, overlaid marks and moments of surprising calligraphy extend the kind of marks Degas employed to describe the dancers and their costumes, while its freedom and ambiguity underscore the unresolved qualities of the work as a whole. Three of the four women rest their hands on the curtain

Spanish Dance *was not Degas's title; his*
bronzes, cast after he died, were named in
1921, *when they were first exhibited. For*
Degas sculpture was personal, something that he
used at first both to work out ideas and to help

him better express himself in two-dimensional
mediums. Offers were made to cast some of the
works, but he did not acquiesce, not wanting to
make of them something permanent.

and push it back as if to see beyond it; but it remains for them, as it does for us, a critical element in the scene as well as a kind of obstacle to awareness, something the last dancer tries to overcome by sticking her head around it. What she and her colleagues seek with such intensity is left to our imagination, but it surely has to do with the nature of their enterprise—the pursuit of approval and success through the creation of something desirable. In their case, it is the creation of a world of grace and order wrought without apparent effort from the mastery of their bodies and the perfection of their craft. That such attractive features are essentially absent or only inferred here is not surprising, as Degas, like Manet and the other Impressionists, clearly sought to question rather than affirm the unconditional existence of such a world. Degas emphasizes this by taking us backstage and reversing the normal relationship of the spectator to the performance, revealing behind the scenes the humanness of the dancers' enterprise and the conflicts of their existence. He also allows us to ponder the realities of his own struggles as an artist in the twilight of a long career. Little wonder, therefore, that the picture is so open-ended or that Degas has disguised nothing, not even the pieces of paper he added at the top and bottom of the sheet or the multiple layers of transparent touches with which he built up the image.

Also made just after the turn of the century, but so different from Degas's dancers, is Aristide Maillol's *Woman with Crab* (ca. 1902 [?]–05) in the Thannhauser Collection. Although she appears as involved in what she is doing, and though she squats in an uncomplimentary fashion like the last dancer on Degas's stage, Maillol's woman appears much calmer and more restrained, more playful and innocent. She also seems unconcerned about anything outside of her sphere, as if she were circumscribed by the rectangular shape of her base. Fuller and more classical, she does not have to struggle for existence in the same manner as Degas's ballerinas or bather, for she is a kind of earth goddess, weighty but removed, recognizable but otherworldly, someone who reminds us of our humanity but also of our origins and long-lost ideals.

These opposing works could have been done in nearly the same year primarily because they were the products of artists of two quite different generations. Born in 1834, Degas was more than twenty-five years older than Maillol, who was born in 1861, the year of Manet's debut at the Paris Salon. Coming long after the call to be of one's time had been uttered and answered, Maillol turned not to the contradictions of his particular moment in time but to the classical world of the past as a kind of escape from those forces that Degas and the Impressionists had been attempting to describe. It was a way of finding solace and purity, qualities that many others in addition to Maillol had begun to claim were necessary antidotes to the pressures of modern life and its wholehearted embrace of the ideals of progress.

This questioning had actually begun among the Impressionists themselves in the late 1870s, when, for example, Monet abandoned Paris and its suburbs where he had lived for nearly twenty years, moving first to Vétheuil and then to Giverny. Over the course of the next four decades he concentrated primarily on views of unaltered nature. In 1880, Monet even returned to the Salon, as did Renoir, who soon thereafter claimed he had "wrung

Degas's women have been referred to as naked rather than nude because they are not idealized. The pose of the seated woman leaning forward seems adventurous in light of Degas's lack of proficiency in building structurally sound works. In addition to the weaknesses in his improvised armatures. Degas tried to rework the statuettes time and time again. a stress the materials. clay in particular. could not withstand.

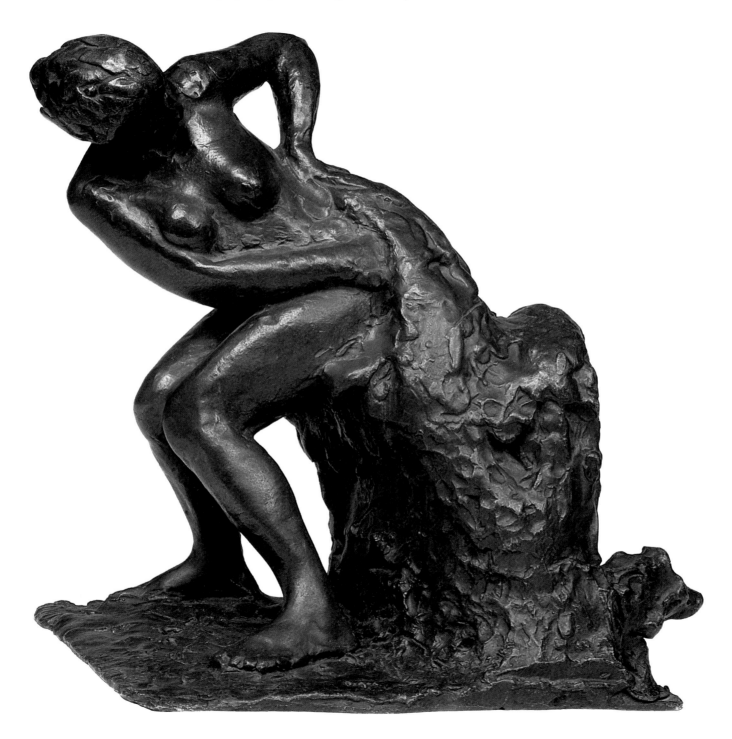

Aristide Maillol
Woman with Crab, *ca. 1902(?)–05*
Bronze, *15.2 x 14.6 x 12.1 cm (6 x 5 ³/₄ x 4 ³/₄ inches)*

Through the monumental and reserved qualities of his sculptures, Maillol sought to renew the classical. The woman represented here, whose beauty is achieved by simplification of the forms of the human body, seems unconcerned with the exterior world. Because Maillol frequently made several versions of compositions such as this one, assigning dates to them is often difficult.

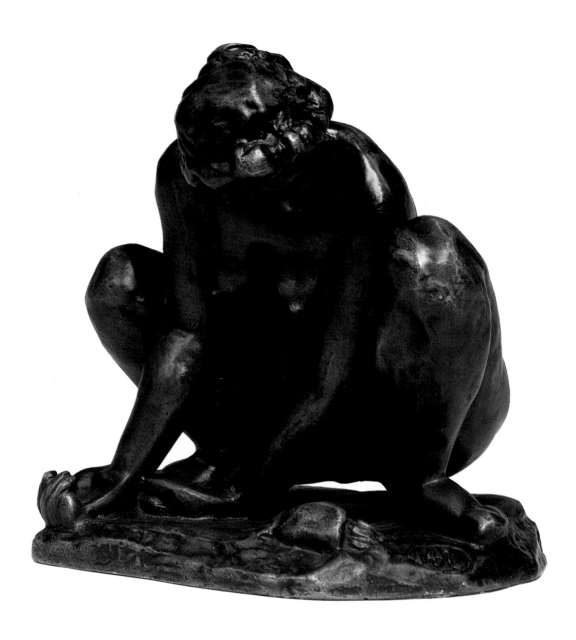

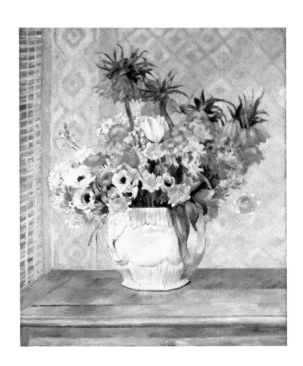

Impressionism dry" and went off to Italy to study Raphael and antiquity.[16] The results for Renoir were paintings such as the Thannhauser Collection's *Still Life: Flowers* (1885), whose precise, chalky touch is just the opposite of the liquid surfaces of Renoir's earlier work. There are no ambiguities, disruptions, or imbalances here, no sense of the dilemmas of modern life—only a scaffolding of strong horizontals and verticals that constitutes a rigorous new order, enhanced by a slightly irregular but still highly regimented decorative patterning. The painting breathes an air of distilled confidence, as if this is what Cézanne's earlier still lifes aspired to but never would have accommodated, given Cézanne's desire to grapple with the mythologies of such a tempered, exacting balance. Cézanne suggests this desire even more emphatically in a portrait of his wife Hortense, *Madame Cézanne* (1885–87), painted at nearly the same time as Renoir's still life.

Whereas Renoir propagates the recovery of the past and a strict adherence to its higher principles, Cézanne implies in this touching image the near impossibility of even envisioning such a renaissance. Though the product of a single working session—and thus not a finished painting, according to standard definitions—and though informed by his own problematic relationship with his wife, Cézanne's portrait in many ways is a complete statement not only about his personal travails as a husband and a father but also about the conditions of the later nineteenth century. For Hortense in this portrait is like Degas's dancers or the *Seated Woman Wiping Her Left Side*; she too is isolated and yet connected, searching for meaning without knowing where or whether it exists. One senses this in her forlorn but penetrating stare, her tilted but firmly supported head, and the highlights that boldly illuminate her before clashing so forcefully with the resulting shadows. One also senses it from the way Cézanne subtly divides her in two along a central vertical axis. On the left, where the light is strongest, she appears Botticelli-like, almost angelic, with features such as her eye and nostril sharply defined. On the right, everything becomes darker and more careworn. Her eyelid hangs heavier, her nostril is flared, and her lip turns up in an unpleasant snarl. Her hair is more tightly compressed against her head on this side, while the brushwork in the background is at once more agitated and regularized than on the left. It is as if we are seeing two sides of this complicated woman, or two sides of Cézanne or the modern individual. Whatever the case, there appears to be no resolution, no apparent middle ground between what Cézanne suggests to be familiar oppositions of desire and rejection, involvement and independence, or between being a lover and a victim, a saint and a sinner. With the truths of the past long lost to the present, the only thing one can be assured of, Cézanne seems to be asserting, is the existence of this dialectic, something Matisse would reiterate in his *The Green Line, Portrait of Mme. Matisse* (1905), whose similar divisions and even bolder colors and strokes is the twentieth-century version of Cézanne's prescient formulation of the modern condition.

When rooted in more specific realities of the late nineteenth century, this dialectical phenomenon could become both more graphic and more pathetic, especially when an artist such as Henri de Toulouse-Lautrec takes us into the airless salons of Paris brothels, as he does in the Thannhauser Collection's *Au Salon* (1893). Isolated within their own worlds,

Henri de Toulouse-Lautrec
Au Salon, 1893
Pastel, gouache, and pencil on cardboard,
53 x 79.7 cm (20 ⁷/₈ x 31 ³/₈ inches)

Toulouse-Lautrec's interest in the psychology of real people—not studio models—led him to look for his subjects in dance halls, theaters, and circuses. Between 1892 and 1896 he often depicted brothel scenes, finding the women there to be candid models. The central figure of Au Salon is recognizable in other works. The lack of interaction between the three women may suggest the effects of submission and boredom on their psyches.

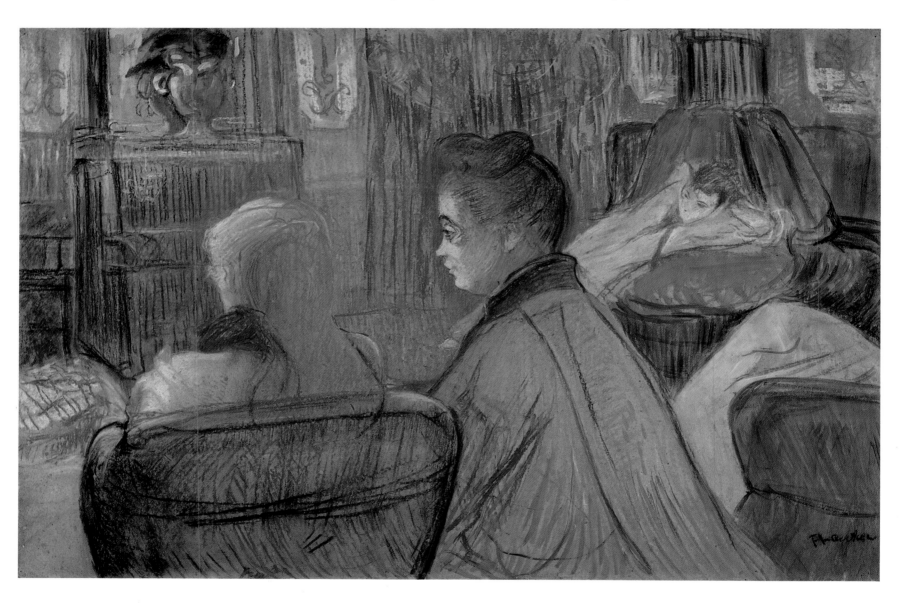

though connected by circumstances and Toulouse-Lautrec's artful formal arrangement, the three women in this scene have nothing to say to each other and, for the moment, do nothing except stare off into space. Nothing is happening here; no sound disturbs the silence, no sense of urgency disrupts the ennui. All of the mystery and potential of Manet's *Before the Mirror*, all of the eagerness and inquisitiveness of Degas's *Dancers in Green and Yellow* are gone. Instead, the weight of fate hangs over the scene, permitting none of the women to rise without being cut off by the frame. Compressed into their restricted space, the women become reflective but forsaken occupants of this well-appointed space, stuck by necessity or volition in a system of exchange that requires their submission. Pleasure is not a factor here; aspirations and meaning have apparently evaporated.

However, artists could find meaning in making art about this loss of innocence and the apparent decline of modern life, as Toulouse-Lautrec and others did around the turn of the century, fulfilling in their own manner the same imperative that had motivated their Realist and Impressionist predecessors thirty and forty years before. Some artists took certain subjects, such as the streets of Paris, that had preoccupied those earlier generations of avant-garde artists and reconstituted them in ways that would extend the possibilities of painting while affirming the continuing vitality of modern urban life, whether or not it was still accurate. Few artists were more up to this task than Edouard Vuillard, whose views of the capital, such as the Thannhauser Collection's two panels from 1908–10 depicting the Place Vintimille, look back to images of the city by Monet and the Impressionists but also stake out quite different territory. Indeed, the Impressionists' prototypes from the 1860s and 1870s seem almost finicky by comparison to these tall, broadly painted panels. Their decorative qualities suggest Vuillard's novel attempt to domesticate the urban environment and seduce his audience by the sheer artifice of his craft, an option that Matisse took to its logical extreme in his views of Notre Dame in the following decade.

But, ironically, the one subject that attracted the most interest during this period was the one that was the most traditional, or at least the most nonmodern, and that was landscape. It is ironic because it would seem that nature, whether it was spoiled, untamed, familiar, or exotic, was too timeless and unpresupposing to bear the weight of contemporary concerns. Yet over and over again it provided avant-garde as well as Salon artists with the means to express what van Gogh described in a letter of 1888 in the Thannhauser Collection as "something passionate and eternal."[17] One senses much of this in van Gogh's own landscapes, several of which are in the Thannhauser Collection—in the rolling seas in his drawing of *Boats at Saintes-Maries* (1888), in the quivering trees and intense sun in his drawing of *The Road to Tarascon* (1888), in the strong perspective lines and distant mountains in *Landscape with Snow* (1888), and in the seething forms of his view of Saint-Rémy. How vital these images are; how impregnated with feeling and how novel are their surfaces. Van Gogh had learned his lessons well during the year he spent in Paris prior to producing these works, as is evident when they are compared with his *Roadway with Underpass* (1887), also in the Thannhauser Collection. In this work, his former Dutch palette of earth tones and surface of caked-on paint have been abandoned for higher-valued hues and a mixture of

Henri Matisse, The Green Line, Portrait of Mme. Matisse. *1905. Oil on canvas, 40.5 x 32.5 cm (15 ⅝ x 12 ¹⁵/₁₆ inches). Statens Museum for Kunst, Copenhagen. Photo: Hans Petersen.*

Edouard Vuillard
Place Vintimille, 1908–10
Distemper on cardboard, mounted on canvas; two
panels: 200 x 69.5 cm (78 ³/₄ x 27 ⁵/₈ inches)
and 200 x 69.9 cm (78 ³/₄ x 27 ¹/₂ inches)

Vuillard depicted life in Paris with a tone much
lighter than that of Toulouse-Lautrec. Place
Vintimille exhibits the muted colors, decorative
qualities, and spatial effects common to his
oeuvre. These two panels, part of a series of eight

Paris street scenes painted for the home of a con-
troversial playwright, show the square visible
from Vuillard's apartment.

Impressionist and Divisionist techniques. Unlike the later pictures, however, everything in this view of a road near the boundary of the capital speaks about restraint and oppositions—sidewalks and trees, verdant banks and dry stone, bold strokes of paint and tight stippled marks. The strong geometric shapes—of the roadway and tunnel, the groomed banks and protruding chimneys—attest to the fact that almost everything in the scene has been manipulated by human hands, even though the human is only marginally present here. In contrast, everything in the later views emphasizes the profundity of the rural world and the fundamental importance of maintaining close contact with nature. Van Gogh suggests this most forcefully in *Mountains at Saint-Rémy* (1889), not only through the extraordinary rise and fall of the wavelike forms of the mountains but also by nestling the small house in the very trough of that activity, screening it from the road by the sentinel line of bulbous trees.

"It seems to me almost impossible to work in Paris," van Gogh declared to his brother in 1888 after leaving the capital for the beauties of the South of France, "unless one has some place of retreat where one can recuperate and get one's tranquillity and poise back. Without that, one would get hopelessly stultified."[18] And for van Gogh that retreat meant nature, the place where one could find one's primitive roots and ultimately oneself. Many artists in the last two decades of the nineteenth century felt this way, though none perhaps more strongly than van Gogh, Monet, and Cézanne. "We must not . . . be satisfied with retaining the beautiful formulas of our illustrious predecessors," Cézanne told the painter Emile Bernard in 1905. "Let us go forth to study beautiful nature, let us try to free our minds from them, let us strive to express ourselves according to our personal temperaments."[19] Like van Gogh and the dozens of artists who left Paris for the South—Paul Signac, Henri-Edmond Cross, and Matisse among them—Cézanne devoted much of his later work to an ardent dialogue with the beauties of his native Provence, returning time and again to paint emotionally charged sites, such as the majestic Mont Sainte-Victoire or the ancient Bibémus quarry outside his home in Aix. The results were canvases such as the Thannhauser Collection's view of the Bibémus quarry (*Bibémus*, ca. 1894–95), a seemingly simple image of elemental forms—earth, air, light, and water—which in Cézanne's hands become richly nuanced and filled with wonder. Shapes expand, contract, and slide across the surface of this painting, echoing and tugging with each other while affirming and denying the existence of space or any secure definition to the scene as a whole. Everything is at once immutable and in flux, ordinary and cryptic, as if nature and Cézanne's process of translating his sensations into paint still held deep mysteries and could continue to testify to the existence of significant meaning—both in art and in life.

One had to believe in that possibility at the end of the century in order to maintain some kind of stability, as well as to move forward; the world was simply becoming too disorderly and disturbing. Unless, of course, one retreated into a world that was truly of one's own making, a world in which imagination took precedence over vision, and artfulness usurped the place of experience. A growing number of artists in the 1880s and 1890s, led by people such as Odilon Redon, Gauguin, Maurice Denis, and Paul Sérusier, argued vigorously for such a withdrawal into the imaginative realm and for cutting ties to the visible and the

Henri Matisse. View of Notre Dame. *spring 1914. Oil on canvas, 147.3 x 94.3 cm (58 x 37 ⅛ inches). The Museum of Modern Art, New York. Acquired through the Lillie P. Bliss Bequest, and the Henry Ittleson, A. Conger Goodyear, Mr. and Mrs. Robert Sinclair funds, and the Anna Erickson Levene Bequest given in memory of her husband, Dr. Phoebus Aaron Theodor Levene. © 1992 The Museum of Modern Art, New York.*

Vincent van Gogh
Boats at Saintes-Maries. *late July–*
early August 1888
Pencil and ink on wove paper, 24.3 x 31.9 cm
(9 ⁹/₁₆ x 12 ⁹/₁₆ inches)

Before moving from Paris to the South of France in February 1888, van Gogh had been studying Japanese prints. After his arrival in Arles he was impressed by the beauty of the land and the strong sun, which solidified the connection in his mind between the Far East and the South. He may have chosen to use reed pen and ink in this and other drawings of the summer of 1888 to emulate Japanese art.

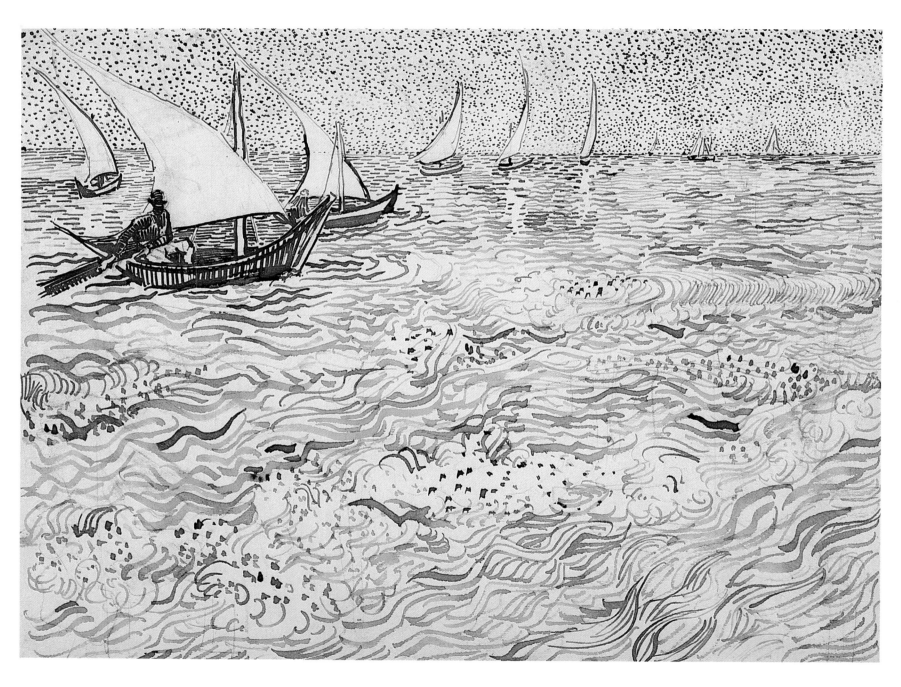

Vincent van Gogh
The Road to Tarascon. *late July–*
early August 1888
Pencil and ink on wove paper. 23.2 x 31.9 cm
(9 ¹/₈ x 12 ⁹/₁₆ inches)

Van Gogh made drawings, including The Road to Tarascon *and* Boats at Saintes-Maries. *after finished paintings to send from the South to his brother and friends. The painting he copied for* The Road to Tarascon *includes a figure of himself weighed down with art supplies, perhaps added after the drawing was made.*

Vincent van Gogh
Landscape with Snow, *late February 1888*
Oil on canvas, 38.2 x 46.2 cm (15 ¹/₁₆ x 18 ³/₁₆ inches)

Landscape with Snow *is believed to have been painted shortly after van Gogh arrived in the South of France in February 1888. He had gone there seeking a different and stronger light for painting, and was surprised to find snow on* the ground and more falling upon his arrival in Arles. He took advantage of the unusual weather conditions, however, painting two snowy landscapes.

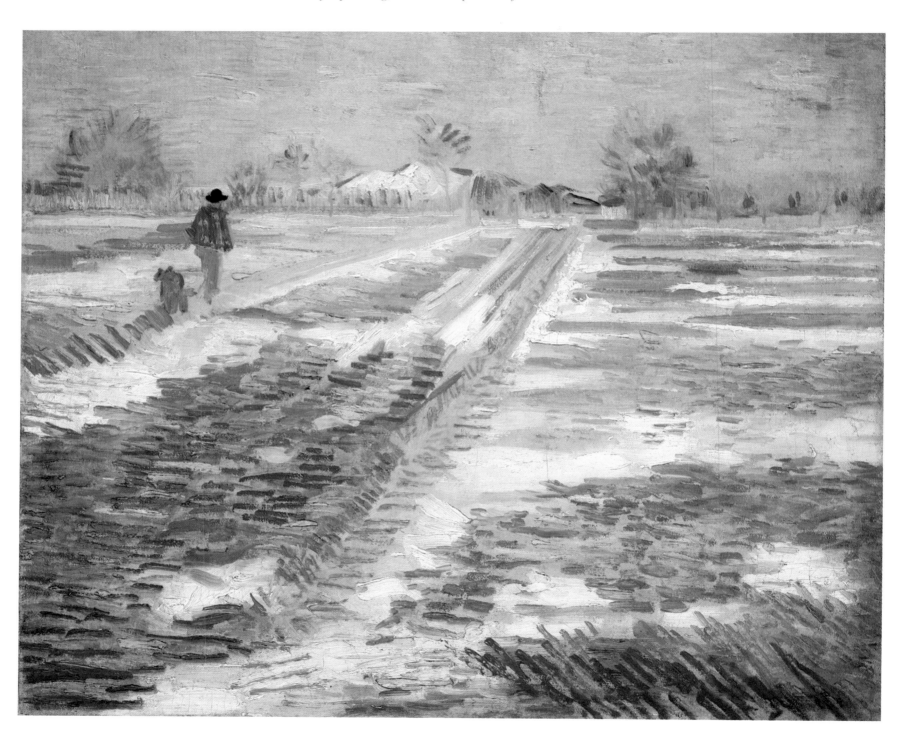

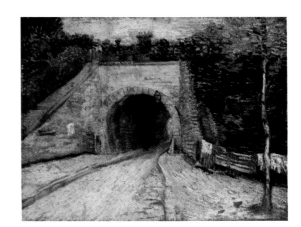

known, claiming that such allegiances were inhibiting and thus expendable. "The Impressionists . . . look and perceive harmoniously, but without any aim. . . . They heed only the eye and neglect the mysterious centers of thought, . . ." Gauguin asserted in 1896–97. "They are the officials of tomorrow, as bad as the officials of yesterday. . . .When they speak of their art, what is it? A purely superficial art, full of affectations and purely material."[20] To Gauguin and his fellow Symbolists (as they soon became known), art had to be based on things of the mind, on thoughts, dreams, memories, and intuition, with abstract elements of line, color, shape, and surface dominating plastic form or spatial illusion. For some of these fin-de-siècle artists, this was a way of fulfilling religious aspirations; for others, it was a means of appropriating for painting the abstract powers of music and asserting the superiority of their particular art form; for still others, it was simply a way of staying at the forefront of French cultural production. Whatever the motivation, most of these Symbolists wanted to suggest something purer and more refined than anything that existed in the world and thereby empower painting (and themselves) to reveal higher truths. They had concluded that verisimilitude was a shackle, and so was the world, which was too rife with corruption and too riddled with inconsistencies to merit their faith, as Gauguin constantly charged. "A terrible epoch is brewing in Europe for the coming generation: the kingdom of gold," he wrote. "Everything is putrefied, even men, even the arts."[21]

Their only alternative, they decided, was to retreat into the mind or into some form of mysticism—a path followed by Redon and the Nabis (Denis, Sérusier, etc.)—or to leave the environment that had bred the unhealthy worship of progress in the first place. But for Gauguin, who chose to go, fleeing Paris for the sun-filled South or the wilds of Brittany was not enough; one had to cross oceans and continents and find a place untainted by the West. After a visit to Martinique, Gauguin sailed off to the South Sea islands, settling in Tahiti in 1891 and finally in the Marquesas Islands, where he died in 1903. It was there, among "uncivilized" peoples, he said, "Far from that European struggle for money. . . . I shall be able to listen to the sweet murmuring music of my heart's beating, in amorous harmony with the mysterious beings of my environment."[22] And it was there that he attempted to renew Modernist art with paintings such as the Thannhauser Collection's *In the Vanilla Grove, Man and Horse* and *Haere Mai*, both from 1891. These works consciously defy many of the time-honored techniques of painting. Modeling is abandoned in these pictures for a more random play of chiaroscuro, resulting in flatter forms and seemingly arbitrary patterns; space is suggested not by Renaissance perspective but by cruder overlapping and vertical arrangements of simple shapes; color is employed for its evocative rather than its descriptive power; and no concern appears to be paid to harmonizing the conflicting, disassociative marks of the brush or to coordinating the forms into a more balanced composition. Even the supports are unsophisticated, for Gauguin painted these scenes on rough burlap, the surfaces of which establish their own patterns distinct from the image, particularly in *Haere Mai*. Like the frankness with which Gauguin employs the elements at his disposal, these patterns call attention to themselves and to the artifice inherent in the traditions of Western picture making.

Paul Gauguin
In the Vanilla Grove, Man and Horse,
1891
Oil on burlap, 73 x 92 cm (28 ³/₄ x
36 ¹/₄ inches)

Originally intending to establish a studio in the tropics to which his friends could come and work, Gauguin traveled alone to Tahiti to escape the Europe he saw going into decay. He arrived in June 1891. Although he believed

"primitive" art to be superior to that of the West, he used a frieze from the Parthenon as a source for the man and horse in this painting. Two female figures in white are discernable working amidst the trees.

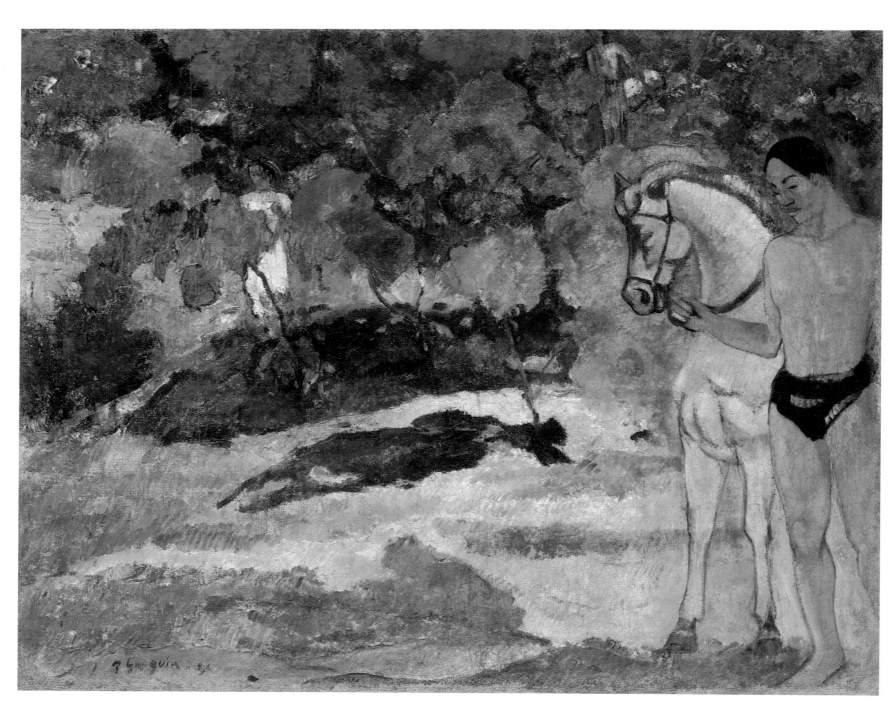

Paul Gauguin
Haere Mai, 1891
Oil on burlap, 72.4 x 91.4 cm (28½ x 36 inches)

Gauguin was disappointed that the Western world had already tainted Tahiti: the French government was encouraging development of its colony and missionaries were trying to gain converts. In spite of these realities, he did little to dispel the myth of a pristine paradise. He painted the Tahitian words "Haere mai" ("Come here!") on this painting to add to its exotic effect, even though the phrase has little meaning in the context of the landscape with swine.

While extraordinarily fruitful, Gauguin's flight from civilization was filled with irony, for the West had discovered the South Sea islands long before this self-proclaimed savage artist arrived. Much to his consternation, natives had already been converted to Christianity by zealous missionaries; old tribal customs had been compromised by European officials who had imposed new administrative and legal systems; even part of the once tropical jungle had been developed into a club for the distraction of French officers. The islands still possessed a lush beauty and a primitive charm, but they were not as pure as Gauguin—or as most French men and women—had been led to believe. Gauguin did nothing to alter those perceptions. Indeed, he wholeheartedly continued to propagate the myths of tropical splendor that had brought him there, heightening the exotic appeal of his paintings by employing such fanciful colors as the pinks, blues, lime-yellows, and oranges that appear in the two Thannhauser pictures. He also gave his paintings Tahitian titles, such as *Haere Mai*, even though he did not speak the language at the time. ("Haere mai" translates simply as "Come here!" and thus is apparently meaningless in terms of what the painting depicts.) In addition, he often based his images not so much on what he may have seen or experienced in his adopted paradise but on elements derived from his Western heritage. The man and horse of *In the Vanilla Grove*, for example, are Gauguin's island versions of similar figures in the Panathenaic frieze from the Parthenon in Athens.

On one level, all of this could be seen as a pathetic charade, made worse by the fact that Gauguin brought to Tahiti the Western disease of syphilis, which he freely dispensed to innocent women who succumbed to his sexual advances. However, on another level, his venture into what inevitably proved to be a paradise lost—and the enormously rich body of work that resulted—was the ultimate culmination of the century's attempt to redefine itself before it closed and to try to discover new value in human existence beyond the material rewards of capital. Although that attempt was only partially successful, just as Gauguin's quest was only partially fulfilled, it was a logical and necessary process for people concerned about the future to go through, particularly those living and working in France, the cultural leader of Europe at the time. That such a search would pull people like Gauguin so far from France's shores also stands to reason. Even van Gogh felt that "the future of painting is in the tropics, either in Java or Martinique, Brazil or Australia."[23] The Western world appeared to them to be too old and misguided to have the vision or stamina to be able to make meaningful art out of life.

Van Gogh and others were wrong in this regard, although the "primitive" forms of African, Oceanic, and Iberian sculpture would help renovate Western art in the early twentieth century. Van Gogh was also incorrect when he assessed his own posterity. In his typical self-deprecating fashion, he declared that neither he nor Gauguin would be "the men of that future," although he was certain that such people existed and that they were practicing their craft as he wrote.[24] He was correct on that count, for when he was penning those hopeful lines to his brother Theo in June 1890—just a few weeks before he put a gun to his head to end his life—the twenty-one-year-old Matisse and the nine-year-old Picasso were completing their very first paintings. Although Matisse was working in Bohain-en-

Paul Cézanne
Bibémus, ca. 1894–95
Oil on canvas, 71.5 x 89.8 cm (28 1/8 x
35 3/8 inches)

Cézanne had moved to Aix-en-Provence in
1882, giving up on winning public acceptance
for his art. Bibémus, the site of a quarry not far
east of the town, has been identified as the sub-
ject of this painting. The painting shows how

Cézanne studied the surfaces of his subject thor-
oughly before breaking them down into small,
colored planes. Often when he felt he had
obtained the right balance in a work he stopped
painting, leaving areas of canvas uncovered.

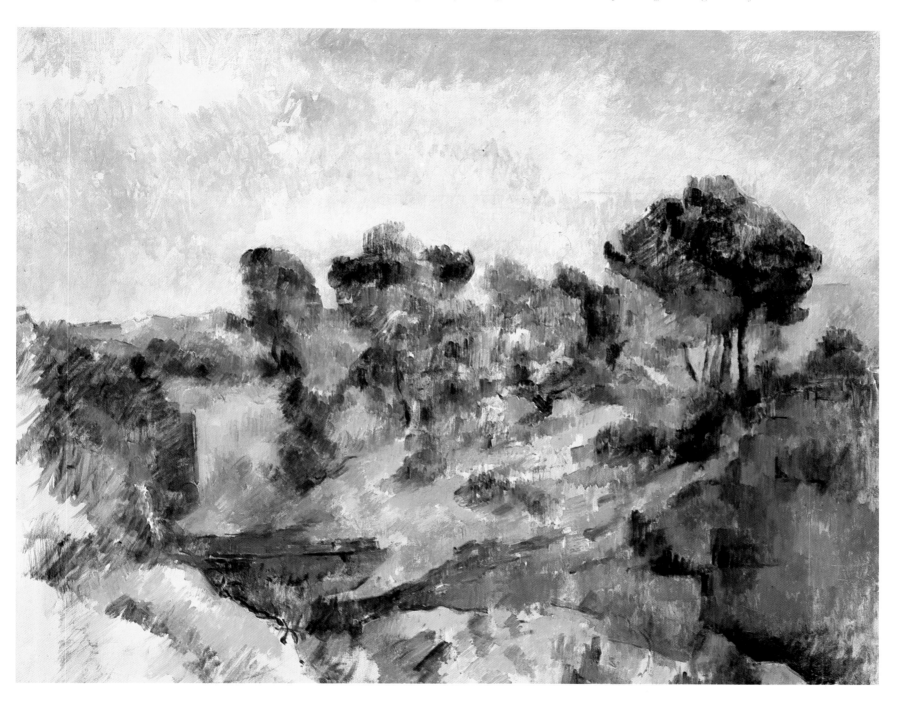

Vermandois outside Saint-Quentin in northern France and Picasso in Málaga on the southern coast of Spain, they would ultimately converge on the same French capital that had nurtured the Impressionists and their Post-Impressionist heirs and that would do the same for these two nascent giants. It was there that they, like so many other artists of their generation, would learn the lessons of their Modernist predecessors and carry their innovations—and their struggles—into the even more complex and contradictory twentieth century.

Notes

1. For the reactions to the so-called first Impressionist exhibition see Jacques Letheve, *Impressionnistes et symbolistes devant la presse* (Paris, 1959), pp. 59–70; Hélène Adhémar and Sylvie Gache, "L'exposition de 1874 chez Nadar," *Centenaire de l'impressionnisme*, exh. cat. (Paris: Grand Palais, 1974), pp. 221–70; Ian Dunlop, "The First Impressionist Exhibition," *The Shock of the New* (New York, 1972), pp. 54–87; Paul Tucker, "The First Impressionist Exhibition in Context," *The New Painting: Impressionism 1874–1886*, exh. cat. (The Fine Arts Museums of San Francisco, 1986), pp. 92–117; and Paul Tucker, "The First Impressionist Exhibition and Monet's 'Impression: Sunrise': A Tale of Timing, Commerce, and Patriotism," *Art History* 7 (December 1984), pp. 465–76. On van Gogh's plight and legend, see Carol M. Zemel, *The Formation of a Legend: Van Gogh Criticism, 1890–1920* (Ann Arbor, 1980). The conversion of old French francs to present U.S. currency is tricky business. In most of the literature on Impressionism, the price of Impressionist paintings is converted at five francs to a dollar. However, this is woefully inaccurate, as it takes few economic factors into consideration, such as the relative value of the franc at the time, inflation, and the eventual devaluation of the French currency. My conversion is extremely crude, but it is an attempt to redress the notion that these paintings were almost valueless. It is based on the fact that doctors and lawyers in Paris in the 1870s were earning approximately 10,000 francs a year; workers made 2–3,000. One hundred francs, therefore, would have been a more substantial sum to either group than has been generally admitted. Today, those professionals make considerably more than their nineteenth-century counterparts. If one used the same ratio of a hundred francs as one percent of a professional's annual income in 1870 and took $40–50,000 as a minimum salary for a professional today, that hundred francs would be the equivalent of four to five hundred dollars. Obviously, there are problems with such ratio applications, but the final figure of several hundred dollars suggests something closer to the relative value of these paintings than what formerly has been asserted.

2. See Claude Monet letter to Durand-Ruel, July 28, 1885, as quoted in Daniel Wildenstein, *Claude Monet: Biographie et catalogue raisonné*, vol. 2, 1882–1886 (Lausanne, 1979), pp. 260–61. On America's enthusiasm for Impressionist art, see Hans Huth, "Impressionism Comes to America," *Gazette des Beaux-Arts* 29 (April 1946), pp. 225–52; and Frances Weitzenhoffer, *The Havemeyers: Impressionism Comes to America* (New York, 1986).

3. On this imperative, see George Boas, "Il faut être de son temps," *Journal of Aesthetics and Ideas* 1 (1941), pp. 52–65; and Linda Nochlin, *Realism* (Harmondsworth, 1971), chapter 3. Also see Thomas Crow, "Modernism and Mass Culture in the Visual Arts," *Modernism and Modernity* (Halifax, 1983), pp. 215–64.

4. See *Explication des Ouvrages de Peinture, Sculpture, Gravure, Lithographie et Architecture des Artistes vivants, exposés au Palais des Champs-Elysées* (Paris, 1859), pp. ix, x, as quoted in Anne Coffin Hanson, *Edouard Manet 1832–1883*, exh. cat. (Philadelphia Museum of Art, 1966), p. 15.

5. See Charles Baudelaire, *Art in Paris 1845–1862: Salons and Other Exhibitions*, trans. and ed. Jonathan Mayne (London, 1965), pp. 117–19.

6. See Charles Baudelaire, *The Painter of Modern Life and Other Essays*, trans. and ed. Jonathan Mayne (London, 1964), pp. 11–12.

7. On the transformation of Paris, see David H. Pinkney, *Napoleon III and the Rebuilding of Paris* (Princeton, 1972); Louis Chevalier, *La Formation de la population parisienne aux XIX siècle* (Paris, 1946); and T. J. Clark, *The Painting of Modern Life: Paris in the Art of Manet and His Followers* (New York, 1984), especially chapter 1.

8. See Hector de Callias in *L'Artiste*, July 1, 1861; and Francion in *L'Illustration*, May 29, 1875, as quoted in George Heard Hamilton, *Manet and his Critics* (New Haven, 1954), p. 26 and p. 191.

9. See Théophile Thoré-Bürger in *L'Indépendence belge*, June 15, 1864, as quoted in Hamilton, *Manet* (see note 8), p. 61.

10. Emile Zola, "Mon salon: IV. Les Actualistes," *L'Evénement illustré*, May 24, 1868. English translation by the author.

11. See Emile Zola, "Les Naturalistes," *L'Evénement illustré*, May 19, 1868 in *Oeuvres complètes*, vol. 12 (Paris, 1969), pp. 866–69. English translation in Pissarro entry in this book, p. 163.

12. See Emile Zola, "Les Naturalistes," *L'Evénement illustré*, May 19, 1868 in *Oeuvres complètes*, vol. 12 (Paris, 1969), pp. 866–69. English translation by the author.

13. On the Intransigeants, see Stephen F. Eisenman, "The Intransigent Artist or How the Impressionists Got Their Name," *The New Painting* (see note 1), pp. 51–60.

14. Stéphane Mallarmé, "The Impressionists and Edouard Manet," *Art Monthly Review*, September 30, 1876. Also see Jean C. Harris, "A Little-Known Essay on Manet by Stéphane Mallarmé," *The Art Bulletin* 46 (December, 1964), pp. 559–63; and Crow, "Modernism" (see note 3).

15. Frédéric Chevalier, "Les Impressionnistes," *L'Artiste*, May 1, 1877, p. 331, as quoted in Paul Tucker, *Monet at Argenteuil* (London, 1982), p. 2.

16. See Barbara Ehrlich White, "The Bathers of 1887 and Renoir's Anti-Impressionism," *The Art Bulletin* 55 (March 1973), pp. 106–26; and Joel Isaacson, *The Crisis of Impressionism: 1878–1882*, exh. cat. (Ann Arbor: The University of Michigan, 1980).

17. Vincent van Gogh to Theo van Gogh, April 1888, letter no. 477a in *The Complete Letters of Vincent van Gogh*; vol. 2 (Greenwich, Conn., 1958), pp. 546–47.

18. Vincent van Gogh to Theo van Gogh, February [21] 1888, letter no. 463 in ibid., p. 525.

19. Paul Cézanne to Emile Bernard, n.d. [1905], letter no. 183 in *Paul Cézanne: Letters*, ed. John Rewald (London, 1941), p. 250.

20. From "Diverses Choses, 1896–1897," an unpublished manuscript by Paul Gauguin that appears in part in Jean de Rotonchamp, *Paul Gauguin, 1848–1903* (Paris, 1925), excerpts from which are translated in Herschel B. Chipp, *Theories of Modern Art: A Source Book by Artists and Critics* (Berkeley, 1968), p. 65.

21. Paul Gauguin to J. F. Willumsen, autumn 1890, as quoted and translated in Chipp, *Theories* (see note 20), p. 79.

22. Paul Gauguin to his wife Mette, n.d. [February 1890], ibid.

23. Vincent van Gogh to Theo van Gogh, June 17, 1890, letter no. 642 in *The Complete Letters*, vol. 3 (see note 17), p. 284.

24. Ibid.

Pablo Picasso
Femme dans un fauteuil, *1922*
Oil on canvas, 91.5 x 62.5 cm (36 x
24 ⁵/₈ inches)

With its simplified forms, generalized facial features, and classical drapery, used both to record sculptural mass on a flat canvas and to conjure the image of eternal woman, this work demonstrates the continuation of Picasso's classical style of the early 1920s. The seated woman was painted in Dinard, Brittany, where Picasso went to spend the summer with his wife Olga and their son, Paolo.

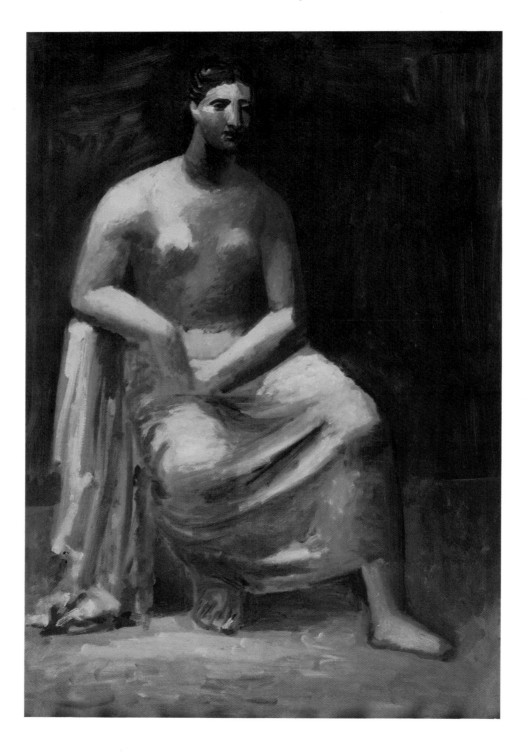

The Thannhauser Picassos
Fred Licht

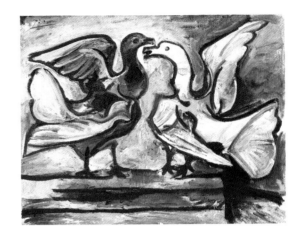

"All Europe contributed to the making of Kurtz," the novelist Joseph Conrad said of one of
his most powerful characters. The same is true of Pablo Picasso, but in addition to Europe
we should also include Africa, Asia, and the Americas. Out of an ever-bewildering and fasci-
nating diversity of sources, Picasso forged an oeuvre that is autonomous. Among these
sources, Diego Velázquez, Henri de Toulouse-Lautrec, Matthias Grünewald, Henri Matisse,
Greek vase-painters, and Oceanic craftsmen caught his interest at various moments of his
long career. Although this startling range may be of interest to the historian of art, we must
beware of regarding art-historical exercises as in any way defining or interpreting the quali-
ty of Picasso's work, just as the multicolored bands of the spectrum in no way prepare us for
the experience of sunlight.

If one considers all of the Picassos that passed through Justin K. Thannhauser's hands
during his long career as an art dealer, it is tempting to think that those he kept for his own
collection represent the "French" Picasso, for they seem to be a fairly natural extension of
the French Impressionist and Post-Impressionist works that he collected for himself. Yet to
group these Picassos as all "French" does not really hold true. This artist's paintings always
provoke and then elude such classifications. Nevertheless, there does seem to be a coherent
logic behind the choices made by Thannhauser when keeping certain Picassos for his collec-
tion. It is this logic that lends an additional fascination to any thoughtful visit to the
Thannhauser galleries of the Guggenheim Museum. Indeed, a study of the entire collection
would reveal the taste and the thinking that guided one of the century's most important art
dealers—a man who deeply and lastingly influenced public perception of Modern art. It
could be said that the dealer is to the art of our century what patronage was to the Middle
Ages, the Renaissance, and the Baroque. Yet, while we have superb studies of the patronage
of the Medici, the popes of Counter-Reformation Rome, and the French monarchy, there is
no adequate analysis of the twentieth-century art market. The Picassos in the Thannhauser
donation will play an important role in such a study. Meanwhile, one is justified in enjoying
this extraordinary series of Picassos for what they have to offer as individual works of art.

Picasso's respect for past tradition remained with him throughout his life, although he
extended that tradition toward the most audaciously advanced positions of his own time.
During the various stages of his career he continually relied on the authority of the past.
Iberian and African art as well as eighteenth- and nineteenth-century philosophical specula-
tion on the nature of space were stimuli for the earliest phases of Cubism; Italian classical
principles were given new life by Picasso in his paintings of the early twenties; the ideals
and experiments of French and German Romanticism were deeply intertwined with his
painting during the phase of his life that, for lack of a better term, is generally called his
Surrealist period. Still more important, I believe, was his continued reliance on the tradi-
tions and underlying principles that lend to the whole gamut of Spanish art such surprising
coherence. The uncompromising Spanish passion for discovering metaphysical depths while
abiding by the pragmatic testimony of surface appearances must always be kept in mind
when looking at Picasso.

Pablo Picasso
The End of the Road, 1898–99
Oil washes and conté crayon on laid paper,
47.1 x 30.8 cm (18 ⁹/₁₆ x 12 ¹/₈ inches)

"Death waits for all at the end of the road, even though the rich go there in carriages and the poor on foot," Picasso said late in life. This drawing, however, was created when he was a young man. The influence of Barcelona's avant- *garde on the artist can be seen in this work's style, the nontraditional use of oil paint, and the weighty subject matter.*

The subject matter, theme, and range of color of *The End of the Road* (1898–99), the earliest of Picasso's works in the Thannhauser Collection, clearly mark it as still thoroughly imbued with the artist's origins. Here, Picasso has depicted two separate processions of people toward a cemetery, above which hovers a winged figure of Death. Vivian Barnett has quite rightly associated this work with several similar images made around the same time. It is the most developed of this group of related works, and the only one that is in a vertical format, which Picasso uses to underscore humankind's arduous ascent through life toward its ultimate destination. He has also added a typically sardonic social comment: while the mass of impoverished humanity struggles steeply upward and on foot, the wealthy citizens travel toward the tomb comfortably by coach on a more-level road.

The theme of *The End of the Road* is derived from a conception of death that received its first great expression at the beginning of the modern epoch in Antonio Canova's *Tomb of the Archduchess Maria Christina* (1798–1805). Of course, the theme of traveling the inevitable road toward death is at least as old as the Book of Ecclesiastes and finds its greatest flowering in the many "Dance of Death" depictions of the late Middle Ages. Death was the great leveler who prepared all men and women to pass before the Last Judgment, where they learned their subsequent fate among the damned or the saved. During the Renaissance and Baroque periods, the implied future of the individual beyond the tomb became the focal point of all funerary or death imagery, and, up to the last decade of the eighteenth century, death was increasingly regarded as a mere transition during which the soul ascends to life everlasting. The great revolutions after 1780 instituted a secular, pragmatic vision and abruptly curtailed the comforting hope formerly held out by Christian doctrine. Before Canova, all tomb figures had faced toward the spectator to celebrate the deceased and to extoll the virtues that lent distinction to his earthly life. Canova reversed this convention in a single revolutionary stroke by turning his figures away rather than toward us. All we can do, all we eventually must do, is join the solemn cortege toward implacable darkness. This theme of death bereft of words of comfort was repeated throughout the nineteenth century in hundreds of printed broadsides, illustrations, paintings, and sculptures that ring their variations on Canova's vision. The last and most impressive of these, Albert Bartholomé's *Monument aux morts* (1899) at Père-Lachaise cemetery in Paris, was surely known to Picasso.

The consciousness of tradition evident in *The End of the Road* is allied with some of the most daring contemporary visual experiments. Picasso's sharp distortion of perspective in this painting demonstrates his familiarity with and understanding of many novel approaches to perspectival space, just as the very narrow range of emotion-charged color associates his picture with Symbolism and the Nabis. Above all, there are strong links to the kind of atmospheric, spontaneous use of lithography that had begun with Francisco de Goya, became the dominant mode of popular graphic expression with Honoré Daumier, and continued in the most original graphics at the turn of the century. From the start, Picasso was thoroughly alert to the lessons that could be gleaned from the great illustrators of his time.

Picasso once said that he had been born knowing how to draw like Raphael. He must have realized from the start that such a great gift could lead to stagnation if the artist was

Antonio Canova. Tomb of the Archduchess Maria Christina. *1798–1805. Church of the Augustinians. Vienna. Photo courtesy Bild-Archiv der Österreichische Nationalbibliothek. Vienna.*

Pablo Picasso
Le Moulin de la Galette, *autumn* 1900
Oil on canvas, 88.2 x 115.5 *cm* (34 ³/₄ x
45 ¹/₂ *inches*)

Le Moulin de la Galette, *the first painting
Picasso made in Paris, depicts an outdoor danc-
ing hall. Pierre Auguste Renoir, Edouard
Manet, Henri de Toulouse-Lautrec, and others
had shown the Parisian bourgeoisie in social*

*settings. While Picasso's scene shows his aware-
ness of these works, his version takes on an eerie,
almost sardonic tone, which is heightened by the
contrast between the whites and colors illumi-
nated by electric light and the darkness.*

not ready at every moment to challenge himself and challenge above all the nature of such an inherited (as opposed to an acquired) gift. Much has been written about Picasso's "primitivism" and about the tendency toward discovering and exploiting the art of "primitive" or exotic cultures in the decade and a half before the outbreak of World War I. It is wise to keep in mind that "primitive" does not necessarily refer to Oceanic tribes or Cycladic idols. It refers first and foremost to the mysterious urge to husband those mysterious extrasensory faculties (which are nevertheless linked to the five senses) that enable us to re-create in image, word, or sound the forms and forces that dwell within and outside us. It is this urge and this power that Picasso forced himself to penetrate, as did the Romantics before him. In his search, he took what he needed from the wealth of sources that surrounded him, whether an Oceanic mask, Michelangelo, or an exceptionally inventive contemporary. This quest, of course, deflected Picasso from his innate gift of being able to "draw like Raphael," although it is precisely this prodigious ability of knowing everything that Raphael knew that allowed him ultimately to set before us the discoveries and encounters made during his voyage to the realm of primordial impulses. These conflicting ways and means were already thoroughly developed when he arrived in Paris in 1900. In Barcelona he had proved to himself and to his restricted public his proficiency and inventiveness as a full-fledged artist. It was Paris that made him aware of how much he still had to learn and how much he still had to discover before he could come into his own. Within a dozen years it was perfectly clear that Picasso had met the challenge. Although Paris had subtly changed him, he was consistently true to himself and would remain so to the end of his life. But the Paris art world would never be the same, for Picasso had redefined the making, the perceiving, and the understanding of art in the twentieth century.

Just as *The End of the Road* has a fundamental precedent in Canova's *Tomb of the Archduchess Maria Christina*, Picasso's painting of a dance-hall scene, *Le Moulin de la Galette* (1900), goes back to Edouard Manet's *Ball at the Opera* (1873) in its sensibility and in the kind of social conditions and the interpretation of worldly phenomena that Manet introduced there. Both paintings are based on a powerful rhythm produced by vertical blacks (the gentlemen in evening dress) alternating with vertical bands of intense colors. However, where Manet absorbs this syncopated beat of black and saturated colors in an atmosphere of garish artificial light, Picasso keeps the yellows, plums, greens, blues, and reds from blending together into an impression of shimmering surface and forces each color area into a specific location within a generally somber ambience. Manet's painting purports to be the dispassionate view of a detached but acute observer. Picasso, by emphasizing the isolating function of the somber setting, evokes a far more emotional intensity, one that springs from the contradiction between an attraction to and simultaneous condemnation of the dance hall's pleasures.

Of the many versions of this celebrated Montmartre dancing spot, the best known is Pierre Auguste Renoir's great masterpiece of 1876, *Dancing at the Moulin de la Galette* (1876). But Picasso's *Le Moulin de la Galette* is far removed from Renoir's. In fact, one might conceive of the Picasso as a flat and forceful contradiction to all that Renoir's depiction of

Henri de Toulouse-Lautrec, At the Moulin Rouge, 1892–95. Oil on canvas, 123 x 141 cm (48 7/16 x 55 1/2 inches). The Art Institute of Chicago, Helen Birch Bartlett Memorial Collection, 1928.610. ©1992 The Art Institute of Chicago, All Rights Reserved.

Félix Vallotton, The Charge, 1893. Woodcut printed in black, block 20 x 26 cm (7 7/8 x 10 1/4 inches). The Museum of Modern Art, New York, Larry Aldrich Fund. © 1992 The Museum of Modern Art, New York.

the same location stands for. What few touches of black there are in the Renoir (and most of the time what one perceives as black is only a deep cobalt blue) have a cheerful, decorative quality and pertain to the coquettish toilettes of the dancing ladies. Picasso, fresh from Spain and thoroughly imbued with the social and moral speculations of the Barcelona intelligentsia, breaks away from the color, illumination, brushwork, mood, emotional response, and scattered composition of the Impressionist masterpiece. It is as if he were deliberately demolishing Impressionist ideals.

The contrast with a similar social scene, this one indoors, by Toulouse-Lautrec, whose oeuvre is dominated by his vision of the seamier side of Parisian night life, is just as marked. In *At the Moulin Rouge* (1892–95), Toulouse-Lautrec's spectacular foreshortenings, eccentric handling of illumination, and discontinuous, speedy brushwork catapult us directly into the midst of the hectic scene. Toulouse-Lautrec is fully conscious of the tawdriness, the feverish artificiality of the dance halls he paints but he is also inextricably caught up in it. The pathos that underlies his interpretations (see *Au Salon* in the Thannhauser Collection, p. 52) arises from his being wounded by life as much as the protagonists in his dance-hall and bordello scenes. Toulouse-Lautrec transmits his state of helpless addiction to the kind of life represented there, and, like all addicts, he simultaneously worships and abominates his enslavement.

Picasso's *Le Moulin de la Galette*, probably the most ambitious and most accomplished composition of the Spaniard's young but already rich career, is based on premises that are radically different. The dark lower zone of the painting, with the exception of the white glove on the extreme left, acts as a threshold that we as spectators hesitate to cross. It is from this privileged position that we view the scene that is at once captivating and lurid. Beginning with the group of figures in the left foreground, with its focal points of intense color, the eye is propelled toward the crowd of dancers in the middle ground and the garlands of lights just beyond, until it is brought to a full stop by the yawning, sinister, flattened arches above them, in the murky darkness of the extreme upper border. A carefully measured equipoise of spontaneity and artifice, of active and static, lends tension to every part of the composition and challenges us to a decision that we need not usually make in Manet, Renoir, or Toulouse-Lautrec: Shall we or shall we not enter the scene before us? Shall we yield to its appeal or not? With typically Spanish impartiality, Picasso challenges us to come to a decision without indicating his own choice.

To place the picture in its proper context, we must also consider the influence of Parisian graphic arts as a great stimulus on Picasso during this phase of his life. Théophile-Alexandre Steinlen played an important role in enabling Picasso to seize the enormous variety and vitality of novel Parisian visual opportunities. Félix Vallotton, Steinlen's great Swiss compatriot, who was active in Paris for decades by the time Picasso settled there, probably counts even more strongly in confirming and encouraging Picasso's intuitions. Vallotton has generally failed ever to attain more than a marginal popularity; only his haunting woodcuts, such as *The Charge* (1893), enjoy sporadic moments of public interest, above all for their magnificently designed compositions, eloquent patterning, and daring syncopations. He

Pablo Picasso.
The Picador. *1900/01?*
Pastel on paper. *19 x 27 cm (7 1/2 x
10 5/8 inches)*

*Picasso addressed the subject of the bullfight
from time to time throughout his career, finding
in the arena the drama and emotions of life and
death and in the bullfighter a hero. He felt
himself, as artist with brush in hand, allied*

with the bullfighter entering the ring. In The
Picador *Picasso used the bright colors and
contrasts of light and shadow inherent to this
spectacle.*

was one of the most talented of the Nabis and shared their religious enthusiasm as well as their goal of a moral revival in the arts. Unlike his confreres, however, Vallotton brought to the regenerative program of the Nabis a Calvinist rather than a Catholic background and was obsessed by humankind's perverse capacity for evil. This awareness of cruelty, sin, and injustice gave much of Vallotton's work an implicit moralizing slant as well as an overt interest in social and political reform that is absent from other French painters of nocturnal life but very much present in Picasso's *Le Moulin de la Galette*. Also, the predominance of black in Vallotton's prints and paintings is not just a matter of aesthetic strategy or a device to heighten suspense. Black for Vallotton becomes an active narrative element and sometimes even the major protagonist of the social and political dramas he portrayed—a brooding presence in the midst of ostensibly normal or fashionable social situations. It is much the same quality that gives the darkness in Picasso's *Le Moulin de la Galette* the upper hand in spite of the flashing highlights of red, blue, yellow, green, and white. Something clandestine makes itself felt and makes us wary of crossing the barrier into the world of the dancing and flirting couples.

Here, as in all other cases of apparent similarity, one must attribute influence with caution. Picasso had an uncanny faculty for absorbing ideas and transforming them to suit his purposes. He himself was fully conscious of his ability to metamorphose the art of others into something uniquely his own. "No matter what anyone thinks or says, we always imitate something, even when we don't know we're doing it. And when we abandon nude models hired at so many francs an hour, we 'pose' all sorts of other things." Or: "What does it mean," says Picasso, "for a painter to paint in the manner of So-and-So or to actually imitate somebody else? What's wrong with that? On the contrary, it's a good idea. You should constantly try to paint like someone else. But the thing is, you can't!"

Le Moulin de la Galette demonstrates Picasso's ability to capture typically French themes that follow French stylistic precedents but are expressed with a somewhat Spanish inflection. Even more idiosyncratic is the miniature masterpiece in pastel on a Spanish theme, *The Picador* (1900/01?), translated into an obviously French visual idiom. The sketchy setting highly stylized into an insistent pattern (noticeable especially in the handling of the arena's barrier) derives directly from the circus scenes of Toulouse-Lautrec and Georges Seurat. The casual, seemingly uncomposed grouping of bullfighters and bull goes back even further to the example of Manet, as do the flat perspective and the strong colors.

Looked at a little more attentively, these French elements reveal themselves as an imposed veneer. Swinging counter to the large red arc of the arena's barrier and cutting across it is a large dark curve, which is the actual controlling element of the entire composition. It is the edge between *sol y sombra*, between light and shadow, and it provides the dramatic background against which the bullfight attains its true intensity. *Sol y sombra* is not only indicative of a social division between rich and poor (the prices for seats in the shade being more expensive) but also represents the shadow of death at the very heart of the bullfight itself. *Sol y sombra* is a metaphor of uncompromisingly opposed forces pitted against each other without the possibility of any neutral ground between them. The ominous note

Pablo Picasso
The Fourteenth of July, *1901*
*Oil on cardboard, mounted on canvas, 48 x
62.8 cm (18 ⁷/₈ x 24 ³/₄ inches)*

*Picasso first witnessed Bastille Day festivities
during his second visit to Paris, in 1901. His
pleasure in the public street celebration is
apparent in the animated but controlled
composition of* The Fourteenth of July, *which*

*makes brilliant use of the color of the crowd and
the flags on display.*

of the spectacle's deeply religious significance lends the picture a depth of drama that has no counterpart in French painting. Other departures from Gallic practice are the bold chromatic scheme and the manipulation of the pastel medium. One would look in vain for similar coloristic juxtaposition of dark violets, greens, and ochers with black and red in even the most audacious Fauve painting. As for the pastels, instead of being used with the light, evanescent touch of French pastels, Picasso achieves an obdurate, material density in his use of the medium that is reminiscent of the impenetrable physicality of seventeenth-century Spanish still lifes.

Except for its relatively small size, *The Fourteenth of July* (1901), is the perfect counterpart to *Le Moulin de la Galette* and illustrates the extremes of style, mood, and traditions that leavened Picasso's imagination during those heady early years in Paris. The space created in *Le Moulin de la Galette* draws us forward; in *The Fourteenth of July* everything seems to be hurtling toward us. In the earlier painting, color is contained within clearly outlined and relatively small areas; here color explodes as freely as the firecrackers set off by the festive crowd. But the composition, far from being cheerfully scattered, is masterfully disciplined. The figures streaming toward us at the lower left are counterbalanced by the wedge-shaped crowd on the right and the steady beat of the stepped roof lines in back. Picasso emphasizes the counterpoint of the two groups by making nearly all the figures on the right blend into an indistinguishable blur of colors (primarily red and blue) while the figures on the left are treated with far more individuality. Many of the faces of the figures on the left are limned with heavy black outlines, and those in the foreground have been given recognizable features and even a certain level of expression. The man in a white shirt with his chin supported on his fist makes a sullen impression similar in mood (and in technique as well) to Daumier's *The Third-Class Carriage* (ca. 1862, National Gallery of Canada, Ottawa; another version from 1863–65, The Metropolitan Museum of Art, New York). Throughout the group on the left, Picasso has highlighted the red and blue with contrasting patches of white, yellow, green, pink, and pale blue. This relatively modest painting encompasses both the general cheer of official holidays as well as the mournful exceptions that are the inevitable concomitant of public festivals. Like Manet in his *The Rue Mosnier with Flags* (1878, The J. Paul Getty Museum, Malibu), which also depicts a national celebration, Picasso adds a throb of melancholy in the midst of the gay celebrations. It is impossible to prove that Picasso knew the picture by Manet. But with Picasso it is always safer to assume that he knew more than one supposes.

A certain sociopolitical bias is constantly at work in Picasso at this time, the kind of attitude one finds in Rainer Maria Rilke's oft-quoted, somewhat sentimental "Armut ist ein grosser Glanz von Innen" (poverty is a great interior radiance). In Picasso's imagery, this mood gradually consolidates into a universal symbol of existence at the extreme margins of human society. It is a theme that is quintessential to all Spanish painting; we encounter it just as unequivocally in the royal personages and minions of Velázquez's *Las Meninas* (1656, Museo del Prado, Madrid) as we do in José de Ribera's *The Beggar*, also known as *Club-foot* (1642, Musée du Louvre, Paris).

Pierre Puvis de Chavannes, The Poor Fisherman, *1881. Oil on canvas, 155.5 x 192.5 cm (59 ⁷/₈ x 75 inches). Musee d'Orsay. © Photo R.M.N.*

Diego Velázquez, Francisco Lezcano, *ca. 1636. Oil on canvas, 107 x 83 cm (42 ¹/₈ x 32 ⁵/₈ inches). Museo del Prado.*

Certainly it is this quality that moved Picasso in 1903 to make a drawing based on Eugène Carrière's painting *The Artist with His Wife and Their Son* (1895–96, The National Gallery of Canada, Ottawa). Stylistically related to another of his drawings, the somewhat more picturesque *Au Café* (1901), Picasso's *Woman and Child* (1903) aims at a deeper pathos and intends to involve us with the disinherited of our society. In a watercolor from 1903–4, *El loco*, the still somewhat inchoate mood takes on a more concretely symbolic appearance. There can be little doubt that Velázquez's series of dwarfs and idiots is related in some tenuous way to this staring beggar accompanied by his scrawny dog. Yet one wonders whether it isn't simply a kind of reflex on our part that automatically associates the work of two great Spanish masters. Velázquez represents his crouching fools, for example *Francisco Lezcano* (ca. 1636), as if he were bearing witness in a court of law to something he had observed. Picasso completely transfigures his lonely, emaciated beggar into a prophetic figure devoid of corporeal density, rapt in an incommunicable vision. *El loco* is essentially whimsical. It gains in importance, however, by being a link in the chain that leads from Picasso's earlier formalism toward an emotionally charged style that perfectly balances personal sentiment with social considerations. The work that is fully emblematic of this development in Picasso's art is the painting *Woman Ironing* (1904).

Although Pierre Puvis de Chavannes may have been far from Picasso's consciousness when he worked on *Woman Ironing*, his work in some respects prefigured Picasso's so-called Blue Period. Puvis de Chavannes, always thought of as an academic or at the very least as an establishment painter, was actually self-taught, but by the 1880s he came to be recognized as a central figure in French art. The avant-garde, especially Gauguin, admired him for his directness, the authenticity of his vision, and his innovative compositions apparent in such works as *The Poor Fisherman* (1881). The leaders of the Beaux-Arts wing saw in him an artist who defended the fundamental values of art in accordance with the ideals of French classicism. Auguste Rodin recognized in him a colleague who was doing in painting what he himself was doing in sculpture: reconciling past and present, creating a profoundly national French art that would serve to unify a country threatened by unscrupulous social and political traitors. For anyone interested in seizing the most irreducible essence of everything that was French in French art, Puvis de Chavannes could serve as a catalyst.

Picasso may have found certain aspects of Puvis's style especially resonant for him at that time. Puvis used an extremely restrained palette—blues, grays, and whites accented by infinitesimal touches of dusty yellow and red—to evoke a veiled, milky atmosphere in which the austere outlines of all forms achieved a highly persuasive, elegiac note. This amorphous space without volumetric definition contributes to the dreamlike, incorporeal, supremely composed mood. The generalized tranquility of Puvis's visions is heightened into a sensation of irremediable loneliness. Willful distortions create dramatic tensions without the necessity of narrative or realistic descriptions of modeled volumes. In Picasso's hands, however, the slightly anemic coloring is given greater expressive force by being brushed on with calligraphic boldness utterly foreign to Puvis and far more reminiscent of Edgar Degas. Unforeseeable at the time but certainly noticeable in retrospect, Picasso's handling

Pablo Picasso
El loco, 1903–04
Watercolor on wove paper, 32.6 x 23.2 cm
(12 ¹⁵/₁₆ x 9 ⅛ inches)

Picasso had studied the street people of Barcelona, and when he found similar subjects in Paris he seems to have realized the universality of social problems. His figure of a madman illustrates the theme of isolation or separation from society, which he dealt with repeatedly in his Blue and Rose Period pictures. The beggar and the little dog appear in other contemporaneous works.

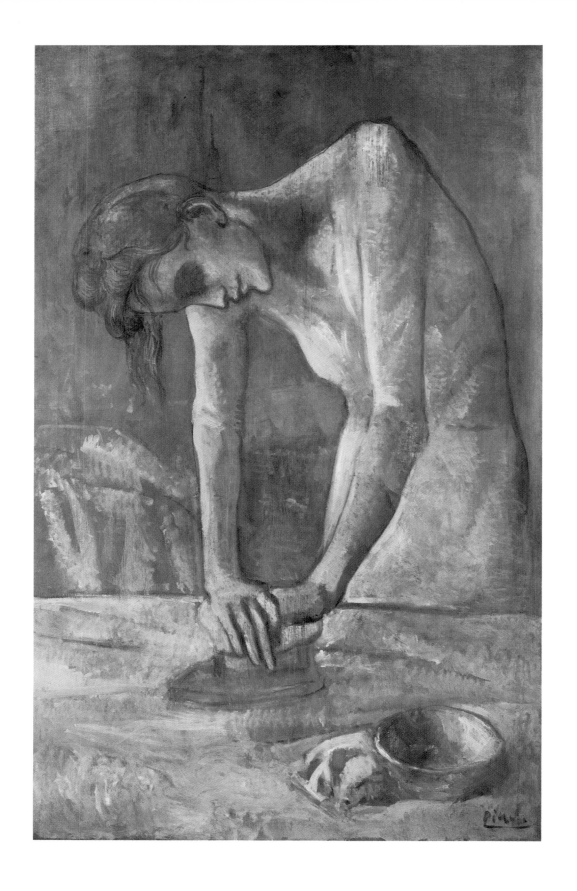

Pablo Picasso
Woman Ironing, 1904
Oil on canvas, 116.2 x 73 cm (45 ⅝ x
28 ¾ inches)

Pablo Picasso
Young Acrobat and Child, March 26, 1905
Ink and gouache on gray cardboard, 31.3 x
25.1 cm (12 ⁵/₁₆ x 9 ⅞ inches)

Picasso was interested in saltimbanques,
migrant acrobats who performed out in the open,
and liked to depict them in nonspecific settings so
that they could be portrayed as outcasts rather
than as the focus of an audience's attention.

of space began to take on a new direction. The depth-progressions of Puvis's paintings were achieved by setting register after register of alternating values of a single hue. Picasso's suggestion of space is just that—a suggestion. Here again, his Spanish background comes into play. In such passages as the heaped linens on the left in *Woman Ironing*, one can sense the indistinct world of Goya's *Caprichos*. The linens, separated by a strong horizontal line from the ironing table, do not actually appear as existing behind it but instead seem to rise like mountains above a horizon. By means of this ambiguity of scale, Picasso achieves a monumentality of space that is appropriate to the looming, haggard figure of the laundress who also appears larger than life. Indeed, following the same strategies used by Goya, Picasso treats her occupation not only as a subject of social compassion but elevates it to the level of a universal symbol. The woman's drudgery, which evokes the plight of an urban proletariat, also assumes a biblical ring akin to the injunction of eternal toil with which God curses mankind in Genesis and which is described with almost unbearable majesty in Ecclesiastes.

It is one of the joys of the Thannhauser Collection that one is afforded a step-by-step documentation of Picasso's development during this heroic period of Modern art. *El loco* introduces the theme of existential isolation by depicting the specific situation of a beggar, with his bowl, his dog, and the placard on which his appeal for alms is inscribed. *Woman Ironing* transforms the theme into a monumental statement of the human condition, while *Young Acrobat and Child* (1905) modulates toward a more pensive, lyrical conception. The two uncostumed circus figures in this painting seem to be associated in some vague way, yet they are disconnected. Within their acute isolation—suggested by the desolate landscape, the bleak house in the distance, the barren trees—they turn away from one another, following their own strains of melancholy. Still, it is here far more than in the *Woman Ironing* that Picasso willingly relinquishes thematic considerations in order to emphasize questions of style. As always happens after Picasso arrives at a great solution, he impatiently moves on in a divergent direction. Linear outlines are erratic and involuntarily tense. Picasso's hand seems to move with the distracted compulsion of a nervous doodler. The choice of color is of a deliberate refinement reminiscent of the most sensuous moments of French Rococo art. In fact the dominant hue is not just "rose," as Gertrude Stein's description of this particular phase of Picasso's work would have it. It is a specific rose that is called *rose pompadour* or *rose fané*, capable of conveying the warmth but also the sadness of love.

Picasso translates this vision of solitude onto a personal level in many of his portraits around this time. With deft touches of almost maudlin surface description, he delineates a sharply drawn portrait in *Profile of Woman with a Chignon* (1904). Yet his draftsmanship possesses a magical ambiguity. Almost every line in *Profile of Woman* can be read simultaneously as contour outline, as modeling line, or as an autonomous conductor of energy. In *Fernande with a Black Mantilla* (1905/6?), Picasso delves further inward. The possibility of expressing the innermost moods of a portrait sitter by means of the surrounding landscape originated with Leonardo da Vinci and made his Mona Lisa the authoritative ancestor of all portraiture that goes beyond physiognomic description. In Picasso's tenderly enigmatic portrait of Fernande Olivier, his mistress during the early Parisian years, he develops Leonardo's strate-

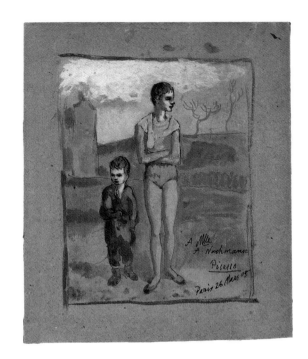

Pablo Picasso
Profile of Woman with a Chignon, *1904*
Pencil, India ink, charcoal, and blue wash on
paper, 37 x 26.7 cm (14 ⁹/₁₆ x 10 ¹/₂ inches)

The preponderance of the color blue along with
the somber subject matter in Picasso's works of
1901 to 1904 prompted the designation Blue
Period for this stage in his artistic career, which
culminated around the time of his permanent

move to Paris. Line is used in a minimal but
powerful fashion in this drawing from the final
year of this phase.

gy. But instead of containing the landscape in back of his sitter as Leonardo did, he makes of the surrounding atmosphere a fluctuating, veiled matrix that no longer appears as a background but envelops the entire figure, interposing itself between us and the sitter. Emotionally, the effect is similar to Corregio's *Jupiter and Io* (ca. 1532, Kunsthistorisches Museum, Vienna), in which an amorous cloud wraps the central figure in its embrace.

Fernande appears before us almost like a wraith materializing out of the insubstantial mist that surrounds her. The technique points to some of Picasso's future experiments during the Analytic phase of Cubism. The periphery of the painting is nothing but canvas rubbed over with thin washes of lightly brushed-in grays. This formless, coordinateless field cannot really be spoken of as a background of the figure but is instead the very matrix from which the figure condenses in the center of the canvas, much as the facets and polygonal forms of Cubism condense toward the center of the canvas out of the deliberately amorphous realities of the painter: brush, pigment, and canvas. Of particular interest here is Picasso's freedom in handling the paint, as shown in his depiction of the right shoulder and arms, where he has thinned the paint and allowed it to drip in accordance with the force of gravity. But there is more to it than that. The streamers of trickling paint originate well above the shoulder, at first adhering to the canvas behind the shoulder and then trickling down to cover it so that an effect of ambiguous, nonperspectival space is created as the paint courses downward.

More than any other painting in the Thannhauser Collection, *Fernande with a Black Mantilla*, in spite of its almost monochrome palette, documents the importance of Fauvism during Picasso's early career. *The Fourteenth of July*, with its bright colors, would seem to indicate that in 1901 Picasso was already investigating areas of what a few years later would be Fauvist theory. Yet *The Fourteenth of July*'s calligraphic brushwork, textural evocations, and patterning of brushstrokes link it to a tradition that begins with Vincent van Gogh and may have been transmitted to Picasso by such artists as Edouard Vuillard or Pierre Bonnard. Fauvism, especially as it appears in the major works by Matisse, militates against calligraphy and against the textural differentiation of which oil paint is capable. Color itself, freed from brushwork and detached from textural description, is the very soul of Fauvism. Line is evoked only where color areas become tangential, and there are frequent deliberately smudgy passages attesting to the free rein that is given to the flow of color or the way it is absorbed and spread by the ground to which it is applied. It is this new, risky manner of paint application that must have attracted Picasso while at work on the portrait of Fernande.

The great Italian, Flemish, and Dutch portraitists introduce us to their sitters by revealing the sitters' personalities to us in various ways. In the hands of Peter Paul Rubens, for instance, such introductions are always delightful; and in the case of Rembrandt they can be overwhelming and unsettling. Spanish painters, for the most part, refrain from revealing their sitters. Respectful of the vulnerable, fragile nature of all men and women, they represent their sitters with utmost reserve. Raphael, Rubens, and Rembrandt predetermine our response to their sitters; Velázquez withdraws and insists that we ourselves unravel the

Pablo Picasso
Fernande with a Black Mantilla. *1905/06?*
Oil on canvas. 100 x 81 cm (39 ⁵/₈ x
31 ⁷/₈ inches)

Picasso met Fernande Olivier in the fall of
1904 in the Montmartre tenement building in
which he lived. Her portrait, thinly painted in
a near monochrome, seems to coalesce from the
ethereal background. It is one of many studies

Picasso made of her during the seven years of
their involvement.

Pablo Picasso
Still Life: Flowers in a Vase, 1906
Gouache on cardboard, 72.1 x 55.9 cm
(28 3/8 x 22 inches)

Picasso used bright accents in addition to the coloring of the Rose Period pictures to create the delicate bouquet, chocolate pot, and the green bowl in Still Life: Flowers in a Vase. *Why the artist scored the surface of the work remains a mystery. He signed the gouache at the Thannhausers' home many years after it was painted.*

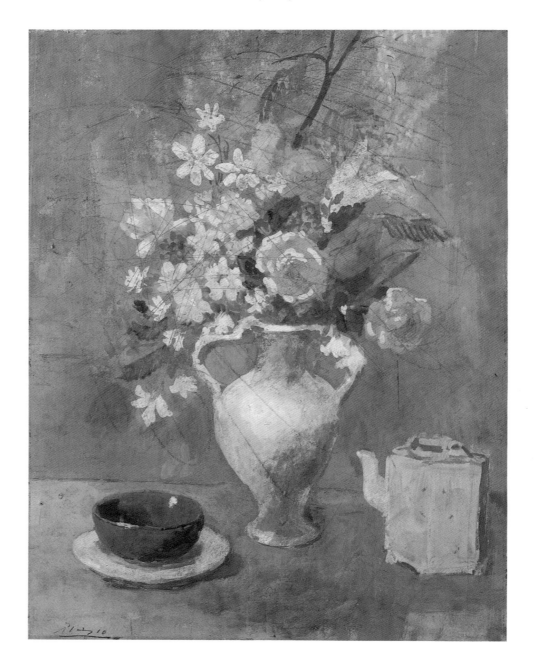

84

Pablo Picasso
Vase of Flowers, 1905–06
India ink on wove paper, 26.7 x 19.7 cm
(10 ½ x 7 ¾ inches)

Drawn at a time when Picasso was making frequent visits to museums and galleries and absorbing the artistic influences he saw around him, this work reflects Vincent van Gogh's style as well as that of Edouard Vuillard. The drawing, in which the flowers take on an animated quality, was made with a variety of pen marks.

enigma of the sitter's individuality. It is much the same in the case of Picasso's portraits, especially in 1906, the *anno mirabilis* of Picasso's life, when he gradually left his apprenticeship behind (an apprenticeship that produced some masterpieces but that is still strongly marked by his assimilation of all the ferment of contemporary French art) and came into his own. It is the year in which he prepared, as the Gosol sketchbooks prove, the ground for that triumphant but unending battleground that is *Les Demoiselles d'Avignon* (1907, The Museum of Modern Art, New York).

Before Modernism, still life was practiced in France primarily for the opportunities it afforded to display brilliant virtuosity. In Flanders and especially in Holland, virtuosity also counted for much but was inflected in the direction of social commentary, bearing witness to the wealth and taste of a sophisticated patronage. In Italy, still life, though occasionally practiced with magisterial skill, never attained great importance and was once again considered a perfect vehicle for decorative and technical virtuosity. Only in Spain did still life transcend both decorative and technical values. It is also in Spain that still life instead of being a more or less secondary field of endeavor rose to the same heights as other genres. Spanish still life evokes the tragic dimension of our existence as isolated individuals in the world. In Jean Baptiste Siméon Chardin, in Caravaggio, in Willem Kalf, plums are paired with glasses of water, worm-eaten apples strike an accord with wilted vine leaves, beautifully fashioned crystal vessels are made to suggest even greater luxury by being shown with exotic fruit. In the still lifes of Spain, the proudly tragic isolation of each element rises to the solemnity and expressive power of the most complex religious paintings, as evident in works such as Juan Sánchez Cotán's *Quince, Cabbage, Melon and Cucumber* (ca. 1602). It is not surprising that Picasso should have sought in still lifes something that goes far beyond innovative harmonies, novel relationships, or carefully elaborated formal solutions, although all of these possibilities are also present.

If we remember that the period from 1900 to circa 1906 is a period of assimilation for Picasso, *Vase of Flowers*, an ink drawing from 1905–6—the earliest of the still lifes in the collection—comes as no surprise. The influence of van Gogh has often been remarked on, but the drawings of Vuillard, with their discontinuous flecks and sharply varying densities of atmosphere, are perhaps even closer to this early Picasso than the great Dutch master. The gouache *Still Life: Flowers in a Vase* (1906), for all its surface appeal and apparent conventionality, presents a series of perplexities. The nature of Picasso's flowers, the space they inhabit, and their relationship to the other objects all have a suspended, undefined air about them. Whereas Renoir's *Still Life: Flowers* (1885) appears convincingly naturalistic, Picasso's attention is focused on creating ambiguities. Indeed, the branch of yellow flowers at the top could easily be read as being not part of the bouquet but a decorative element of the wallpaper just behind it. But is that pink background anything as substantial as wallpaper, or is it a vaporous cloud of rose-colored light? In these respects, the still lifes of Odilon Redon must have been of prime importance to Picasso during the brief span of the Rose Period.

Another puzzle in this still life is the random scoring of the surface by means of two dif-

Juan Sánchez Cotán, Quince, Cabbage, Melon and Cucumber, ca. 1602. Oil on canvas, 69 x 84.5 cm (27 ⅛ x 33 ¼ inches). San Diego Museum of Art. Gift of Anne R. and Amy Putnam, 1945:043.

85

Pablo Picasso
Table Before the Window, *1922*
Watercolor and pencil on laid paper, 14.1 x
11 cm (5 9/16 x 4 5/16 inches)

Picasso once said, "The more you paint, the
nearer you get to something. That's the only
way. . . . You must do as many as possible."
Throughout his career he tended to explore
subjects in depth, repeating them in many works.

From 1919 through 1925 he made many
pictures depicting objects on a table in front of a
window. The shapes of the fish and the wine
bottle appear in many of these works.

ferent instruments. Did the artist wish to destroy his picture after he had finished it? He would hardly have bothered then to scratch it rather delicately with both a blunt point and a sharp point. Or did he wish to give it the look of an etching plate from which all the impressions had been pulled—that is, is the scoring an indication of being finished with the painting's lyricism and sensuous indulgences? Equally puzzling are the two forms that flank the central motif of the vase of flowers. They are a startling instance of Picasso's penchant for juxtaposing in a single canvas forms that belong to radically different traditions and emotional intensities. The dark-green bowl on the left, which seems to have been transported from an early Velázquez still life, is earthy and dense, an aggressive contrast to the pervasive pink atmosphere. The chocolate pot on the right, however, appears almost transparent in the way its hues mimic the colors immediately surrounding it and merge with the overall tonality of the picture. This ability to bring contradictory styles and divergent degrees of finish together within the confines of a single painting became one of the dominant principles of Picasso's artistic conception, perhaps most notably in *Les Demoiselles d'Avignon* and in his Synthetic Cubist works.

The later still lifes in the collection all depend to some degree on the Cubist revolution wrought by Picasso and Braque during the six years before the outbreak of World War I. But Thannhauser seems to have been more interested, at least as far as his personal collection was concerned, in the postwar transformations of Cubism than with Analytic Cubism itself. *The Table* (1922), is a good example of how Picasso adapted Cubist techniques in his Synthetic Cubist works. Here, space is represented as a variable entity that insinuates itself between forms, and recognizable objects such as the tabletop or the glasses set out on it have a now-you-see-it-now-you-don't ambiguity. Many forms "bleed" into a contiguous but very different object. Take for instance the glass with a diamond decoration etched on its side. The right side of its base is not completely defined but merges with the area surrounding it, as the white on the interior of the glass appears to drain into the white of the tablecloth. This use of Cubist *passage* has a clear precursor in the Thannhauser *Before the Mirror* (1876; illustrated p. 36) by Manet. In the Manet, the woman's left shoulder strap tilts toward the mirror and at a certain point the shoulder and its reflection, though belonging to two different levels of reality and to two different positions in space, are subsumed by a series of autonomous brushstrokes that can be interpreted as representing the shoulder, the reflection of the shoulder, or a pictorial definition of the actual canvas surface of the painting in which the shoulder and its reflection are both absorbed. What is just a small visual incident in Manet becomes a frequent effect in Paul Cézanne and a ruling principle of Cubism. Depicted reality, the reflection of depicted reality, and adherence of both these illusions to the physical realities of canvas and pigment are paramount concerns of Cubism. This already vertiginous juggling is compounded in Cubist collage, which introduces random bits of extraneous reality (newspaper clippings, etc.) into the interplay of varying levels of pictorial illusion.

These fundamental elaborations of Cubism are given a new monumentality in two still lifes of the late thirties, *Still Life: Fruit Dish and Pitcher* (1937) and *Still Life: Fruits and*

Pablo Picasso
The Table. *December 24, 1922*
Watercolor and gouache on laid paper. 16.3 x
10.3 cm (6 ⁷/₁₆ x 4 ¹/₁₆ inches)

As in other Synthetic Cubist paintings of the
1910s and 1920s, Picasso used flat planes of
color and surface texture to construct the image
in The Table. *He used areas of color that merge*
ambiguously in this picture of still-life objects on
a guéridon. *a round table with a pedestal leg.*
a form that Georges Braque often depicted.

Pablo Picasso
Still Life: Fruits and Pitcher,
January 22, 1939
Oil and enamel (?) on canvas, 27.2 x 41 cm
(10 ³/₄ x 16 ¹/₈ inches)

While rooted in the achievements of Synthetic Cubism, this work uses an informal painting technique and outlined, simple shapes. Picasso painted at least four other still-life compositions on the same day that he made this

one, which was probably painted in the country. The still lifes of 1939 are related to those created in 1937 that also depict two objects.

Pablo Picasso
Still Life: Fruit Dish and Pitcher.
January 21–22, 1937
Enamel on canvas. 49.8 x 60.8 cm (19 ⁷/₈ x
23 ¹⁵/₁₆ inches)

The importance of the still life in Picasso's
oeuvre continued in the 1920s and 1930s. In
Still Life: Fruit Dish and Pitcher, *planes of
color create spatial effects. and shape is
emphasized over form. Around the time he made*

*this one. Picasso created many other still lifes
with two or only a few very simple objects.*

Jean Baptiste Siméon Chardin. The Ray. *1728. Oil on canvas, 114 x 146 cm (44 ⅞ x 57 ½ inches). Musée du Louvre. © Photo R.M.N.*

Pitcher (1939). The latter is a lyrical hymn to joie de vivre, which in retrospect derives a particular poignancy from having been painted just a few months before the outbreak of World War II. More imposing is the earlier still life, with its ample geometry and its resonant colors. The table and the objects on it are presented as if they are surging forward on the crest of a wave. The effect is in part due to the daringly simple construction of the background, divided into two halves of slightly different brown hues, against which the vividly colored table and objects appear to float. This evocation of a space dynamically moving forward is not arrived at by any kind of calculated perspectival construction but depends on the interaction of all the colors and forms of the painting. The conjunction of the two brown "walls" clearly dictates the color shifts that occur in the two nearly symmetrical halves of the image and sets the objects into sharp relief; and at the same time, it creates the illusion of separating the fruit dish and pitcher, an isolating effect that is in full accord with the ancient tradition of Spanish still life.

The latest of Picasso's works in the Thannhauser donation, *Le Homard et le chat* (1965), attests to his unbroken creative energy during the last years of his life. The painting demonstrates Picasso's ability to derive serious implications from what is essentially humorous. The subject of the lobster and cat refers to one of the most beloved paintings of French art, Chardin's *The Ray* (1728). In both paintings, a cat is aroused to vicious hissing by the menacing aspect of an item of seafood that is as delicious to the palate as it is horrendous to the eye. What is so astonishing in Picasso's painting is that he is able to retain the humorously anecdotal premise of the eighteenth-century painting while simultaneously heightening the encounter between cat and lobster into a miniature but extremely effective metaphor of aggression aroused by fear. It is a theme that preoccupied Picasso. If one makes all due allowances for the differences between the categories of miniature and monumental expression, it is a theme that also occurs in *Guernica* (1937, Museo del Prado, Madrid). The comparison strikes an absurd note until one remembers Picasso's frequent shifts from monumental to miniature, from trifling to significant and back again. These ostensibly erratic whimsicalities aim at an ironic demonstration of the artificial conventions of our thought and of our feelings. Here again, as in our still life and in so much of Picasso's work, it is impossible to assign unequivocal ethical values to the animal protagonists. Just as it is impossible to think of *Guernica*'s bull and horse as being either all good or all evil, so is it impossible (on quite a different level of seriousness, of course) to come to a clear decision regarding the lobster and the cat in our painting. Both animals are potentially as innocent as they are dangerous.

In Picasso's career, the Rose Period represents a moment in which the artist indulged personal whims before turning to the most audacious and demanding adventure in the history of twentieth-century art: Cubism. However, even during the teens and twenties, in which his work was dominated by Analytic and Synthetic Cubism, there were frequent returns to classicism in his drawings and his paintings. Picasso's classicism can be studied in its purest form in two paintings of small dimensions but of monumental effect in the Thannhauser

Pablo Picasso
Le Homard et le chat. *January 11, 1965*
Oil on canvas, 73 x 92 cm (28 ¹/₄ x
36 ¹/₄ inches)

*Picasso depicted a confrontation between a cat
and a lobster several times, perhaps following
the precedent set by Chardin's* The Ray. *The
artist presented this version to Justin
Thannhauser in honor of the friendship between*
*artist and dealer. During this late period,
Picasso created vast numbers of works, even for
an artist who had proved himself so prolific
throughout the century.*

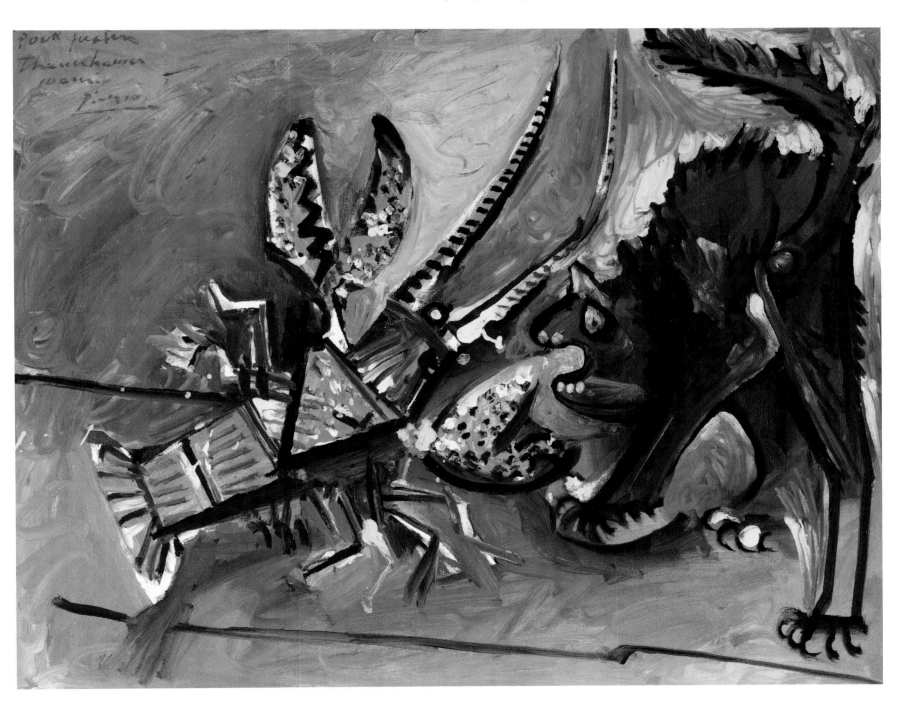

Pablo Picasso
Three Bathers, *August 1920*
Pastel with oil and pencil on laid paper,
47.8 x 61.4 cm (18 $^{15}/_{16}$ x 24 $^{3}/_{16}$ inches)

During the early 1920s, while simultaneously working in a Cubist vein, Picasso used a classical style that he had experimented with earlier and would return to throughout his career. Three nude women (the third protrudes from the water in this picture) appear in other works of 1919 and the 1920s, in many of which their forms are distorted. Picasso painted nudes on the beach frequently after World War I, when sunbathing became enormously popular.

Collection: *Three Bathers* (1920) and *Femme dans un fauteuil* (1922). Both belong to a stage of the artist's career that indicates a joyful relaxation after the violent years of World War I. Powerfully persuasive modeling, melodically long outlines, vigorous earth colors, and a noble harmony between spirit and carnality prove that there was nothing vain in Picasso's claim of kinship with Raphael.

Picasso's approach to portraiture evolved continuously throughout his career. By the 1930s, neither the consistency of a given personality nor the description of an individual's physiognomy was the primary goal of his portraits, even though he continued to produce such intimate likenesses as the *Portrait of Dora Maar* (1936). In the Thannhauser Collection's *Head of a Woman (Dora Maar)* (1939), Picasso penetrates to yet another dimension of portraiture. Here, through the effect of powerful patterning and clamorous colors, Picasso expresses a generalized state of existence comparable in some ways to the medieval notions of the humours or temperaments, in which individuality is subsumed in the psychological and existential type. The confident forthrightness and self-possessed dignity of the sitter radiate from this intricately composed portrait.

The vital characterization of works such as *Still Life: Fruit Dish and Pitcher* or *Still Life: Fruits and Pitcher*, in which apples or crockery have the presence of fully developed *dramatis personae*, has its concomitant in several of Picasso's figure paintings, such as the most celebrated and appealing of the Picassos in the Thannhauser collection, *Woman with Yellow Hair* (1931), a portrait of Marie-Thérèse Walter sleeping. She is cradled within the gentle perimeter of her arms; contained and container are compactly one, like the germ within a seed. In sleep, she is liberated from the need to recognize and react to the world. Nothing impinges on the figure from the outside. In many of his paintings, drawings, and etchings, Picasso represented the drama that binds artist and model, autonomous personalities that are nevertheless incomplete without the other. The model in most of these artist-and-model images is usually depicted as the detached and triumphantly innocent partner. Although she herself remains passive, she induces a dynamic transformation, a creative reaction within the fantasy and intuition of the artist. In *Woman with Yellow Hair*, the artist seems to vanish altogether. The painting emanates a serene chastity which can only be the attribute of the unobserved. How Picasso arrived at making manifest this sense of unconditional intimacy without violating the intimacy by the very act of painting it is the supreme secret of his art.

A long tradition extends behind this remarkable painting. Picasso, always conscious of living and working at the point at which past and future intersect, was certainly fully aware of this tradition, which begins with Giorgione's *Sleeping Venus* (Gemäldegalerie, Dresden) and which always contains the double theme of chastity and fecundity. Without recourse to the symbolic language of mysticism (best exemplified by the biblical Song of Songs) this pictorial tradition reconciles physical opulence with utmost purity. It is apparent that Picasso willingly associated himself with this tradition, which includes J. A. D. Ingres and Eugène Delacroix, Matisse and Rembrandt but which definitely excludes Rubens—or rather, the kind of Rubens that Picasso imagined when he spoke disparagingly of the great

Picasso had met the sitter for this work, Marie-Thérèse Walter, by chance in 1927. He painted her well into the next decade, frequently showing her in repose. The figure's curves and simplified forms and the pose with her head cradled in her arms help to suggest a serenity, a private moment, which the viewer of the painting is able to observe, or perhaps share.

Pablo Picasso, Portrait of Dora Maar, *1936. Oil on canvas, 65 x 54 cm (25 ⁹/₁₆ x 21 ¹/₄ inches). Private collection. Photo courtesy of Giraudon, Paris. © S.P.A.D.E.M.*

Flemish master. It is in rare moments such as the one represented by *Woman with Yellow Hair* that Picasso rescues for our time an optimism that would seem to be precluded by the harsh and cruel realities of the century. We need only glance at *Girl Before a Mirror* (1932, The Museum of Modern Art, New York), to realize that Picasso knows all the poisons of our epoch—poisons that fragment the personality and turn our inmost selves into savage battle-fields. But for each poison, he also finds the antidote. One cannot help but sense the healing quality that emanates from such a masterpiece.

Every moment of our lives turns into memory. It is one of the great powers of true artists to endow memory with permanence. No artist of our century was possessed of a more prodigious memory or of a more persuasive power to bring life to what he remembered than Picasso. By that token, Picasso extended not only our memories but our lives. No wonder that his very name continues to cast a spell of admiration and gratitude over us all.

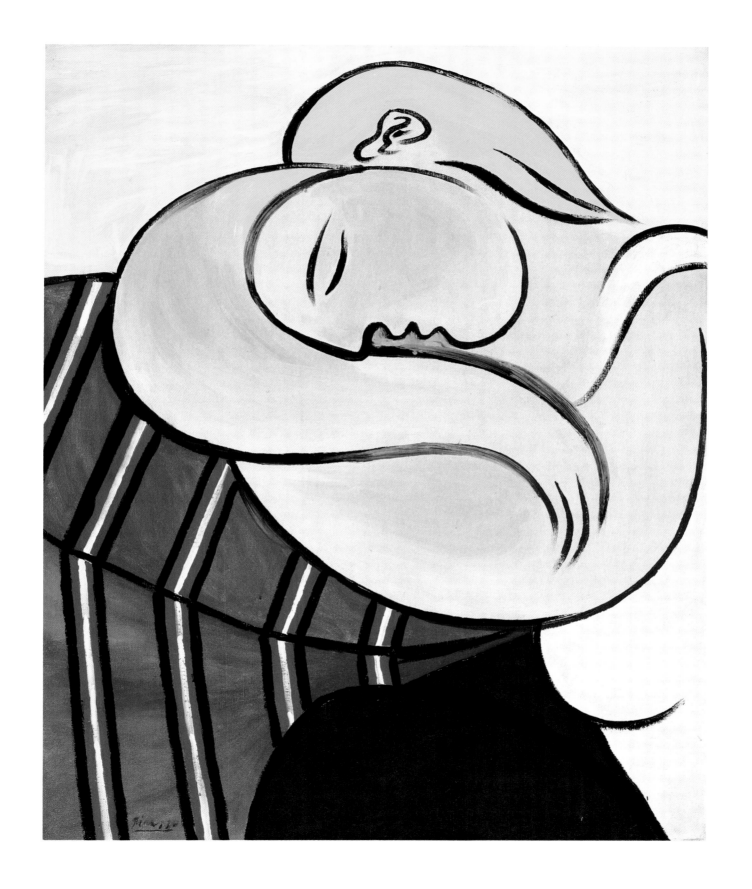

95

Explanatory Notes to the Catalogue Entries

The Revised Publication:
Vivian Endicott Barnett's catalogue entries from
Guggenheim Museum: Justin K. Thannhauser Collection
(New York, The Solomon R. Guggenheim
Foundation, 1978) are reprinted in this revised
edition with her permission. However, she has not
had the opportunity to update the texts, which she
completed in 1977. The exhibition histories and
references from those entries were updated in 1991
and their formats changed, but without the
involvement of Mrs. Barnett. For this edition, she
has contributed new catalogue entries for three
works that entered the Thannhauser Collection in
the 1980s: Georges Braque's *Guitar, Glass, and
Fruit Dish on Sideboard* (1919), Pablo Picasso's *Still
Life: Fruits and Pitcher* (1939), and Vincent van
Gogh's *Landscape with Snow* (1888).

The Thannhauser Collection:
Guggenheim Museum: Justin K. Thannhauser Collection
included entries and reproductions of all of the
works from the original 1978 gift from Justin K.
Thannhauser (Thannhauser Collection, Gift, Justin
K. Thannhauser, 1978). The three additional works
mentioned above were added to the Thannhauser
Collection subsequent to the original gift and
appear within this publication with complete
entries (Thannhauser Collection, Gift, Hilde
Thannhauser). Ten works were transferred to the
Guggenheim after the death of Hilde Thannhauser
(Thannhauser Collection, Bequest of Hilde
Thannhauser, 1991). Comprehensive research has
commenced on them. The results of that research
will be published in the next edition; in this
publication, a preliminary cataloguing appears on
page 191.

Titles:
If the artist's title is known, it is given first in
English. Since this is rarely the case, the title
corresponds with that in a catalogue raisonné or an
accurate title commonly used to refer to the work.
Generally the title in French and other titles by
which the work has been known follow in
parentheses. Most of the titles are those designated
by Justin K. Thannhauser; any changes have been
indicated in the catalogue entry.

Medium:
In the discussion of related works where no medium
is specified, oil on canvas is understood.

Measurements:
Dimensions are given in centimeters followed by
inches. Height precedes width followed by depth,
where applicable.

Inscriptions:
All inscriptions and signatures on the reverse of a
work are recorded in the entry. Unless otherwise
indicated, all inscriptions are in the artist's hand.

Condition:
The absence of condition notes signifies that the
work is in good condition, and that there is no
evidence of any prior treatment. If a painting has
been lined or is unvarnished, such information is
noted. Comments are intended to provide further
information about the medium and the support, to
explain what is visible in the work itself, and to
indicate what cannot be readily observed (i.e.,
changes in composition and old repairs.)

Exhibitions:
The exhibition histories are as complete as possible
considering the fact that the records of the
Thannhauser galleries no longer exist (see
Introduction). All works from the Thannhauser
Collection are permanently on display at the
Guggenheim Museum. As exhibition within the
Guggenheim Museum is assumed since 1978, in-
house exhibitions have not been included in the
exhibitions listings in the individual entries.

References:
References are comprehensive and, like exhibition
histories, often include in parentheses the title,
date, or collector's name relevant to the discussion
in the text.

Exhibitions:
1978. Kunstmuseum Bern:
1978. Kunstmuseum Bern, *Sammlung Justin Thannhauser*, June 8–Sept.16, 1978. Exh. cat.

1990. Venice, Palazzo Grassi:
1990. Venice, Palazzo Grassi. *From van Gogh to Picasso, From Kandinsky to Pollock: Masterpieces of Modern Art (Da van Gogh a Picasso, Da Kandinsky a Pollock: Il percorso dell'arte moderna)*. Organized by the Solomon R. Guggenheim Museum. Sept. 9–Dec. 9. Exh. cats. in English and Italian.

1992. The Montreal Museum of Fine Arts:
1992. The Montreal Museum of Fine Arts. *Masterpieces from the Guggenheim (Chefs-d'oeuvre du Musée Guggenheim)*. Organized by the Solomon R. Guggenheim Museum. Feb. 3–April 26. Exh. cats. in English and French.

References:
Blunt and Pool. 1962:
Blunt, A., and P. Pool. *Picasso: The Formative Years*. Greenwich, Conn. 1962.

Cirici Pellicer. 1946:
Cirici Pellicer, A. *Picasso antes de Picasso*. Barcelona, 1946.

Cirici Pellicer. 1950:
Cirici Pellicer, A. *Picasso avant Picasso*. Trans. M. de Floris and V. Gasol. Geneva, 1950.

Cirlot. 1972:
Cirlot, J.-E. *Picasso: Birth of a Genius*. New York and Washington, 1972.

CLVG:
The Complete Letters of Vincent van Gogh. Greenwich, Conn., 1958, vols. I–III.

Daix. 1965:
Daix, P. *Picasso*. New York, 1965.

Daix. 1977:
Daix, P. *La Vie de peintre de Pablo Picasso*. Paris, 1977.

Daix and Boudaille. 1967/D-B.:
Daix, P., and G. Boudaille. *Picasso: The Blue and Rose Periods*. Trans. P. Pool. Greenwich, Conn., 1967.

Daulte. 1971:
Daulte, F. *Auguste Renoir: catalogue raisonné de l'oeuvre peint*. Lausanne, 1971, vol. I.

de la Faille. 1928:
de la Faille, J.-B. *L'Oeuvre de Vincent van Gogh*. Paris and Brussels, 1928, vols. I–IV.

de la Faille. 1939:
de la Faille, J.-B. *Vincent van Gogh*. Paris, 1939.

de la Faille. 1970:
de la Faille, J.-B. *The Works of Vincent van Gogh: His Paintings and Drawings*. Rev. ed. Amsterdam, 1970.

Duncan. 1961:
Duncan, D. D. *Picasso's Picassos*. New York, 1961.

Gordon. 1974:
Gordon, D. E. *Modern Art Exhibitions 1900–1916*. Munich, 1974, vols. I–II.

Solomon R. Guggenheim Museum, *Masterpieces*. 1972:
Solomon R. Guggenheim Museum. *A Picture Book of 19th and 20th Century Masterpieces from the Thannhauser Foundation*. New York, 1972.

Hulsker. 1980:
Hulsker, J. *The Complete van Gogh: Paintings, Drawings, Sketches*. New York, 1980.

Lemoisne. 1946:
Lemoisne, P. A. *Degas et son oeuvre*. Paris, 1946, vols. I–IV.

Penrose. 1958:
Penrose, R. *Picasso: His Life and Work*. London, 1958.

Rewald. 1944:
Rewald, J. *Degas: Works in Sculpture, A Complete Catalogue*. New York, 1944.

Rewald. 1956:
Rewald, J. *Degas Sculpture: The Complete Works*. Rev. ed. New York, 1956.

Rewald. 1962:
Rewald, J. *Post-Impressionism: From van Gogh to Gauguin*. 2nd ed. New York, 1962.

Venturi. 1936:
Venturi, L. *Cézanne: son art, son oeuvre*. Paris, 1936, vols. I–II.

Wildenstein. 1964:
Wildenstein, G., and R. Cogniat. *Gauguin*. Paris, 1964.

Zervos. 1932–77/Z.:
Zervos, C. *Pablo Picasso*. Vol. I, Paris and New York, 1932. Vols. II–XXXII, Paris, 1942–77.

Georges Braque
Born May 1882, Argenteuil
Died September 1963, Paris

Landscape near Antwerp, 1906
(Paysage près d'Anvers; La Rivière; The River)
78.2514 T1

Oil on canvas, 60 x 81 cm (23 ⅝ x 31 ⅞ inches)
Signed lower left:[1] G Braque
Not dated.

Detail. Full image on page 4.

Braque spent the summer of 1906 in Antwerp, his only visit to the city. He went there with Emile-Othon Friesz (1879–1949), who had already been in Antwerp the previous summer. Braque had grown up in Le Havre, where he became friends with Raoul Dufy and Friesz. Friesz was slightly older than Braque and, at that time, farther along in his career. In Antwerp, Braque and Friesz lived in a pension near the port and rented an abandoned casino as a studio on the banks of the Scheldt River. From the balcony of the studio they had a view of the harbor and the river traffic (H. R. Hope, *Georges Braque*, New York, 1949, p. 23; Oppler, p. 51, fn. 3).

In his Fauve period, which began that summer in Antwerp, Braque often made more than one version of the same composition (unpublished research by Margaret Potter). Nicole de Romilly finds that when there are two pictures of the same view it is possible to postulate which one was done in front of the motif and which one was probably done later in the studio (conversation, May 1977). Braque painted two variations of the scene near Antwerp depict-ed in the present picture: *Landscape near Antwerp*, (42 x 50 cm [16 ½ x 19 ¾ inches], 1906, signed, private collection, Paris; J. Russell, *Georges Braque*, New York, 1959, color pl. 3) and *Bay at Antwerp* (50 x 61 cm [19 ⅝ x 24 inches], signed and dated 1906, Sidney Janis Gallery, New York; Christie's, New York, *Impressionist and Modern Paintings and Sculpture*, Oct. 21, 1980, no. 227, color repr.)

Although the former is extremely close to the present work in terms of what is represented, it dis-plays none of the stylized brushwork found in the Thannhauser painting. In addition, the palette has more blues and greens than in the present picture. The predominance of pale yellow and lavender tones in the Thannhauser version would indicate a development in Braque's Fauve style and leads to the hypothesis that our version was painted after the *Landscape near Antwerp* in a private collection, Paris (de Romilly concurred in conversation, May 1977). In *Bay at Antwerp*, the sky is decidedly blue, the left foreground area has more orange, and the right foreground area contains more green than in the present picture. Furthermore, the colors become more expressive in *Bay at Antwerp*. Here, the artist has omitted the large background building found at the left in the present work and in the related *Landscape near Antwerp* (private collection, Paris) and has added a pier in the foreground suggestive of that in *L'Estaque* (50 x 60 cm [19 ⅝ x 23 ⅝ inches], Musée National d'Art Moderne, Paris). While the use of color in *Bay at Antwerp* also sug-gests that it was painted after the Thannhauser ver-sion, no conclusive evidence exists to place the can-vases in a sequence.

Although Braque and Friesz often painted the identical view, no corresponding picture by Friesz has been located. There are similar distant build-ings in Friesz's *La Cale rouge* (A. Salmon, *Emile-Othon Friesz*, Paris, 1920, p. 25, repr.) and *Anvers* (M. Gauthier, *Othon Friesz*, Geneva, 1957, pl. 16).

The palette of the Thannhauser work resembles that in another of Braque's paintings of Antwerp, *The Mast* (48 x 35.5 cm [18 ⅞ x 14 inches], 1906, Wally Findlay Galleries, New York; Russell, pl. 1) and that of his *Still Life with Pitchers* (52.5 x 63.5 cm [20 ¾ x 25 inches], signed and dated 1906, private collection, Switzerland; J. Elderfield, *Fauvism*, 1976, p. 128, color repr., where the author gives a date of 1906–07).

Braque is said to have executed over a dozen paintings that he thought worth keeping during that summer of 1906 (Hope, p. 24). George Isarlov (*Georges Braque*, Paris, 1932, pp. 79–80) lists ten Antwerp paintings, but includes neither the Thannhauser picture nor the two versions related to it. The Thannhauser painting (60 x 81 cm) is larger than any works catalogued by Isarlov under 1906, although some canvases executed in 1907 measure 60 x 81 cm and 65 x 81 cm.

Following his stay in Antwerp, Braque was in Paris during September and part of October. He spent the rest of the autumn at l'Estaque with Friesz. Braque continued to work in a Fauve man-

1. R. Lebel remembers that when he acquired it about 1935, the painting was unsigned and that he took it soon there-after to Braque, who then signed it (correspondence with D. C. Rich, March 1974). Braque signed most of his early works years after he painted them. An example of an early signature is found on the related painting, *Bay at Antwerp*, which is discussed in this entry. Likewise, Braque only rarely dated his early pictures and often added dates at a later time (J. Elderfield, *The "Wild Beasts": Fauvism and Its Affinities*, exh. cat., The Museum of Modern Art, New York, 1976, p. 158, fn. 107).

ner through 1907, when he lived in the south of France and in Paris.

John Elderfield (correspondence, May 1976) considers the present picture more advanced stylistically than the Antwerp harbor paintings and even some Paris paintings, but points out that Braque's development is by no means a clear progression, a conclusion also arrived at by de Romilly (conversation, May 1977). The brushwork of *Landscape near Antwerp* is stylized in a manner not common to the summer of 1906. However, the colors are not as extreme as those found in the work of 1907. Ellen Oppler agrees on a date of 1906 (correspondence, Jan. 1977). Potter thinks it likely that Braque painted the Thannhauser picture in his studio when he was no longer in Antwerp (conversation, April 1975).

Provenance:
Purchased from an unknown private collection in Paris by Robert Lebel, ca. 1935; purchased from Lebel by J. K. Thannhauser, 1950–51 (correspondence with Lebel, March 1974).

Condition:
Support is fine-weave canvas that was glue lined at an unknown date prior to 1965. Flattening of the pigment especially in area of sky. Scattered minor areas of abrasion (Jan. 1975).

Exhibitions:
1938. Paris, Galerie Pierre. *Georges Braque: Paysages de l'époque fauve*. Feb. 4–21 [2] (1906).

1941. New York, Marie Harriman Gallery. *Les Fauves*. Oct. 20–Nov. 22. No. 27 (*La Rivière*, 1906).

1943. New York, Buchholz Gallery (Curt Valentin). *Early Work by Contemporary Artists*. Nov. 16–Dec. 4. No. 3 (*The River*, 1906, lent by Lebel).

1944. New York, Mortimer Brandt Gallery. *Color and Space in Modern Art Since 1900*. Feb. 19–March 18. No. 10.

1944. Boston, Institute of Modern Art. *Pioneers*. March 28–April 30. No. 1.

1946. The Toledo Museum of Art. *The Spirit of Modern France: An Essay on Painting in Society 1745–1946*. Nov.–Dec. No. 67. Traveled to the Art Gallery of Toronto, Jan.–Feb. 1947.

1950. Venice, XXV Esposizione Biennale Internazionale d'Arte. *Mostra dei Fauves*. 2nd ed. No. 6 bis (?) [3] (*Riviera* [sic], 1906, coll. Robert Lebel, New York).

1950. New York, Sidney Janis Gallery. *Les Fauves*. Nov. 13–Dec. 23. No. 2 (*River*, 1906, lent by Lebel).

1955. The Art Institute of Chicago, on loan from J. K. Thannhauser (correspondence with W. D. Bradway, Dec. 1973). May–Aug.

1960. Pasadena Art Museum. *Georges Braque*. April 20–June 5. No. 2 (*Landscape*, 1906).

1988. New York, Solomon R. Guggenheim Museum. *Georges Braque* (organized with Kunsthalle der Hypo-Kulturstiftung, Munich, the first venue). June 10–Sept. 11 (shown in New York only). Exh. cat., pp. 38–39, no. 4, color repr.

1990. Los Angeles County Museum of Art. *The Fauve Landscape*. Oct. 7–Dec. 30 (first venue only). Exh. cat., p. 271, no. 282, repr.

References:
Arnason, H. H. *History of Modern Art*. New York, 1968, pp. 122–23, repr.

de Romilly, N. W., and J. Laude. *Braque: Cubism: 1907–1914*. Paris, 1982, p. 17, repr., and 18 (*La Petite Baie d'Anvers*).

Solomon R. Guggenheim Museum. *Masterpieces*. 1972, p. 78, repr.

Oppler, E. C. *Fauvism Reexamined*. New York, 1976, p. 52, fn. 2 (photo reprint of Ph.D. dissertation, Columbia University, 1969).

Wilkin, K. "Georges Braque at the Guggenheim." *New Criterion*, vol. 7, no. 2, Oct. 1988, p. 53.

2. According to a list of exhibitions given by Lebel to Thannhauser. A copy of the catalogue has not been found if, in fact, one existed.

3. In a list of exhibitions for the present picture given to Thannhauser, Lebel included the 1950 Biennale exhibition, citing the painting as no. 6 bis. On the other hand, he stated (in correspondence, March 1974) that another Fauve Braque, which he still owns, was exhibited there and the present painting was not. The presence of a sticker from the "XXV Biennale Internazionale d'Arte di Venezia–1950" on the reverse of the stretcher of the Thannhauser work would favor the former alternative.

Guitar, Glass, and Fruit Dish on Sideboard.
early 1919
*(Guitare, verre et compotier sur un buffet: Le Buffet: The
Sideboard: Verre posé sur papier à musique: La Guitare:
Nature morte à la guitare). 81.2821*

Oil on canvas, 81 x 100.3 cm (31 ⁷/₈ x 39 ⁵/₂ inches)
Signed and dated on reverse: <u>G. Braque / 19.</u>

Detail. Full image on page 42.

When Braque resumed painting after World War I, he limited his artistic production almost exclusively to still lifes. His predilection for musical instruments—often juxtaposed with fruit or a newspaper—is evident in the present picture and other large canvases. In 1918 and 1919, Braque sometimes placed the still lifes on a sideboard or, more often, on a round-topped, pedestal table (*guéridon*). The Thannhauser painting displays the frontal design and rectangular motif of a sideboard or buffet, which also appears prominently in the closely related still life *Guitare et compotier* of 1919 (73.5 x 130 cm [29 x 51 ¼ inches], Musée National d'Art Moderne, Paris; Mangin, pl. 47; Pouillon and Monod-Fontaine, p. 61, color repr.) and in *Le Buffet* of 1920 (81 x 100 cm [31 ⁷/₈ x 39 ³/₈ inches]; private collection, Basel; Mangin, pl. 72). Although the still-life objects appear in many coeval works, the guitar and compotier can be related specifically to those in Mangin pls. 23, 45, and 47–49. The glass closely resembles those in Mangin pls. 23, 60, and 63, and the pattern of red dots on green cloth is prominent in Mangin pls. 23, 26, 45, 47, 54, and

60–63. The Thannhauser picture is distinguished by a black background, adjacent tan areas contrasting with the red and green patterned tablecloth, and three light-blue zones. Stylistically, it reflects the artist's awareness of Juan Gris's still lifes, an increased emphasis on planes of color, and the use of black offset by brighter colors.

According to Douglas Cooper (correspondence, June 1981, and conversation, Nov. 1981), the present picture was exhibited at Léonce Rosenberg's Galerie L'Effort Moderne in March 1919. A year later, Rosenberg published Roger Bissière's book *Georges Braque*, in which still lifes, including eight from 1919, were reproduced. A photograph of our still life (no. 160) exists in the Léonce Rosenberg photo archive at the Monuments Historiques et des Sites in Paris (correspondence, June 1981). Both Bissière and Rosenberg referred to the painting simply as *Nature morte*; the artist himself rarely assigned titles to his works.

Isarlov (1932, no. 256) catalogued the painting as *Verre posé sur papier à musique* and cited Rosenberg's inventory number (L.160-6358). On

the reverse of the original stretcher, an old label from the Galerie L'Effort Moderne bears the same number as well as the date "mai 1919." According to Nicole de Romilly (formerly Mangin), it is not possible to determine to what this date specifically refers (correspondence, June 1981). Clearly the painting dates from early 1919, most likely in January or February.

As a young banker, Raoul La Roche (1889–1965), who purchased the painting from Galerie L'Effort Moderne, had gone to Paris in 1912. He became a close friend of Le Corbusier in 1918, who founded *L'Esprit nouveau* the following year with Amédée Ozenfant. La Roche acquired many works by Braque, Picasso, Gris, and, later, Léger. He bought many pictures from Léonce Rosenberg and from the 1921–24 auctions of works belonging to D.-H. Kahnweiler. (For further information about La Roche, see Öffentliche Kunstsammlung, Basel, *Die Schenkung Raoul La Roche*, exh. cat., 1963, and *Basler Nachrichten*, June 17, 1965.)

Provenance:
Purchased from Galerie L'Effort Moderne (Léonce Rosenberg), Paris, by Raoul La Roche, Paris and Basel, 1919–20 (correspondence with D. Cooper, June 1981); La Roche Family Collection, 1965; acquired by Stephen Hahn, Inc., New York, 1980 (conversation with S. Hahn, Nov. 1981); purchased from Hahn, 1981, by Solomon R. Guggenheim Museum: Gift, Justin K. Thannhauser Foundation, by exchange.

Condition:
The painting is unlined and in good condition. The ground and paint layers are very dry, and there is no varnish layer. Besides the signature on the reverse, there is an area of paint in the top right of the reverse that shows as a "stain" at the top left of the front. In places on the reverse there appear to be areas of what is possibly mold or something similar (March 1992).

Exhibitions:
1919. Paris, Galerie L'Effort Moderne (Léonce Rosenberg). *Braque.* March 5–31 (correspondence with D. Cooper, June 1981).

1949. The Cleveland Museum of Art. *Georges Braque*. Jan. 25–March 13. Traveled to New York, The Museum of Modern Art (organizer). March 29–June 12. No. 41, pp. 77, repr., and 83 (*The Buffet*).

1961. Paris, Musée du Louvre. *L'Atelier de Braque*. Nov. No. 24, repr. (*La Guitare*).

1962. Basel, Galerie Beyeler. *Le Cubisme: Braque, Gris, Léger, Picasso*. May–July. No. 28, repr. (*Nature morte à la guitare*).

1962. Paris, Galerie Knoedler. *Le Cubisme: Picasso, Braque, Gris, Léger*. Oct. 9–Nov. 10. No. 24, color repr. (*Nature morte à la Guitare*).

1963. Munich, Haus der Kunst. *Georges Braque*. Oct. 18–Dec. 15. No. 60, color repr. (*Stilleben mit einer Gitarre* [*Nature morte avec une guitare*]).

1968. Basel, Galerie Beyeler. *G. Braque*. July–Sept. No. 25, color repr. (*Nature morte à la guitare*).

References:
Bissière, [R.]. *Georges Braque*. Paris, 1920, pl. 15 (*Nature morte*).

Bulletin de L'Effort Moderne, no. 3, March 1924, repr. betw. pp. 8–9 (*La guitare*).

Cahiers d'Art. Numéro consacré à Georges Braque, 8^e année, no. 1–2, 1933, pp. 36–37, repr.

Cooper, D. *Braque: The Great Years*. Exh. cat., The Art Institute of Chicago, 1972, pp. 37–38 (*The Sideboard*).

L'Esprit Nouveau, no. 25, July 1924.

Fumet, S. *Georges Braque*. Paris, 1965, p. 70, color repr. (*Le buffet*).

Isarlov, G. *Georges Braque*. Paris, 1932, p. 22, no. 256 (*Verre posé sur papier à musique*).

Judkins, W. *Fluctuant Representation in Synthetic Cubism: Picasso, Braque, Gris, 1910–1920*. New York and London, 1976, pp. 79–80 and 456, no. 77, repr. (*The Buffet*).

Mangin, N. *Catalogue de l'oeuvre de Georges Braque: Peintures 1916–1923*. Paris, 1973, pl. 46, repr. (*Le Buffet*).

Ponge, F. *Braque le réconciliateur*. Geneva, 1947, no. 8, color repr. (*Verre et Guitare*).

Pouillon, N., and I. Monod-Fontaine. *Braque*. Paris, 1982, pp. 62–63, repr. (*Le Buffet*).

Russell, J. *G. Braque*. London, 1959, pp. 22 and 122, no. 27, color repr. (*The Sideboard*).

Sélection, no. 5, Dec. 15, 1920, p. 13, repr.

Tériade, E. "Documentaire sur la jeune peinture: II. L'avènement classique du Cubisme." *Cahiers d'Art*, 4^e année, no. 10, 1929, p. 451, repr. (*Nature-morte*).

Valsecchi, M., and M. Carra. *L'opera completa di Braque dalla scomposizione cubista al recupero dell'oggetto 1908–1929*. Milan, 1971, p. 94, no. 172, repr. (*Natura morta con chitarra {La credenza}*).

Zervos, C. "Georges Braque." *Gaseta de les Arts*, Añy II, no. 9, May 1929, p. 128, repr. (*Nature morta*).

Teapot on Yellow Ground. *1955*
(*Théière sur fond jaune*)
78.2514 T2

Oil on canvas. 35 x 65 cm (13 ½ x 25 ⅝ inches)
Signed at bottom left of center: <u>G Braque</u>
Not dated.

Fig. a. Reverse of Teapot on Yellow Ground.

A related version from the same year is *La Théière grise* (19 x 60 cm [7 ½ x 23 ⅝ inches], Galerie Rosengart, Lucerne; Mangin, pl. 99). The still-life arrangement with teapot first appears in 1942 (Mangin, *Catalogue de l'oeuvre de Georges Braque 1942–1947*, Paris, 1960, vol. II, pls. 16–19, 21–24) and recurs from time to time, especially around 1950.

On the reverse of the present picture is an earlier attempt (fig. a) which Nicole de Romilly (formerly Mangin) considers to be almost certainly a work of 1910 (correspondence, March 1976). She does not know of another fragment from the same period used in the same manner. However, throughout his life Braque sometimes painted on the reverse of a canvas he had already begun (correspondence with de Romilly, March 1976).

Provenance:
Purchased from the artist by Galerie Maeght, Paris, 1955; purchased from Maeght by J. K. Thannhauser, Feb. 1956 (correspondence with N. de Romilly, March 1974).

Condition:
The support is sized but unprimed linen. The canvas has tack holes on the top and right sides, and it has been cut on the bottom and left sides. On the reverse is a fragment of a Cubist landscape painted on commercially primed canvas. Small losses above the handle and spout of the teapot (Jan. 1975).

Exhibition:
1982–83. Washington, D.C., The Phillips Collection. *Georges Braque: The Late Paintings 1940–1963*. Oct. 9–Dec. 12. Traveled to The Fine Arts Museums of San Francisco, The California Palace of the Legion of Honor, Jan. 1–March 15, 1983; Minneapolis, Walker Art Center, April 14–June 14; and Houston, The Museum of Fine Arts, July 7–Sept. 14. Exh. cat., p. 83, no. 38, repr.

References:
Solomon R. Guggenheim Museum. *Masterpieces.* 1972, p. 79, repr.

Mangin, N. *Catalogue de l'oeuvre de Georges Braque 1948–1957.* Paris, 1959, vol. I, pl. 98 (*Théière sur fond jaune*).

Paul Cézanne
Born January 1839, Aix-en-Provence
Died October 1906, Aix-en-Provence

Still Life: Flask, Glass, and Jug, *ca. 1877*
(Fiasque, verre et poterie; La Bouteille paillée; La Bouteille treillissée; Le Pichet)
78.2514 T3

Oil on canvas, 45.7 x 55.3 cm (18 x 21 1/4 inches)
Not signed or dated.

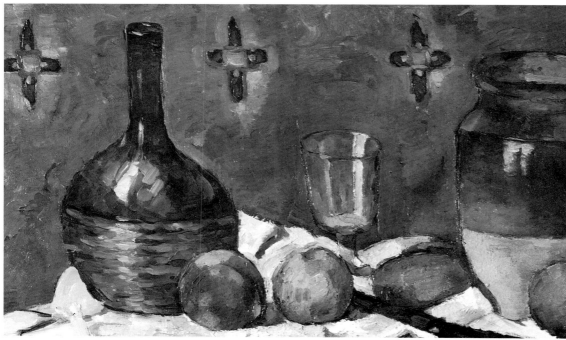

Detail. Full image on page 44.

Still Life: Flask, Glass, and Jug has been dated ca. 1877 by Lionello Venturi, Lawrence Gowing, John Rewald (correspondence with D. C. Rich, Feb. 1975), Douglas Cooper (correspondence, March 1977), Robert W. Ratcliffe (correspondence, June 1977), and Theodore Reff (correspondence, Nov. 1977). At that time, Cézanne lived at 67, rue de l'Ouest in Paris. Georges Rivière was the first to associate the background wallpaper in the still lifes with the apartment Cézanne occupied in Paris from late 1876 to early 1878 and again for a short time while in 1879 (*Cézanne: le peintre solitaire*, Paris, 1933, p. 126). The present work is included as no. 139 in Vollard's photo archive, where it is annotated 1874 (Rewald correspondence, Feb. 1975). Rewald finds the Thannhauser still life close in style to two pictures known to have been painted in 1877: a portrait of Victor Chocquet (Venturi 373) and a still life (Venturi 494; see "A propos du catalogue raisonné de l'oeuvre de Paul Cézanne et de la chronologie de cette oeuvre," *La Renaissance*, XX° année, March–April 1937, p. 54).

Venturi (vol. I, p. 112) grouped together five still lifes (nos. 209, 210, 212, 213, and 214) and two portraits of Mme Cézanne (nos. 291 and 292) where the background wallpaper has the same pattern: a blue lozenge motif repeated on an olive-yellow background. *The Plate of Apples* (Venturi 210; The Art Institute of Chicago) has the same dimensions as the present picture. Comparison of the two demonstrates how the artist adapted the lozenge pattern of the wallpaper to correspond with the composition of the still life. In the Thannhauser still life the lozenges are arranged horizontally and are closer together than in the Chicago painting. Likewise, there are similar discrepancies between the wallpaper patterns in the *Portrait of Madame Cézanne* in the Museum of Fine Arts in Boston (Venturi 292; 72.5 x 56 cm [28 1/2 x 22 inches]) and *Madame Cézanne Sewing* in the National-museum, Stockholm (Venturi 291; 60 x 49.7 cm [23 5/8 x 19 5/8 inches]).

Provenance:
Eugène Murer, Auvers-sur-Oise;[1] purchased from Murer by Bernheim-Jeune family collection, Paris,

ca. 1907 (correspondence with G. Gruet, May 1977); purchased from Bernheim-Jeune by Joseph Brochier, Lyons, probably after 1934;[2] acquired from Brochier by J. K. Thannhauser, ca. 1957 (notes by D. C. Rich from conversation with Thannhauser, March 1975).

Condition:
Glue lined at an unknown date before 1965 and edges trimmed. *Pentimenti* reveal that the rim of the glass has been lowered by approximately one-half inches. Indication of reworking in area of jug and flask (Dec. 1974).

Exhibitions:
1912. Paris.[3]

1934. London, Alex Reid and Lefevre, Ltd. *Renoir, Cézanne, and Their Contemporaries*. June. No. 3, repr. (*La Bouteille paillée*, 1883).

1935. Paris, Bernheim-Jeune. *Quelques Tableaux d'Ingres à Gauguin*. June 11–July 13. No. 3 (acc. to Venturi).

1939. Paris, Paul Rosenberg. *Exposition Cézanne organisée à l'occasion de son centenaire*. Feb. 21–April 1. No. 5, repr. (1877, coll. Joseph Brochier).

1939. London, Wildenstein and Co., Ltd. *Homage to Paul Cézanne*. July. No. 20 (correspondence with L. Foster, Nov. 1973).

1939. Musée de Lyon. *Centenaire de Paul Cézanne*. No. 19 and pl. viii.

1942. Musée de Lyon. *Exposition de peinture française de l'Impressionisme à nos jours*. May. No. 6.

1953. Aix-en-Provence, Musée Granet. *Cézanne*. Traveled to Nice. No. 7.

1. According to J. Rewald (correspondence with D. C. Rich, Feb. 1975), Murer may have acquired the present picture directly from the artist or from his friend Dr. Gachet, who could have purchased it from Cézanne. Murer died in 1906.

2. The picture was returned to Josse Bernheim after the exhibition at Alex Reid and Lefevre, Ltd., in June 1934 (correspondence with D. L. Corcoran, Aug. 1977).

3. Rewald (correspondence, Feb. 1975) agrees that the reference might be to *Exposition d'art moderne* at Galerie Manzi-Joyant et Cie., Paris, at an unknown date in 1912 where nos. 1, 3, 12, 13, 20, 21, or 23 could be the present picture (Gordon, 1974, vol. II, p. 530).

1955. Saint-Etienne, Musée d'Art et d'Industrie. *Nature mortes de Géricault à nos jours*. No. 15, repr.

1956. Aix-en-Provence, Pavillon de Vendôme. *Exposition pour commemorer le cinquantenaire de la mort de Cézanne*. July 21–Aug. 15. No. 16, repr. (private coll., Lyons).

1962. The Cleveland Museum of Art. Summer. (Lent by J. K. Thannhauser; correspondence with T. Hinson, Jan. 1974).

1990. Venice, Palazzo Grassi. Pp. 58–59, no. A2, color repr.

References:
L'Art moderne et quelques aspects de l'art d'autrefois: cent-soixante-treize planches d'après la collection privée de MM. J & G. Bernheim-Jeune. Paris, 1919, vol. I, p. 90 and pl. 31 (*Le Pitchet*).

Bernard, E. *Souvenirs sur Paul Cézanne*. Paris, 1926, opp. p. 61, repr.

Brion-Guerry, L. *Cézanne et l'expression de l'espace*. Paris, 1966, pp. 91 and 276, no. 21.

Dunlop, I., and S. Orienti. *The Complete Paintings of Cézanne*. 1972. Reprint, Harmondsworth, England, 1985, pp. 94 and 96, no. 212, repr. (*Flask, Glass and Fruit*).

Dunlop, R. O. "Modern Still Life Painting in Oils." *The Artist*, vol. XIII, May 1937, p. 67, repr.

Eddy, A. J. *Cubists and Post-Impressionism*. Chicago, 1914, opp. p. 36, repr.

Gatto, A., and S. Orienti. *L'opera completa di Cézanne*. Milan, 1970, pp. 94 and 96, no. 212., repr.

Gaunt, W. "P. Cézanne: An Essay in Valuation." *The London Studio*, vol. 16, Sept. 1938, p. 148, repr. (*La Bouteille paillée*, 1883).

Gowing, L. "Notes on the Development of Cézanne." *The Burlington Magazine*, vol. XCIII, June 1956, p. 188 (1877).

Solomon R. Guggenheim Museum. *Masterpieces*. 1972, p. 18, repr.

Meier-Graefe, J. *Cézanne und sein Kreis*. Munich, 1922, p. 190, repr.

Mirbeau, O., et al. *Cézanne*. Paris, Bernheim-Jeune, 1914, pl. XXXV.

Paul Cézanne Mappe. Munich, 1912, no. 2 (*Stilleben mit Weinflasche*).

Ratcliffe, R. W. *Cézanne's Working Methods and Their Theoretical Background*. Ph.D. dissertation, Courtauld Institute of Art, University of London, 1960, pp. 140, 158, 290, 383, fn. 35, and 430, fn. 151.

Raynal, M. *Cézanne*. Paris, 1936, pl. lxxxvi.

Rivière, G. *Le Maître Paul Cézanne*. Paris, 1923, p. 211 (*La Bouteille trellissée*, 1883).

Samleren, vol. 6, no. iii, 1929, p. 138, repr.

Schapiro, M. "Les Pommes de Cézanne." *Revue de l'Art*, no. 1–2, 1968, p. 80, fn. 44.

Venturi. 1936, vol. I, p. 113, no. 214, and vol. II, pl. 58 (*Fiasque, verre et poterie*, ca. 1877).

Zeisho, A. *Paul Cézanne*. Tokyo, 1921, pl. 5.

Z[ervos], C. "Les Expositions." *Cahiers d'Art*, 9ᵉ année, no. 5–8, 1934, p. 127, repr. (*La Bouteille paillée*, 1883).

Still Life: Plate of Peaches. *1879–80*
(Assiette de pêches; L'Assiette bleue)
78.2514 T4

Oil on canvas, 59.7 x 73.3 cm (23 ¹/₂ x 28 ⁷/₈ inches)
Not signed or dated.

Detail. Full image on page 45.

The background in the present picture is gray-blue wallpaper with sprays of leaves. It occurs in thirteen still lifes (Venturi 337–48 and 353) as well as in the portraits of Louis Guillaume (Venturi 374) and Mme Cézanne (Venturi 369). Lionello Venturi (vol. I, p. 138) stated that the leaf-patterned wallpaper was from either the house in Melun, where Cézanne lived in 1879 and 1880, or from his apartment at 32, rue de l'Ouest, where he lived in 1881 and 1882. No documentary evidence has emerged to resolve the question.

John Rewald thinks that the wallpaper decorated Cézanne's lodgings in Melun (correspondence with D. C. Rich, Feb. 1975). Cézanne was in Melun from April 1879 through March 1880 (Rewald, *Paul Cézanne: A Biography*, New York, 1948, p. 218). Robert W. Ratcliffe places the Thannhauser still life in the winter of 1879–80 (correspondence, June 1977), while Theodore Reff prefers a date of ca. 1880 (correspondence, Nov. 1977).

Although Douglas Cooper dates the present picture ca. 1879, he thinks that it was painted in

Paris, probably in the summer. He refers to similarities with *Bridge at Maincy* (Venturi 396) and to the fact that the latter was painted during the summer of 1879 (correspondence, March 1977). While Maincy is near Paris, it is far closer to Melun. Cézanne's letters give the distinct impression that he was in Melun all summer (Rewald, ed., *Paul Cézanne's Letters*, trans. M. Kay, Oxford, 1946, Letters LXI–LXX, esp. LXV).

Provenance:
Egisto Fabbri, Florence;[1] purchased from Fabbri by Paul Rosenberg, Paris, 1928 (correspondence with A. Rosenberg, Nov. 1973); acquired from Rosenberg by J. K. Thannhauser, 1929 (notes, Dec. 1972).

Condition:
Glue lined at an unrecorded date before 1965 and margins trimmed. Considerable reworking in tablecloth and in background. Especially true in area over table where there is impasto and visible evidence of four pieces of fruit that have been painted over by the artist. The effect of emerging background shapes is augmented by the leaf wallpaper (Dec. 1974).

Exhibitions:
1910. Paris, Bernheim-Jeune. *Exposition Cézanne*. Jan. 10–22. No. 20.[2]

1920. Venice, XII Esposizione Internazionale d'Arte della città di Venezia, French Pavilion. *Mostra individuale di Cézanne*. No. 4, 5, or 6.[3]

1931. Basel, Kunsthalle. *Maîtres du XXᵉ siècle*. Sept. 27–Oct. 25. No. 2 (correspondence with M. Suter, Dec. 1973).

1952. The Art Institute of Chicago. *Cézanne*. Feb. 7–March 16. No. 25, repr. Traveled to New York, The Metropolitan Museum of Art. April 1–May 16.

1955. Kansas City, William Rockhill Nelson Gallery of Art. *Summer Exhibition* (label on reverse).

1963. New York, Solomon R. Guggenheim Museum. *Cézanne and Structure in Modern Painting*. June–Aug.

1990. Venice, Palazzo Grassi. Pp. 60–61, no. A3, color repr.

1992. The Montreal Museum of Fine Arts. Pp. 62–63, no. 4, color repr.

References:
"La Collection Egisto Fabbri." *L'Amour de l'art*, Vᵉ année, Nov. 1924, p. 340, repr.

Dunlop, I., and S. Orienti. *The Complete Paintings of Cézanne*. 1972. Reprint, Harmondsworth, England, 1985, pp. 107, no. 455, repr., and 108 (*Plate of Peaches*).

Gatto, A., and S. Orienti. *L'opera completa di Cézanne*. Milan, 1970, pp. 107, no. 455, repr., and 108.

Solomon R. Guggenheim Museum. *Masterpieces*. 1972, p. 19, repr. (1879–82).

Henraux, L. "I Cézanne della raccolta Fabbri." *Dedalo*, no. 1, 1920, p. 67, repr.

Venturi. 1936, vol. I, p. 113, no. 347, and vol. II, pl. 96 (*Assiette de pêches*, 1879–82).

1. Egisto Fabbri (1866–1933) was an early collector of Cézanne's work. He lived in Paris for many years before returning to Florence late in life. He owned sixteen works as of May 1899. L. Venturi's catalogue raisonné lists twenty-six paintings that once belonged to Fabbri. He probably purchased his Cézanne's from Amboise Vollard (correspondence with Rewald, Feb. 1975, and with Cooper, March 1977).

2. According to G. Gruet of Bernheim-Jeune (correspondence, Dec. 1973), it was no. 20 and not 19 as stated in the catalogue.

3. The *Mostra individuale di Cézanne* included twenty-four paintings from the collection of Egisto Fabbri. Comparing the

Biennale catalogue to Venturi's catalogue raisonné, all but nos. 4–6 ("Tre Nature Morte") and nos. 15, 16, and 22 (landscapes) in the Biennale can be readily identified. Venturi catalogues four still lifes that belonged to Fabbri (193, 220, 221, and 347) of which three must have been in the Biennale. Of the four, only the present picture has a reference to the Biennale in Venturi. A coeval article on the Fabbri collection in *Dedalo* reproduces fourteen pictures (including the present one). Venturi catalogues each of these as having been exhibited at the Biennale, and all but the Thannhauser painting can be associated with a specific catalogue number. Thus, it seems certain that the present picture was exhibited.

Paul Cézanne

Madame Cézanne. 1885–87
78.2514 T5

Oil on canvas. 55.6 x 45.7 cm (21 ⅞ x 18 inches)
Not signed or dated.

Detail. Full image on page 51.

The sitter is Hortense Fiquet, who was to become Mme Cézanne. She was born in 1850 in the region of the Jura Mountains in France near the Swiss border. The artist met her about 1869 in Paris, and their son Paul was born there in January 1872 (J. Rewald, "Cézanne and His Father," *Studies in the History of Art*, 1971–72, p. 52). They were married April 28, 1886, in Aix-en-Provence. During the three years before their marriage, Cézanne lived in Provence while Hortense stayed in Paris most of the time, although in 1886, Cézanne spent much of the year with her in Gardanne. The same pattern persisted after their marriage with visits and occasional trips together (J. Rewald, *Paul Cézanne: A Biography*, New York, 1948, pp. 113–14, 131, and 218–19). Photographs of Mme Cézanne at a later age can be found in W. Andersen, *Cézanne's Portrait Drawings*, Cambridge, 1970, p. 113, figs. 91 a and b. Mme Cézanne was buried May 6, 1922, in Père-Lachaise Cemetery, Paris (conversation with Rewald, Oct. 1977).

When they were together, Cézanne frequently painted her portrait. These portraits have always

been dated on the basis of style in the absence of documentary evidence. A system of dating has also been proposed based on the fashion of Mme Cézanne's clothes, the date a new style appeared providing a *terminus post quem* (Ann H. van Buren, "Madame Cézanne's Fashions and the Dates of Her Portraits," *The Art Quarterly*, vol. XXIX, no. 2, 1966, pp. 111–27). Mme Cézanne wears the navy-blue jacket with upright collar that came into fashion in the spring of 1886 in the *Portrait of Mme Cézanne* (Venturi 523; 81 x 65 cm [31 ¹⁵/₁₆ x 25 ⅝ inches], Musée du Louvre, Galerie du Jeu de Paume, Paris, Bequest of Jean Walter-Paul Guillaume; Paris, Musée de l'Orangerie, exh. cat., 1974, p. 16, color repr. of face), and either the same jacket or a dress with wide vertical pleats in the *Portrait of Mme Cézanne* (Venturi 524; 46 x 38 cm [18 ⅛ x 15 inches], Collection J. V. Pellerin; van Buren, p. 119). In the Thannhauser sketch (Venturi 525), she appears to wear the same style of dress and hairdo as in the above pictures. Thus, by implication, van Buren would date the present work no earlier than 1886. However, the lack of description in the present work rules out conclusive proof. In the Thannhauser version and in the Pellerin portrait, the artist has painted the sitter's head tipped at a slight angle so that only one ear is visible.

Lionello Venturi dated the present picture 1885–87, the same as the Pellerin work, and gave a date of 1885–90 for the picture in the Walter-Guillaume Bequest. John Rewald suggested a date of ca. 1885(?) for the Thannhauser work (correspondence with D. C. Rich, Feb. 1975). Douglas Cooper (correspondence, March 1977) prefers a date of ca. 1883 for the present work and three he relates to it: *Portrait of Mme Cézanne* in the Walter-Guillaume Bequest; *Madame Cézanne in the Conservatory* (Venturi 569; The Metropolitan Museum of Art, New York); and the pencil drawing from page vii of the *Album* owned by Paul Mellon (Venturi 1303; Chappuis, vol. I, p. 246, no 1068). The Metropolitan's painting has also been dated ca. 1890 by Venturi and ca. 1891 by Georges Rivière and Rewald. Rewald (conversation, Oct. 1977) disagrees with suggestions that the Thannhauser picture is a study for the portrait in the Walter-Guillaume Bequest or a reworking of it (Paris, Musée de l'Orangerie, exh. cat., 1966, no. 11, and 1974, no. 35).

Provenance:
Ambroise Vollard, Paris;[1] probably purchased from Vollard by Marie Harriman, New York, by 1933; purchased from Marie Harriman by J. K. Thannhauser, Jan. 1946 (conversation with A. Sardi, July 1974); purchased from Thannhauser by Vladimir Horowitz, New York, 1946–47 (correspondence with B. Stein, Feb. 1974); purchased from Horowitz by the Cincinnati Art Museum, 1947; acquired by J. K. Thannhauser through exchange, 1955 (correspondence with P. R. Adams, Nov. 1973).

Condition:
Glue lined at an unknown date prior to 1965 and edges trimmed. Considerable soil on surface (Dec. 1974).

Exhibitions:
1933. New York, Marie Harriman Gallery. *French Paintings*. Opened Feb. 21.[2] No. 2 (*Tête de Femme*).

1934. Philadelphia, Pennsylvania Museum of Art. *Cézanne*. Nov. 10–Dec. 10. No. 34[3] (*Head of a Woman*, ca. 1890–91, 22 x 18 ½ inches, lent by Marie Harriman Gallery).

1935. San Francisco Museum of Art. *Opening Exhibition*. From Jan. 18. No. 1[4] (*Head of a Woman*, 1890–91, lent by Marie Harriman Galleries).

1936. New York, Marie Harriman Gallery. *Paul Cézanne, André Derain, Walt Kuhn, Henri Matisse, Pablo Picasso, Auguste Renoir, Vincent van Gogh*. Feb. No. 5 (*Study: Madame Cézanne*).

1937. San Francisco Museum of Art. *Paul Cézanne*. Sept. 1–Oct. 4. No. 22, repr. (*Portrait of Madame Cézanne*, lent by Marie Harriman Gallery).

1. Vollard first saw Cézanne's work at Père Tanguy's shop in 1892 and, three years later, gave an exhibition of Cézanne's paintings at his own gallery in the rue Laffitte (G. Rivière, *Le Maître Paul Cézanne*, Paris, 1923, p. 111).
According to John Rewald, a photograph of the Thannhauser work is not in Vollard's photo archive (correspondence with D. C. Rich, Feb. 1975).
2. Information from Frick Art Reference Library photograph (no. 522–9/c).
3. Confirmed by information on Frick Art Reference Library photograph and in *Cincinnati Art Museum News*, vol. II, no. 7, Nov. 1947, p. i.
4. Ibid.

1939. New York, Marie Harriman Gallery. *Cézanne Centennial Exhibition*. Nov. 7–Dec 2. No. 12 (1885–87).

1940. Lynchburg (Va.), Randolph-Macon Woman's College. *Modern French Paintings*. May 6–June 5. No. 1 (*Portrait de Mme Cézanne*).

1940. Oberlin (Ohio), Allen Memorial Art Museum. *Modern Paintings*. Nov. 1–27.[5]

1941. New York, The Museum of Modern Art. *Advisory Committee Exhibition: Techniques of Painting*. Aug. 4–Oct. 15 (No cat.; MoMA Registrar's files 41.1423).

1947. New York, Wildenstein and Co. *Cézanne*. March 27–April 26. No. 38 (lent by Mr. and Mrs. Vladimir Horowitz).

1956. Raleigh, The North Carolina Museum of Art. *French Painting of the Last Half of the Nineteenth Century*. June 15–July 29. Repr. (lent by J. K. Thannhauser).

1963. New York, Solomon R. Guggenheim Museum. *Cézanne and Structure in Modern Painting*. June–Aug.

1990. Venice, Palazzo Grassi. Pp. 62–63, no. A4, color repr.

References:
Chappuis, A. *The Drawings of Paul Cézanne: A Catalogue Raisonné*. Greenwich, 1973, vol. I, p. 246, no. 1068 (refers to Reff).

Cincinnati Art Museum News, vol. II, no. 7, Nov. 1947, p. i, repr.

Dunlop, I., and S. Orienti. *The Complete Paintings of Cézanne*. 1972. Reprint, Harmondsworth, England, 1985, p. 110, no. 532, repr.

Gatto, A., and S. Orienti. *L'opera completa di Cézanne*. Milan, 1970, p. 110, no. 532, repr.

Solomon R. Guggenheim Museum. *Masterpieces*. 1972, p. 20, repr.

Hoog, M., with H. Guicharnaud and C. Giraudon. *Catalogue de la collection Jean Walter et Paul Guillaume*. Paris, Musée de l'Orangerie, 1984, p. 32.

Musée de l'Orangerie, Paris. *Cézanne dans les musées nationaux*. Exh. cat., 1974, p. 92, no. 35 (Venturi 525 is "esquisse" or "reprise" for 523).

_____. *Collection Jean Walter-Paul Guillaume*. Exh. cat., 1966, no. 11 (suggests Venturi 524 and 525 are studies for 523).

Musée Granet, Aix-en-Provence. *Cézanne au Musée d'Aix*. Aix-en-Provence, 1984, p. 221.

Museo Español de Arte Contemporáneo, Madrid. *Paul Cézanne*. Exh. cat., 1984, p. 134.

Reff, T. Review of "Album de Paul Cézanne." *The Burlington Magazine*, vol. CIX, Nov. 1967, p. 653 (relates Venturi 525 to p. 7 of *Album*).

Venturi. 1936, vol. I, p. 177, no. 525, and vol. II, pl. 163.

5. Ibid.

Bibémus. *ca. 1894–95*
(*Bibémus: rochers rouges*; *Die roten Felsen bei Gardanne*)
78.2514 T6

Oil on canvas. 71.5 x 89.8 cm (28 ⅛ x 35 ⅝ inches)
Not signed or dated.

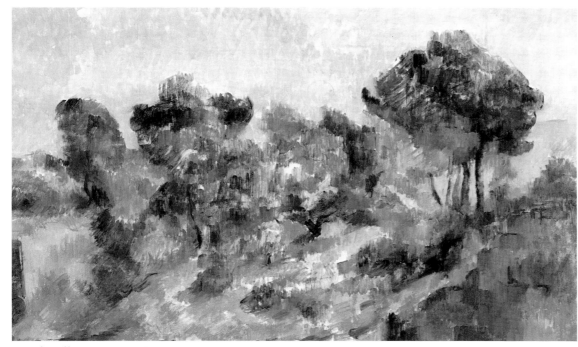

Detail. Full image on page 63.

Discussion of the present picture focuses on the questions of where and when the landscape was painted. Lionello Venturi identified the site as Bibémus. John Rewald (correspondence with D. C. Rich, Feb. 1975) thinks that the landscape resembles the area, and Robert W. Ratcliffe (correspondence, June 1977) agrees that it recalls the terrain. By now the foliage has grown so as to obscure the sites around the Bibémus quarry, and even in the late 1920s Erle Loran found it difficult to photograph them.

The rugged and remote area of Bibémus lies a short distance to the east of Aix-en-Provence off the road to Vauvenarges. It is slightly north of Le Château Noir and Le Tholonet (see J. Rewald, "The Last Motifs at Aix," in *Cézanne: The Late Work*, exh. cat., The Museum of Modern Art, New York, 1977, pp. 93–97). The quarry, which was abandoned when Cézanne painted there, is said to date from Roman times (E. Loran [Johnson], "Cézanne's Country," *The Arts*, vol. XVI, April 1930, pp. 520–51). One of Loran's photographs bears a strong resemblance to the Thannhauser painting (*Cézanne's*

Composition: Analysis of His Form with Diagrams and Photographs of His Motifs, Berkeley and Los Angeles, 1959, p. 113).

With the probable identification of the landscape as Bibémus, the question of date arises since Cézanne's first recorded payment of rent for a hut at the quarry dates from November 1, 1895. Evidence compiled by Ratcliffe would place the artist's work at Bibémus between that date and September 1899 (*Cézanne's Working Methods and Their Theoretical Background*, Ph.D. dissertation, Courtauld Institute of Art, University of London, 1960, pp. 22–26). Yet Cézanne certainly could have painted in the area of the Bibémus quarry before the autumn of 1895. Furthermore, Rewald (conversation, Oct. 1977) points out that it is impossible to know if the rent paid November 1, 1895, was for past or future use of the hut and even if it was actually the first payment Cézanne made. Rewald dates the Thannhauser picture ca. 1894 (correspondence, Feb. 1975), allowing that it could have been painted in 1895 (conversation, Oct. 1977).

Ratcliffe (correspondence, June 1977) tentative-

ly places the Thannhauser picture not later than 1896–97. He finds it close in style to *Arbre at pigeonnier provençal* (Venturi 300; Boerlage collection, Laren), which is painted from the plateau that is pierced by the Bibémus quarry, and to *Le Rocher rouge* (Venturi 776; Collection Jean Walter-Paul Guillaume, Musée du Louvre, Paris). Theodore Reff also dates the present picture 1895–97 (correspondence, Nov. 1977).

In his catalogue, Venturi listed nine works as representing Bibémus (nos. 767, 772, 773, 777, 778, 781, 782, 785, and 786). He dates none earlier than 1898 and most, including the present picture, ca. 1900.

The Thannhauser landscape is closely related to *Corner of Quarry* in the Barnes Foundation, Merion, Pa. (Venturi 782; 45.1 x 54.6 cm [17 ¾ x 21 ½ inches]) with which it shares similar palette, brushwork, and terrain. Similarities in style can also be detected in the upper portion of *Bibémus Quarry* (Venturi 767; Museum Folkwang, Essen), which Rewald considers one of Cézanne's earliest views of the quarry (*Cézanne: The Late Work*, p. 390, no. 11).

In contrast, Douglas Cooper (correspondence, March 1975) thinks that the Thannhauser painting does not represent Bibémus. He finds the subject, palette, and style close to Renoir and prefers a date of 1883–84, soon after Cézanne worked with Renoir in the south of France in 1882–83. Cooper places the present picture with *Le Grand pin et les terres rouges* (Venturi 459; Lecomte collection, Paris) and *La Ferme au Jas de Bouffan* (Venturi 461), both of which he dates ca. 1885, and *Edge of a Wood in Provence* (Venturi 446; National Museum of Wales, Cardiff), which he dates slightly later.

Provenance:
Ambroise Vollard, Paris; purchased from Vollard by J. K. Thannhauser, Nov. 1929 (notes by D. C. Rich from conversation with Thannhauser, March 1975).

Condition:
Glue lined at an unknown date prior to 1965 and edges trimmed. Smoothly and very thinly painted, with drawing visible. At upper left, unpainted areas in sky. (Dec. 1974).

Exhibitions:

1931. Frankfurt, Städelsches Kunstinstitut. *Von Abbild zum Sinnbild.* June 3–July 3. No. 25 *(Die roten Felsen bei Gardanne*, lent by Galerie Thannhauser; correspondence with P. Eich, Nov. 1973).

1939. Musée de Lyon. *Centenaire de Paul Cézanne.* No. 37 (*Rochers rouges à Bibémus*).

1939. Paris, Grand Palais. Société des Artistes Indépendants, *Centenaire du peintre indépendant Paul Cézanne.* March 17–April 10. No. 47 (*Bibémus: rochers rouges*).

1939. Adelaide, The National Art Gallery. *Exhibition of French and British Contemporary Art.* Opened Aug. 21. No. 24 (*Rochers rouges à Bibémus*, ca. 1900). Traveled to Melbourne, Town Hall, opened Oct. 16, and Sydney, David Jones, opened Nov. 20.[1]

1952. The Art Institute of Chicago. Feb. 7–March 16. *Cézanne.* No. 105, repr. (*Bibémus*, ca. 1900). Traveled to New York, The Metropolitan Museum of Art, April 1–May 16.

1955. San Francisco Museum of Art. *Art in the 20th Century: Commemorating the Tenth Anniversary of the Signing of the United Nations Charter.* June 17–July 10. P. 5, repr.

1963. New York, Solomon R. Guggenheim Museum. *Cézanne and Structure in Modern Painting.* June–Aug.

1990. Venice, Palazzo Grassi. Pp. 64–65, no. A5, color repr.

References:
Dunlop, I., and S. Orienti. *The Complete Paintings of Cézanne.* 1972. Reprint, Harmondsworth, England, 1985, pp. 118–19, no. 709, repr.

Gatto, A., and S. Orienti. *L'opera completa di Cézanne.* Milan, 1970, pp. 118–19, no. 709, repr.

Solomon R. Guggenheim Museum. *Masterpieces.* 1972, p. 21, repr. (1900).

Reff, T. "Painting and Theory in the Final Decade." In *Cézanne: The Late Work.* Exh. cat., The Museum of Modern Art, New York, 1977, p. 24.

Venturi. 1936, vol. I, p. 232, no. 781, and vol. II, pl. 258 (ca. 1900).

1. The exhibition was brought to Adelaide by *The Advertiser* and the French section was arranged under the auspices of the *Association française d'action artistique.* Information on the exhibition has kindly been provided by R. Appleyard (Nov. 1973 and June 1975) and A. Dixon (Nov. 1973).

Hilaire-Germain-Edgar Degas
Born July 1834, Paris
Died September 1917, Paris

Dancer Moving Forward, Arms Raised. 1882–95
(*Danseuse s'avançant, les bras levés; Tänzerin vorschreit-end, Arme erhoben*)
78.2514 T8

Bronze, height 35 cm (13 ¹/₄ inches)
Signature incised at left side of base: Degas; stamp of the founder in relief in base near model's right foot: CIRE
PERDUE/A.A. HÉBRARD: *incised identifying mark near model's right foot:* 19. *Not dated.*
D

Detail. Full image on page 47.

After Degas's death, about one hundred and fifty pieces of sculpture were found scattered about his atelier. Ranging in date from the 1870s to 1911, many of the models had been executed in wax or wax and plasteline and occasionally in clay. Many of the sculptures were in pieces and needed restoration, and half of them were damaged beyond repair (see Millard, 1976, pp. 25–26). None had been cast in bronze during the artist's lifetime and only three in plaster. Soon after the discovery, a decision was made to have seventy-three wax statues cast in bronze. These wax figures were taken into the cellar of the founder Adrien A. Hébrard (Millard, 1976, pp. 30–32). At the end of World War I, Hébrard's master founder, Albino Palazzolo, returned from his native Italy and prepared the waxes for casting. The casting was done according to a variation of the lost-wax (*cire-perdue*) method so that the originals were not destroyed. Work was probably begun toward the end of 1919.

Jean Adhémar described the process as follows: "Palazzolo covered the figures with earth, then he enveloped the whole with a coat of plaster, then he removed the earth and poured in its place a specially prepared gelatine, which he then allowed to harden, thus obtaining a gelatine mold. He extracted the original wax figures unharmed and poured wax into the mold reinforcing it with a central core of sand. The duplicate wax figure, being expendable, was cast by the ordinary lost-wax method with the advantage that the resulting bronze cast could be compared with Degas's original wax and given the same tone and finish" ("Before the Degas Bronzes," trans. M. Scolari, *Art News*, vol. 54, Nov. 1955, p. 70). Most of the extant original wax figures came to light in 1955 and belong to Paul Mellon, Upperville, Virginia (sixty-four waxes); he gave four additional ones to the Louvre.

The founders decided to make a bronze master cast (marked *modèle*) from each duplicate wax figurine (first mentioned by Adhémar, 1955, p. 70). The entire set of master casts remained with Hébrard's heirs until 1976, when it was exhibited at the Lefevre Gallery in London and acquired by the Norton Simon Museum of Art, Pasadena.

From each master cast twenty-two casts were made: twenty were for sale, lettered A to T, and two were reserved for the founder and Degas's heirs. The bronzes marked *modèle* are generally one percent larger, vary slightly in their markings, and have more clearly defined forms and crisper details than those of other casts (conversation with Arthur Beale, July 1977). This practice of *surmoulage*, making a cast from another cast, was common in the nineteenth century.

One of the complete set of bronzes was ready for exhibition at the Galerie A. A. Hébrard in May 1921 (Millard, 1976, p. 33). The titles by which the statuettes are known were assigned at this time by Hébrard and Joseph Durand-Ruel with the assistance of Paul-Albert Bartholomé (Millard, 1976, p. 5, fn. 13). Yet Palazzolo recalled that all of the casting was not completed until 1932 (Adhémar, p. 70).

Nearly complete or intact lettered sets can be found at the Metropolitan Museum of Art, New York (A); Musée du Louvre, Galerie du Jeu de Paume, Paris (P); Ny Carlsberg Glyptotek, Copenhagen (R); and the Museu de Arte, São Paulo.

The present work (like the two that follow) belongs to set D. *Dancer Moving Forward, Arms Raised* bears bronze number 19. It has been dated within the middle range, 1882–95, of Degas's sculptures by John Rewald and Charles Millard (1971, Appendix I, ca. 1889). Michèle Beaulieu dates it ca. 1898–1900 on the basis of a group of pastels of dancers in the same pose (Lemoisne 1336–39 and 1386–90). Theodore Reff thinks that pastels and sculptures cannot reliably be given coeval dates (conversation, April 1977). In this case, it appears that Degas modeled the figure in wax before treating the pose several times in pastel.

Degas represented full-length female figures without ballet costumes, with the left leg forward and both arms raised, in a charcoal drawing entitled *Trois danseuses en maillot, les bras levés* (78 x 51 cm [30 ³/₄ x 20 ¹/₈ inches], Second Sale of Degas's Studio, Dec. 11–13, 1918, no. 259). Degas's *impression*, or counterproof, of *Deux femmes nues, les bras levés* (65 x 43 cm, [25 ⁵/₈ x 16 ¹⁵/₁₆ inches], Fourth Sale of Degas's Studio, July 2–4, 1919, no. 350; Rewald, 1944, p. 76, repr.) displays similar figures, although the right leg assumes a forward position.

The attitude of the present statue is found in a larger version, *Dancer Moving Forward, Arms Raised, Right Leg Forward* (bronze no. 72, Rewald no xxvi). Hébrard identified the latter as "second state," a distinction that Rewald chose not to adopt (1944, p. 16).

As to Degas's source, Millard finds the statuette similar in pose to the Naples *Dancing Faun* and suggests that Degas may have known smaller-scale plaster casts like that owned by Gustave Moreau as well as the original statue (1976, p. 69).

Attempts were made in the casting process to retain the color of the wax originals. While the bronze marked *modèle* has a decidedly greenish-black color, it is less evident in the present work.

Provenance:
Galerie Hébrard, Paris; Walther Halvorsen[1] (notes

1. According to his widow, Halvorsen destroyed all his correspondence before his death in 1972. She remembers that her husband sold the remainder of his collection to Flechtheim, Berlin, before leaving Paris in 1920 (correspondence with Anita Halvorsen, Nov. 1976). It appears likely that the bronzes went from Halvorsen to Flechtheim and/or Thannhauser ca. 1926. It is not known whether Halvorsen owned the complete set D. Bronze nos. 23, 52, 65, 68, and 72 from set D belonged to Halvorsen and then Thannhauser (see New York, Parke Bernet, *Modern and Other French Paintings*, April 12, 1945) as well as bronze nos. 20 and 46.

by J. K. Thannhauser, Dec. 1972); J. K.
Thannhauser, probably 1926.

Exhibitions:
1926. Berlin, Galerie Flechtheim. *Das Plastische
Werk von Edgar Degas*. May. No. 18 (*Tänzerin
vorschreitend, Arme erhoben* [Erster Zustand]).
Traveled to Munich, Moderne Galerie
(Thannhauser), July–Aug., and Dresden, Galerie
Arnold, Sept.

1990. Venice, Palazzo Grassi. Pp. 66–67, no. A6,
color repr.

References:
Beaulieu, M. "Les Sculptures de Degas: Essai de
chronologie." *Revue du Louvre*, 19ᵉ année, no. 6,
1969, p. 377, fn. 69.

Boggs, J. S., D. W. Druick, H. Loyrette, M.
Pantazzi, and G. Tinterow. *Degas*. Exh. cat., The
Metropolitan Museum of Art, New York, and
National Gallery of Canada, Ottawa, 1988, p. 473.

Glaser, C., and W. Hausenstein. *Das Plastische Werk
von Edgar Degas*. Berlin, 1926, p. 13, no. 18
(*Danseuse s'avançant, les bras levés* [Premier état]).

Solomon R. Guggenheim Museum. *Masterpieces*.
1972, p. 13, repr.

M. Knoedler and Co., New York. *Edgar Degas:
Original Wax Sculptures*. Exh. cat., 1955, no. 24
(wax original).

The Lefevre Gallery, London. *The Complete Sculptures
of Degas*. Exh. cat., 1976, p. 37, no. 18, repr. (*modèle*
cast).

Millard, C. W. *The Sculpture of Edgar Degas*. Ph.D.
dissertation, Harvard University, 1971, p. 126, fig
100, and Appendix I (author gives date of 1889).

———. *The Sculpture of Edgar Degas*. Princeton,
1976, p. 69 and fig. 97.

Musée de l'Orangerie, Paris. *Degas: Oeuvres du Musée
du Louvre*. Exh. cat. by M. Beaulieu, 1969, no. 268
(ca. 1898–1900; another cast).

Rewald. 1956, p. 146, no. xxiv, and fig. 8 (original:
greenish-black wax).

———. 1944, pp. 22 and 76, no. xxiv, repr.

Hilaire-Germain-Edgar Degas

Spanish Dance. *1896–1911*
(Danse espagnole; Spanischer Tanz)
78.2514 T9

Bronze. *height 40.5 cm (16 inches)*
Signature incised at left side of base: Degas; stamp of the founder in relief on base near model's left foot: CIRE PERDUE /A.A. HEBRARD: *incised identifying mark near model's left foot:* 20. *Not dated.*
D

Detail. Full image on page 48.

Spanish Dance is not the artist's title. As indicated on p. 111, all titles for Degas's sculpture (with the exception of *Little Dancer*) were decided upon by Adrien A. Hébrard and Joseph Durand-Ruel with the help of Paul-Albert Bartholomé at the time the bronzes were first exhibited at the Galerie Hébrard in 1921 (C. W. Millard, *The Sculpture of Edgar Degas*, Princeton, 1976, p. 5, fn. 13).

There is another version of the *Spanish Dance* (bronze no. 45, Rewald no. xlvii), which is an inch higher and smoother in execution than the present statuette. Degas had the larger version (height 43.2 cm [17 inches]) cast in plaster around 1900 (see Rewald, 1944, p. 104, and Millard, 1976, fig. 73). Hébrard referred to the present one (bronze no. 20) as the first state and the other one (bronze no. 45) as the second state. John Rewald considers the present version to date from 1896–1911 because of its rather summary but expressive treatment of the surface. He places the larger *Spanish Dance* earlier, from the years 1882–95 (Rewald, 1944, pp. 16 and 25).

Degas first treated the pose of the *Spanish Dance* in the mid-1880s not only in sculpture but also in

pastel (Lemoisne 689, *Danseuse espagnole* and Lemoisne 690, *Danseuse au tambourin*; both are dated ca. 1882). A charcoal drawing (60 x 46 cm [23 5/8 x 18 1/8 inches]), present whereabouts unknown; Rewald, 1944, p. 131, repr., and T. Reff, "The Degas of Detroit," *Bulletin of the Detroit Institute of Arts*, vol. 53, no. 1, 1974, p. 41, where it is dated ca. 1890) shows the figure in both front and back views; another drawing is a study for the legs (present whereabouts unknown; Millard, 1976, fig. 74). In the bronze the dancer's right leg is longer than the left.

Millard (1976, p. 67) suggests a variety of sources for the pose of Degas's *Spanish Dance*: the Herculaneum bronze of a *Dancer* in Naples; the *Marsyas* from the Lateran Museum, Rome; and the standard representation of Siva Nataraja popularized by Indian bronzes. He gives the statuette a date of after 1890 (correspondence, Aug. 1977).

See p. 111 for general information about Degas's bronzes.

Provenance:
Galerie Hébrard, Paris; Walther Halvorsen (see p. 111, fn. 1); J. K. Thannhauser, probably 1926.

Exhibitions:
1926. Berlin, Galerie Flechtheim. *Das Plastische Werk von Edgar Degas*. May. No. 16 (*Spanischer Tanz* [Erster Zustand]). Traveled to Munich, Moderne Galerie (Thannhauser), July–Aug., and Dresden, Galerie Arnold, Sept.

1954. Houston, Museum of Fine Arts. *House of Art*. Oct. 17–Nov. 28. No. 65, repr. (*Danse espagnole*, lent by J. K. Thannhauser).

1990. Venice, Palazzo Grassi. Pp. 66 and 68–69, no. A7, color repr.

References:
Beaulieu, M. "Les Sculptures de Degas: Essai de chronologie." *Revue du Louvre*, 19ᵉ année, no. 6, 1969, p. 375.

Boggs, J. S., D. W. Druick, H. Loyrette, M. Pantazzi, and G. Tinterow. *Degas*. Exh. cat., The Metropolitan Museum of Art, New York, and National Gallery of Canada, Ottawa, 1988, p. 473.

Glaser, C., and W. Hausenstein. *Das Plastische Werk von Edgar Degas*. Berlin, 1926, p. 13, no. 16 (*Danse espagnole* [Premier état]).

Solomon R. Guggenheim Museum. *Masterpieces*. 1972, p. 16, repr.

M. Knoedler and Co., New York. *Edgar Degas: Original Wax Sculptures*. Exh. cat., 1955, no 62, repr. (wax original).

The Lefevre Gallery, London. *The Complete Sculptures of Degas*. Exh. cat., 1976, p. 35, no. 16, repr. (*modèle* cast).

Millard, C. W. *The Sculpture of Edgar Degas*. Ph.D. dissertation, Harvard University, 1971, Appendix I (1892).

Musée de l'Orangerie, Paris. *Degas: Oeuvres du Musée du Louvre*. Exh. cat. by M. Beaulieu, 1969, no. 254 (1882; another cast).

Rewald. 1956, p. 156, no. lxvi, and pl. 51 (original: greenish wax, pieces of wire appear in left hand).

———. 1944, pp. 27 and 130, no. lxvi, repr. (1896–1911).

Hilaire-Germain-Edgar Degas

Seated Woman Wiping Her Left Side, *1896–1911*
(*Femme assise, s'essuyant le côté gauche; Frau im Sessel Sitzend, sich die linke Seite trocknend*)
78.2514 T10

Bronze, height 35 cm (13 ³/₄ inches)
Signature incised on base near model's left foot: Degas; stamp of the founder in relief on base in back of chair: CIRE PERDUE /A.A. HEBRARD; *incised identifying mark also on base in back of chair:* <u>46</u>. *Not dated.*
D

Detail. Full image on page 49.

References:

Cooper, D. *Pastels d'Edgar Degas*. Basel, 1952, p. 25 (after 1895).

Glaser, C., and W. Hausenstein. *Das Plastische Werk von Edgar Degas*. Berlin, 1926, p. 15, no. 67 (*Femme assise dans un fauteuil s'essuyant le côté gauche*).

Solomon R. Guggenheim Museum. *Masterpieces*. 1972, p. 17, repr.

M. Knoedler and Co., New York. *Edgar Degas: Original Wax Sculptures*. Exh. cat., 1955, no. 65, repr. (wax original).

The Lefevre Gallery, London. *The Complete Sculptures of Degas*. Exh. cat., 1976, p. 84, no. 67, repr. (*modèle cast*).

Millard, C. W. *The Sculpture of Edgar Degas*. Princeton, 1976, p. 109 and pl. 133 (another cast).

Musée de l'Orangerie, Paris. *Degas: Oeuvres du Musée du Louvre*. Exh. cat. by M. Beaulieu, 1969, no. 287 (*Femme assise s'essuyant la hanche gauche*, ca. 1884; another cast).

Rewald. 1956, p. 157, no. lxix, and pls. 85–88 (original: red wax with large pieces of cork and wood visible from behind).

———. 1944, pp. 28 and 135, no. lxix, repr. (1896–1911).

Zweig, A. "Degas als Plastiker." *Der Querschnitt*, Jg. VI, 1926, opp. p. 177, repr.

Degas's sculptural series of seated women bathing and drying themselves is generally placed late in his career. John Rewald dates this group 1896–1911, and Charles Millard tentatively proposes more precise dates within this time span (see The Metropolitan Museum of Art, New York, *Degas in the Metropolitan*, exh. checklist, 1977).

The present work (bronze no. 46) resembles the sculpture *Seated Woman Wiping Her Left Hip* (bronze no. 54, Rewald no. lxxi; dated 1896–1911 by Rewald and 1900–1912 by Millard). However, in the latter, the support on which she sits is clearly defined as a chair; in addition, the woman's pose is slightly different from the Thannhauser version, especially noticeable in the placement of the head.

The sitter's pose closely resembles an earlier pastel, *Femme s'essuyant* (Lemoisne 886; 55 x 71 cm [21 ⁵/₈ x 28 inches], Collection James Archdale, Birmingham, England; Cooper, no. 25, color repr.), which is dated ca. 1886 by Paul André Lemoisne and Douglas Cooper. Degas executed another version in pastel ca. 1895, *Après le bain* (Lemoisne 1179; 82 x 71 cm [32 ¹/₄ x 28 inches], The

Hermitage, Leningrad).

While two-dimensional representations frequently predate their sculptural counterparts (Millard, 1976, p. 46, fn. 19), such a general observation is not without exception (see p. 111).

Provenance:
Galerie Hébrard, Paris; Walther Halvorsen (see p. 111, fn. 1); J. K. Thannhauser, probably 1926.

Exhibitions:
1926. Berlin, Galerie Flechtheim. *Das Plastische Werk von Edgar Degas*. May. No. 67 (*Frau im Sessel Sitzend, sich die linke Seite trocknend*). Traveled to Munich, Moderne Galerie (Thannhauser), July–Aug., and Dresden, Galerie Arnold, Sept.

1945. New York, Buchholz Gallery (Curt Valentin). *Degas: Bronzes, Drawings, Pastels*. Jan. 3–27. No. 48 (*Seated Woman*, Rewald no. lxix).

1990. Venice, Palazzo Grassi. Pp. 66 and 70–71, no. A8, color repr.

Dancers in Green and Yellow. *ca. 1903*
*(Danseuses vertes et jaunes: Four Dancers: Quatre
danseuses: Vier Tänzerinnen)*
78.2514 T12

Pastel on several pieces of paper, mounted on board.
98.8 x 71.5 cm (38 7/8 x 28 1/8 inches)
Red signature stamp lower left: degas
Not dated.

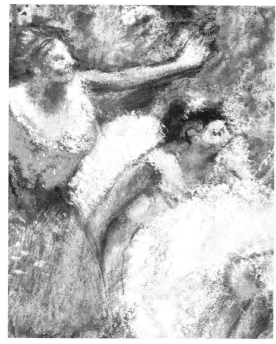

Detail. Full image on page 23.

The composition of four dancers waiting in a line in
the wings occurs several times around 1903 in
Degas's pastels and drawings. The Thannhauser
example is decidedly more vertical in format than
the other six pastels closely related to it. They are
Quatre danseuses (Lemoisne 1431 bis; 80 x 89.6 cm
[31 1/2 x 35 1/4 inches]; Paris, Galerie Schmit, *Degas*,
exh. cat., 1975, no. 46, color repr.); *Quatre danseuses*
(Lemoisne 1431 ter; 84 x 73 cm [33 x 28 3/4 inch-
es]; D. C. Rich, *Degas*, New York, 1951, p. 127,
color repr.); *Quatre danseuses* (Lemoisne 1432; 92 x
80 cm [36 1/4 x 31 1/2 inches]; Lemoisne, vol. III, p.
819, repr.); *Danseuses (Jupes jaunes)* (Lemoisne
1433; 82 x 92 cm [32 1/4 x 36 1/4 inches]; P.
Cabanne, *Edgar Degas*, Paris and New York, 1958,
no. 148, repr.); *Danseuses* (Lemoisne 1434; 75 x 61
cm [29 1/2 x 24 inches]; Basel, Galerie Beyeler,
Autour de l'Impressionisme, exh. cat., 1966, no. 12,
color repr.); and *Quatre danseuses dans les coulisses*
(Lemoisne 1435; 95 x 80 cm [37 1/2 x 31 1/2 inches];
Lemoisne, vol. III, p. 821, repr.). Of the works in
this group, Degas has added strips of paper at the
top and bottom only to the present work and to

Quatre danseuses dans les coulisses (clearly visible in a
photograph at Durand-Ruel, Paris).

Among the related versions listed above,
Danseuses (Jupes jaunes) appears to be closest to the
present work not only because of the dancers' yel-
low and orange skirts but because of the identical
position of the dancers' arms and legs. A charcoal
drawing of *Trois danseuses en maillot* (86 x 76 cm
[33 7/8 x 30 inches], Collection Durand-Ruel, Paris;
First Degas Sale, May 6–8, 1918, no. 318, and L.
Browse, *Degas Dancers*, New York, 1949, no. 250,
repr.) is perhaps a sketch for the present work. This
drawing contains visible evidence of how the artist
has rubbed out the charcoal in places to alter the
dancers' poses so that they correspond with the
poses found in the Thannhauser pastel. In this
drawing and a close variant (First Degas Sale, May
6–8, 1918, no. 319, repr.) the dancers wear only
maillots rather than the costumes found in the pre-
sent picture.

Daniel Catton Rich agreed with Paul André
Lemoisne's date of ca. 1903 (conversation, May
1976). In contrast, Lillian Browse would appear to
place it later since she dates the charcoal drawing
discussed above 1905–12 and places within the
same years a pastel, *Trois danseuses dans les coulisses*,
in The Museum of Modern Art, New York (Browse
no. 231 and Lemoisne 1429, where it is dated
1903). A definitive chronology of Degas's late work
has yet to be established.

Provenance:
Included in the First Sale of Degas's Studio, Paris,
Galerie Georges Petit, *Catalogue des tableaux, pastels
et dessins par Edgar Degas et provenant de son atelier*,
May 6–8, 1918, no. 167 (*Danseuses { Jupes vertes et
jaunes}*); purchased at sale by Paul Rosenberg, Paris
(conversation with A. Rosenberg, Feb. 1977);
acquired by J. K. Thannhauser, probably by 1926.

Condition:
Large piece of paper (82 x 68 cm [32 1/4 x 26 3/4
inches]) was cut by hand at left edge. Strips of the
same kind of paper were added: four inches at the
top and one and one-quarter inches at the bottom.
The pastel has not been fixed, and it appears to have
been done in a wet technique (Jan. 1975).

Exhibitions:
1926. Munich, Moderne Galerie (Thannhauser).
*Edgar Degas: Pastelle, Zeichnungen, Das Plastische
Werk*. July–Aug. No. 20 [2] (*Vier Tänzerinnen*).

1927. Lucerne, Galerie Thannhauser. *Maîtres
français du XIX^e siècle*. No. 72. [3]

References:
Solomon R. Guggenheim Museum. *Masterpieces*.
1972, p. 15, repr.

Kendall, R., ed. *Degas by himself: Drawings, Prints,
Paintings, Writings*. Boston, 1987, p. 292, repr., and
326.

Lemoisne. 1946, vol. III, pp. 818–19, no. 1431,
repr. (*Danseuses vertes et jaunes {Quatre danseuses}*, ca.
1903).

Russoli, F., and F. Minervino. *L'opera completa di
Degas*. Milan, 1970, p. 137, no. 1149, repr.
(ca. 1903).

Varnedoe, K. "The Ideology of Time: Degas and
Photography." *Art in America*, vol. 68, no. 6, sum-
mer 1980, pp. 99, 102, repr., fig. 7, and 105.

1. A stamp of Degas's signature was used with red ink on
pastels and drawings included in the studio sales after the artist's
death.
2. J. K. Thannhauser (notes, Dec. 1972) confirmed this ref-
erence.
3. According to J. K. Thannhauser's notes. No catalogue has
been located, and it is not known if one was even produced.

Paul Gauguin
Born June 1848, Paris
Died May 1903, Atuana, the Marquesas

In the Vanilla Grove, Man and Horse, *1891*
*(Dans la Vanillère homme et cheval; In the Vanilla
Field, Man and Horse; Le Rendez-Vous; The White
Horse; Pferdeführer; Mann mit Pferd im Walde)*
78.2514 T15

Oil on burlap, 73 x 92 cm (28 ¹/₄ x 36 ¹/₄ inches)
Signed and dated lower left: P Gauguin.91

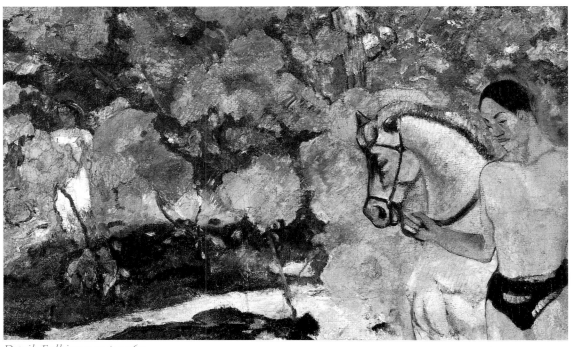

Detail. Full image on page 60.

Gauguin's list of paintings on page 2R of the *Carnet de Tahiti* (1891 into 1892) includes "Dans la Vanillère homme et cheval." Surely Gauguin intended the word "vanillière," which means a place where vanilla is grown. The present picture is the single known work by the artist representing a vanilla grove as well as a man and horse. Richard Field (p. 305) was the first to identify the present picture with the title "Dans la Vanillère homme et cheval," a conclusion with which Merete Bodelsen and Bengt Danielsson agree (conversation between Bodelsen and Danielsson kindly transmitted in correspondence with Bodelsen, May 1977). In addition, Bodelsen finds no narrative or symbolic meaning in the present picture (correspondence, July 1976 and May 1977).

Douglas Cooper thinks that there is insufficient proof to identify the present painting with the title "Dans la Vanillère homme et cheval" in Gauguin's *Carnet.* He prefers the title *Le Rendez-Vous* to refer to a meeting between the man and woman depicted (correspondence, May 1977). However, the background trees in the Thannhauser picture conceal

not one but two female figures who are picking or otherwise tending the vanilla plants. Vanilla, a creeping plant with flowers and pods that climbs up poles and sometimes on trees, is grown not in fields, but in groves (kindly brought to my attention by Cooper, March 1977). Photographs of vanilla growing in Tahiti around the turn of the century resemble the background of the present picture (Gilbert Bouriquet, *Le Vanillier et la vanille dans le monde,* Paris, 1954, p. 455, fig. 171 and pls. vi–ix).

Gauguin arrived in Tahiti in early June of 1891 and soon left the capital city of Papeete for the countryside, where he spent much of his time in the district of Mataiea. Evidence compiled by Field (pp. 20–22) indicates that he began to paint about September–October. Field places the present picture in October–November of the same year.

A pencil drawing of *Man and Horse in a Landscape* (21.6 x 27 cm [8 ¹/₂ x 10 ⁵/₈ inches], Collection M. Français, Paris; Rewald, 1962, p. 494, repr.) is related to the present painting in the juxtaposition of man and horse and in the pose of the man's legs and torso. However, in the draw-

ing, the man's left arm is raised so as to recall *Man with an Axe* (Wildenstein 430; 92 x 70 cm [36 ¹/₄ x 27 ¹/₄ inches], signed and dated 1891, Collection Alex M. Lewyt, New York; Rewald, 1962, p. 495).

The source for the man and horse is the West Frieze of the Parthenon, as suggested by Alfred Langer (p. 53) and Theodore Reff (review of A. Blunt and P. Pool, *Picasso: The Formative Years, The Art Bulletin,* vol. XLVIII, June 1966, p. 266) and not the Column of Trajan as proposed by Samuel Wagstaff (Field, p. 41) and William M. Kane (p. 357). Field agrees that the figures came from the Parthenon frieze (correspondence, Aug. 1974).

The hypothesis proposed by the present writer is that Gauguin knew the specific part of the frieze from Slab N of *Les Frises du Parthénon* (Paris, 1868; fig. a), which contained an essay by Charles Yriarte and twenty-two phototypes of casts taken by Gustave Arosa, Gauguin's close friend and former guardian. In his Tahitian works, Gauguin used figures from Slabs M, N, O, and U of this portfolio. Significantly, the *Man with an Axe* represents Slab U. At the sale of Gauguin's possessions from Tahiti, Victor Segalen purchased several photographs, including one of Slab O, which now belong to his daughter, Mme Anne Joly-Segalen, Bourg-la-Reine (correspondence with A. Joly-Segalen, Nov. 1976).

Before his trip, in autumn 1890, Gauguin wrote to Odilon Redon: "Gauguin est fini pour ici, on ne verra plus rien de lui. Vous voyez que je suis un égoïste. J'emporte en photographies, dessins, tout un petit monde de camarades qui me causeront tous les jours" (R. Field, "Plagiaire ou créateur?" in *Gauguin,* Paris, 1961, p. 123). ("Gauguin is finished here, you'll see nothing more of him. You see that I am an egotist. I am taking away with me in photographs and drawings a whole small world of friends who will chat with me every day.") Gauguin's use of photographs as the source of figures in the Tahitian paintings has been well documented.

Near the end of his life, in *Avant et après,* Gauguin refers to the horses of the Parthenon: "Quelquefois je me raculé [sic] bien loin, plus loin que les chevaux du Parthénon . . . jusqu'au dada de mon enfance, le bon cheval de bois" (facsimile ed., Copenhagen [1948], p. 16). ("Sometimes I stepped very far back, farther than the horses of the Parthenon . . . back to the hobbyhorse of my childhood, the good wooden horse.")

Fig. a. Slab N from C. Yriarte, Les Frises du
Parthénon. *Paris, 1868.*

Provenance:
Galerie Barbazanges, Paris, by 1923; Vignier, Paris,
by 1928; Wildenstein and Co., New York; pur-
chased from Wildenstein by Baron Eduard von der
Heydt, Zandvoort, The Netherlands, and Ascona,
Switzerland, ca. 1935 (correspondence with M. R.
Fisher, Jan. 1978); S. Wright Ludington, Santa
Barbara, by Jan. 1941 and until Dec. 1942; pur-
chased from Ludington by J. K. Thannhauser, 1942
(conversation with D. C. Rich, March 1975).

Condition:
Glue lined at unrecorded date before 1965. The
support is similar to that of *Haere Mai* (p. 118). A
glossy varnish and overpaint at the edges were
removed in 1988. The painting was revarnished
with a thin mat varnish and local cleavage was set
down at that time (March 1992).

Exhibitions:
1928. Basel, Kunsthalle. *Paul Gauguin.* July–Aug.
No. 65 or 76 (depending on cat. ed.), repr. (*Mann
mit Pferd im Walde,* coll. Vignier, Paris).

1928. Berlin, Galerien Thannhauser. *Paul Gauguin.*
Oct. No. 51, repr. (*Mann mit Pferd im Walde*).

1935. London, Wildenstein and Co., Ltd. *Nineteenth
Century Masterpieces.* May 9–June 15. No. 12, repr.
(*The White Horse,* coll. Baron von der Heydt).

1935. The Art Gallery of Toronto. *Loan Exhibition
of Paintings.* Nov. No. 177 (Wildenstein).

1936. New York, Wildenstein and Co. *Paul
Gauguin.* March 20–April 18. No. 18 (von der
Heydt).

1936. Cambridge, Mass., The Fogg Art Museum.
Paul Gauguin. May 1–21. No. 16.

1936. The Baltimore Museum of Art. *Paul
Gauguin.* May 24–June 5. No. 11.

1936. San Francisco Museum of Art. *Paul Gauguin.*
Sept. 5–Oct. 4. No. 15, repr.

1941. Los Angeles County Museum. *Aspects of
French Painting from Cézanne to Picasso.* Jan. 15–
March 2. No. 22 (*The White Horse,* coll. S. Wright
Ludington).

1946. New York, Wildenstein and Co. *Paul
Gauguin.* April 3–May 4. No. 21, repr. (J. K.
Thannhauser).

1990. Venice, Palazzo Grassi. Pp. 72–73, no. A9,
color repr.

1992. The Montreal Museum of Fine Arts.
Pp. 66–67, no. 6, color repr.

References:
Blunt, A., and P. Pool. *Picasso: The Formative Years.*
Greenwich, 1962, pl. 166.

de Gravelaine, F. *Paul Gauguin: la vie, la technique,
l'oeuvre peint.* Lausanne, 1988, pp. 116–17, color
repr. (*Le Rendez-vous {Dans le champs de vanille}*).

Dietrich, L. S. *A Study of Symbolism in the Tahitian
Painting of Paul Gauguin: 1891–1893.* Ph.D. disser-
tation, University of Delaware, 1973, pp. 234, 274.

Dorival, B. *Carnet de Tahiti.* Facsimile ed., Paris,
1954, p. 2R and text pp. 18–19 and 37.

Field, R. S. *Paul Gauguin: The Paintings of the First
Voyage to Tahiti.* Ph.D. dissertation, Harvard
University, 1963, pp. 21, 38–41, 304, and 312,
no. 8 (*The White Horse,* Oct.–Nov. 1891).

Galerie Marcel Guiot, Paris. *Gauguin: Documents
Tahiti.* Exh. cat., 1942, p. 38 (incorrectly lists Basel
exhibition as Bremen).

Solomon R. Guggenheim Museum. *Masterpieces.*
1972, p. 25, repr. (*In the Vanilla Field, Man and
Horse*).

Kane, W. M. "Gauguin's *Le Cheval Blanc:* Sources
and Syncretic Meanings." *The Burlington Magazine,*
vol. CVIII, July 1966, pp. 357 and 359, fig. 27.

Kantor-Gukovskaya, A., A. Barskaya, and M.
Bessonova. *Paul Gauguin in Soviet Museums.* Trans.
A. Mikoyan. Leningrad, 1988, p. 82, repr. (*The
Rendezvous*). French edition: *Paul Gauguin: Musée de
l'Ermitage, Musée des Beaux-Arts Pouchkine,* Paris,
1988 (*Le Rendez-vous*). German edition: *Paul
Gauguin in den Museen der Sowjetunion,* Düsseldorf
and Leningrad, 1989 (*Das Rendezvous*).

Langer, A. *Paul Gauguin.* Leipzig, 1963, pp. 53–54
(detail repr.), and 87.

le Pichon, Y. *Gauguin: Life, Art, Inspiration.* Trans.
I. Mark Paris. New York, 1987, pp. 159, no. 298,
color repr., and 262. French edition: *Sur les traces de
Gauguin.* Paris, 1986 (*Le Rendez-vous*).

Malingue, M. *Gauguin.* Paris, 1948, pl. 166
(*Le Rendez-Vous*).

Sugana, G. M. *L'opera completa di Gauguin.* Milan,
1972, p. 102, no. 258, repr.

Taralon, J. *Gauguin.* Paris, 1953, p. 6, no. 32, repr.

van Dovski, L. *Paul Gauguin.* Basel, 1947, pl. 19
(*Homme avec un cheval dans la fôret,* coll. Vignier).

———. *Paul Gauguin oder die Flucht vor der
Zivilisation.* Bern, 1950, p. 348, no. 253 (J. K.
Thannhauser).

Wiese, E. *Paul Gauguin.* Leipzig, 1923, n.p., repr.
(*Pferdeführer,* Galerie Barbazanges, Paris).

Wildenstein. 1964, p. 175, no. 443, repr.
(*Le Rendez-Vous*).

Paul Gauguin

Haere Mai, *1891*
*(Haere temai; Les Deux cochons airani; Tahitian
Landscape with Black Hogs)*
78.2514 T16

Oil on burlap, 72.4 x 91.4 cm (28 ¹/₂ x 36 inches)
Signed and dated lower left: P Gauguin 91; *inscribed
lower right:* HAERE MAI.

Detail. Full image on page 61.

Condition:
In 1968, the painting was lined with wax resin, and
a small hole repaired in the head of the pig at bot-
tom right of center. In 1988, the painting was
cleaned, and a thick glossy varnish was removed.

Exhibitions:
1910–1911. London, Grafton Galleries. *Manet and
the Post-Impressionists.* Nov. 8–Jan. 15. No. 44A (*Les
Cochons noirs dans la prairie,* lent by Vollard; con-
firmed by D. Cooper, correspondence, March 1977).

1923. Prague, Spolku Vytvarnych Umelcu Mánes.
Vystava francouzského umení XIX a XX století [*French
Art of the 19th and 20th century*]. May–June.
No. 183 (Vollard).

1938. Amsterdam, Stedelijk Museum. *Honderd Jaar
Fransche Kunst.* July 2–Sept 25. No. 125, repr.
(J. K. Thannhauser).

1939. Buenos Aires, Museo Nacional de Bellas
Artes. *La pintura francesa de David a nuestros días.*
July–Aug. No. 57. Traveled to Montevideo,
Ministerio de Instrucción Pública, April–May
1940, and Rio de Janeiro, Museu Nacional de Belas
Artes, June 29–Aug. 15.

1940–41. San Francisco, M. H. De Young
Memorial Museum. *The Painting of France Since the
French Revolution.* Dec.–Jan. No. 41, repr.

1941. Los Angeles County Museum. *Aspects of
French Painting from Cézanne to Picasso.* Jan.
15–March 2. No. 19.

1941. The Art Institute of Chicago. *Masterpieces of
French Art.* April 10–May 20. No. 64.

The third entry, "Les 2 cochons airani," of
Gauguin's list on page 2R of the *Carnet de Tahiti*
refers to *Haere Mai.* Presumably by "airani" is
intended the French word "airain," which means
bronze or metals of which copper is the base.

Since Gauguin inscribed the Tahitian words
"Haere Mai" on the canvas, they are retained here as
the title. According to Bengt Danielsson, "Haere
Mai" is a very common phrase meaning "Come
here!" (*The Burlington Magazine,* p. 230). Common
also in Tahiti is the sight of black pigs running
loose (*Gauguin in the South Seas,* trans. R. Spink,
London, 1965, pp. 288–89, fig. 59). Gauguin knew
very little Tahitian during his first year there, but
he used words in his paintings to make them appear
more exotic to the Parisian public. Thus the expres-
sions inscribed on paintings are ordinary ones that
do not relate closely to the content of the paintings
(correspondence with M. Bodelsen summarizing her
conversation with Danielsson, May 1977).

Gauguin's Tahitian sketchbook contains several
drawings of pigs: those on pages 37V and 39V
resemble those in *Haere Mai.* A sketch for the palm

tree is on page 71V. Richard Field dates the present
picture October–November 1891.

Gauguin had treated the theme earlier in
Brittany (Wildenstein 255; *The Swineherd,* 73 x 93
cm [29 x 36 ¹/₂ inches], signed and dated 1888,
Collection Norton Simon, Los Angeles). Landscapes
related by subject and date are *The Black Hogs*
(Wildenstein 446; 91 x 72 cm [35 ⁷/₈ x 28 ³/₈
inches], signed and dated 1891, The Museum of
Fine Arts, Budapest) and *Tahitian Landscape*
(Wildenstein 442; 64 x 47 cm [25 ³/₈ x 18 ⁵/₈
inches], The Metropolitan Museum of Art, New
York). However, the colors of *Haere Mai,* bolder
and brighter than in the latter, anticipate *Tahitian
Landscape* (Wildenstein 504; 68 x 92.5 cm [26 ³/₄ x
36 ³/₈ inches], 1893, The Minneapolis Institute of
Arts; R. Goldwater, *Paul Gauguin,* New York,
1958, p. 107, color repr.).

Provenance:
Ambroise Vollard, Paris;[1] purchased from Vollard
by J. K. Thannhauser, June 1934.

1. The original document of sale from Vollard, dated June
1934, was in the possession of J. K. Thannhauser. It has not been
possible to determine conclusively whether the picture was
exhibited with others owned by Vollard at the Moderne Galerie
(Heinrich Thannhauser) in Munich in Aug. 1910 and the follow-
ing month at the Galerie Arnold in Dresden (mentioned by
Field, 1963, p. 312, and further discussed in correspondence,
Aug. 1974). Rich, Gordon, and Field were unable to locate a
copy of the catalogue. Contemporary newspaper accounts men-
tion as many as seventeen of the twenty-one paintings exhibited
and none resembles *Haere Mai* (D. E. Gordon, "Kirchner in
Dresden," *The Art Bulletin,* vol. XLVIII, Sept.–Dec. 1966, p.
356, fn. 124). Thus it was probably not exhibited at the
Moderne Galerie in 1910.

1941. The Portland Art Museum. *Masterpieces of French Painting from the French Revolution to the Present Day*. Sept. 3–Oct. 5. No. 42.

1942–46. Washington, D.C., The National Gallery of Art. On loan from Feb. 1942–July 1946 (correspondence with P. Davidock, Nov. 1973).

1946. Pittsfield (Mass.), The Berkshire Museum. *French Impressionist Painting*. Aug. 2–31. No. 10.

1956. New York, Wildenstein and Co. *Gauguin*. April 5–May 5. No. 20, repr.

1990. Venice, Palazzo Grassi. Pp. 74–75, no. A10, color repr.

1992. The Montreal Museum of Fine Arts. Pp. 68–69, no. 7, color repr.

References:
Bodelsen, M. "The Wildenstein-Cogniat Gauguin Catalogue." *The Burlington Magazine*, vol. CVIII, Jan. 1966, p. 38 (correcting error of ex. coll. Fayet).

Bouge, L.-J. "Traduction et interprétation de titres en langue tahitienne . . . " in *Gauguin: sa vie, son oeuvre*. Paris, 1958, p. 162, no. 14.

Danielsson, B. "Gauguin's Tahitian Titles." *The Burlington Magazine*, vol. CIX, April 1967, p. 230, no. 16.

Dorival, B. *Carnet de Tahiti*, facsimile ed., Paris, 1954, p. 2R and text pp. 18, 23, 28, 37, and 40.

Field, R. S. *Paul Gauguin: The Paintings of the First Voyage to Tahiti*. Ph.D. dissertation, Harvard University, 1963, pp. 21, 38, 39, 304, and 311, no. 7 (Oct.–Nov. 1891).

Solomon R. Guggenheim Museum. *Masterpieces*. 1972, p. 24, repr.

Malingue, M. *Gauguin*. Paris, 1948, no. 170, repr.

Rewald, J. *Gauguin*. 1938, p. 105, color repr. (*Haere Temai*).

Sterling, C., and M. M. Salinger. *French Paintings: A Catalogue of the Collection of the Metropolitan Museum of Art*. New York, 1967, vol. III, p. 174.

Sugana, G. M. *L'opera completa di Gauguin*. Milan, 1972, p. 102, no. 259, repr.

van Dovski, L. *Paul Gauguin oder die Flucht vor der Zivilisation*. Bern, 1950, p. 347, no. 244 (*Haere Temai*).

Wildenstein. 1964, p. 177, no. 447, repr. (*Haere Mai Venez!*).

Woman with Crab, *ca. 1902(?)–05*
(La Femme au crabe; Frau mit Krebs)
78.2514 T26

Bronze, 15.2 x 14.6 x 12.1 cm (6 x 5 ³/₄ x 4 ³/₄ inches)
Signed with the artist's monogram "AM" in a circle on the
base between the crab and the figure's left foot.
Not dated.

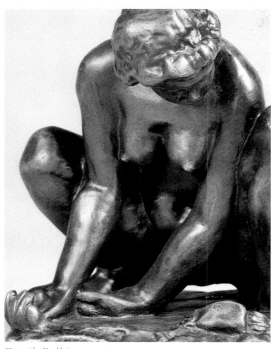

Detail. Full image on page 50.

Woman with Crab is one of the bronzes cast by
Ambroise Vollard. About 1900 Vuillard introduced
Maillol to Vollard, who bought some terra-cottas
and had them cast in bronze (Johnson, pp. 39–40,
and New York, Paul Rosenberg and Co., *Aristide
Maillol*, exh. cat., 1958, p. 10). According to Una
Johnson, Vollard's edition of *Woman with Crab* was
first issued about 1903 (p. 102, no. 97, and p.
195). It has not been possible to locate a catalogue
of the Maillol exhibition that took place at the
Galerie Vollard from June 15–30, 1902 (conversa-
tion with L. Konheim and correspondence with
Johnson, Nov. 1976). Consequently, a precise date
for *Woman with Crab* cannot be determined. The
artist certainly had conceived of the image by April
1905, when Octave Mirbeau, writing about the
women in Maillol's sculpture, specifically mentions
"qu'elle joue enfantinement, sur la sable, avec un
crabe" ("Aristide Maillol," *La Revue*, XVIᵉ année,
vol. LV, April 1905, p. 328).

Dina Vierny dates *Woman with Crab* 1930, cit-
ing the fact that Maillol listed it in *L'Inventaire de
l'oeuvre sculptée* under that year (correspondence, Feb.

1976). However, a bronze of the same subject was
reproduced as early as 1922 (B. Ternovets, "French
Sculpture in Moscow," *Sredi Kollektsionerov*, no. 10,
Oct. 1922, p. 3) and appeared also in Germany in
the 1920s (C. Einstein, *Die Kunst des 20.
Jahrhunderts*, Berlin, 1926, p. 514, repr. [Silberberg
collection, Breslau] and Düsseldorf, Galerie
Flechtheim, *Lebende Ausländische Kunst aus Rhein-
ischem Privatbesitz*, exh. cat., Oct. 1928, no. 90).

Linda Konheim notes (Jan. 1978) that although
the 1902–05 date attributed to this work is very
plausible, it is not possible to document a date ear-
lier than 1917 for this piece. (The 1917 date has
been clearly established on the basis of the prove-
nance of this bronze.) She feels that since there is no
illustration of the woman with crab mentioned by
Mirbeau in 1905, it cannot be determined if he is
referring to the same piece or a different version of
the same subject until further evidence is obtained.
Maillol frequently reworked his own motifs, and
two versions of *Woman with Crab* already exist.

An apparently identical cast of *Woman with Crab*
is in the Art Institute of Chicago and another is in
the collection of Dr. Ruth M. Bakwin, New York.
A bronze with two artist's monograms is in the
Dial Collection, on loan to the Worcester Art
Museum. The first-edition cast by Vollard bears
Rudier's foundry mark (conversation with A.
Rosenberg, Feb. 1977); an example was included in
an exhibition at the National Museum of Western
Art, Tokyo (*Maillol*, 1963, no. 46). Later, Maillol
executed terra-cottas of the same subject that differ
slightly from the bronze: one is dated ca. 1930 by
John Rewald (*Maillol*, London, 1939, pp. 108–09,
repr., and 166); another, in which the position of
the hands varies, has two artist's monograms (New
York, Sotheby Parke Bernet, *Important Impressionist
and Modern Paintings and Sculpture*, May 26, 1976,
no. 22, repr., dated 1920, Collection John Rewald).
Vierny knows of only one drawing of a similar sub-
ject, which depicts a crouching woman without the
crab (pencil and ink on gray paper, 19.5 x 21.5 cm
[7 ³/₄ x 8 ¹/₂ inches], Collection D. Vierny, Paris;
New York, Solomon R. Guggenheim Museum,
Artiside Maillol, exh. cat., 1975–76, no. 144,
repr.).

Provenance:
Acquired from the artist by Alfred Wolff, Munich,
by 1917;¹ acquired from Wolff by J. K.
Thannhauser.

Exhibition:
1990. Venice, Palazzo Grassi. Pp. 90–91, no. A18,
color repr.

References (not specifically to the Thannhauser
cast):
Bouvier, M. *Aristide Maillol*. Lausanne, 1945, pp.
118–19, repr.

Solomon R. Guggenheim Museum. *Masterpieces*.
1972, p. 36, repr. (ca. 1900–05).

Johnson, U. E. *Ambroise Vollard Editeur*. New York,
1944, pp. 40, 102, and 195, no. 97.

Musée Départemental des Beaux-Arts, Yamanashi,
Japan. *Exposition Maillol au Japon*. Exh. cat., 1984,
p. 194, repr., no. S-51 (Alexis Rudier no. 1/6,
1930, Fondation Dina Vierny, Musée Maillol,
Paris).

1. According to notes made by J. K. Thannhauser (Dec.
1972), Wolff was a director of the Deutsche Bank. The archives
of the Bank confirm that Wolff was director of the Munich
branch from 1905 until 1909 and from 1911 until 1917 (corre-
spondence with W. Kohl, Feb. 1977). Thus, it appears likely
that Wolff acquired the sculpture before 1917 although no doc-
umentary evidence exists.

Edouard Manet
Born January 1832, Paris
Died April 1883, Rueil

Before the Mirror. *1876*
(Devant la glace; Devant la psyché; Frau vor dem Spiegel)
78.2514 T27

Oil on canvas. 92.1 x 71.4 cm (36 ¼ x 28 ⅛ inches)
Signed lower right: Manet
Not dated.

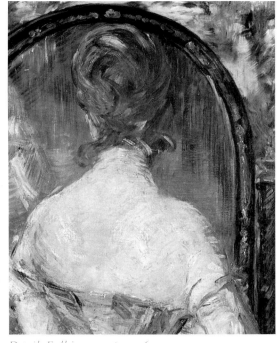

Detail. Full image on page 36.

The theme of a woman before a mirror appears in the late 1870s not only in the present picture but also in Manet's *Nana* (150 x 116 cm [60 ⅝ x 45 ¼ inches], Kunsthalle, Hamburg; Hofmann, color repr. as frontispiece) and in Berthe Morisot's work (M.-L. Bataille and G. Wildenstein, *Berthe Morisot*, Paris, 1961, nos. 64 and 84). As Werner Hofmann indicates, the theme has its origins earlier (pp. 69–88).

Daniel Catton Rich (conversations, autumn 1973 and April 1975) found no direct relationship between *Nana* and *Before the Mirror*. The backgrounds and mirrors are different, and the Thannhauser painting does not have the complexity of meaning implicit in the presence of the gentleman. Rich agreed with Hofmann's placing the Thannhauser picture before *Nana*, which must have been begun in the autumn of 1876 (pp. 17–18).

Provenance:
Inventory of the contents of Manet's studio on Dec. 28, 1883, no. 20;[1] Paris, Hôtel Drouot, *Vente Manet*, Feb. 4–5, 1884, no. 43 (*Devant la glace*); acquired at

sale by Dr. Albert Robin;[2] purchased from Robin, Feb. 1901, by Bernheim-Jeune; sold jointly to Durand-Ruel and Cassirer, March 1901[3] (correspondence with G. Gruet, Nov. 1976); purchased from Cassirer by Durand-Ruel, Paris, Dec. 1902; sold to Durand-Ruel, New York, Jan. 1903; bought back by Durand-Ruel, Paris, Jan. 1910; acquired again by Durand-Ruel, New York, Aug. 1916; sold to Flanagan, April 1917 (above from correspondence with C. Durand-Ruel, Nov. 1976); included in New York, American Art Association, *Catalogue of Highly Important Old and Modern Paintings belonging to . . . Mr. Joseph F. Flanagan, Boston*, Jan. 14–15, 1920, no. 65, repr. (*Devant la psyché*); purchased by American Art Association, Feb. 1920; sent to Carl O. Nielsen,[4] Feb. 1923 (correspondence with C. Durand-Ruel, Nov. 1976); belonged to J. K. Thannhauser by 1927.

Condition:
Lined with an aqueous adhesive at an unrecorded date prior to 1965. In 1990, the painting was cleaned and revarnished. X-radiographs and photographs of an infrared videocon image taken at this time suggest that Manet moved the position of the model's proper right hand and arm from below her corset across to the right, its present position (March 1992).

Exhibitions:
1880. Paris, Galerie de la Vie Moderne. *Exposition des oeuvres nouvelles d'Edouard Manet*. April 10–30. No. 8 (*Devant la glace*).

1910. Vienna, Galerie Miethke. *Manet-Monet*. May. No. 6, repr. (*Vor dem Spiegel*).

1. See Jamot and Wildenstein, vol. I, p. 107. Fernand Lochard photographed all the paintings and drawings in Manet's studio at his death. Of these photographs the present picture is no. 246.
2. Dr. Robin of Paris acquired at the Manet sale nos. 11, 43, 48, 57, 66, 73, and 100, which included not only *Before the Mirror* but also *Nana* (no. 11). He bequeathed no. 73 to the Musée de Dijon in 1920.
3. Rouart-Wildenstein lists "Gerard, Paris 1901" after Bernheim-Jeune and before Cassirer. Not mentioned by Bernheim-Jeune or Durand-Ruel.
4. Nielsen's name is omitted by Rouart-Wildenstein. Nielsen, from Oslo, lent three paintings to the Manet exhibition at the Ny Carlsberg Glyptotek, Copenhagen, from Jan. 27–Feb. 17, 1922; none is the present picture.

1916. New York, Durand-Ruel. *Exhibition of Paintings and Pastels by Edouard Manet and Edgar Degas*. April 5–29. No. 2.

1920. New York, Durand-Ruel. *Exhibition of Paintings by Modern French Masters*. April 18–24. No. 7 (*Devant la psyché*).

1927. Berlin, Künstlerhaus (organized by the Galerien Thannhauser). *Erste Sonderausstellung in Berlin*. Jan. 9–Feb. 15. No. 146, repr. (*Vor dem Spiegel*).

1961. San Antonio, The Marion Koogler McNay Art Institute. *A Summer Exhibition*. June–Aug. No. iii, repr.

1983. Paris, Galeries Nationales du Grand Palais, April 22–Aug. 8; New York, The Metropolitan Museum of Art, Sept. 10–Nov. 27. *Manet: 1832–1883*. Exh. cats. (French and English), pp. 390–92, no. 156, color repr. (1876–77).

1990. Venice, Palazzo Grassi. Pp. 92–93, no. A19, color repr.

1992. The Montreal Museum of Fine Arts. Pp. 58–59, no. 2, color repr.

References:
Adler, K. *Manet*. Oxford, 1986, pp. 220–21, no. 215, repr., and 235.

Bodelsen, M. "Early Impressionist Sales 1874–94." *The Burlington Magazine*, vol. CX, June 1968, p. 342.

Burger, F. *Einführung in die Moderne Kunst*. Berlin, 1917, vol. I, p. 96, repr.

Cachin, F. *Manet*. Chêne, 1990, pp. 122–23, no. 5, color repr., and 158 (*Devant la glace*).

Daix, P. *La vie de peintre d'Edouard Manet*. Paris, 1983, pp. 274 and 303, fig. 43 (1877).

Darragon, E. *Manet*. Paris, 1989, p. 281.

Daulte, F. "Une Donation sans précédent: la collection Thannhauser." *Connaissance des Arts*, no. 171, May 1966, pp. 62–63, repr. (statements made without proof).

Duret, T. *Edouard Manet et son oeuvre*. Paris, 1902, p. 246, no. 213 (*La Toilette devant la glace*, 1875–77).

————. *Histoire de Manet et de son oeuvre*. Paris, 1926, p. 266, no. 213.

————. *Manet and the French Impressionists*. Trans. J. E. C. Flitch. London, 1912, p. 238, no. 213.

Fleischer, V. "Ausstellungen." *Der Cicerone*, Jg. II, 1910, p. 369 (*Vor dem Spiegel*).

Gottlieb, C. "Picasso's *Girl Before a Mirror*." *Journal of Aesthetics and Art Criticism*, vol. XXIV, summer 1966, p. 517, fn. 15.

Solomon R. Guggenheim Museum. *Masterpieces*. 1972, p. 11, repr.

Hanson, A. C. *Manet and the Modern Tradition*. New Haven and London, 1977, p. 101, fn. 213.

Hofmann, W. *Nana: Mythos und Wirklichkeit*. Cologne, 1973, pp. 18, 89, 177, and 194, and pl. 25 (*Frau vor dem Spiegel*, 1876).

Isaacson, J. "Impressionism and Journalistic Illustration." *Arts*, vol. 56, no. 10, June 1982, p. 115, fn. 86.

Jamot, P., and G. Wildenstein. *Manet*. Paris, 1932, vol. I, pp. 107 and 154, no. 278, and vol. II, fig. 85 (*Devant la glace*, ca. 1877).

Meier-Graefe, J. *Edouard Manet*. Munich, 1912, p. 321 and pl. 187.

————. *Entwicklungsgeschichte der Modernen Kunst*. Stuttgart, 1904, vol. III, p. 56, repr. (*Devant la psyché*, 1876).

————. "Die Franzosen in Berlin." *Der Cicerone*, Jg. XIX, Jan. 1927, p. 50, repr.

Micha, R. "Manet." *Art International*, vol. XXVI, no. 3, July–Aug. 1983, p. 6 (*Devant la glace*, 1876–77).

Monneret, S. "L'Immédiate fraîcheur de la rencontre." *Connaissance des arts*, no. 374, April 1983, pp. 50–51, color repr. (*Devant la glace*, 1877).

Moreau-Nélaton, E. "Catalogue général: peintures et pastels." Manuscript on deposit in the Cabinet des Estampes, Bibliothèque Nationale, Paris [1906], no. 216 (*Devant la glace*, D. 213).

————. *Manet raconté par lui-même*. Paris, 1926, vol. II, pp. 43, 66–67, 141, and fig. 222 (*Devant la glace*, ca. 1877).

Osborn, M. "Klassiker der Französischen Moderne." *Deutsche Kunst und Dekoration*, vol. 59, March 1927, p. 343, repr. (*Vor dem Spiegel*).

Rey, R. *Manet*. Trans. E. Lucie-Smith. New York, n.d., p. 66, color repr. (1876–77).

Rosenblum, R. "Picasso's *Girl before a Mirror*: Some Recent Reflections." *Source*, vol. I, no. 3, Spring 1982, pp. 2, repr., and 4.

Ross, N. *Manet's* Bar at the Folies-Bergère *and the Myths of Popular Illustration*. Ann Arbor, 1982, pp. ix, 49, and pl. 32.

Rouart, D., and D. Wildenstein. *Edouard Manet*. Lausanne and Paris, 1975, vol. I, pp. 212–13, repr., no. 264 (*Devant la glace*, 1877)

Schneider, P. *The World of Manet 1832–1883*. New York, 1968, pp. 7–11, repr., and 142.

Stuckey, C. F. *Manet*. Mount Vernon, 1983, n.p., checklist published in conjunction with exhibition at the Metropolitan Museum of Art.

Sutton, D. "Edouard Manet: The Artist as Dandy." *Apollo*, vol. CXVIII, n.s., no. 260, Oct. 1983, p. 339 (*Woman and the Mirror*).

Tabarant, A. *Manet et ses oeuvres*. Paris, 1947, pp. 290–91, 540, and 611, pl. 255.

————. *Manet: Histoire catalographique*. Paris, 1931, pp. 298–99 and 582, no. 246 (*Devant la glace*, 1876).

Venturi, M., and S. Orienti. *L'opera pittorica di Edouard Manet*. Milan, 1967, no. 216.

Werner, B. E. "Französische Malerei in Berlin." *Die Kunst für Alle*, Jg. 42, April 1927, p. 224, repr.

Zervos, C. "Manet et la femme." *Cahiers d'Art*, 7ᵉ année, nos. 8–10, 1932, p. 331, repr.

Woman in Evening Dress. 1877–80
(Femme en robe de soirée; Femme en robe du bal; Jeune
femme à l'écran; Portrait de Mlle S. Reichenberg)
78.2514 T28

Oil on canvas. 174.3 x 83.5 cm (68 5/8 x 32 7/8 inches)
Signed at center left edge. 'not by the artist:' Ed Manet
Not dated.

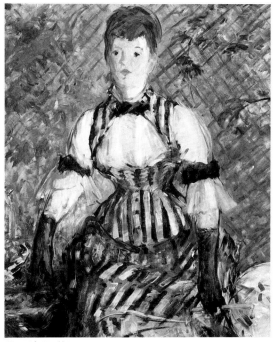

Detail. Full image on page 14.

Some time after its completion, Manet considered reducing the size and thus the composition of the present painting. In a photograph taken in 1883 by Fernand Lochard in Manet's atelier after his death, a white line clearly defines a rectangle indicating the proposed dimensions. The artist considered cutting down the canvas by 45.5 cm at the bottom, 5 cm at the top, 20 cm at the left, and 5 cm on the right (Tabarant, 1931, p. 323) so as to eliminate the table, fan, and lower portion of the dress below the model's gloved hands. However, the proposed changes were not carried out, and any trace of the line has disappeared.

Although Woman in Evening Dress was found in the atelier after the artist's death, it was neither included in the inventory of the contents of Manet's studio nor in the Manet sale at the Hôtel Drouot on February 4–5, 1884. In the photographs annotated by Etienne Moreau-Nélaton (Cabinet des Estampes, Bibliothèque Nationale, Paris, DC.300g, vol. III), the present picture is among those marked "Réserve" rather than numbered according to the Manet sale (see Provenance).

The sitter has occasionally been identified as Suzanne Reichenberg: first, when the painting was lent by Bernheim-Jeune to an exhibition in 1904 at La Libre Esthétique in Brussels and later by Adolphe Tabarant in 1931 (p. 323) and 1947 (p. 322). However, Théodore Duret, Moreau-Nélaton, and Paul Jamot and Georges Wildenstein do not mention the identity of the sitter. Daniel Wildenstein knows of no documentary evidence to connect the painting and the person (correspondence, May 1977). No painting by Manet is known to represent Reichenberg and her descendants are not aware of the existence of a portrait by Manet of their distant relative (correspondence with Baron Philippe de Bourgoing, Nov. 1976).

Suzanne Angélique Charlotte Reichenberg (1853–1924) was an actress who appeared regularly with the Comédie Française from 1868 until 1898. Upon her marriage in 1900, she became the Baronne de Bourgoing (H. Lyonnet, Dictionnaire des comédiens français, Geneva, 1912, vol. II, p. 593). Reichenberg had blond hair, blue eyes, and retained her youthful looks (Château de Versailles, La Comédie Française 1680–1962, exh. cat., 1962, p. 130). Comparison of the present picture with portraits of the actress does not provide conclusive proof, but makes it unlikely that Manet's Woman in Evening Dress represents Suzanne Reichenberg (A. Houssaye, La Comédie Française 1680–1880, Paris, 1880, n.p.; Paris illustré, no. 66, April 6, 1889 [p. 1]; The Cosmopolitan, vol. XI, Oct. 1891, p. 642).

The present picture has been dated 1875–77 by Duret, 1878 by Tabarant, 1879 by Jamot and Wildenstein, and 1880 by Denis Rouart and Daniel Wildenstein. Anne Coffin Hanson finds relatively

little change in style between 1877 and 1880 and prefers a broader range in date (correspondence, Nov. 1976).

According to Tabarant (1947, no. 341), Panier fleuri (65 x 82 cm [25 5/8 x 32 1/4 inches], private collection, New York; Rouart and Wildenstein, p. 263, repr., no. 342) is a sketch of the basket of flowers on the table in the present picture.

Provenance:
Probably retained by the artist's widow;[2] Cognacq, Paris, by 1902;[3] purchased from Monteux by Bernheim-Jeune, Paris, Jan. 6, 1903[4] (stock book no. 12898, Femme en robe du bal, 175 x 85 cm); Carl Reininghaus, Vienna;[5] J. K. Thannhauser by 1931.

Condition:
Lined at an unknown date before 1965 in such a manner that margins were trimmed on all sides. Thinly painted with some abrasion at lower right and center left edges (Dec. 1974).

Exhibitions:
1904. Brussels, La Libre Esthétique. Exposition des peintres Impressionistes. Feb. 25–March 29. No. 84 (Portrait de Mlle S. Reichenberg).[6]

1955. Kansas City, William Rockhill Nelson Gallery of Art. Summer Exhibition (Lady in a Striped Dress, lent by J. K. Thannhauser).

1990. Venice, Palazzo Grassi. Pp. 94–95, no. A20, color repr.

1992. The Montreal Museum of Fine Arts. Pp. 60–61, no. 3, color repr.

1. D. Wildenstein (correspondence, May 1977) thinks that the signature was added later by Mme Manet or some other member of the family. However, A. C. Hanson (correspondence, Nov. 1976) states that the signature is not by Mme Manet.

2. Tabarant, 1947, p. 322. It is not known when the picture left the family.

3. Although the indexes in Jamot and Wildenstein and Rouart and Wildenstein list Gabriel Cognacq (d. 1952), the reference is probably to Ernest Cognacq (1839–1928). Study of Gabriel Cognacq's sale catalogue (Paris, Galerie Charpentier, May 14, 1952) indicates that Ernest purchased works ca. 1901. Gabriel inherited part of his uncle's collection. However, no Cognacq archives remain (correspondence with T. Burollet, Nov. 1976).

4. Bernheim-Jeune still owned the picture in March 1904. Unfortunately the gallery records do not indicate when or to

whom it was sold. Tabarant (1947, p. 322) lists Jos. Hessel after Bernheim-Jeune and before Reininghaus. Rouart and Wildenstein make no mention of either Bernheim-Jeune or Hessel. Hessel's records do not exist (conversation with G. Gruet, May 1977).

5. It is not known when and from whom Reininghaus obtained the picture. No work by Manet was included in the Ausstellung Preis-Konkurrenz at the Kunstsalon G. Pisko, Vienna, Jan.–Feb. 1914. Carl Reininghaus's collection was dispersed soon after World War I (correspondence with E. Marik, Dec. 1976).

6. In addition, two Bernheim-Jeune lists preserved in the archives of Octave Maus in the Département d'Art Moderne at the Musées Royaux des Beaux-Arts, Brussels, mention "12898, Manet, Reichenberg" (M. Colin kindly provided the above information in correspondence, Dec. 1976).

References:

Adler, K. *Manet*. Oxford, 1986, pp. 195, 197, repr., and 235, no. 188 (*Woman in an Evening Gown*, 1880).

Cachin, F. *Manet*. Chêne, 1990, p. 154, no. 12, repr. (*Femme en robe de soirée*, 1878).

Colin, P. *Edouard Manet*. Paris, 1932, p. 180, pl. lxv.

Duret, T. *Edouard Manet et son oeuvre*. Paris, 1902, p. 250, no. 231 (*Femme en robe de soirée*, 1875–77, coll. Cognacq, Paris).

————. *Histoire de Manet et de son oeuvre*. Paris, 1926, p. 269, no. 231 (*Femme en robe de soirée*, 1875–77).

————. *Manet and the French Impressionists*. Trans. J. E. C. Flitch. London, 1912, p. 239, no. 231 (*Woman in Evening Dress*, 1875–77, coll. Cognacq, Paris).

Florisoone, M. *Manet*. Monaco, 1947, p. 79, repr. (*Femme en robe de soirée {Suzanne Reichenberg}*, 1879).

Solomon R. Guggenheim Museum. *Masterpieces*. 1972, p. 12, repr. (1878).

Jamot, P., and G. Wildenstein. *Manet*. Paris, 1932, vol. I, p. 161, no. 331, and vol. II, fig. 138 (*Femme en robe de soirée*, 1879, Galerie Thannhauser).

Moreau-Nélaton, E. "Catalogue général: peintures et pastels." Manuscript on deposit in the Cabinet des Estampes, Bibliothèque Nationale, Paris [1906], no. 257 ("Jeune femme à l'écran, 180 x 85 cm, D. 231").

Rouart, D., and D. Wildenstein. *Edouard Manet*. Lausanne and Paris, 1975, vol. I, pp. 262–63, no. 341, repr. (*Femme en robe de soirée {Suzanne Reichenberg?}*, 1880).

Stuckey, C. F. "Manet Revised: Whodunit?" *Art in America*, vol. 71, no. 10, Nov. 1983, pp. 163 and 165, repr. (photograph of painting before cropping).

Tabarant, A. *Manet et ses oeuvres*. Paris, 1947, pp. 322–23, 541, and 612, pl. 288 (*Une femme en robe de soirée*, 1878).

————. *Manet: Histoire catalographique*. Paris, 1931, pp. 322–23, and 583, no. 272 (*Femme en robe de soirée*, 1878, Galerie Thannhauser, Berlin-Lucerne).

Venturi, M., and S. Orienti. *L'opera pittorica di Edouard Manet*. Milan, 1967, p. 108, no. 246, repr. (1878).

Zervos, C. "Manet et la femme." *Cahiers d'Art*, 7ᵉ année, nos. 8–10, 1932, p. 331, repr. (*Femme en robe de soirée*).

Male Model. *ca. 1900*
(Homme nu debout: Male Nude: Aktstudie)
78.2514 T29

India ink on wove paper. 31.3 x 26.5 cm (12 ⁵/₁₆ x 10 ⁷/₁₆ inches)
Watermark upside down at bottom edge:
ADALON-LES-ANNONAY B CRAYON
Signed lower right: Henri-Matisse. *Not dated.*

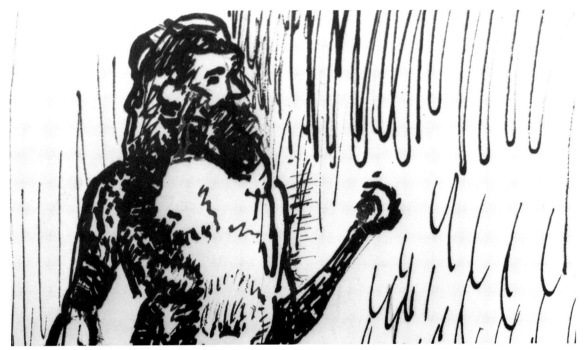

Detail. Full image on page 39.

The model is Bevilaqua, an Italian who posed for Matisse's first major bronze, *Le Serf.* It is recorded that he posed hundreds of times while Matisse was working on the sculpture from about 1900 to 1903 (Barr, pp. 48 and 530, fn.1).

Bevilaqua was an Abruzzi peasant (originally named Pignatelli) who posed for Auguste Rodin as early as 1877–78. He was the model for the legs of Rodin's *Walking Man* and *Saint John the Baptist* (Elsen, p. 28). Not surprisingly, both works are cited as sources for *Le Serf.* According to Albert E. Elsen (p. 29), Matisse was well aware of Bevilaqua's association with Rodin and discussed the latter's working methods with his model. Earlier, perhaps in 1898 or 1899, Matisse had taken some of his drawings to Rodin but was discouraged by his lack of interest (Elsen, p. 16, and Geldzahler, p. 500).

The Thannhauser drawing belongs with a group of works done in the first years of the century that culminated in *Le Serf.* This group includes a drawing of two male nudes and a head titled *Savages* (black ink applied with pen and brush on white paper, 33 x 24 cm [12 ½ x 9 ½ inches], Isabella

Stewart Gardner Museum, Boston; Hadley, p. 60, no. 30, repr.) and a bust-length drawing of Bevilaqua (pencil, 30.5 x 23 cm [12 x 9 inches], Musée Matisse, Nice-Cimiez, kindly brought to my attention by Victor Carlson in correspondence, Oct. 1976). In addition, two paintings, the *Male Nude* (100 x 72 cm [39 ¾ x 28 ⅜ inches], ca. 1900, The Museum of Modern Art, New York; J. Jacobus, *Henri Matisse*, New York, 1972, p. 95, color repr.) and *Académie d'homme* (65 x 46 cm [25 ⅝ x 18 ⅛ inches], Statens Museum for Kunst, Copenhagen; G. Diehl, *Henri Matisse*, Paris, 1954, pl. 13), have the subject, date, and overall composition in common with the present drawing.

Elsen (p. 27) and Carlson (correspondence, Oct. 1976) consider the Thannhauser drawing to be more closely related to Matisse's paintings than to his sculpture. The horizontal molding or articulation of the background wall is found in the present drawing and in the painting at the Museum of Modern Art. Elsen (p. 27) cites the way the arms project out from the body in the drawing to relate it to the paintings. Indeed, the raised arm appears

in the Copenhagen *Académie* and in an *Academic Study* published by Elsen (48.3 x 33 cm [19 x 13 inches]), Collection Dr. Maurice Galanté, San Francisco; fig. 36).

Le Serf itself differs from the Thannhauser drawing in the downward angle of the head, the striding pose of the legs, and the absence of the lower arms (height 92 cm [36 ¼ inches]; casts are in the Museum of Modern Art, New York; the Cone Collection, the Baltimore Museum of Art; the Art Institute of Chicago; and the Fogg Art Museum, Harvard University, Cambridge, Mass.). The sculpture was originally designed with arms which, either by the artist's intention or perhaps by accident, no longer existed when the plaster was cast in bronze (see Geldzahler, p. 499, and Elsen, pp. 29–30). A photograph taken by Hans Purrmann showing Matisse in his studio at 19, quai St. Michel depicts *Le Serf* with the arms and with clenched fists at his thighs (Elsen, p. 30, and J. Russell, *The World of Matisse*, New York, 1969, p. 33).

Provenance:
Presumably acquired from the artist by Heinz Braune;[1] acquired from Braune by J. K. Thannhauser, Oct. 1929.

Exhibition:
1930. Berlin, Galerien Thannhauser. *Henri Matisse.* Feb.–March. Probably no. 113.[2]

References:
The Baltimore Museum of Art. *Matisse as a Draughtsman.* Exh. cat., 1971, pp. 14 and 26.

Barr, A. H., Jr. *Matisse: His Art and His Public.* New York, 1951, pp. 44, repr., 48–49, and 531 (*Male Model*, ca. 1900).

1. Braune, who knew Matisse, was Director of the Breslau Museum and, later, Director of the Stuttgart Museum. J. K. Thannhauser acquired several works by Matisse from him. Braune knew Hans Purrmann since their student years in Munich, and on at least one occasion Purrmann bought a work from Matisse for Braune (B. and E. Göpel, *Leben und Meinungen des Malers Hans Purrmann*, Wiesbaden, 1961, pp. 230 and 250).
2. In the exhibition, no. 113 was *Das Modell*; no. 109, *Männlicher Akt*; and no. 105, *Stehender Akt.* J. K. Thannhauser remembered that the present drawing was included (notes, Dec. 1972).

Elsen, A. E. *The Sculpture of Henri Matisse*. New York, 1972, p. 27, fig. 30 (*Male Model*, ca. 1900).

Geldzahler, H. "Two Early Matisse Drawings." *Gazette des Beaux-Arts*, vol. LX, Nov. 1962, pp. 497–502, repr. (*Male Nude*, 1900–01).

Solomon R. Guggenheim Museum. *Masterpieces*. 1972, p. 40, repr.

Hadley, R.vN., ed. *Drawings*. Isabella Stewart Gardner Museum, Boston, 1968, p. 59 (in comparison with *Savages*).

Jacobus, J. *Henri Matisse*. New York, 1972, p. 64, fig. 80 (*Male Model*, ca. 1900).

Musée National d'Art Moderne, Paris. *Henri Matisse: Dessins et sculpture*. Exh. cat., 1975, p. 64 (*Homme nu debout*).

Schacht, R. *Henri Matisse*. Dresden, 1922, p. 64, repr. (*Aktstudie*, private coll., Breslau).

Schneider, P., M. Carrà, and X. Deryng. *Tout l'oeuvre peint de Matisse: 1904–1928*. Trans. S. Darses. Paris, 1982, pp. 85, repr., and 86, no. 13A.

Selz, J. *Matisse*. Trans. A. P. H. Hamilton. New York, 1964, p. 8, repr. (*Model*, ca. 1900).

Henri Matisse

Woman Before Mirror. *November 1939*
(*Jeune femme devant un miroir*)
78.2514 T30

India ink on wove paper, 38.1 x 28.3 cm (15 x 11 ⅛ inches)
No watermark.
Signed and dated lower left: Henri Matisse nov. 39

Detail. Full image on page 40.

This drawing, which is dated November 1939, was executed at the Hôtel Régina in Cimiez, near Nice, where Matisse returned around mid-October 1939, having stayed there the previous year. A photograph of the *camera lucida* in Matisse's quarters at the hotel includes the same mirror, door, and iron grillwork of the balcony as in the drawing (L. Aragon, *Henri Matisse, A Novel*, trans. J. Stewart, New York, 1971, vol. I, p. 59, fig. 23).

Matisse represented the motif of a woman reflected in a mirror frequently in drawings from 1936–37 (see, for example, *Cahiers d'Art*, IIᵉ année, nos. 3–5, 1936, pp. 101, 103, and 105; R. J. Moulin, *Henri Matisse: Drawings and Paper Cut-Outs*, New York, 1969, pls. 22 and 23; and Paris, Musée National d'Art Moderne, *Henri Matisse: Dessins et sculpture*, exh. cat., 1975, sculpture nos. 93 and 97).

The motif of a woman looking in a mirror with her arms raised over her head appeared as early as 1901 in *La Coiffure* (93 x 69.9 cm [36 ⅝ x 27 ½ inches], Philadelphia Museum of Art; A. H. Barr, Jr., *Matisse: His Art and His Public*, New York, 1951, p. 306, repr.). Likewise, the pose of the model can be traced back to a 1906 sculpture, *Standing Nude with Arms Raised over Her Head* (A. E. Elsen, *The Sculpture of Henri Matisse*, New York, 1972, p. 68, fig. 82).

Provenance:
Purchased from Mrs. Cramer, Paris, by H. C. Goldsmith, 1951; purchased from Goldsmith by J. K. Thannhauser, 1952 (correspondence with H. C. Goldsmith, April 1977).

Exhibition:
1955. Kansas City, William Rockhill Nelson Gallery of Art. *Summer Exhibition* (label on reverse reads: *Woman Before a Mirror*; incorrectly dated 1954, lent by J. K. Thannhauser).

References:
Solomon R. Guggenheim Museum. *Masterpieces*. 1972, p. 41, repr.

Malingue, M. *Matisse: Dessins*. Paris, 1949, pp. 14 and 18, repr. (*Dessin à l'encre de chine*).

Pablo Ruiz Picasso
Born October 1881, Málaga
Died April 1973, Mougins

The End of the Road. 1898–99
(*Au Bout de la route; Redemption; Le Double cortège*)
78.2514 T33

*Oil washes and conté crayon on laid paper. 47.1 x
30.8 cm (18⁹/₁₆ x 12¹/₈ inches)*
*Watermark of a crown above a shield upon which appears
diagonally:* JOHANNOT[1]
Signed lower right: <u>P. Ruiz Picasso</u>. *Not dated.*

Detail. Full image on page 70.

The signature, which includes the names of both
his father (Ruiz) and mother (Picasso), belongs to
an early form used by the artist primarily before
1900 and occasionally through 1901.

John Richardson thinks that the watercolor was
done in 1898, either in Barcelona or Horta de Ebro,
after Picasso had been ill with scarlet fever in
Madrid (p. 16). Pierre Daix places it in Barcelona
and allows for a date of 1898–99 (Daix and
Boudaille, p. 107, and correspondence, June 1975).

According to Jaime Sabartés, who met the artist
in Barcelona after his return from Horta de Ebro in
1899, Picasso went to Horta de Ebro in the
mountainous countryside of Tarragona for seven or
eight months after a short stay in Barcelona in late
June 1898 (*Picasso: An Intimate Portrait*, trans. A.
Flores, New York, 1948, p. 42). Juan-Eduardo
Cirlot (1972, p. 174) specifies June 24 as the date
Picasso accompanied his friend Pallarés to Horta de
Ebro, where he remained until February 1899.
Later, in the summer of 1909, Picasso returned to
the same village which, since 1919, is called Horta
de San Juan.

In the early 1960s, when Richardson showed
Picasso a photograph of this work, the artist said:
"Death waits for all at the end of the road, even
though the rich go there in carriages and the poor
on foot" (p. 16, and correspondence with D. C.
Rich, Nov. 1973). In the background, a row of
carriages proceeds to the right while a line of people
follows a curving road from the foreground to the
same point in the upper right. There, awaiting
them, is a winged figure of Death, who carries a
scythe and whose facial features suggest a skeleton.
Beyond are cypress trees and the walls of a
cemetery.

The same figures of a woman holding a child by
the hand are found in a crayon drawing (Z. I. 12,
1898) formerly in the collection of Josef Stransky
(crayon on paper, 48.2 x 25.4 cm [19 x 10 inches],
ex. coll. Gargalo, Madrid; *French Masters of the XIX
and XX Century: The Private Collection of Josef
Stransky*, New York, ca. 1935, n.p.).

The theme of death, the overall composition,
the walled cemetery, and the procession of figures
seen in back view all occur in a pastel in the Museu

Picasso in Barcelona (first brought to my attention
by Marilyn McCully). The pastel, *Entierro en el campo*
(*Burial in the Country*, MAB 110.233), has
predominantly dark green and dark purple tones
accented by white and touches of red. In the work
in the Museu Picasso, the artist shows a funeral
procession with a priest and men bearing a coffin
along the road to the cemetery. However, in the
work in the Thannhauser Collection, Picasso
presents an allegorical view of death.

There are also two pen-and-ink drawings in
the Museu Picasso related to the present work.
La llamada de la muerte (*The Call of Death*, MAB
110.780) includes male figures walking with
crutches and a figure carrying another, as does
The End of the Road. Although the figures are seen
frontally moving from right to left, their poses
generally correspond to those seen in back view in
the Thannhauser work. Certain figures also appear
in *La llamada de la muerte* (*The Call of Death*, MAB
110.688), where the man with a cane corresponds
to the man with a crutch, and the adult figure
carrying another recurs. However, here, at the left
stands a figure of Death. (I am grateful to Rosa
Maria Subirana for advice, information, and
permission to reproduce the three works in the
Museu Picasso that appear in the first edition of
this book, *Guggenheim Museum: Justin K. Thann-
hauser Collection*.)

A winged figure of Death with a scythe appears
in two conté-crayon drawings, *The Kiss of Death*,
both in the Museu Picasso (MAB 110.750 and
110.778R; Cirlot, 1972, p. 118, repr., no. 199 and
p. 234, repr., no. 664, respectively, where they are
dated Barcelona 1899–1900).

Anthony Blunt and Phoebe Pool found *The End
of the Road* close to the work of Isidro Nonell
(1873–1911) both in style and in the representation
of a line of peasants (pl. 65). In addition, Nonell's
drawings of single figures, which were published
before 1898, resemble individual figures in the
Picasso (see E. Jardi, *Nonell*, New York, 1970,
pls. 8, 30, 202, and 212). McCully (conversation,
Dec. 1977) thinks that the present work reflects
Nonell's *Annunciation in the Slums* (Jardi, pl. 9).

1. The paper is manufactured in France and was often used by
Picasso: for example in Z. I. 12 (discussed in text) and XXI. 66,
67, 115, and 117.

Provenance:
Unidentified private collection, Barcelona; J. K. Thannhauser by 1957.

Condition:
The support is worn at corners. Removed from cardboard mount, tear at upper right repaired, and work deacidified by C. Gaehde (Aug. 1976).

Exhibitions:
1957. New York, The Museum of Modern Art. *Picasso: 75th Anniversary Exhibition*. May 22–Sept. 8. P. 14, repr. (*Redemption*). Traveled to the Art Institute of Chicago, Oct. 29–Dec. 8.

1958. Philadelphia Museum of Art. *Picasso*. Jan. 8–Feb. 23. No. 1, repr.

1960–61. New York, The Museum of Modern Art. *Art Nouveau: Art and Design at the Turn of the Century*. June 6–Sept. 6. No. 222, repr. (*The End of the Road*). Traveled to Pittsburgh, Carnegie Institute Museum of Art, Oct. 13–Dec. 12; Los Angeles County Museum, Jan. 17–March 5, 1961; and the Baltimore Museum of Art, April 1– May 15.

1981. Cambridge, Mass., Fogg Art Museum. *One Hundred Master Drawings by Picasso*. Feb. 20–April 15. Exh. cat., pp. 34–35, no. 3, repr. (1898). Traveled to the Art Institute of Chicago, April 29–June 14, and Philadelphia Museum of Art, July 11–Aug. 23.

1990. Venice, Palazzo Grassi. Pp. 96–97, no. A21, color repr.

References:
Arnason, H. H. *History of Modern Art*. New York, 1968, pp. 117–18, fig. 187.

Blunt and Pool. 1962, p. 30 and pl. 64 (*The End of the Road*, 1898).

Daix. 1977, pp. 29 and 33, fn. 6.

Daix and Boudaille. 1967, no. I.2, pp. 22 and 107, repr. (1898–99).

Solomon R. Guggenheim Museum. *Masterpieces*. 1972, p. 44, repr. (ca. 1898).

Kunsthalle Bielefeld. *Picasso: Todesthemen*. Exh. cat., 1984, p. 12, fig. 2 (*Das Ende der Straße*, ca. 1900), 283, fig. 29a (*Die letze Wegstrecke*, 1898), repr., and 284.

McCully, M. *Els Quatre Gats. Art in Barcelona around 1900*. Princeton, 1978, pp. 37–38, 54–55, fig. 15, repr. (*End of the Road*, ca. 1899).

Palau i Fabre, J. *Picasso: The Early Years: 1881–1907*. Trans. K. Lyons. New York, 1981, pp. 178, no. 370, repr., 179, and 528 (*The Angel of Death*, 1900). Catalan edition: *Picasso Vivent 1881–1907. Infantesa i primera joventut d'un demiürg*, 1980.

Richardson, J. *Pablo Picasso: Watercolours and Gouaches*. London, 1964, pp. 16–17, pl. 1 (1898).

Richardson, J., with M. McCully. *A Life of Picasso: Volume I: 1881–1906*. New York, 1991, pp. 50 and 151, repr. (1900).

Rojas, C. *El mundo mítico y mágico de Picasso*. Barcelona, 1984, pp. 111 and 113, repr. (*El final del camino, El ángel de la muerte*).

Seling, H., ed. *Jugendstil: Der Weg ins 20. Jahrhundert*. Munich, 1959, pp. 29 and 113, and pl. 24 (ca. 1898).

Zervos. 1969, vol. XXI, no. 79 and pl. 35 (*Le Double Cortège*, 1898).

Le Moulin de la Galette, *autumn* 1900
78.2514 T34

Oil on canvas, 88.2 x 115.5 cm (34 ³/₄ x 45 ¹/₂ inches)
Signed lower right: P. R. Picasso
Not dated.

Detail. Full image on page 72.

Picasso confirmed to Pierre Daix that *Le Moulin de la Galette* was the first painting he did after arriving in Paris in October 1900 (correspondence, June 1975). Alfred Barr was the first to propose that this was so (*Picasso: Forty Years of His Art*, exh. cat., 1939, p. 24).

Evidently the World's Fair had attracted the young artist and several of his Spanish friends to Paris (Blunt and Pool, 1962, p. 12). They had originally intended to go to London, a destination they never reached (Penrose, p. 62). Picasso lived in the studio Isidro Nonell had used at 49, rue Gabrielle in Montmartre with Carlos Casegemas and Manuel Pallarés. He was back in Barcelona for Christmas (J. Sabartés, *Picasso: An Intimate Portrait*, trans. A. Flores, New York, 1948, pp. 43, 47, 223). It was during this stay in Paris that he adopted the signature P. R. Picasso.

The Moulin de la Galette was a dancing spot at the site of a mill atop Montmartre. Long a favorite of artists, Renoir, van Gogh, Toulouse-Lautrec, Steinlen, van Dongen, Dufy, and Utrillo painted there. A photograph showing Toulouse-Lautrec seated at a white rectangular table is reproduced in P. Huisman and M. G. Dortu, *Lautrec by Lautrec*, New York, 1964, p. 75. Other photos of the Moulin appear on p. 79 of the same book and in M. Pianzola, *Théophile-Alexandre Steinlen*, Lausanne, 1971, p. 47.

Ramón Casas (1866–1932) lived in the apartment that Santiago Rusiñol had leased in the Moulin de la Galette (M. McCully, *Els Quatre Gats and Modernista Painting in Catalonia in the 1890's*, Ph.D. dissertation, Yale University, 1975, p. 25). Casas painted the subject several times in the 1890s: for example, *Baile en el "Moulin de la Galette"* (Museo del Cau Ferrat, Sitges). His plein-air painting of the Moulin de la Galette was undoubtedly known to Picasso before he went to Paris since it had been in the Museo de Bellas Artes in Barcelona from 1891 (J. F. Ráfols, *Ramón Casas*, Barcelona, ca. 1949, pl. 10). The art editor of *Pèl & Ploma*, Casas drew the portrait of Picasso with Montmartre and the Moulin de la Galette in the background that appeared in the June 1901 issue of the magazine (vol. III, no. 77, p. 14).

Picasso's painting has frequently been compared to the work of Toulouse-Lautrec. His debt to Lautrec was acknowledged by critics at the time of Picasso's 1901 Vollard exhibition (Blunt and Pool, p. 13) and later by the artist himself (D. Ashton, *Picasso on Art: A Selection of Views*, New York, 1972, p. 51). Closest among Lautrec's works to the Thannhauser picture is *Au Moulin Rouge*, 1892 (122.5 x 139.7 cm [48 ¹/₂ x 55 ³/₈ inches], The Art Institute of Chicago; see D. C. Rich, *Toulouse-Lautrec: Au Moulin Rouge*, London, ca. 1949, p. 10 and fig. 10). The Lautrec would appear to be the source for the cut-off figure in the foreground, the strong diagonal at the left, and for the figures grouped around the table; however, it lacks the dancing figures, the night setting, and the emphasis on black of Picasso's palette. M. G. Dortu lists the work as belonging to the Galerie Manzi-Joyant by 1902 (*Toulouse-Lautrec et son oeuvre*, New York, 1971, vol. II, p. 258, no. 427). Dortu does not know if *Au Moulin Rouge* was in the possession of Manzi-Joyant in 1900 and has not found it exhibited in that year (correspondence, Feb. 1976).

For Picasso, an accessible source reflecting Lautrec's painting could have been the cover of *Gil Blas illustré* for the July 13, 1900, issue by Théophile-Alexandre Steinlein (1859–1923), which appeared under the caption "Au bal du 14 juillet, par Jacques Crépet" (fig. a). A night scene with lights and dancing couples, it includes female figures in the left foreground and even the two with their heads close together that appear in Picasso's painting. In both, the colors are predominantly black with red, yellow, and white. Picasso's knowledge of *Gil Blas* before the Paris visit is well documented (Vallentin, p. 30; P. Pool, "Sources and Backgrounds of Picasso's Art," *The Burlington Magazine*, vol. CI, May 1959, p. 179).

Michel Hoog (*Impressionism*, exh. cat., 1974, p. 186) emphasized Picasso's indebtedness to Renoir's *Dancing at the Moulin de la Galette*, 1876 (130.8 x 174.6 cm [51 ¹/₂ x 68 ⁷/₈ inches], Musée du Louvre, Galerie du Jeu de Paume, Paris), which was painted at the site. Although Picasso could have seen the Renoir at the Luxembourg in Paris in 1900, the pictures do not seem related in style, color, and light, or in the appearance of the figures.

The woman dancer at the far right in the Thannhauser picture clearly refers to the work of

Toulouse-Lautrec. It is probably closest to a lithograph of Marcel Lender, the actress (L. Delteil, *Le Peintre graveur illustré*, Paris, 1920, vol. X, no. 102), of which a special third state was published in *Pan* (vol. I, no. 3, 1895, p. 197).

The same woman seated at the left, whose gaze boldly confronts the spectator, may appear at the far right in Picasso's drawing *Le Retour de l'exposition* (not in Z.; 47 x 62 cm [18 ¹/₂ x 24 ³/₈ inches], private collection; Daix, 1977, pp. 36–37, pl. 4; kindly brought to my attention by Marilyn McCully). In addition, Picasso's sketch of two women seated at a table (Z. XXI. 255; conté crayon, 21 x 13 cm, 1901) captures the spirit and contains the profile of the woman at the left at the table in his *Le Moulin de la Galette* so as to suggest a contemporary date. Unlike the Toulouse-Lautrec and the Renoir, Picasso's *Moulin de la Galette* is strikingly dominated by women. Their white faces, red mouths, and fashionable hats stand out in a night illuminated by electric lights.

Provenance:
Purchased from Galerie Berthe Weill, Paris, by M. Huc,[1] ca. 1900; Moderne Galerie (Heinrich Thannhauser), Munich, ca. 1909; purchased from Moderne Galerie by Paul von Mendelssohn Bartholdy, Berlin, ca. 1910;[2] repurchased from Bartholdy by J. K. Thannhauser, ca. 1935.

Condition:
Glue lined prior to 1965. Scattered areas of inpainting along right edge (May 1975).

1. Weill (p. 67) specified: "à M. Huc, une peinture importante: *Le Moulin de la Galette* vendue, (eh! eh!) 250 francs . . ." The reference is to Arthur Huc, manager of *La Dépêche de Toulouse*, who commissioned two posters from Toulouse-Lautrec (J. Adhémar, *Toulouse-Lautrec: His Complete Lithographs and Drypoints*, New York, 1965, nos. 4 [L.D. 340] and 74 [L. D. 67]) and owned two paintings by Lautrec (M. G. Dortu, *Toulouse-Lautrec et son oeuvre*, New York, 1971, vol. I, nos. 243, 264). Years later, in 1941, Matisse remembered that Huc of *La Dépêche de Toulouse* bought one of his works from Weill (J. D. Flam, *Matisse on Art*, London, 1973, p. 87).
2. J. K. Thannhauser notes, Dec. 1972. Bartholdy also owned Z. I. 274, 351, and 206 (*Head of a Woman*, formerly in the Thannhauser Collection). The family is that of the composer Felix Mendelssohn (M. F. Schneider, *Mendelssohn oder Bartholdy?* Basel, 1962).

Exhibitions:
1939–40. New York, The Museum of Modern Art. *Picasso: Forty Years of His Art*. Nov. 15, 1939–Jan. 7, 1940. No. 5, repr. Traveled to the Art Institute of Chicago, Feb. 1–March 3; Boston, Institute of Modern Art, April 27–May 26.

1941. New York, The Museum of Modern Art. *Masterpieces of Picasso*. July 15–Sept. 7. No. 5.

1947. New York, M. Knoedler and Co. *Picasso Before 1907*. Oct. 15–Nov. 8. No. 3.

1957. New York, The Museum of Modern Art. *Picasso: 75th Anniversary Exhibition*. May 22–Sept. 8. P. 15, repr. Traveled to the Art Institute of Chicago, Oct. 29–Dec. 8.

1958. Philadelphia Museum of Art. *Picasso*. Jan. 8–Feb. 23. No. 4, repr.

1960. London, Tate Gallery (organized by the Arts Council of Great Britain). *Picasso*. July 6–Sept. 18. No. 4, pl. Ib.

1966–67. Paris, Grand Palais. *Hommage à Pablo Picasso*. Nov. 1966–Feb. 1967. No. 3, repr.

1980. New York, The Museum of Modern Art. *Pablo Picasso: A Retrospective*. May 14–Sept. 16. Exh. cat., p. 32, repr.

1990. Venice, Palazzo Grassi. Pp. 98–99, no. A22, color repr.

1992. The Montreal Museum of Fine Arts. Pp. 70–71, no. 8, color repr.

References:
Arnason, H. H. *History of Modern Art*. New York, 1968, pp. 117–18, repr.

Auckland City Art Gallery. *Pablo Picasso: The Artist Before Nature*. Exh. cat., Auckland, 1989, p. 40.

Aznar, J. C. *Picasso y el cubismo*. Madrid, 1956, p. 319, fig. 214.

Barr, A. H., Jr. *Picasso: Fifty Years of His Art*. New York, 1946, pp. 18, repr., 19, and 253.

Boeck, W., and J. Sabartés. *Picasso*. New York, 1955, p. 117.

Boone, D. *Picasso*. Trans. J. Greaves. London, 1989, p. 10. French edition, Paris, 1989.

Fig. a. Steinlen's cover for Gil Blas illustré. *10° année. no. 28. July 13. 1900.*

Broude, N. F. "Picasso's Drawing, *Woman with a Fan*: The Role of Degas in Picasso's Transition to his 'First Classical Period.'" *Oberlin College Bulletin*, vol. 29, winter 1972, p. 87, fn. 9.

Cassou, J. *Picasso*. Paris, 1940, p. 36, repr.

Cirici Pellicer. 1946, p. 64 and no. 20, repr.

———. 1950, no. 18, repr.

Cooper, D. *Picasso Theatre*. New York, 1968, p. 341 and pl. 25.

Daix. 1965, p. 28.

———. 1977, p. 37.

Daix and Boudaille. 1967, no. II. 10, pp. 28–29, repr., 33, and 122.

Daulte, F. "Une Donation sans précédent: la collection Thannhauser." *Connaissance des Arts*, no. 171, May 1966, p. 68, repr.

Daval, J.-L. "Guidelines." In J. Leymarie, *Picasso: The Artist of the Century*. New York, 1972, pp. 203, repr., and 291.

de Champris, P. *Picasso: ombre et soleil*. Paris, 1960, pl. 3.

Elgar, F., and R. Maillard. *Picasso*. Rev. ed. New York, 1972, p. 182.

Fermigier, A., ed. *Picasso*. Paris, 1967, p. 41, repr.

Finkelstein, S. *Der junge Picasso*. Dresden, 1970, pp. 44–45, 162, and pl. 54.

Frankfurter, A. M. "Picasso in Retrospect: 1939–1900." *Art News*, vol. 38, Nov. 18, 1939, p. 11, repr.

Galleria d'Arte Moderna e Contemporanea Palazzo Forti, Verona. *Picasso in Italia*. Exh. cat., Milan, 1990, p. 200.

Glimcher, A., and M. Glimcher, eds. *Je Suis Le Cahier: The Sketchbooks of Picasso*. Boston and New York, 1986, p. 308.

Solomon R. Guggenheim Museum. *Masterpieces*. 1972, p. 45, repr.

Jaffé, H. L. C. *Picasso*. New York, 1964, p. 15.

Kramer, H. "Picasso's Very First Painting in Paris." *The New York Times*, July 28, 1974, Section D, p. 17, repr.

Kunstmuseum Bern. *Der Junge Picasso: Frühwerk und Blaue Periode*. Exh. cat., Zurich, 1984, pp. 55, fig. a, repr., and 174.

Lieberman, W. S. *Pablo Picasso: Blue and Rose Periods*. New York, 1954, pl. 12.

The Metropolitan Museum of Art, New York. *Impressionism*. Exh. cat., 1974, p. 186.

Mackenzie, H. F. *Understanding Picasso*. Chicago, 1940, pl. 1.

Merli, J. *Picasso, el artista y la obra de nuestro tiempo*. Rev. ed. Buenos Aires, 1948, pl. 24.

Musée des Arts Décoratifs, Paris. *Picasso*. Exh. cat., 1955, definitive ed., p. 20.

Palais des Beaux-Arts, Charleroi, Belgium. *Picasso/Miró/Dalí: Evocations d'Espagne*. Exh. cat., Charleroi, 1985, p. 20 (1901).

Palau i Fabre, J. *Picasso: The Early Years: 1881–1907*. Trans. K. Lyons. New York, 1981, pp. 208–09, no. 509, repr., and 531. Catalan edition: *Picasso Vivent 1881–1907. Infantesa i primera joventut d'un demiürg*, 1980.

Penrose. 1958, no. 8, pl. 1.

Picasso: 1881–1973: Exposició Antològica. Exh. cat., Museo Español de Arte Contemporáneo, Madrid, and Museu Picasso, Barcelona. Barcelona, 1981, p. 16, repr.

Porzio, D., and M. Valsecchi. *Understanding Picasso*. New York, 1974, color pl. 2.

Quinn, E., and P. Descargues. *Picasso*. Paris, 1974, p. 206, repr.

Reff, T. Review of A. Blunt and P. Pool, *Picasso: The Formative Years*. *The Art Bulletin*, vol. XLVIII, June 1966, p. 267.

Richardson, J., with M. McCully. *A Life of Picasso: Volume I: 1881–1906*. New York, 1991, pp. 166, repr., 167–68, 182, and 195.

Vallentin, A. *Pablo Picasso*. Paris, 1957, p. 48.

Warnod, J. *Washboat Days*. Trans. C. Green. New York, 1972, pp. 61 and 65.

Weill, B. *Pan! dans l'Oeil!* Paris, 1933, p. 67.

Wertenbaker, L. *The World of Picasso*. New York, 1967, pp. 21, repr., and 31.

Zervos. 1932, vol. I, no. 41, pl. 20.

Pablo Picasso

Au Café. 1901
(Le Comptoir: The Counter)
78.2514 T35

Charcoal on paper. 21.4 x 25.6 cm (8 7/16 x
10 1/16 inches)
Signed lower left: P. R. Picasso
Not dated.

Detail. Full image on page 77.

1934. Buenos Aires, Galería Müller.² *Picasso*. Oct.
No. 28 (label on reverse of frame reads: *Café*,
Madrid 1900).

References:
Cirici Pellicer. 1946, no. 37, repr. (*El Mostrador*,
1900).

————. 1950, no. 33, repr. (*Le Comptoir*, 1901).

Solomon R. Guggenheim Museum. *Masterpieces*.
1972, p. 46, repr.

Zervos. 1932, vol. I, no. 37, pl. 18 (*The Counter*,
Madrid, 1900).

Alejandro Cirici Pellicer states that this drawing
was published in *Arte Joven*, the small magazine for
which Picasso was art editor and Francisco de Asis
Soler literary editor, in Madrid in 1901. According
to Joseph Phillip Cervera, it is reproduced in *Arte
Joven*, no. 3, May 3, 1901, n.p., without title or
caption, and, although it appears on the same page
as Soler's short story "La última sensación," it is not
an illustration for the story (correspondence, Dec.
1975).

In the Café (Z. VI. 373; D-B. d.III; 30 x 42 cm
[11 7/8 x 16 1/2 inches], Collection Masoliver,
Barcelona), which was also published in *Arte Joven*,
includes figures which appear to be the same as the
man with the hat standing at the left and the man
at the far right in the Thannhauser drawing.
Another related drawing shows Picasso and a group
of artists in Madrid. These are from left to right: an
unknown man, the poet Cornuti, Soler, Picasso, and
Alberto Lozano (Z. I. 36; D-B. d.III. 5; 23.5 x 30.5
cm [9 1/4 x 12 inches], Collection Mr. and Mrs.
Walter Bick, Canada). Pierre Daix dates both
Madrid, early in 1901. In the signatures for each of

these related works the artist reverts to an early
form, *P. Ruiz Picasso*, whereas the Thannhauser
drawing is signed *P. R. Picasso* (see p. 130).

Provenance:
J. K. Thannhauser by 1932.¹

Condition:
Flattened and creases at top and bottom retouched
by C. Gaehde (June 1973).

Exhibitions:
1932. Kunsthaus Zürich. *Picasso*. Sept. 11–Oct. 30.
No. 252 (label on reverse of frame reads: *Café*,
1900).

1. J. K. Thannhauser (notes, Dec. 1972) stated that he
acquired the present drawing and *Woman and Child*, pp. 136–37,
and *Man with Pack*, formerly in the Justin K. Thannhauser
Collection at the Guggenheim, from Santiago Laporta in
Barcelona. No collector by this name is known.
2. J. K. Thannhauser arranged for the exhibition and lent

many of the works (conversation with D. C. Rich, March 1975).
No catalogue has been located although the bibliography in J.
Merli, *Picasso. el artista y la obra de nuestro tiempo*, Buenos Aires,
1942, p. 305, states that the preface was by Frederico C. Müller.
The exhibition numbers are derived from a printed label on the
reverse of each work.

The Fourteenth of July, 1901
(Le Quatorze juillet)
78.2514 T36

*Oil on cardboard, mounted on canvas, 48 x 62.8 cm
(18 ⁷/₈ x 24 ³/₄ inches)
Signed upper right:* Picasso
Not dated.

Detail. Full image on page 76.

In the preface to the catalogue of the April 1–15, 1902, exhibition at the Galerie Berthe Weill, Adrien Farge describes the Thannhauser picture in these terms: "a brilliant 14th of July brings together in the most glittering colors all the surging movement and intense life of a popular holiday" (trans. J. Emmons in Leymarie).

July 14, 1901, was the first time Picasso experienced Bastille Day. Fernande Olivier, whom he met in 1904, recalled that "only the popular festivals and carnivals interested him in France. He always enjoyed being a spectator at the July Fourteenth celebrations, but he never felt involved in them emotionally" (*Picasso and His Friends*, trans. J. Miller, New York, 1965, p. 126; first published 1931).

Picasso left for Paris in May 1901, where he remained until the end of the year. A drawing by Picasso dated 1901 represents the artist arriving in Paris with Jaume André Bonsons (Z. VI. 342; D-B. d.IV. 12). Picasso's patron Mañach provided a studio at 130ter, boulevard de Clichy where they lived. It was during this stay in Paris that he began

to use only his mother's name as a signature. All sources date the Thannhauser painting from this time.

Early in June Picasso was introduced to Ambroise Vollard (J. Sabartés, *Picasso: An Intimate Portrait*, New York, 1948, p. 51). Subsequently an exhibition of paintings by Francisco de Iturrino (1864–1924) and Picasso took place at the Galerie Vollard in rue Laffitte from June 25 until July 14.

In 1901, the most accessible representations of the Fourteenth of July appear to have been by two non-French artists, van Gogh and Steinlen. Van Gogh's *Impression de 14 juillet*, 1886, was exhibited in Paris at his important retrospective at Bernheim-Jeune from March 15–31, 1901, as no. 22. At that time the picture belonged to Joseph Hessel, Paris (de la Faille, 1970, F222, p. 118; 44 x 39 cm [17 ¹/₄ x 15 ¹/₄ inches], Collection Mrs. L. Jäggli-Hahnloser, Winterthur, Switzerland; Gordon, 1974, vol. II, p. 27; J. Leymarie, *Fauvism*, Lausanne, 1959, p. 20, color repr.). The most striking similarity between the two pictures is the boldly expressive red, white, and blue brushwork representing flags and bunting. While the possibility that Picasso saw the van Gogh is remote, it seems certain that he would have known about the Bernheim-Jeune exhibition, which was an important impetus to the Fauves. Antonina Vallentin relates that "asked later what had been the predominant influence on him during the early days in Paris, he unhesitatingly replies: 'Van Gogh!'" (p. 32).

Théophile-Alexandre Steinlen (1859–1923) did many versions of the subject, including one in the July 11, 1901, issue of *L'Assiette au Beurre* (vol. I, no. 15, pp. 3–4), the cover of the July 13, 1900, *Gil Blas illustré* (10ᵉ année), and an 1895 oil of *Le 14 Juillet* (Musée Petit Palais, Geneva; M. Pianzola, *Théophile-Alexandre Steinlen*, Lausanne, 1971, cover, color repr.). Picasso's painting does not bear a significant resemblance to Steinlen's representations, which are night scenes with hanging lanterns (see pp. 130–31).

Picasso's *The Fourteenth of July* resembles his *On the Upper Deck* (Z. XXI. 168; D-B. V. 61; 49.2 x 64.2 cm [19 ³/₈ x 25 ¹/₄ inches], The Art Institute of Chicago) and *The Flower Seller* (Z. XXI. 207; D-B. V. 65; 33.7 x 52.1 cm [13 ¹/₂ x 20 ¹/₂ inches], Glasgow Art Gallery and Museum) in the use of

light-colored background buildings to limit depth and in the cutting off of the scene represented. All three are close in style, painted on cardboard, signed in a similar manner, and date from 1901.

Provenance:
Purchased by J. K. Thannhauser, Paris, 1936–39 (conversation with D. C. Rich, March 1975); Gift of Justin K. Thannhauser, 1964 (64.1707).

Condition:
The cardboard support was adhered to fabric with an aqueous-type adhesive and mounted onto a stretcher at an unrecorded date prior to 1975. The brown color of the support is visible in many places as part of the design. The painting was cleaned, that is, the varnish was removed in 1991 (March 1992).

Exhibitions:
1902. Paris, Galerie Berthe Weill. *Tableaux et pastels de Louis Bernard-Lemaire et de Picasso*. April 1–15. No. 5.

1944. Mexico City, Sociedad de Arte Moderno (organized by The Museum of Modern Art, New York). *Picasso*. June. P. 41 and Added Corrections List.

1953. Santa Barbara Museum of Art. *Fiesta Exhibition 1953: Picasso, Gris, Miró, and Dali*. Aug. 4–30. No. 2.

1984–85. Kunstmuseum Bern. *Der Junge Picasso: Frühwerk und Blaue Periode*. Dec. 9, 1984–March 3, 1985. Exh. cat., pp. 57, 226, no. 127, color repr., and 323 (*Der 14. Juli*, 1901).

1990. Venice, Palazzo Grassi. Pp. 100–01, no. A23, color repr.

1. According to Daix and Boudaille (p. 52), when Picasso returned to Barcelona in Jan. 1902, Pedro Mañach kept some of his work, which was shown at Berthe Weill's gallery at 25, rue Victor-Massé in April. This exhibition was organized by Mañach and included fifteen paintings by Picasso. According to Vallentin none was sold. Picasso was exhibited there again from June 2–15 (jointly with Matisse) and Nov. 15–Dec. 15, 1902. Sabartés mentions that Picasso first met Mañach at Berthe Weill's gallery in 1900 (*Picasso: An Intimate Portrait*, p. 48).

References:

Arnason, H. H. *History of Modern Art*. New York, 1968, p. 90, repr.

Cirici Pellicer. 1946, pp. 95, 168, and 170.

————. 1950, pp. 100, 172, and 174.

Daix. 1977, pp. 44 and 49, fn. 19.

Daix and Boudaille. 1967, no. V. 70, pp. 42, 43, 45, and 187, repr.

Solomon R. Guggenheim Museum. *Masterpieces*. 1972, p. 47, repr.

Leymarie, J. *Picasso: The Artist of the Century*, New York, 1972, p. 207.

Nochlin, L. "Picasso's Color: Schemes and Gambits." *Art in America*, vol. 68, no. 10, Dec. 1980, pp. 109, fig. 5, color repr., and 113–14.

Palau i Fabre, J. *Picasso: The Early Years: 1881–1907*. Trans. K. Lyons. New York, 1981, pp. 258, no. 649, repr., and 535. Catalan edition: *Picasso Vivent 1881–1907. Infantesa i primera joventut d'un demiürg*, 1980.

Vallentin, A. *Picasso*. English edition edited by K. Woods. Garden City, 1963, p. 46.

Zervos, C. "Oeuvres et images inédites de la jeunesse de Picasso." *Cahiers d'Art*, 25ᵉ année, no. II, 1950, p. 314, repr.

Zervos. 1932, vol. I, pp. xxvi–xxvii.

————. 1954, vol. VI, no. 334 and pl. 41.

Pablo Picasso

Woman and Child, *1903*
*(Femme et enfant; Deux enfants; Two Children; Frau
mit Kind nach Carrière)*
78.2514 T37

*Conté crayon on wove paper. 33.7 x 23.2 cm (13 ¹/₄ x
9 ¹/₈ inches). Watermark:* VILASECA
Signed lower right: Picasso; *inscribed lower right, not by
the artist:* D'Eugéne Carriére; *inscribed, not by the
artist, on reverse:* 10 centimetro. *Not dated.*

Detail. Full image on page 77.

According to J. K. Thannhauser (notes, Dec. 1972), Picasso remembered having made the present drawing for a Barcelona newspaper in connection with an article on contemporary art. The *Woman and Child* does, in fact, appear in slightly modified form on the front page of *El Liberal* in Barcelona on Monday, August 10, 1903 (fig. a). The newspaper reproduction has translated the solid black areas of conté crayon into linear patterns of parallel lines and crosshatching, undoubtedly so that it would reproduce better. Under the newspaper reproduction of the present drawing is printed "Eugenio Carrière." The present work and two other drawings are identified at the end of the article (p. 2) as the work of Pablo Ruiz Picasso. The other drawings represent a figure from Puvis de Chavannes and Auguste Rodin's sculpture of Jules Dalou. The former, which depicts a man with a pack, reproduces line for line a drawing formerly in the Justin K. Thannhauser Collection, *Man with Pack* (conté crayon on wove paper, 33.8 x 23.2 cm [13 ⁵/₁₆ x 9 ¹/₈ inches]; see first edition of present catalogue, 1978, cat. no. 38). Richard J.

Wattenmaker has pointed out that *Man with Pack* is derived from a work by Puvis de Chavannes (the right section of *Sainte Geneviève ravitaillant Paris* in the Pantheon, Paris, which he completed in 1897 [*Puvis de Chavannes and the Modern Tradition*, exh. cat., Art Gallery of Ontario, Toronto, 1975, p. 170]). All three illustrate an article, "Las Crónicas de Arte: La Pintura y La Escultura allende los Pirineos," written by Carlos Juñer Vidal, brother of Sebastian Juñer and a friend of Picasso.

The exact source for *Woman and Child* is a painting by Eugène Carrière entitled *The Artist with His Wife and Their Son* (fig. b). It represents Carrière (1849–1906) with his wife, Sophie Demousseaux, born 1855, and youngest son, Jean-René, born 1888. Neither Picasso's conté crayon drawing nor the illustration in *El Liberal* included the figure of the artist in the background.

The question of how Picasso knew the Carrière painting remains unanswered. The picture is not mentioned in the Carrière bibliography, it is not included in exhibitions, and reproductions of it have not been found in magazines Picasso is known to have seen regularly. The provenance of the large canvas has not been traced farther back than the mid-1960s.

Carrière's painting is not dated but a date can be arrived at on the basis of the age of Jean-René. Myron Laskin (correspondence, Jan. 1974) suggests 1895–96. His argument is reinforced by the great similarity between Jean-René in the Ottawa painting and in an oil sketch of the boy's head, which has been dated 1895 (J.-P. Dubray, *Eugène Carrière*, Paris, 1931, repr. opp. p. 25). Robert J. Bantens prefers a date of 1897–1900 (correspondence, Nov. 1975).

It is entirely possible that Picasso saw Carrière's painting during a visit to Paris. From 1900 Carrière's atelier was in the Villa des Arts, 15, rue Hégésippe-Moreau (J.-R. Carrière, *De la vie d'Eugène Carrière: Souvenirs, lettres, pensées*, Toulouse, 1966, p. 24). From at least June through December 1901, Picasso lived a few blocks away at 130ter, boulevard de Clichy. In 1902 Hermen Anglada Camarasa's address is listed as 9, rue Hégésippe-Moreau (Brussels, La Libre Esthétique, *Neuvième Exposition*, exh. cat., 1902, p. 9). Among Picasso's Catalan friends, Ramón Casas, Santiago Rusiñol, Miguel Utrillo, Sebastian Juñer, and Herman

Anglada Camarasa had contact with Carrière's work (conversation with M. McCully, Oct. 1976).

Picasso was in Paris from October 1902 until the beginning of January 1903, although he did not live near Carrière's studio at the time. Before the 1903 newspaper came to light, Pierre Daix (correspondence, March 1976) dated the Thannhauser drawing from the winter of 1902–03, during Picasso's sojourn in Paris.

Since the Thannhauser drawing relies so essentially on Carrière's painting, it has to be assumed that Picasso saw either the original or a reproduction of it. Rosa Maria Subirana finds Picasso's copy uncharacteristically close to the Carrière and she questions its authorship (conversation, May 1977), whereas Marilyn McCully accepts the present drawing as by Picasso (conversations, Oct. 1976 and Dec. 1977). The inauthentic inscription on the present drawing was added by the same person who wrote "D'August Rodin" under the third drawing in *El Liberal*. Daix (correspondence, March 1976) considers the signature authentic, dating it from 1903–4.

The article for which Picasso contributed the three illustrations is a review of a book by Manuel Rodríguez Codolá, *La pintura en la Exposición Universal de Paris de 1900*, which was published in Barcelona in May 1903. The book itself contains no illustrations. The works by Carrière and Puvis de Chavannes that Picasso used to illustrate the article were not exhibited at the World's Fair, which he surely visited. The third drawing is of a sculpture by Rodin, *Jules Dalou* (1883), which was on view at the fair (*Catalogue officiel illustré de l'art français de 1800 à 1889*, no. 1794). However, this drawing is not included in the Picasso literature if, in fact, it survives.

Picasso's illustrations appeared in other issues of *El Liberal* from 1902: a drawing of a woman, dated Paris 1902 (Z. VI. 444), accompanies an article by Carlos Juñer Vidal (Año II, num. 353, April 6, 1902 [p. 7]); a large drawing of the festival of the Merced published by Alejandro Cirici Pellicer, 1950, under "Documents" (Año II, num. 540, Oct. 5, 1902, p. 1); and a drawing of Sebastian Juñer-Vidal (Año II, num. 551, Oct. 16, 1902, p. 1). In addition to numerous illustrations published in the five issues of *Arte Joven* (1901), his work was accepted by *Joventut, Catalunya Artística, Pèl &*

Ploma in Spain, and *Gil Blas illustré* in Paris
(12e année, no. 30, July 25, 1902, p. 4).

 A complete list of Picasso's illustrations in these
Spanish periodicals (except for *Arte Joven*) follows:
Joventut: Añy I, no. 22, July 12, 1900, p. 345;
no. 27, Aug. 16, 1900, p. 424; Añy V, no. 204,
Jan. 7, 1904, pp. 8 and 13; *Catalunya Artística*:
Añy I, no. 13, Sept. 6, 1900, p. 208; no. 17, Oct. 4,
1900, p. 268; Añy II, no. 38, Feb. 1901, p. 104; *Pèl
& Ploma*: Añy I, no. 65, Dec. 1, 1900, p. 4; Añy III,
no. 77, June 1901, pp. 15–18; no. 80, Sept. 1901,
p. 110, and Añy IV, no. 100, Dec. 1903, p. 368.

Provenance:
J. K. Thannhauser by 1932.[1]

Condition:
Same manufacture of paper and same watermark as
Man with Pack.[2] Likewise, similar horizontal grid
patterns on the reverse of both drawings (May
1973).

Exhibition:
1932. Kunsthaus Zürich. *Picasso*, no. 258 (*Frau mit
Kind nach Carrière*, 1902). Sept. 11–Oct. 30.

References:
Bantens, R. J. *Eugène Carrière—His Work and His
Influence*. Ph.D. dissertation, Pennsylvania State
University, 1975, pp. 260–63 and 745, repr.

Blunt and Pool. 1962, pp. 10, 31, and pl. 93.

Cirici Pellicer. 1946, pl. 143 (*Dos Niños*, 1902).

———. 1950, pl. 136 (*Deux Enfants*, 1902).

Solomon R. Guggenheim Museum. *Masterpieces*.
1972, p. 48, repr. (ca. 1902).

Reff, T. Review of A. Blunt and P. Pool, *Picasso:
The Formative Years*. *The Art Bulletin*, vol. XLVIII,
June 1966, p. 267 (first identifies source).

Zervos. 1932, vol. I, no. 134 and pl. 66 (*Two
Children*, 1902).

Fig. b. Carrière. The Artist with His Wife and
Their Son. *1895–96. 240 x 124.5 cm (94 ¹/₂ x 49
inches). The National Gallery of Canada. Ottawa.*

1. J. K. Thannhauser (notes, Dec. 1972) stated that he
acquired the present drawing, *Au Café*, p. 133, and *Man with
Pack*, formerly in the Justin K. Thannhauser Collection at the
Guggenheim, from Santiago Laporta in Barcelona. No collector
by this name is known.

2. According to Oriol Vals, Conservator of Paper, Museo de Arte
Moderno, Barcelona, paper with the JOSE VILASECA watermark
was manufactured near Barcelona at the beginning of the
twentieth century and still is (conversation, May 1977).

El loco, 1903–04
(Le Fou au chien; Fool with a Dog; Madman with
a Dog)
78.2514 T40

Watercolor on wove paper, 32.6 x 23.2 cm (12 ¹³/₁₆ x
9 ¹/₈ inches)
Inscribed upper right: El loco
Not signed or dated.

Detail. Full image on page 79.

El loco means "the madman" in Spanish. The inscription is in Picasso's handwriting.

Caridad (Z. VI. 438; D-B. d.IX. 22; 26 x 36 cm [10 ¹/₄ x 14 ¹/₄ inches], Collection Marcel Mabille, Brussels) includes the madman with a dog from *El loco*. There, the man sits cross-legged with a hand outstretched to accept the coin offered him while the dog cowers behind him. The dog appears again in two watercolors dated Barcelona 1903–04 (D-B. X. 1 and X. 3). A madman is also depicted in a large watercolor, which is signed and dated 1904 and inscribed to Sebastian Junyent (*Madman*, Z. I. 232; D-B. X. 6; 86 x 36 cm [33 ⁷/₈ x 14 ³/₁₆ inches], Museu Picasso, Barcelona).

Picasso had returned from Paris to Barcelona by mid-January of 1903 and remained there into March 1904. He shared a studio with Angel de Soto at 17, Calle Riera de San Juan until the beginning of 1904. At that time, Picasso rented a studio for himself at 28, Calle del Commercio. Pierre Daix and Georges Boudaille (p. 62) suggest a date at the beginning of 1904 for the present work but indicate that Picasso's "last works from Barcelona in

the first months of 1904 could just as well have been from 1903" (p. 218).

Provenance:
Ricardo Viñes, Paris;[1] A. Bellier, Paris,[2] until 1935; acquired from Bellier by Alex Reid and Lefevre, Ltd., London; purchased from Reid and Lefevre, 1935, by R. J. L. Griffin (correspondence with G. S. Corcoran of Reid and Lefevre, Dec. 1973); Mr. and Mrs. Jonathan Griffin, London, by 1938–42 (correspondence with A. S. Murray, Feb. 1974, and L. Thomas, Nov. 1973); purchased from Griffin by Theodore Schempp, New York, 1942 (correspondence with D. C. Rich, Oct. 1974); acquired from Schempp by J. K. Thannhauser, New York, ca. 1943.

Condition:
Unidentified watermark center right. Small tear lower right. Removed from mount and rehinged by C. Gaehde (June 1973).

Exhibitions:
1939–42. Boston, The Museum of Fine Arts. On loan from Mr. and Mrs. Jonathan Griffin.

1940. Boston, The Museum of Fine Arts. *Drawings and Prints by Picasso.* Apr. 26–June 12 (correspondence with L. Thomas, Museum of Fine Arts, Nov. 1973).

1984–85. Kunstmuseum Bern. *Der Junge Picasso: Frühwerk und Blaue Periode.* Dec. 9, 1984–March 3, 1985. Exh. cat., pp. 306, no. 201, repr., and 326 (*Der Wahnsinnige, mit Hund—«El Loco»*, 1904).

1990. Venice, Palazzo Grassi. Pp. 102–03, no. A24, color repr.

References:
Daix and Boudaille. 1967, no. X. 5, pp. 62, 233, and 235, repr. (*El Loco {Madman with a Dog}*, Barcelona, 1903–04).

Solomon R. Guggenheim Museum. *Masterpieces.* 1972, p. 49, repr. (1903).

Lecaldano, P. *The Complete Paintings of Picasso: Blue and Rose Periods.* New York, 1970, no. 103, pl. xx (*Beggar Man with Dog*).

Zervos. 1932, vol. I, no. 184 and pl. 86 (*Fool with a Dog*, 1903, coll. Viñes, Paris).

1. Viñes (1885–1943) was a Spanish pianist who lived in Paris. As early as 1904 he won a prize there in music (F. Michel et al., *Encyclopédie de la musique*, Paris, 1961, vol. III, p. 861). His association with Picasso is attested to by a photograph of them together with Mme Picasso ("Spectacles espagnols à Paris," *Cahiers d'Art*, 3ᵉ année, no. 3, 1928, p. 142, repr.). Viñes owned another Barcelona 1903 watercolor (Z. I. 186; D-B. d.IX. 20).

2. Probably Alphonse Bellier, who once owned D-B. VI. 16.

Woman Ironing. *1904*
(La Repasseuse; Die Büglerin; Die Plätterin)
78.2514 T41

Oil on canvas. 116.2 x 73 cm (45 ¹/₄ x 28 ³/₄ inches)
Signed lower right: Picasso
Not dated.

Detail. Full image on page 80.

Twice before, Picasso had treated the theme of a woman ironing: *Girl Ironing*, 1901 (not in Z; D-B. VI. 27; 49.5 x 25.7 cm [19 ¹/₂ x 10 ¹/₈ inches], The Metropolitan Museum of Art, New York) and *Woman Ironing*, 1904 (D-B. d.XI. 11; pastel, 38.1 x 53.3 cm [15 x 21 inches], coll. Fuji Television Gallery, Tokyo). The earlier painting and the pastel are predominantly blue with white in the woman's bodice and white highlights on her face. In both the figure is represented virtually full-length and from the side. The shoulder is not raised, although the head leans forward and the outline of the front leg is slightly accentuated. The pastel includes an interior scene with bed, stove, lamp, and two chairs that support the ironing board.

The large painting in the Thannhauser Collection is far removed from these two versions. The figure is seen frontally and half-length. The blue tonality and specific details have disappeared to be replaced by neutral colors and a stark, anonymous figure and space.

The present composition reflects Degas's work, specifically *Les Repasseuses* (*Women Ironing*), 1882 (fig. a; Lemoisne, 1946, vol. II, no. 686), which was in the Durand-Ruel collection in Paris from 1895, and *Women Ironing*, ca. 1884 (76 x 82 cm [30 x 32 ³/₈ inches], Lemoisne, 1946, vol. III, p. 447, repr., no. 785). Because the latter belonged to Count Isaac de Camondo, Paris, from 1893 until 1908 when it went to the Louvre (G. Bazin, *Trésors de l'impressionnisme au Louvre*, Paris, 1958, p. 208), it seems improbable that Picasso saw it. It is possible but unlikely that Picasso saw the former in the Durand-Ruels' apartment in rue de Rome, which was open to the public every Tuesday (correspondence with C. Durand-Ruel, Jan. 1976). Picasso was certainly aware of the firm, which figures in a humorous sketch (R. Penrose, *Portrait of Picasso*, rev. ed., New York, 1971, pl. 54).

In both pictures Degas uses a table with a bowl on it at the front of the composition to cut off the figures. Picasso was inspired by the woman on the right who presses down hard with both arms extended, both hands on the iron, and her head bent forward. Common to all three paintings are the neutral mottled background and the textural quality of the painted surface. However, in Picasso's figure, the head leans far down to the left, accentuated by the raised shoulder.

When the Thannhauser painting was exhibited in Berlin in 1913, a critic in *Der Cicerone* compared the *Woman Ironing* to Degas's painting of the same subject then at Paul Cassirer's. It is not known which version was shown at the Cassirer exhibition, *Degas and Cézanne*, in November 1913, as no. 22, *Die Plätterin* (Gordon 1974, vol. II, p. 753). Degas's versions of the subject include Lemoisne 276, 277, 329, 356, 685–87, 785, and 786. A preparatory drawing for *Woman Ironing* (*Etude pour La Repasseuse* [*Study for Woman Ironing*], 1904, 37.3 x 27 cm [14 ³/₄ x 10 ⁵/₈ inches], Musée Picasso, Paris; Z. XXII. 48) makes explicit the evolution of the woman's pose. The artist changed the position of her head from raised to leaning forward and emphasized the line of her neck and shoulders. The same pose as in the Thannhauser painting appeared earlier in Picasso's *The Blue Room*, 1901 (Z. I. 103; D-B. VI. 15; 51 x 62.5 cm [20 ¹/₈ x 24 ⁵/₈ inches] The Phillips Collection, Washington, D.C.) in the form of a woman bathing (observed by Finkelstein, p. 35).

Picasso's *Old Guitarist* (oil on panel, 122.3 x 82.5 cm [48 ¹/₈ x 32 ¹/₂ inches], The Art Institute of Chicago; Z. I. 202, D-B. IX. 34, p. 63, color repr.), which was painted in Barcelona in 1903, provides deeper insight into the *Woman Ironing*. The left shoulder of each figure is distorted so that it becomes the highest point from which the contour line of the body descends in a smooth movement to the horizontal of the neck and the curve of the lowered head. The facial features are viewed in profile. The woman's eye is not described: instead there is a dark area of shadow which must be interpreted as the equivalent of the old guitarist's sightless eye (see R. W. Johnson, "Picasso's 'Old Guitarist' and the Symbolist Sensibility," *Artforum*, vol. XIII, Dec. 1974, pp. 52–62; D-B., pp. 228–29; Finkelstein, p. 35). When the artist painted *Woman Ironing*, he must have had in mind the figure of the *Old Guitarist*, which he had finished about a year earlier. Like him, the woman ironing becomes an image of suffering and isolation. As Erich Steingräber has suggested (p. 52), it is a secular *imago pietatis*.

Picasso arrived in Paris in April 1904 with Sebastian Juñer. He lived at 13, rue Ravignan (place Emile-Goudeau) in the building that Max Jacob called the "Bateau-Lavoir," in the studio that his friend, Paco Durio (1875–1940), had used from 1901–04.

Pierre Daix and Georges Boudaille (p. 64) identify the sitter as Margot, the daughter of Frédé, who owned the café *Le Lapin Agile* in rue des Saules. She later married the writer Pierre Mac Orlan and lived until 1963. She is also recognizable in *Woman with a Crow* (Z. I. 240; D-B. XI. 10) and *Woman with a Helmet of Hair* (Z. I. 233; D-B. XI. 7), both done in 1904. Daix and Boudaille (p. 65) place *Woman Ironing* slightly later in that year than these pictures because of its lack of color and greater degree of abstraction. However, in the Museum of Modern Art's exhibition of 1980, William Rubin assigns *Woman Ironing* an earlier date, spring 1904, than *Woman with Helmet of Hair*, dated summer 1904.

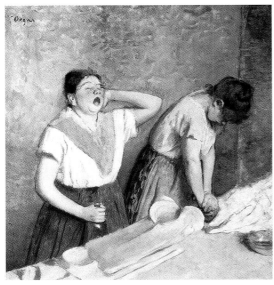

Fig. a. Degas. Les Repasseuses *(Women Ironing),
1882. 81.2 x 75.2 cm (32 x 29 ⁵/₈ inches), Collection
Durand-Ruel, Paris.*

Provenance:
Ambroise Vollard, Paris; Der Neuer Kunstsalon,
Munich (?);[1] Moderne Galerie (Heinrich Thann-
hauser), Munich, ca. 1913 (J. K. Thannhauser
notes, Dec. 1972); Karl Adler, Berlin and
Amsterdam, 1916; purchased from Adler by J. K.
Thannhauser, late 1930s.[2]

Condition:
The painting was glue lined at an unknown date.
The painting was superficially cleaned of grime,
and a glossy varnish removed in 1989. The painting
was examined with an infrared vidicon system in
1989, which revealed a three-quarter-length
portrait of a mustachioed man beneath the image of
the woman visible on the surface (March 1992).

Exhibitions:
1913. Munich, Moderne Galerie (Heinrich
Thannhauser). *Pablo Picasso*. Feb. No. 28 (1906).

1913. Stuttgart, Kgl. Kunstgebäude. *Grosse
Kunstausstellung*. May–Oct. No. 420.

1913. Berlin, Ausstellungshaus am
Kurfürstendamm. *Herbstausstellung*. Autumn.
No. 171.

1927. Hamburg, Kunstverein. *Europäische Kunst der
Gegenwart*.[3]

1939. Amsterdam, Stedelijk Museum. *Parijsche
Schilders*. Feb. 25–April 10. No. 85 (correspondence
with J. M. Joosten, Dec. 1973).

1939–40. New York, The Museum of Modern Art.
Picasso: Forty Years of His Art. Nov. 15, 1939–
Jan. 7, 1940. No. 27, repr. Traveled to the Art
Institute of Chicago, Feb. 1–March 3, and Boston,
Institute of Modern Art, April 27–May 26.

1941. New York, The Museum of Modern Art.
Masterpieces of Picasso. July 15–Sept. 7. No. 27.

1944. New York, The Museum of Modern Art. *Art
in Progress*. May 24–Oct 15. P. 99, repr.

1947. The Minneapolis Institute of Arts. *20th
Century French Painters* (correspondence with S.
L'Heureux, March 1974). May 3–June 1.

1947. New York, M. Knoedler and Co. *Picasso
Before 1907*. Oct. 15–Nov. 8. No. 18.

1949. The Art Gallery of Toronto. *Picasso*. April.
No. 2.

1952. Paris, Musée National d'Art Moderne.
L'Oeuvre du XXᵉ siècle. May–June. No. 85, repr.

1957. New York, The Museum of Modern Art.
Picasso: 75th Anniversary Exhibition. May 22–Sept. 8.
P. 20, repr.

1980. New York, The Museum of Modern Art.
Pablo Picasso: A Retrospective. May 14–Sept. 16. Exh.
cat., p. 60, color repr. (spring 1904).

1990. Venice, Palazzo Grassi. Pp. 104–05, no. A25,
color repr.

1992. The Montreal Museum of Fine Arts.
Pp. 72–73, no. 9, color repr.

References:
Arnason, H. H. *History of Modern Art*. New York,
1968, pp. 95 and 117, pl. 40.

Auckland City Art Gallery. *Pablo Picasso: The Artist
Before Nature*. Exh. cat., Auckland, 1989, p. 42.

Barr, A. H., Jr. *Picasso: Fifty Years of His Art*. New
York, 1946, p. 32, repr.

Blunt and Pool. 1962, p. 21.

Boeck, W., and J. Sabartés. *Picasso*. New York,
1955, pp. 38–39, 123.

Broude, N. F. "Picasso's Drawing, *Woman with a
Fan*: The Role of Degas in Picasso's Transition to
his 'First Classical Period.'" *Oberlin College Bulletin*,
vol. 29, winter 1972, pp. 83 and 85, repr.

Cahiers d'Art, 2ᵉ année, no. 6, 1927, supp. p. 7,
repr. (installation view, Hamburg exhibition).

Cassou, J. *Picasso*. Paris, 1940, p. 49, repr.

Cirici Pellicer. 1946, pp. 175 and 179, pl. 188
(1904).

———. 1950, pp. 179 and 183, pl. 180.

Cirlot. 1972, p. 157 (1905).

Crespelle, J-P. *Picasso and His Women*. New York,
1969, p. 49.

Daix. 1969, pp. 39, repr., 40–41, and 262.

Daix and Boudaille. 1967, no. XI. 6, pp. 56,
64–65, and 240, repr.

Daulte, F. 'Une Donation sans précédent: la
collection Thannhauser." *Connaissance des Arts*,
no. 171, May 1966, pp. 66, repr., and 67.

de Champris, P. *Picasso: Ombre et soleil*. Paris, 1960,
pp. 17 and 287, pl. 7.

1. According to *Die Kunst für Alle*, Jg. 28, May 1913,
p. 383, Der Neuer Kunstsalon owned the present picture as well
as Z. I. 79, 167, 302. J. K. Thannhauser told D. C. Rich that the
picture did not belong to the Moderne Galerie at the time of the
Feb. 1913 exhibition (conversation, March 1975).

2. Correspondence with E. Adler, Oct. 1974, who gave 1939
as the date J. K. Thannhauser bought the painting, whereas
Thannhauser mentioned 1937 (notes, Dec. 1972).

3. Known only from installation photographs in *Cahiers
d'Art*, 2ᵉ année, no. 6, 1927, supp. p. 7. The Kunstverein has no
records or catalogue of this exhibition (correspondence with C.
Zinn, April 1974).

Einstein, C. *Die Kunst des 20. Jahrhunderts*. Berlin, 1926, vol. I, pl. vii (1903).

Elgar, F. *Picasso*. New York, 1956, p. 22 and n.p., repr.

Elgar, F., and R. Maillard. *Picasso*. Rev. ed. New York, 1972, p. 186, repr.
Fermigier, A., ed. *Picasso*. Paris, 1967, p. 179, repr.

Finkelstein, S. *Der junge Picasso*. Dresden, 1970, pp. 35, 161, and pl. 25.

Friedeberger, H. "Die Berliner Herbstausstellung." *Der Cicerone*, Jg. V, Nov. 1913, p. 800.

Gaya Nuño, J. A. *Picasso*. Barcelona, 1950, pl. 13.

Solomon R. Guggenheim Museum. *Masterpieces*. 1972, p. 52, repr.

Hildebrandt, H. "Die Frühbilder Picassos." *Kunst und Künstler*, Jg. 11, April 1913, p. 378, repr.

Hochschule Bremen. *Was glauben Sie denn ist Picasso?* Fischerhude, Germany, 1985, p. 165.

Jaffé, H. L. C. *Pablo Picasso*. Garden City, 1980, pp. 70–71, repr.

———. *Picasso*. New York, 1964, pp. 19 and 70–71, repr.

Lecaldano, P. *The Complete Paintings of Picasso: Blue and Rose*. New York, 1970, p. 96, no. 125, and pl. xxiii.

Level, A. *Picasso*. Paris, 1928, p. 55 and pl. 9.

Lieberman, W. S. *Pablo Picasso: Blue and Rose Periods*. New York, 1954, pl. 20.

Lindahl, G. "Konstnären och Samhället." *Paletten*, vol. 12, no. 4, 1951, p. 98, repr.

Merli, J. *Picasso, el artista y la obra de nuestro tiempo*. Rev. ed. Buenos Aires, 1948, pl. 106.

O'Brian, J. *Degas to Matisse: The Maurice Wertheim Collection*. New York and Cambridge, Mass., 1988, p. 112, fig. 1, repr.

Penrose. 1958, p. 106.

Richardson, J., with M. McCully. *A Life of Picasso: Volume I: 1881–1906*. New York, 1991, pp. 222, 303, repr., and 304.

Richet, M. *The Picasso Museum, Paris: Drawings, Watercolors, Gouaches, and Pastels*. Trans. A. Audubert. New York, 1989, p. 18. French edition, Paris, 1985.

Rohe, M. K. "Pablo Picasso." *Die Kunst für Alle*, Jg. 28, May 15, 1913, p. 383, repr. (1906, lent by Neuer Kunstsalon, Munich).
Schiff, G. *Picasso At Work At Home: Selections from the Marina Picasso Collection*. Exh. cat., Center for the Fine Arts, Miami, 1985, p. 25.

Steingräber, E. "La Repasseuse: zur frühesten Version des Themas von Edgar Degas." *Pantheon*, vol. XXXII, Jan.–Feb.–March 1974, pp. 52–53, repr.

Vallentin, A. *Pablo Picasso*. Paris, 1957, p. 90.

Wertenbaker, L. *The World of Picasso*. New York, 1967, pp. 44–45, repr.

Zervos, 1932, vol. I, no. 247, pl. 111 (1904, ex. coll. A. Vollard).

Young Acrobat and Child. March 26, 1905
(*Jeune acrobate et enfant; Two Harlequins;*
Saltimbanques et enfants; Harlequin and Boy; Two
Boys)
78.2514 T42

Ink and gouache on gray cardboard, 31.3 x 25.1 cm
(*12 ⁵/₁₆ x 9 ⁷/₈ inches*)
Signed and dated lower right: Picasso / Paris 26 Mars
05: *inscribed above signature:* A Mlle / A. Nachmann

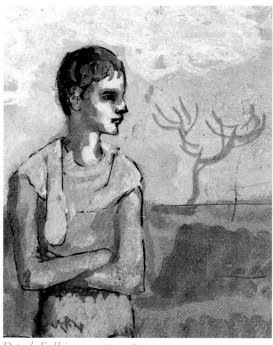

Detail. Full image on page 81.

The present picture has previously been called *Two
Harlequins* although it does not represent them
(Daix and Boudaille). The young acrobat at the
right is portrayed in similar attire in a drypoint
dated March 1905 (B. Geiser, *Picasso: Peintre-
Graveur*, Bern, 1933, vol. I, no. 6, repr. [*Les Deux
Saltimbanques*]).

A considerably larger gouache (*Two Acrobats
with a Dog*, gouache on cardboard, 105.4 x 74.9 cm
[41 ¹/₂ x 29 ¹/₂ inches], Collection Mr. and Mrs.
William A. M. Burden, New York; Z. I. 300; D-B.
XII. 17; Rubin, p. 32, color repr.) shares with the
Thannhauser version the same house and landscape
as well as the two boys, although they appear
somewhat younger in the present picture. The
Burden gouache must have been completed by mid-
April since it was published in the May 15 issue of
La Plume. It seems to combine motifs from *Boy with
a Dog* (Z. I. 306; D-B. XII. 16) and the present
picture (Rubin).

Theodore Reff points out that at the end of
1904 Picasso again began to paint the harlequins
and saltimbanques that had occupied him in 1901.

He connects these harlequins and jesters with
Picasso's idiots and madmen of 1902–04. Like
them, clowns and acrobats were seen as symbols of
human suffering ("Themes of Love and Death in
Picasso's Early Work," in *Picasso in Retrospect*, New
York, 1973, p. 29).

The warm brown and pink hues place the
Thannhauser work, like others from 1905, within
the Rose Period. Significantly, it is painted on gray
board and includes various blues and grays as well
as white.

During the Rose Period, Picasso's studio was
near the Médrano circus. He later recalled: "I was
really under the spell of the circus! Sometimes I
came three or four nights in one week" (quoted in
Brassaï, *Picasso and Company*, trans. F. Price, New
York, 1966, p. 20, and confirmed by F. Olivier,
Picasso and His Friends, trans. J. Miller, New York,
1965, pp. 51, 125–28). The rose tone that
permeates Picasso's work of this time was the actual
color of the interior of the Cirque Médrano (T.
Reff, "Harlequins, Saltimbanques, Clowns, and
Fools," *Artforum*, vol. X, Oct. 1971, p. 35).

The identity of the Mlle Nachmann referred to
in the inscription remains unknown.

Provenance:
Acquired through an unknown source from
A. Nachmann, Cannes, by J. K. Thannhauser, Aug.
1939 (conversation with D. C. Rich, March 1975).

Condition:
White pigment at bottom has oxidized (May
1973).

Exhibitions:
1980–81. Washington, D.C., National Gallery of
Art. *Picasso: The Saltimbanques*. Dec. 14, 1980–
March 15, 1981. Exh. cat., pp. 36, fig. 33, repr.,
and 87, no. 35.

1990. Venice, Palazzo Grassi. Pp. 106–07, no. A26,
color repr.

References:
Arnason, H. H. *History of Modern Art*. New York,
1968, p. 119.

Cirlot. 1972, p. 157.

Daix and Boudaille. 1967, no. XII. 15, repr. (*Young
Acrobat and Child*).

Solomon R. Guggenheim Museum. *Masterpieces*.
1972, p. 53, repr. (*Two Harlequins*).

Kay, H. *Picasso's World of Children*. Garden City,
1965, p. 64, repr.

Lecaldano, P. *The Complete Paintings of Picasso: Blue
and Rose Periods*. New York, 1970, p. 99, no. 158,
and color pl. xxx.

Palau i Fabre, J. *Picasso: The Early Years:
1881–1907*. Trans. K. Lyons. New York, 1981,
pp. 403, no. 1046, repr., and 545. Catalan edition:
*Picasso Vivent 1881–1907. Infantesa i primera joventut
d'un demiürg*, 1980.

Picasso: Fifteen Drawings. New York, 1946, pl. 3.

Rubin, W. *Picasso in the Collection of The Museum of
Modern Art*. New York, 1972, pp. 33 and 191
(*Young Acrobat and Child*).

Zervos, C. "Oeuvres et images inédites de la
jeunesse de Picasso." *Cahiers d'Art*, 25ᵉ année, no. 2,
1950, p. 328, repr.

Zervos. 1954, vol. VI, no. 718, pl. 87.

Vase of Flowers. *1905–06*
(*Vase de fleurs: Bouquet de fleurs*)
78.2514 T43

India ink on wove paper, 26.7 x 19.7 cm (10 ¹/₂ x
7 ³/₄ inches)
Signed upper left: Picasso
Not dated.

Detail. Full image on page 85.

Provenance:
J. K. Thannhauser before 1940.

Condition:
Support somewhat discolored. Deacidified,
flattened, and rehinged by C. Gaehde (June 1973).

Exhibition:
1990. Venice, Palazzo Grassi. Pp. 108–09, no. A27,
color repr.

References:
Cassou, J. *Picasso*. Paris, 1940, p. 149, repr.
(*Bouquet de fleurs*, coll. Thannhauser).

Daix and Boudaille. 1967, no. d.XV. 41, repr.
(*Vase of Flowers*, summer 1906).

de Champris, P. *Picasso: Ombre et soleil*. Paris, 1960,
pp. 211, 293, and pl. 251.

Solomon R. Guggenheim Museum. *Masterpieces*.
1972, p. 54, repr. (ca. 1905).

Zervos. 1970, vol. XXII, no. 339 and pl. 122 (*Vase
de fleurs*, 1906).

Pierre Daix (p. 245) places all still lifes of flowers
in 1906, when Picasso went to Gosol in Spain (see
p. 144 of this book). However, this ink drawing
resembles van Gogh's paintings of sunflowers so
closely as to suggest van Gogh rather than Gosol as
the point of departure. The van Gogh retrospective
at the Salon des Artistes Indépendants in Paris from
March 24 to April 30, 1905, included a painting of
Sunflowers as no. 8 (de la Faille 455; 92 x 72.4 cm
[36 ¹/₄ x 28 ¹/₂ inches], Jan. 1889, Philadelphia
Museum of Art). Picasso was in Paris at the time;
reproductions would have been accessible if he did
not see the exhibition.

Pierre de Champris (p. 211) points out the
similarity between Picasso's drawing and another
van Gogh, *Still Life: Fritillaries in a Copper Vase* (de
la Faille 213; 73.6 x 60.3 cm [29 x 23 ³/₄ inches],
summer 1887, Musée du Louvre, Galerie du Jeu de
Paume, Paris), which has a spotted pattern in the
background.

The signature is considerably later in date but
had been added before 1940, when the work was
published by Jean Cassou.

Still Life: Flowers in a Vase, *1906*
(Nature morte: fleurs dans un vase)
78.2514 T44

Gouache on cardboard, 72.1 x 55.9 cm (28 ⅛ x 22 inches)
Signed lower left: <u>Picasso</u>
Not dated.

Detail. Full image on page 84.

References:

Daix and Boudaille. 1967, no. XV. 16, repr. (Gosol, summer 1906).

Solomon R. Guggenheim Museum. *Masterpieces.* 1972, p. 56, repr. (1905–06).

Lecaldano, P. *The Complete Paintings of Picasso: Blue and Rose Periods.* New York, 1970, pp. 111, repr., and 112, no. 285 (*Pottery and Vase with Flowers,* 1906).

Zervos, C. "Oeuvres et images inédites de la jeunesse de Picasso." *Cahiers d'Art,* 25ᵉ année, no. II, 1950, p. 324, repr. (*Fleurs,* 1905).

Zervos. 1954, vol. VI, no. 889 and pl. 107 (1905).

Still Life: Flowers in a Vase dates from the summer of 1906 when Picasso, accompanied by Fernande Olivier, went to Gosol in Spain. The chocolate pot is included in *Still Life with a Portrait* (Z. I. 342; D-B. XV. 14; 82 x 100.3 cm [32 ¼ x 39 ½ inches], The Phillips Collection, Washington, D.C.), which also depicts a Spanish wine vessel. Pierre Daix points out that Picasso did not paint still lifes of flowers in 1905 (p. 245), and that the earthenware he painted at Gosol drew him back to still life, a genre in which he had worked in 1901 in Paris (pp. 99 and 168–70; D-B. 292).

The roses and the blue flowers are reminiscent of the background flowers in *Boy with a Pipe* from the preceding year (Z. I. 274; D-B. XIII. 13; 100 x 81.3 cm [39 ⅜ x 32 inches], Collection Mr. and Mrs. John Hay Whitney, New York; W. Lieberman, *Pablo Picasso: Blue and Rose Periods*, New York, 1959, color pl. 31).

According to Christian Zervos, the painting was scratched with a penknife (*canif*) by the artist at the time it was painted (*Cahiers d'Art*, p. 324). When exhibited in 1932, the work was unsigned. J. K.

Thannhauser remembered that Picasso signed it at the Thannhausers' home in Paris (notes, Dec. 1972).

Provenance:
Acquired from the artist by J. K. Thannhauser, Paris, 1937–39.

Condition:
The work was scratched by the artist with a sharp, pointed instrument and with a blunt one. Small nail punctures from the reverse at upper corners and near the two pieces of pottery (May 1975).

Exhibitions:
1932. Paris, Galeries Georges Petit. *Picasso.* June 16–July 30. No. 29 (*Nature morte au vase de fleurs,* 1905, 71 x 54 cm).

1990. Venice, Palazzo Grassi. Pp. 108 and 110–11, no. A28, color repr.

Woman with Open Fan. *1906*
(Femme à l'éventail: Portrait of a Lady)
78.2514 T45

Ink on wove paper. 17.1 x 11 cm (6 ³/₄ x 4 ³/₁₆ inches)
No watermark.
Not signed or dated.

The woman's identity is not known. However, the line of her nose, the distinctive curls at the nape and forehead, and the pin at the neckline identify her as the model (shown half-length and without fan) in three other very similar drawings (Z. XXII. 451; Z. XXII. 452, D-B. d.XV. 37; and Z. XXII. 448, D-B. d.XV. 38). Less closely related but representing the same model are Z. VI. 762–64, 781, and 782.

An ink drawing, *Peasant Women of Andorra* (Z. VI. 780; 55.9 x 35 cm [22 x 13 ³/₄ inches], The Art Institute of Chicago), depicts two full-length female figures. Their features are similar to those of the sitter in the present work, and the woman at the left holds a fan. Pierre Daix assigns the Chicago drawing to the summer of 1906 at Gosol (p. 292),

and Maurice Jardot states that it was drawn "from a photograph Picasso had found" (*Pablo Picasso Drawings*, New York, 1959, p. 153, no. 15). Both figures in the Chicago drawing are shown nude in Z. VI. 875, and the figure at the left holding a fan is portrayed with a man in D-B. d.XV. 28.

All the drawings referred to above were executed during Picasso's trip to Gosol in the summer of 1906. The model in the Thannhauser drawing is not represented in the *Carnet catalan*, Picasso's sketchbook of that summer. The year before, in Paris, Picasso had painted a large picture, *Woman with a Fan* (Z. I. 308; D-B. XIII. 14; National Gallery of Art, Washington, D.C., Gift of W. Averell Harriman), but the model and composition bear little resemblance to those of the present drawing.

Provenance:
Probably acquired from the artist by Arthur B. Davies, Nov. 1912;¹ purchased from Davies collection (New York, American Art Association, *The Arthur B. Davies Art Collection*, April 16–17, 1929, no. 15, repr. [*Portrait of a Lady*]) by J. B. Neumann, New York; purchased from Neumann by Mr. and Mrs. Charles J. Liebman, New York, 1929;² purchased from Liebman collection (New York, Parke Bernet, *The Liebman Collection of Valuable Modern Paintings. Drawings and Sculptures*, Dec. 7, 1955, no. 27 [*Portrait of a Lady*]) by J. K. Thannhauser, New York.

Condition:
Horizontal tears repaired and loss at lower right replaced in 1971 by C. Gaehde (May 1973).

Exhibition:
1990. Venice, Palazzo Grassi. Pp. 112–13, no. A29, color repr.

References:
Daix and Boudaille. 1967, no. d.XV. 38 (mentioned as related version).

Solomon R. Guggenheim Museum. *Masterpieces.* 1972, p. 57, repr.

Tinterow, G. *Master Drawings by Picasso*. Exh. cat., Fogg Art Museum. Cambridge, Mass., 1981, p. 70.

Zervos. 1954, vol. VI, no. 786, pl. 95 (*Dessin à la plume*, 1906, incorrect dimensions listed, coll. Mrs. Charles J. Liebman, New York).

1. Ronnie Owen, the daughter of Davies, remembers that her father bought directly from Picasso. She thinks the drawing was most likely acquired in Nov. 1912, when her father was assembling works for the Armory Show and first met Picasso. Davies was also in Paris in 1924 and 1925. Since Miss Owen does not remember seeing the drawing brought home, the earlier date of 1912 is more likely. (I am indebted to Miss Owen for the above information from conversation, May 1975.) In addition, the fact that the drawing is not signed points to the earlier date. A pencil drawing of *Two Nudes* by Picasso (D-B. XVI. 18; Paris, autumn, 1906, The Art Institute of Chicago) also belonged to Davies. The Davies papers at the Archives of American Art, New York, do not mention the drawing.

2. Correspondence with C. J. Liebman, the collector's son, May 1977.

Pablo Picasso

Woman and Devil, 1906
(Femme et diable; Courtship)
78.2514 T46

India ink on laid paper, 30.8 x 23.2 cm (12 ⅛ x
9 ⅛ inches)
Not signed or dated.

Provenance:
Curt Valentin,[1] New York, by 1940; acquired from
Valentin by J. K. Thannhauser.

Condition:
Removed from cardboard mount, cleaned, deacid-
ified, and mat burn minimized by C. Gaehde (May
1973).

Exhibitions:
1940. New York, Buchholz Gallery (Curt
Valentin). Pablo Picasso: Drawings and Watercolors.
March 5–30. No. 9 (Woman and Devil, 1906).

1941. New York, Buchholz Gallery. Beaudin,
Braque, Gris . . . and Picasso, no. 39 (Woman and
Devil, 1906). April 7–26.

1990. Venice, Palazzo Grassi. Pp. 112 and 114–15,
no. A30, color repr.

References:
Solomon R. Guggenheim Museum. Masterpieces.
1972, p. 55, repr. (Courtship, 1905–06).

Curt Valentin Gallery, New York. Picasso. N.d.,
vol. II of unpublished "Black Albums" of
photographs on deposit at the Museum of Modern
Art, New York [pp. 29–30], repr. (Woman and
Devil).

Zervos. 1954, vol. VI, no. 804 and pl. 97 (1905 or
1906).

The drawing is related to The Flower Girl (Z. XXII.
346; D-B. XV. 58; pen and ink, 63.2 x 48.3 cm
[24 ⅞ x 19 inches], 1906, The Museum of Modern
Art, New York; confirmed by P. Daix in
correspondence, June 1975). Both figures have in
common the same facial features and the ropelike
curly hair that encloses the body. However, the girl
in the Museum of Modern Art drawing is clothed,
holds a bouquet of flowers, and is dispropor-
tionately slim through the waist and hips. This
drawing was probably done in Gosol during the
summer of 1906 and is a study for the painting The
Peasants (Z. I. 384; D-B. XV. 62; 218.5 x 129.5 cm
[85 ⅝ x 51 inches], Paris, Aug. 1906, The Barnes
Foundation, Merion, Pa.).

Christian Zervos places the Thannhauser
drawing with one of a nude girl with a cupid on the
right and a devil on the left (VI. 805) and another
where a devil is on either side of the girl (803).
These drawings lack the sexual overtones of the
present work.

1. Curt Valentin's records and correspondence do not
indicate where he acquired the drawing. It did not come from
Kahnweiler (correspondence with Galerie Louise Leiris, Paris,
June 1975).

Glass, Pipe, and Packet of Tobacco. *1914*
(*Verre, pipe et paquet de tabac; Composition: Nature morte au paquet de tabac*)
78.2514 T47

Gouache with pencil on wove paper. 19.8 x 29.7 cm
(*7 ¹¹/₁₆ x 11 ¹¹/₁₆ inches*)
Signed on reverse: Picasso
Not dated.

Detail. Full image on page 12.

References:
Daix, P., and J. Rosselet. *Picasso—The Cubist Years 1907–1916. A Catalogue Raisonné of the Paintings and Related Works.* Boston, 1979, p. 328, no. 733, repr. (*Wineglass, Pipe and Packet of Tobacco*, Paris or Avignon, 1914.).

Solomon R. Guggenheim Museum. *Masterpieces.* 1972, p. 58, repr. (*Composition*, 1914–15).

Zervos. 1975, vol. XXIX, no. 69 and pl. 28 (*Nature morte au paquet de tabac*, spring 1914).

Pierre Daix tentatively places the work with those executed in 1914 at Avignon (correspondence with J. Rosselet, April 1977). The signature on the reverse is appropriate for the period. Both Picasso and Braque reintroduced strong and varied colors in their work during 1913–14. They employed the dotting technique of pointillism to animate the surface, suggest a play of light, and create a decorative effect.

Evolving from the *papiers collés*, the colorful but not scientific technique of stippling appears in Picasso's paintings, watercolors, and gouaches. The confettilike dots decorate the contemporary sculpture, *Glass of Absinth*, in which each of the five bronze casts is painted differently (Z. II. pt. 2, 581–84; see W. Rubin, *Picasso in the Collection of The Museum of Modern Art*, New York, 1972, p. 95, color repr.).

The same glass and background area but without the stippled effect are found in a 1914 painting (Z. XXIX. 38; 16 x 13 cm [6 ⁵/₁₆ x 5 ¹/₈ inches]; Duncan, 1961, p. 207, repr.). The pipe and glass also appear in another painting of 1914 (Z.

XXIX. 33; 12.5 x 18 cm [4 ⁷/₈ x 7 ¹/₁₆ inches]; Duncan, p. 207, repr.).

Provenance:
Acquired from M. Perel, Paris, by Galerie Jeanne Bucher, Paris, 1947; purchased from Bucher by Paul Martin a few years later (correspondence with Galerie Jeanne Bucher, Sept. 1975); Robert Lebel, New York and Paris, until ca. 1950;¹ purchased from Lebel by J. K. Thannhauser, New York.

Condition:
Removed from cardboard mount and rehinged by C. Gaehde (June 1973).

1. Although Jeanne Bucher's records indicate otherwise, Lebel remembers purchasing the work before World War II and selling it to Thannhauser around 1950 (correspondence, March 1974).

2. Picasso rarely signed his paintings on the obverse between 1907–14 (see Brassaï, *Picasso and Company*, trans. F. Price, Garden City, 1966, p. 68, and Paris, Musée des Art Décoratifs, *Picasso*, exh. cat., 1955, definitive ed., p. 46).

Three Bathers. *August 1920*
(*Trois baigneuses: Women by the Sea*)
78.2514 T49

*Pastel with oil and pencil on laid paper. 47.8 x
61.4 cm (18 ¹³/₁₆ x 24 ³/₁₆ inches)*
Watermark: CANSON & MONTGOLFIER FRANCE
Signed lower right: Picasso; *dated upper right:* 19.8.20

Detail. Full image on page 92.

A pastel (Z. VI. 1404) identical in size and very close in composition to the *Three Bathers* (differing only in the lack of lateral rocks and background mountains) probably precedes it as may a pencil drawing of *Six Bathers* (Z. IV. 166; 20 x 21 cm [7 ⁷/₈ x 8 ¹/₄ inches]), which includes the same three figures.

Individual figures in the Thannhauser pastel appear in other works from the summer of 1920, which was the first Picasso spent at Juan-les-Pins. The reclining woman with a book is repeated in Z. IV. 163, 166, VI. 1387 and 1403. In Z. IV. 161, 166, and VI. 1387, a similar seated figure is placed at the right. The swimmer is identical to those in Z. IV. 166, VI. 1365 and 1387. She faces the opposite direction in a pastel (not in Z.; 52.1 x 66 cm [20 ¹/₂ x 26 inches], Collection Mr. and Mrs. Joseph H. Hazen, New York; *Picasso, An American Tribute: The Classic Phase*, exh. cat., 1962, no. 9, repr.) and rises further out of the water in another pastel (Z. IV. 173; 49.5 x 63.5 cm [19 ¹/₂ x 25 inches], Winterthur, Kunstmuseum, *Picasso: 90 Drawings and Works in Color*, exh. cat., 1971, no.

16, color repr.). In fact, the swimmer's arms and shoulders (all that is visible here) resemble the woman running in *By the Sea* (Z. IV. 169; oil on wood panel, 80 x 99 cm [31 ¹/₂ x 39 inches], erroneously dated 1923; New York, Sotheby Parke Bernet, *The Collection of . . . the Late G. David Thompson*, March 24, 1966, no. 31, color repr.).

The enlargement of hands and feet seen in the present picture occurs as early as 1919 in *Sleeping Peasants* (Z. III. 371; tempera, 31.1 x 48.9 cm [12 ¹/₄ x 19 ¹/₄ inches], The Museum of Modern Art, New York). Interpretations of their distorted size are proposed by Roland Penrose (1958, p. 220) and Françoise Gilot (*Life with Picasso*, New York, 1964, p. 119).

The signature belongs to the period. Picasso first began the precise dating of his works in January 1920 (Z. IV. 15) and continued this practice frequently during that summer.

Provenance:
Acquired from the artist by Galerie Simon (D.-H. Kahnweiler), Paris; purchased from Galerie Simon by G. F. Reber, Lugano,[1] June 1924 (correspondence with Galerie Louise Leiris, Paris, June 1975); probably purchased from Valentine Gallery, New York,[2] by Lee Ault soon after World War II (correspondence with Ault, Feb. 1974); acquired from Ault shortly thereafter by J. K. Thannhauser.

Condition:
Removed from cardboard mount, deacidified, and rehinged by C. Gaehde (Dec. 1976).

Exhibitions:
1953. Santa Barbara Museum of Art. *Fiesta Exhibition 1953: Picasso, Gris, Miró, and Dali.* Aug. 4–30. No. 15 (*Bathers*, 1920, incorrect dimensions listed).

1962. New York, Duveen Brothers, Inc. *Picasso, An American Tribute: The Classic Phase.* April 25–May 12. No. 12, repr. (*Three Bathers*).

References:
Boeck, W., and J. Sabartés. *Picasso*. New York, 1955, p. 467, no. 101, repr.

Daix, 1965, pp. 120, repr., and 265 (*Women by the Sea*, pastel, 64 x 49 cm, coll. Reber, Lausanne).

Solomon R. Guggenheim Museum. *Masterpieces.* 1972, p. 60, repr.

Vallentin, A. *Pablo Picasso*. Paris, 1957, n.p., repr. under "Catalogue des oeuvres."

Zervos. 1951, vol. IV, no. 165 and pl. 52 (*Trois baigneuses*, pastel, 49 x 64 cm).

1. D. Cooper (correspondence with A. Rudenstine, Nov. 1975) remembers seeing the present picture at Reber's house but doubts that it was acquired directly from Reber by the Valentine Gallery. Reber died in 1959.

2. The catalogue of the April 12–May 1, 1937, exhibition at the Valentine Gallery, New York, *Drawings, Gouaches and Pastels by Picasso*, lists five bathers (nos. 43–46 and 48). It is not possible to prove that the present picture was included although it seems likely. Nor has it been possible to determine when and from whom the Valentine Gallery might have acquired the work.

Pablo Picasso

Dinard, *Summer 1922*
(*Saint-Servan; Saint Servan, near Dinard*)
78.2514 T50

Pencil on wove paper, 42.2 x 29.4 cm (16⅝ x
11⁹⁄₁₆ inches)
Signed lower left: Picasso
Not dated.

Detail. Full image on page 20.

The drawing was done in Dinard and depicts Pointe Bric-à-Brac. Dinard, the fashionable seaside resort in Brittany, is on the left bank of the Rance River, near its mouth. At the time, villas and hotels were located at Pointe Bric-à-Brac near the Grand-Rue (now avenue George V).

The precise view that Picasso drew is found in a photograph of Dinard in which even such details as the dock and boat ramp in the foreground and the tree and archway at the lower left are shown from the same viewpoint (*Normandy and Brittany: Guide to the Seaside Resorts and Places of Interest*, London, 1930, p. 184, fig. 3). An earlier photograph is taken from the same angle but at a slightly greater distance so that it shows the vantage point from which the artist must have drawn it (N. H. Thomson, ed., *The Emerald Coast and Brittany: An English Guide to Brittany*, Dinard, 1913, p. 30, repr.).

The drawing must be dated 1922 since during that summer Picasso first went to Dinard, where he rented a villa for his wife and their young son (Penrose, 1958, p. 224).

The Thannhauser drawing is closely related to Z. XXX. 340, which represents the same view, and XXX. 327–30 as well as to Z. IV. 372–74 and 376. The present work is signed in a manner prevalent in the mid-1920s (see W. Boeck and J. Sabartés, *Picasso*, Paris, 1955, p. 485, for a typical signature of 1923).

Provenance:
Acquired from the artist by Paul Rosenberg, Paris, in 1926 (correspondence with A. Rosenberg, Dec. 1974); purchased from Rosenberg by J. K. Thannhauser by 1932.

Condition:
Left edge of paper is serrated. Removed from mount, flattened, and deacidified by C. Gaehde (June 1973).

Exhibitions:
1927. Paris, Paul Rosenberg. *Exposition de cent dessins par Picasso*. June–July. Probably no. 73 (*Vue de Saint-Servan*, 1921).

1932. Kunsthaus Zürich. *Picasso*. Sept. 11–Oct. 30. No. 319 (*Blick auf Saint-Servan*, ca. 1921).

1934. Buenos Aires, Galería Müller. *Picasso*. Oct. No. 43.[1] (label on reverse reads: *Vista de Servan*, 1921).

1957. New York, The Museum of Modern Art. *Picasso: 75th Anniversary Exhibition*. May 22–Sept. 8. P. 54, repr. (*St. Servan, near Dinard*, 1922). Traveled to the Art Institute of Chicago, Oct. 29–Dec. 8.

1958. Philadelphia Museum of Art. *Picasso*. Jan. 8–Feb. 23. No. 105, repr. (*St. Servan, near Dinard*, 1922).

References:
Cassou, J. *Picasso*. New York, 1940, p. 28, repr. (*View of St. Servan*).

Solomon R. Guggenheim Museum. *Masterpieces*. 1972, p. 61, repr. (*Saint-Servan, near Dinard*).

Solmi, S. *Disegni di Picasso*. Milan, 1945, pl. xxii (*Veduta di St. Servan*).

Zervos. 1951, vol. IV, no. 375, pl. 153 (*Vue de Dinard*, 1922, incorrect medium listed).

1. J. K. Thannhauser arranged for the exhibition and lent many of the works (conversation with D. C. Rich, March 1975). No catalogue has been located although the bibliography in J. Merli, *Picasso, el artista y la obra de nuestro tiempo*, Buenos Aires, 1942, p. 305, states that the preface was written by Frederico C. Müller. The exhibition numbers are derived from a printed label on the reverse of each work.

Table Before the Window. *1922*
(*Table devant la fenêtre*)
78.2514 T51

Watercolor and pencil on laid paper. 14.1 x 11 cm
(*5 9/16 x 4 5/16 inches*)
Signed and dated upper right: Picasso / 22

Detail. Full image on page 86.

References:
Cassou, J. *Picasso*. New York, 1940, pp. 116, repr., and 166.

Solomon R. Guggenheim Museum. *Masterpieces*. 1972, p. 63, repr.

Picasso: Fifteen Drawings. New York, 1946, pl. 11.

Zervos. 1951. Vol. IV, no. 432 and pl. 179 (*Table devant la fenêtre*, incorrect medium listed).

Picasso frequently treated the theme of a still life on a table in front of a window between 1919 and 1925. This watercolor sketch has the same composition as other small works on paper (see Z. IV. 403, 405, and 406). The shape of the wine bottle first appears in 1922. The motif of fish on newspaper is found in Z. XXX. 395, Z. IV. 397, 404, 409–11, and 448. In discussing the latter work, *Still Life with Fish* (130 x 97 cm [51 3/16 x 38 3/16 inches], dated 1922–23, Collection Mrs. Albert D. Lasker, New York), Maurice Jardot indicates that such still lifes were done both at Dinard and later in Paris (Paris, Musée des Arts Décoratifs, *Picasso*, exh. cat., 1955, definitive ed., no. 58).

Provenance:
Purchased from the Galerie Simon (D.-H. Kahnweiler), Paris, by J. K. Thannhauser, June 1929 (correspondence with Galerie Louise Leiris, Paris, June 1975).

Condition:
Top edge of paper is serrated. Removed from mount, flattened, deacidified, and rehinged by C. Gaehde (June 1973).

Exhibitions:
1932. Kunsthaus Zürich. *Picasso*. Sept. 11–Oct. 30. No. 323.

1934. Buenos Aires, Galería Müller. *Picasso*. Oct. No. 25. (J. K. Thannhauser notes, Dec. 1972).

1939. Adelaide, The National Art Gallery. *Exhibition of French and British Contemporary Art*. Opened Aug. 21. No. 90. Traveled to Melbourne, Town Hall, opened Oct. 16, and Sydney, David Jones, opened Nov. 20.

The Table. *December 24, 1922*
(Le Guéridon: Nature morte sur une table ronde)
78.2514 T52

Watercolor and gouache on laid paper, 16.3 x 10.3 cm
(6 ⁷/₁₆ x 4 ¹/₁₆ inches)
Signed lower right: Picasso; *dated on reverse:*
24 Decembre/1922

References:
Solomon R. Guggenheim Museum. *Masterpieces.*
1972, p. 62, repr.

Zervos. 1975, vol. XXX, no. 425, pl. 135 (*Nature morte sur une table ronde*).

Detail. Full image on page 87.

A *guéridon* is a round table with a pedestal leg. The theme is virtually the same as in *Table Before the Window*, p. 150. Stylistically close to Z. IV. 433 and Z. XXX. 420, 421, and 428 from the same day and Z. IV. 431 of the following day, it remains remarkably similar to a small gouache done three years earlier (Z. III. 422; *Nature morte devant une fenêtre*, 20 x 13.2 cm [7 ⁷/₈ x 5 ¹/₄ inches], dated 24 Decembre 1919).

The Table is executed in watercolor and gouache, a technique Picasso favored from 1915 to 1922 more than at any other time. The manner of representing objects is essentially that of Synthetic Cubism. Contrasting with the green tablecloth, the blue provides open space and air around the table and window.

The work was signed when purchased from the artist in 1952 (correspondence with Galerie Leiris, June 1975); the style of the signature does indeed appear to date from that time.

Provenance:
Purchased from the artist by Galerie Louise Leiris, Paris, 1952; purchased from Galerie Leiris by Mrs. Jaray, London, Oct. 1953 (correspondence with Galerie Leiris, June 1975); Curt Valentin Gallery, New York;¹ acquired from Valentin by J. K. Thannhauser.

1. According to J. K. Thannhauser (notes, Dec. 1972), the drawing came from Valentin. A label on the reverse, from Valentin's Gallery, bears the number L4193. The Gallery's unpublished "Black Albums" of photographs on deposit at the Museum of Modern Art, New York, do not include *The Table*, but the work is in the "Green Albums" at the Modern of other photographs Valentin had (under *P*, vol. 6 [p. 8], repr. [*Round Table*, 6 ¹/₂ x 4 inches]). Attempts to locate this work or any others from the Thannhauser Foundation in Valentin's records or correspondence have been unsuccessful. (I am indebted to Ralph Colin's generosity of time and advice and to the assistance of Pearl Moeller at the Museum of Modern Art.) Surely the work was at Curt Valentin's Gallery although it is not certain that he owned it. It is not known how long Mrs. Jaray owned the watercolor nor to whom it subsequently went.

Pablo Picasso

Two Groups of Bathers. *1923*
(*Deux groups de baigneuses*)
78.2514 T54

*Ink on wove paper. 25.9 x 35.2 cm (10 ⁴/₁₆ x
13 ⁷/₈ inches)*
Signed lower right: <u>Picasso</u>
Not dated.

Exhibitions:
1927. Paris, Paul Rosenberg. *Exposition de cent
dessins par Picasso*. June–July. Probably no. 61 (*Deux
groupes de baigneuses*, 1923).

1932. Kunsthaus Zürich. *Picasso*. Sept. 11–Oct. 30.
No. 343 (label on reverse reads: *Zwei
Frauengruppen*).

References:
Solomon R. Guggenheim. *Masterpieces*. 1972, p. 65,
repr.

Zervos. 1952, vol. V, no. 18, and pl. 12.

During the summer of 1923 Picasso stayed at the Hôtel du Cap at Cap d'Antibes. Douglas Cooper thinks that the drawing was probably done at that time (correspondence, July 1974).

Picasso often drew bathers during the early 1920s, combining them with classical themes, beach scenes, and toilette subjects. Three women or three graces appear frequently among Picasso's etchings from 1922–23 (B. Geiser, *Picasso: Peintre-Graveur*, Bern, 1933, vol. I, nos. 68, 102–8) and drawings from 1923 (Z. V. 98–104).

Related drawings of bathers that Picasso did in 1923 include Z. V. 19–21, 24–28, 31–36, 39–43, 46–51, 54–59, 105–6, and 136–39. The Thannhauser drawing was not part of a sketchbook when acquired from the artist (correspondence with A. Rosenberg, Dec. 1974). It is closest to Z. V. 19, where two groups of bathers are separated by an identical framing device and where the woman

holding her hair to the side with both hands is repeated. With this exception, the poses of the bathers in the Thannhauser drawing are not found in the works listed above.

The gesture of a nude woman holding her hair to the side goes back to 1906, where it is found in a drawing, *Nude Combing Her Hair* (D-B. d.XVI. 6), and a painting of the same title (Z. I. 344; D-B. XVI. 9), which Daix relates to *The Harem* (Z. I. 321; D-B. XV. 40).

Provenance:
Purchased from the artist by Paul Rosenberg, Paris, 1924 or 1925 (correspondence with A. Rosenberg, Dec. 1974); probably acquired from Rosenberg by J. K. Thannhauser by 1932.

Pablo Picasso

Three Dancers, *April 1925*
(*Trois danseurs*)
78.2514 T55

India ink on wove paper, 34 x 24.8 cm (13 ³/₈ x 9 ³/₄ inches)
Signed and dated upper right: <u>Picasso</u> /25

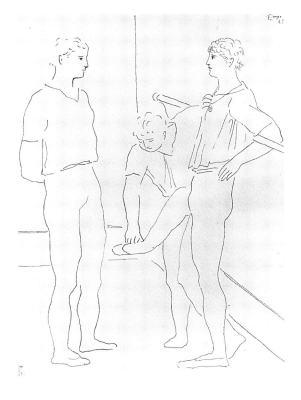

The ballet played an important role in Picasso's life from 1917 through 1925. He designed the curtain, decor, and costumes for several productions in collaboration with Sergei Diaghilev's Russian Ballet. Picasso married a ballerina, Olga Koklova, from the Russian Ballet in 1918.

In April 1925, while on their way to Juan-les-Pins, Picasso and his family stopped at Monte Carlo, where Diaghilev's company was performing. It is possible to document his visit from April 12 at the latest through April 29. The ballet troupe left Monte Carlo at the end of the month (R. Alley, *Picasso: The Three Dancers*, Newcastle upon Tyne, 1967, p. 10).

Picasso sketched the boys from the corps de ballet practicing at the bar and, as here, resting. Although they reappear in other Monte Carlo drawings, the figures cannot be identified (correspondence with D. Cooper, July 1974). Jean Sutherland Boggs observed that the artist was working from life in this group of drawings (The

Art Gallery of Toronto, *Picasso and Man*, exh. cat., 1964, p. 99).

When published in 1926 by Waldemar George in *Picasso Dessins* as "Album inédit de l'artiste (1925)," none of the sketches was signed. Predominantly drawings of two, three, or four dancers, the sketchbook included Z. V. 418, 422–25, 429, 431, 433, 435, 436, 455, and pls. 372, 374, and 375 in Cooper, *Picasso Theatre*. All have been signed and dated since that time (see Paris, Musée des Arts Décoratifs, *Picasso*, exh. cat., 1955, definitive ed., p. 47, for a discussion of the artist's signature in 1925).

Provenance:
Purchased from the artist by Paul Rosenberg, Paris (conversation with A. Rosenberg, Feb. 1977); acquired from Rosenberg by G. F. Reber; acquired from Reber by Paul Adamidi Frascheri;[1] J. K. Thannhauser, New York.

Condition:
Collector's mark at lower right.[2] Tear at upper right. Slight stains from foxing. Removed from mount, flattened, and deacidified by C. Gaehde (June 1973).

References:
Blunt, A. "Picasso's Classical Period (1917–25)." *The Burlington Magazine*, vol. CX, April 1968, p. 188.

Cooper, D. *Picasso Theatre*. New York, 1968, p. 353 and pl. 358 (*Three Dancers Resting*, 1925, not signed or dated).

George, W. *Picasso Dessins*. Paris, 1926, pl. 27 (not signed or dated; pls. 23–64 of "Album inédit de l'artiste [1925]").

Solomon R. Guggenheim Museum. *Masterpieces*. 1972, p. 66, repr.

Zervos. 1952, vol. V, no. 431 and pl. 173 (*Trois danseurs*, signed and dated 1925).

1. D. Cooper (correspondence with A. Rudenstine, Nov. 1975) stated that the drawing went from Reber to Adamidi, perhaps ca. 1931–32, and that the latter sold it in the 1940s. According to A. Rosenberg (conversation, Feb. 1977) Adamidi probably obtained the drawing from Reber.

2. Collector's mark not in F. Lugt, *Les Marques de collections de dessins et d'estampes . . . Supplement*, The Hague, 1956. According to J. K. Thannhauser (notes, Dec. 1972) and D. Cooper, it is that of the Adamidi collection, Geneva.

Pablo Picasso

Bird on a Tree. *August 1928*
(*L'Oiseau; Bird on a Branch; L'Oiseau sur la branche;
Vogel auf Zweig*)
78.2514 T57

Oil on canvas, 34.9 x 24.1 cm (13 ¾ x 9 ½ inches)
Signed and dated upper right: Picasso / 28

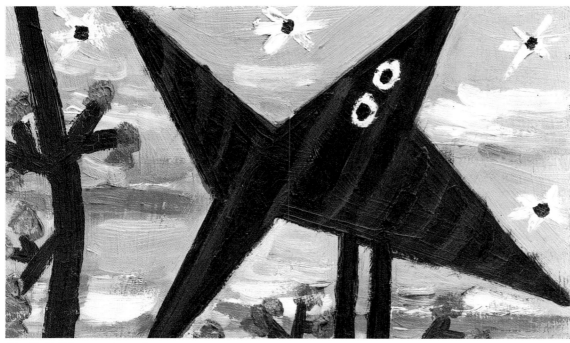

Detail. Full image on page 18.

Picasso told J. K. Thannhauser that during his
sojourn in 1928 at Dinard "he was angry because
this bird awakened him for quite a while unusually
early every morning. Then suddenly one morning
he jumped out of bed, looked out of his window,
saw the bird in front of the rising sun, painted it,
and from the following night on he slept through"
(J. K. Thannhauser notes, Dec. 1972).

Christian Zervos specified August 13, 1928, as
the date for *Bird on a Tree*. A drawing for the
present picture, bearing this date, is contained in
Carnet 1044, which belongs to Marina Picasso
(W. Spies, ed., *Pablo Picasso: Werke aus der
Sammlung Marina Picasso*, Munich, 1981, no. 149,
p. 148, repr.). During that month Picasso painted
at least twenty-five small canvases of bathers on the
beach (Z. VII. 209–16, 218–27, 230, 232–36, and
239). Brilliantly colored, the work done at Dinard
is characterized by vibrant stripes and flat patterns.
Picasso was at Dinard by July 8 (Z. VII. 199)
and remained there until at least August 28
(Z. VII. 239).

When first reproduced in 1929 the picture was

neither signed nor dated. However, by the follow-
ing year it was: undoubtedly Picasso added his
signature and date at the time the painting went to
Thannhauser.

The shape of the bird reappears in 1931 in *Deux
hirondelles* (Z. VII. 342).

Provenance:
Acquired from the artist by J. K. Thannhauser by
1930.

Condition:
The painting is not lined or varnished. Prior to
1965 minor repairs at lower left and lower right.
Local consolidation and minor filling and
inpainting of small losses carried out in 1986
(March 1992).

Exhibitions:
1932. Kunsthaus Zürich. *Picasso*. Sept. 11–Oct. 30.
No. 177.

1934. Buenos Aires, Galería Müller. *Picasso*. Oct.
No. 15 (J. K. Thannhauser notes, Dec. 1972).

1990. Venice, Palazzo Grassi. Pp. 112 and 114–15,
no. A30, color repr.

References:
Bernier, G. "Humorage à Picasso." *L'Oeil*,
nos. 217–18, Aug.–Sept. 1973, p. 44, repr.

Cahiers d'Art, 7ᵉ année, no. 3–5, 1932, p. 177, repr.
(not signed or dated).

Cassou, J. *Picasso*. New York, 1940, pp. 134, repr.,
and 167.

Daix. 1965, pp. 138, 139, repr., and 266.

Documents. Vol. 2, no. 3, 1930, p. 126, repr. (signed
and dated; Thannhauser, Berlin).

Elgar, F., and R. Maillard. *Picasso*. Trans. F. Scarfe.
Rev. ed. New York, 1972, p. 212, repr.

Eluard, P. *A Pablo Picasso*. Geneva and Paris, 1944,
p. 112, repr.

——. *Pablo Picasso*. New York, 1947, p. 112,
repr.

Solomon R. Guggenheim Museum. *Masterpieces*.
1972, p. 68, repr.

Runnqvist, J. *Minotauros*. Stockholm, 1959,
pp. 90–91, pl. 99.

Zervos, C. *Pablo Picasso*. Milan, 1932, pl. xxiv
(signed and dated).

——. *Pablo Picasso*. Milan, 1937, pl. xxii.

——. 1955, vol. VII, no. 217 and pl. 85
(*L'Oiseau*, Dinard, 13 août 1928).

——. "Picasso à Dinard été 1928." *Cahiers d'Art*,
4ᵉ année, no. 1, 1929, p. 7, repr. upside down (not
signed or dated; caption reads: Dinard, 13 août
1928).

154

Woman with Yellow Hair. *December 1931*
(Femme aux cheveux jaunes; Woman with Blond Hair;
Woman Sleeping; Femme endormie)
78.2514 T59

Oil on canvas, 100 x 81 cm (39 ¼ x 31 ⅞ inches)
Signed lower left: Picasso; *dated on reverse of stretcher:*
27 Decembre/M.CM.XXXI.

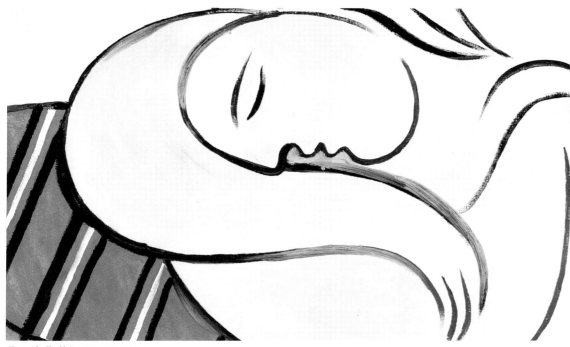

Detail. Full image on page 95.

The sleeping woman with yellow hair is Marie-Thérèse Walter (1909–77). Young and athletic, her striking looks intrigued Picasso. Here he has united forehead and nose in a single curve and has emphasized her full lips and prominent chin. (A photograph of her is included in P. Cabanne, "Picasso et les joies de la paternité," *L'Oeil*, no. 226, May 1974, p. 2, and another taken at a later date is in Porzio and Valsecchi, p. 41).

Upon meeting Marie-Thérèse years later, Françoise Gilot saw that "she was certainly the woman who had inspired Pablo plastically more than any other . . . she had that high-color look of glowing good health one sees often in Swedish women. Her forms were handsomely sculptural, with a fullness of volume and purity of line that gave her body and her face an extraordinary perfection" (F. Gilot and C. Lake, *Life with Picasso*, New York, 1964, pp. 241–42).

It is generally agreed that Picasso met Marie-Thérèse when she was seventeen years old. A date of 1931 for this meeting has been assumed. However, Marie-Thérèse and Picasso met by chance at six

o'clock on Saturday, January 8, 1927, in front of the Galeries Lafayette in Paris (Daix, 1977, p. 213, fn. 2). Marie-Thérèse remembered that Picasso commented on her interesting face and expressed the wish to do her portrait (Cabanne, p. 2). Soon thereafter she went to his studio every day. Picasso continued to see her and their daughter Maïa, born October 5, 1935, regularly even when he was involved with Dora Maar and Françoise Gilot (Gilot and Lake, p. 129).

In 1964 Gilot stated (p. 241) that "the whole series of portraits of blonde women Pablo painted between 1927 and 1935 are almost exact replicas" of Marie-Thérèse. William Rubin (p. 226) proposes the summer of 1931 for the first images of Marie-Thérèse, and Alan Bowness refers to *The Sculptor* (Z. VII. 346), which bears the date of December 7, 1931, as the earliest representation of her (*Picasso in Retrospect*, New York, 1973, p. 141). However, her profile is recognizable in *Woman, Sculpture and Vase of Flowers*, which bears the date of April 24, 1929 (Z. VII. 259; 193 x 129.5 cm [76 x 51 inches], Collection Mr. and Mrs. Nathan Cummings).

The Thannhauser picture is dated December 27, 1931. Chronologically it belongs with three other paintings of Marie-Thérèse (Z. VII. 334, 346, 358) and a drawing (dated Feb. 4, 1931; Duncan, 1961, p. 214, repr.). Another painting, known from a photograph Cecil Beaton took of Picasso at 25, rue la Boétie in 1931, provides two images of Marie-Thérèse—one a sleeping figure, the other a sculpture (not in Z.; Rubin, p. 226, repr.).

Marie-Thérèse remembers Picasso's always saying: "Ne ris pas, ferme les yeux" (Cabanne, p. 7). He preferred the image of her sleeping. She is seen asleep in the present picture as well as in many others (Z. VII. 331, 332, 348–50, 359, 360, 362–64, 377, 378, 382–84, 387, 388, 390, 396–403, and 407–09 among works from the years 1931–32). In fact, the identical sleeping pose with head facing down cradled in her arms is found in Z. VII. 378 (*Le Miroir*, March 14, 1932), 382 (*Femme nue couchée sur un cousin rouge*, May 22, 1932), 398 (drawing, dated July 30, 1932), 399 (drawing, 1932), and a painting in Picasso's collection (Duncan, p. 215, dated May 16, 1932).

In these works, the sleeping figure is expressed in lush rounded forms. The arms lack articulation and taper off rather than terminating in hands. Robert Rosenblum refers to the "shades of lavender and purple, nocturnal colours that, in the thirties, often convey for Picasso a growing intensity of sleep and inwardness that would vanish under the physical light of day" ("Picasso as a Surrealist," in the Art Gallery of Toronto, *Picasso and Man*, exh. cat., 1964, p. 16).

Provenance:
Acquired from the artist by J. K. Thannhauser, Paris, 1937 (notes, Dec. 1972).

Exhibitions:
1939–40. New York, The Museum of Modern Art. *Picasso: Forty Years of His Art.* Nov. 15, 1939–Jan. 7, 1940. No. 250 (*Woman Sleeping*, 1932). Traveled to the Art Institute of Chicago, Feb. 1–March 3, and San Francisco Museum of Art, June 25–July 22.

1944. Buffalo, Albright Art Gallery. *French Paintings of the Twentieth Century, 1900–1939.* Dec. 6–31. No. 50 (*Woman Sleeping*). Traveled to the Cincinnati Art Museum, Jan. 18–Feb. 18, 1945, and City Art Museum of St. Louis, March 8–April 16, 1945.

1953. Santa Barbara Museum of Art. *Fiesta Exhibition, 1953: Picasso, Gris, Miró, Dali.* Aug. 4–30. No. 29 (*Woman Sleeping*, 1932).

1990. Venice, Palazzo Grassi. Pp. 56–57, no. A1, color repr.

1992. The Montreal Museum of Fine Arts. Pp. 74–75, no. 10, color repr.

References:
Cassou, J. *Picasso.* New York, 1940, p. 137, repr. on its side.

Daix. 1977, p. 237, fn. 10 and pl. 32.

de Champris, P. *Picasso: Ombre et soleil.* Paris, 1960, pp. 128, 290, and pl. 132 (*Femme endormie*, 1931).

Solomon R. Guggenheim Museum. *Masterpieces.* 1972, p. 70, repr.

Nochlin, L. "Picasso's Color: Schemes and Gambits." *Art in America*, vol. 68, no. 10, Dec. 1980, pp. 119, fig. 17, repr., cover, and 178.

Porzio, D., and M. Valsecchi. *Understanding Picasso.* New York, 1974, p. 10, repr. (*Woman with Yellow Hair*, 1931–32).

Rubin, W. *Picasso in the Collection of The Museum of Modern Art.* New York, 1972, p. 226, fig. 108 (*Woman with Blond Hair*, 1931).

Schiff, G. *Picasso At Work At Home: Selections from the Marina Picasso Collection.* Exh. cat., Center for the Fine Arts, Miami, 1985, pp. 68 and 83.

Zervos. 1955, vol. VII, no. 333 and pl. 138 (*La Femme aux cheveux jaunes*, 1931).

Still Life: Fruit Dish and Pitcher. January 21–22. 1937
(*Nature morte: compotier et cruche: Table bleue, orange, jaune et blanche*)
78.2514 T61

Enamel on canvas, 49.8 x 60.8 cm (19 ⅝ x 23 ¹⁵/₁₆ inches)
Signed and dated upper left: 21 janvier XXXVII/ Picasso; dated on stretcher upper right: 22 janvier XXXVII.

Detail. Full image on page 89.

Picasso painted *Still Life: Fruit Dish and Pitcher* on Thursday, January 21, 1937, and, according to the inscription on the reverse, on the following day. Pierre Daix confirms that Picasso did it at Le Tremblay-sur-Mauldre, near Versailles, where he often spent three or four days a week at a farmhouse and studio owned by Ambroise Vollard (p. 273, fn. 9). Later Marie-Thérèse Walter recalled that Picasso generally went there from Thursday to Sunday night (P. Cabanne, "Picasso et les joies de la paternité," *L'Oeil*, no. 226, May 1974, p. 7).

The series of still lifes painted at Le Tremblay from late 1936 to 1938 are characterized by their subdued color and by the simplicity of the objects (jug, cup, candle, plate, knife, pitcher) represented. Jaime Sabartés emphasizes that in spirit these still lifes are set apart from other work. "The same objects painted in the city would have had a different aspect. One felt that he had seen them breathing pure air, free from extraneous worries" (*Picasso: An Intimate Portrait*, trans. A. Flores, New York, 1948, p. 142).

On January 22 Picasso painted another version

of the present composition with only minor changes in the pitcher and more simplified forms in the compotier (49.8 x 61 cm [19 ⅝ x 24 inches]; Duncan, 1961, p. 220, repr.). In a still life, *Nature morte au pichet*, dated January 20 (Z. VIII. 326), the pitcher had been treated in a representational manner. Yet the shapes of the base, body, handle, and mouth of the pitcher, which later become abstract designs, are already accentuated. Likewise, the "figure eight" designs at the base of and across the fruit dish are suggested in the January 20 painting, developed in the January 21 version, and modified slightly in that of January 22. This distinctive configuration of fruit appeared in 1931 in Braque's still lifes (N. Mangin, *Catalogue de l'oeuvre de Georges Braque: peintures 1928–1935*, Paris, 1962, pls. 73–74).

Picasso had painted still lifes with a compotier on the left and a pitcher on the right the month before (December 8; Z. VIII. 328; Duncan, p. 219; and December 14, 1936; not in Z.). In a picture dated January 16 (Z. VIII. 327; *La Renaissance de l'art français et des industries de luxe*, vol. XXI, Jan. 1939, foll. p. 16, color repr.), the same objects are quite clearly described without emphasis on abstract shapes.

The division of the background and the differentiation of planes in the table through color are developed further in still lifes with pitchers painted in April 1937 (Z. VIII. 358, 359, 364–67).

Provenance:
Purchased from the artist by Paul Rosenberg, Paris, 1938 (correspondence with A. Rosenberg, Dec. 1974); on consignment to Bignou Gallery, New York, ca. 1939; purchased from Paul Rosenberg, New York, by Vladimir Golschmann between Feb. 1944 and Oct. 1947 (correspondence with A. Rosenberg); Mary Callery, probably late 1947 or 1948–56 (correspondence with Callery, April 1974); Perls Galleries, New York, April 1956–57 (correspondence with K. G. Perls, Jan. 1974); purchased from Perls Galleries by J. K. Thannhauser, Feb. 1957.

Condition:
Not lined. Repair at upper left in fruit dish (May 1975).

Exhibitions:
1939–40. New York, The Museum of Modern Art. *Picasso: Forty Years of His Art.* Nov. 15, 1939–Jan. 7, 1940. No. 277 (*Still Life*, dated Jan. 21, 1937, lent by the Bignou Gallery, on consignment from Paul Rosenberg). Traveled to the Art Institute of Chicago, Feb. 1–March 3.

1947. Cincinnati Modern Art Society. *Golschmann Collection.* April 30–June 1 (probably *Still Life*, 1937, oil).

1947. New York, Rosenberg Galleries. *Vladimir Golschmann Collection.* Oct. 6–25. No. 14 (*Table bleue, orange, jaune et blanche*, 1937, 19 ½ x 23 ¾ inches).

1957. New York, The Museum of Modern Art. *Picasso: 75th Anniversary Exhibition.* May 22–Sept. 8. Addenda p. 115, repr. (*Fruit Dish and Pitcher*). Traveled to the Art Institute of Chicago, Oct. 29–Dec. 8.

1958. Philadelphia Museum of Art. *Picasso.* Jan. 8–Feb. 23. No. 192.

References:
Daix. 1977, p. 273, fn. 9.

Solomon R. Guggenheim Museum. *Masterpieces.* 1972, p. 72, repr.

Merli, J. *Picasso, el artista y la obra de nuestro tiempo.* Rev. ed. Buenos Aires, 1948, pl. 447.

Zervos. 1957, vol. VIII, no. 329 and pl. 154 (*Nature morte*).

1. Callery (correspondence, April 1974) remembered purchasing the painting from Paul Rosenberg, New York, during World War II. Rosenberg's records indicate otherwise.

Pablo Picasso Still Life: Fruits and Pitcher. *January 22, 1939* Oil and enamel (?) on canvas. 27.2 x 41 cm (10 ¹/₂ x
(*Nature morte: fruits et pot*) 16 ¹/₈ inches)
84.3231 *Signed and dated upper left:* 22.1.39/Picasso: *dated on
reverse of stretcher:* 22.1.39.

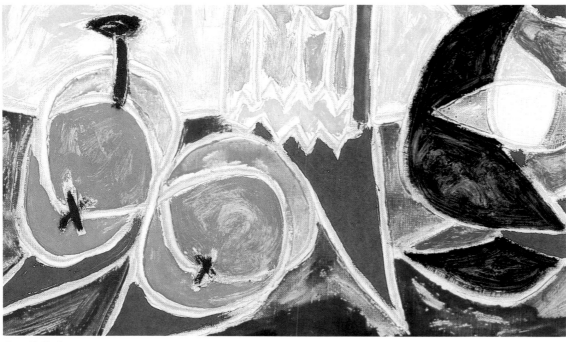

Detail. Full image on page 88.

In January 1939 Picasso stayed primarily in Paris because of an attack of sciatica; however, he went occasionally to Le Tremblay-sur-Mauldre. He had recovered by January 17, when his exhibition opened at the Galerie Paul Rosenberg in Paris, where thirty-three still lifes from the preceding three years were shown (see J. Sabartés, *Picasso: An Intimate Portrait*, New York, 1948, p. 142). There is no documentary evidence to prove where Picasso painted the present work although it was probably done at Le Tremblay. This painting is definitely dated Sunday, January 22, and according to Sabartés the artist created many of the still lifes in the country, where he usually spent the weekend. The day before, the artist executed two canvases of identical dimensions depicting a reclining female figure. According to Zervos, the one of Dora Maar (Z. IX. 252) was made at Le Tremblay. However, the other, the picture of Marie-Thérèse Walter (Z. IX. 253), is said to have been painted in Paris (The Museum of Modern Art, *Pablo Picasso: A Retrospective*, exh. cat., New York, 1980, p. 349) as is another canvas dated January 21, *Femme au*

fauteuil rouge (Collection Marina Picasso; Duncan, p. 238). Since Picasso visited Marie-Thérèse and their daughter Maïa at Le Tremblay, it is likely that he painted all three pictures there.

On January 22 Picasso portrayed Marie-Thérèse in a spontaneous pencil drawing (Z. IX. 241) and in an oil painting (Z. IX. 244). He also painted at least four additional still lifes, including one that closely resembles the present picture (19 x 24 cm [7 ¹/₂ x 9 ¹/₂ inches]; Duncan, p. 238, repr. top center). There is also a related canvas dated February 4, 1939 (Not in Z.; 33 x 45.5 cm [13 x 18 inches]; Collection Dr. Herschel Carey Walker; The Museum of Modern Art, *Picasso: 75th Anniversary Exhibition*, exh. cat., 1957, p. 80, repr.).

The Thannhauser picture recalls similar works from 1937 that show a jug on the right and fruit on the left in front of a window (Z. VIII. 367 and another belonging to Rosenberg, reproduced in *Art in Australia*, vol. 4, no. 4, Dec. 1941, p. 28, repr.). Since these two works were probably among those on view at the Galerie Paul Rosenberg in Paris (for example, nos. 6, 7, 9, and 18) in January 1939, this

exhibition may have inspired Picasso to resume using the same motifs.

Provenance:
Probably acquired from the artist by Paul Rosenberg, New York;¹ J. K. Thannhauser, New York, probably 1940s–until 1976; Mrs. Justin K. Thannhauser, Bern, 1976–84.

Condition:
The painting is in very good condition (March 1992).

Exhibition:
1978. Kunstmuseum Bern. *Sammlung Justin Thannhauser*. June 8–Sept. 16. Exh. cat., pp. 89, no. 48, repr., and 112 (*Nature morte, fruits et pot*).

Reference:
Zervos. 1958, vol. IX, no. 260, p. 124, repr. (*Nature Morte. Fruits et Pot*).

1. On the basis of a label from Paul Rosenberg and Co. at 16 East 57th Street in New York, which bears the number 1557, it is assumed that the work belonged to Rosenberg. However, no records have been found to confirm this information and to provide the precise date the picture went to Thannhauser, who acquired other works by Picasso from Rosenberg (for example, T50, T53, and T54). Paul Rosenberg's gallery was located on 57th Street from 1940 to 1953 (I appreciate the assistance of Mrs. Alexandre Rosenberg, July 1990).

Head of a Woman (Dora Maar).
March 28, 1939
(Tête de femme: Girl with Blond Hair)
78.2514 T62

Oil on wood panel. 59.8 x 45.1 cm (23 ⁵⁄₁₆ x 17 ³⁄₄ inches)
Signed and dated lower right: Picasso / 39; *dated on reverse: 28.3.39*

Detail. Full image on page 93.

Dora Maar was a photographer and, by 1934, a member of Surrealist art circles in Paris. According to Pierre Daix, Picasso was introduced to her at St. Germain-des-Prés early in 1936 by Paul Eluard, whom he had met only recently (1965, p. 157). However, Brassaï (who had known Dora since the early 1930s) states that the artist made her acquaintance in the autumn of 1935 (*Picasso and Company*, Garden City, 1966, p. 42). Picasso's earliest portraits of her date from their stay at Mougins during the autumn of 1936 (Penrose, 1958, p. 303).

Dora Maar was born in Paris of a French mother and a Yugoslav father, an architect named Markovitch. After living for years in Argentina, she was in Paris by the early 1930s. An exhibition of her photographs took place in 1937. Due to her association with Picasso, she turned increasingly to painting, which she showed in the 1940s and 1950s.

The present painting was executed when Dora Maar was twenty-nine years old (*Time*, vol. XXXIII, Feb. 13, 1939, p. 46. A photograph of

Picasso by Dora Maar is on the cover). Her hair was brown rather than blond as Picasso has chosen to portray it here. Her eyes were "dark and beautiful" and "her quick decisive speech and low-pitched voice were an immediate indication of character and intelligence" (Penrose, p. 260). She appears in Picasso's work until 1945.

In spite of the dislocation of the features, the painting resembles the sitter. Photographs of her are reproduced in A. Fermigier, ed., *Picasso*, Paris, 1967, p. 196; C. Beaton, "Picasso's Studio 1944," *Horizon* (London), vol. XI, Jan. 1945, opp. p. 49; and R. Penrose, *Portrait of Picasso*, rev. ed., New York, 1971, pp. 64–65.

This panel is one of several very similar pictures of the sitter, all the same size, painted late in March 1939 at the time of the fall of Madrid. These include works of March 27 (The Art Gallery of Toronto, *Picasso and Man*, exh. cat., 1964, no. 229, repr.); March 28 (Z. IX. 276 and pl. 129); March 29 (not in Z.; New York, Parke Bernet, *The Collection of . . . the Late G. David Thompson*, March 24, 1966, no. 69, color repr.); March 29 (not in Z.;

Duncan, 1961, p. 240, repr.); and March? (Duncan, p. 240, repr.). Her image also appears in monotypes dated March 22 (Z. IX. 270–73, 277).

Provenance:
Purchased from the artist by Paul Rosenberg, Paris, 1939 (correspondence with A. Rosenberg, Dec. 1974); purchased from Paul Rosenberg, New York, by Keith Warner, Oct. 1943;[1] G. David Thompson, Pittsburgh;[2] J. K. Thannhauser.

Condition:
Panel, which is warped, has veneer on each side of plywood core: total thickness is approximately one-quarter inch. The pattern of cracks follows grain of the veneer. Panel's unpainted surface visible in places in woman's hair (May 1975).

Exhibition:
1939–40. New York, The Museum of Modern Art. *Picasso: Forty Years of His Art*. Nov. 15, 1939–Jan. 7, 1940. No. 360 (*Girl with Blond Hair*, Paris, dated March 28, 1939, lent by Rosenberg and Helft, Ltd.). Traveled to the Art Institute of Chicago, Feb. 1–March 3, and San Francisco Museum of Art, June 25–July 22.

Reference:
Solomon R. Guggenheim Museum. *Masterpieces*. 1972, p. 75, repr.

1. The present picture was not included in the sale of Warner's collection at the Parke Bernet Galleries, New York, on March 16, 1950, nor in earlier auctions at Parke Bernet that contained pictures from Warner's collection (Dec. 15, 1949, and Oct. 18, 1950). Warner died in 1959.

2. Mrs. G. David Thompson confirmed that the picture was once in her husband's collection and had belonged to Warner but could not provide specific dates (correspondence with D. C. Rich, April 1974). Thompson died in 1965.

Françoise Gilot. *September 9, 1947*
78.2514 T63

*Sanguine on wove paper. 65.9 x 50.5 cm (25 ¹⁵/₁₆ x
19 ⁷/₈ inches)*
Signed and dated lower left: Golfe-Juan 9 septembre
47 <u>Picasso</u>.

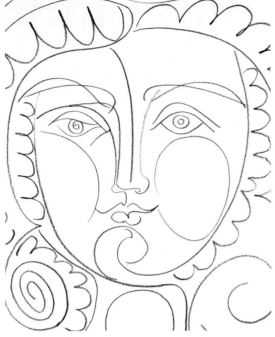

Detail. Full image on page 13.

In September 1947, while in southern France,
Justin Thannhauser stopped to visit Picasso at
Golfe-Juan. At that time Picasso drew for him this
festive, decorative image of Françoise Gilot.

Picasso, Gilot, and their infant son Claude, born
May 15, 1947, had come to Golfe-Juan in August,
where they were living at Louis Fort's house.
During that month M. and Mme Georges Ramié
invited Picasso to see the results of his first work in
pottery, done the year before, which they had had
fired (F. Gilot and C. Lake, *Life with Picasso*, New
York, 1964, p. 183f.). By the autumn he was
working every day in the late morning and all
afternoon at the Madoura pottery works in Vallauris
(see D. de la Souchère, *Picasso in Antibes*, New York,
1960, pls. 58 and 61, and J. Sabartés, "Picasso à
Vallauris," *Cahiers d'Art*, 23ᵉ année, 1948, pp. 138,
144, and 149 for ceramics with similar faces made
in October 1947).

The playfully curving lines of the present work
create a motif suggestive of the sun or a flower;
both images Picasso associated with Françoise. The
painting *La Femme-fleur* (Z. XIV. 167) dates from

May 5, 1946. Also from the same year is a
lithograph of Gilot as the sun (F. Mourlot, *Picasso
Lithographe*, Monte Carlo, 1949, vol. I, no. 48). In
1945 the artist returned to lithography, a medium
which he had not employed since 1919. For related
lithographs of Gilot, see Mourlot, vol. I, nos.
38–48, 68, and vol. II, nos. 84 and 106.

In style the Thannhauser drawing is closest to
two drawings of Gilot done on July 5, 1946 (Z.
XIV. 192 and 193). The designs of her hair and
bodice in the July drawings are elaborated in the
Thannhauser work in the shapes of the chin and
cheeks. Picasso's treatment of the cheeks and chin
resembles representations of the sun. Even the curls
and waves of the hair suggest the sun rather than
Gilot's hair, which was straight (see photographs of
her at that time in Gilot and Lake, pp. 33, 169, and
176).

Françoise Gilot, a young painter born
November 26, 1921, met Picasso in May 1943.
From 1946 to 1953 she occupied an important
place in his life and art.

Provenance:
Purchased from the artist by J. K. Thannhauser,
Sept. 1947.

References:
Solomon R. Guggenheim Museum. *Masterpieces*.
1972, p. 74, repr.

Zervos. 1965, vol. XV, no. 73 and pl. 43 (*Tête de
femme*).

Pablo Picasso

Garden in Vallauris. *June 10, 1953*
(*Jardin à Vallauris: Pine Tree and Palm Tree: Paysage de Vallauris*)
78.2514 T64

Oil on canvas. 18.7 x 26.7 cm (7 ¾ x 10 ½ inches)
Signed lower right: Picasso; dated upper right:
10/juin/53; inscribed on reverse: 1

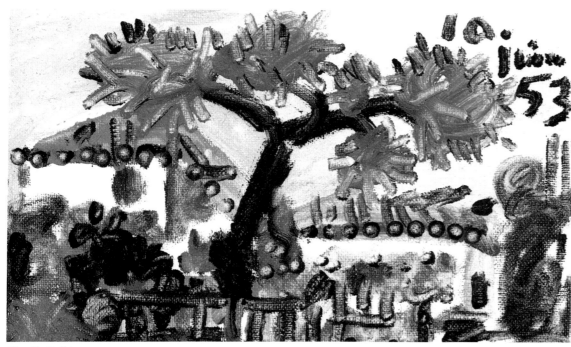

Detail. Full image on page 21.

Exhibition:
1953. New York, Curt Valentin Gallery. *Pablo Picasso 1950–1953*. Nov. 24–Dec. 19. No. 24 (*Pinetree and Palmtree*, 1953, 7 ½ x 11 inches).

References:
Gallwitz, K. *Picasso at 90: The Late Work*. New York, 1971, p. 66 and pl. 67 (*Pine and Palm*).

Solomon R. Guggenheim Museum. *Masterpieces*. 1972, p. 75, repr.

Curt Valentin Gallery, New York. *Picasso*. N.d., vol. IV of unpublished "Black Albums" of photographs on deposit at the Museum of Modern Art, New York [p. 61], repr. (no. 15722, *Pine Tree and Palm Tree*).

Zervos. 1965, vol. XV, no. 272 and pl. 150 (*Paysage de Vallauris*).

Garden in Vallauris is one of thirteen canvases Picasso painted of a transformer station during June 1953. Trees and building are common elements in all; yet the composition differs in each painting.

For several years Picasso had painted landscapes of Vallauris and its distinctive houses and gardens (photographs in J. Sabartés, *Picasso: Documents iconographiques*, Geneva, 1954, pls. 154, 175, 176; see also Z. XV. 174, 185–89). Vallauris, a pottery center prior to Roman times, was located three miles from Golfe-Juan. It was in the 1930s that Picasso first discovered it with Paul and Nusch Eluard (Daix, 1965, p. 163). He began working in ceramics there in 1947, and from May 1948 to 1954 he lived at the Villa La Galloise. He also had a studio with separate areas for painting and sculpture in an old factory in rue du Fournas in Vallauris from 1949 on (F. Gilot and C. Lake, *Life with Picasso*, New York, 1964, pp. 253–54).

On the reverse of *Garden in Vallauris*, written in black paint, is the number 1, indicating that it was executed before the other two paintings also dated June 10. This would contradict Klaus Gallwitz's

placing *Le Transformateur* (Z. XV. 273) first in the series followed by another version (XV. 274) and the present picture (XV. 272; pp. 66–67).

In the 1950s at Vallauris Picasso told Alexander Liberman: "I never do a painting as a work of art. All of them are researches. I search incessantly and there is a logical sequence in all this research. That is why I number them. It's an experiment in time. I number them and date them. Maybe one day someone will be grateful, he added laughingly" (quoted in D. Ashton, ed., *Picasso on Art: A Selection of Views*, New York, 1972, p. 72).

Provenance:
Acquired from the artist by Galerie Louise Leiris, Paris, 1953; purchased from Galerie Leiris by Curt Valentin, New York, Jan. 1954 (correspondence with Galerie Leiris, June 1975); purchased from Valentin by J. K. Thannhauser shortly thereafter.

Condition:
Not varnished (May 1975).

Pablo Picasso

Two Doves with Wings Spread.
March 16–19, 1960
(*Deux pigeons aux ailes déployées*)
78.2514 T66

Oil on linen, 59.7 x 73 cm (23 ⁹⁄₁₆ x 28 ¾ inches)
Signed upper left: Picasso ; *dated on reverse:*
16.3.60
19.
I

References:
Barnett, V. E. "The Thannhauser Collection." In *From Van Gogh to Picasso, From Kandinsky to Pollock, Masterpieces of Modern Art.* Exh. cat., Solomon R. Guggenheim Museum, 1990, p. 53.

Solomon R. Guggenheim Museum. *Masterpieces.* 1972, p. 77, repr.

Zervos. 1968, vol. XIX, no. 220 and pl. 65 (*Deux pigeons aux ailes déployées*).

Detail. Full image on page 69.

When Picasso signed the painting in September 1960 at La Californie, David Douglas Duncan was with him and took photographs (conversation with K. Lee of Guggenheim Museum, Jan. 1975. Prints of the photographs of Picasso signing this painting are in the Guggenheim Museum files). Picasso painted this version on March 16 and went back to it on March 19. He did another version, begun after the present picture (Z. XIX. 221). The placing of the doves perching on a ledge recurs in the two birds at the right in *Trois pigeons* (Z. XIX. 219; March 20, 1960, 65 x 81 cm [25 ⁵⁄₈ x 31 ⁷⁄₈ inches]).

The paintings of doves from February and March 1960 were all done at La Californie, the villa on a hill over Cannes, where Picasso had made a dovecote on the third-floor balcony (see photograph in D. D. Duncan, *The Private World of Pablo Picasso,* New York, 1958, pp. 46–47). Earlier he had designed a poster of a dove for the 1948 Peace Congress and had made ceramic pigeons and doves in 1953 (see D.-H. Kahnweiler, *Picasso Keramik,* Hannover, 1957, pls. 36–38 and J. Sabartés,

"Picasso à Vallauris," *Cahiers d'Art,* 23ᵉ année, 1948, pp. 93, 143, 168, and 186).

Jaime Sabartés (*Picasso: An Intimate Portrait,* New York, 1948, pp. 7–8, 26–27) discusses not only Picasso's love of pigeons but also his father's. For painting of doves and pigeons by Picasso's father, José Ruiz Blasco, see R. Penrose, *Portrait of Picasso,* rev. ed., New York, 1971, p. 17, fig. 15 and p. 122, fig. 321.

Provenance:
Acquired from the artist by J. K. Thannhauser, Sept. 1960.

Condition:
Not varnished. In places unpainted support visible. Considerable impasto in other areas, especially in center between doves (May 1975).

Camille Pissarro
Born July 1830, Saint Thomas, West Indies
Died November 1903, Paris

The Hermitage at Pontoise. *ca. 1867*
(Les Côteaux de l'Hermitage. Pontoise; Pontoise:
Hügellandschaft)
78.2514 T67

Oil on canvas. 151.4 x 200.6 cm (59 ⅛ x 79 inches)
Signed at lower left: C. Pissarro.
Not dated.

Detail. Full image on page 34.

The view represented is the rue du Fond de l'Hermitage (now rue Maria Deraismes) in Pontoise. A photograph of the site as it appeared in May 1962 is reproduced in L. Reidemeister (p. 39 and correspondence with Reidemeister, Nov. 1976). The small square or open space at the foot of rue Maria Deraismes still exists. The houses joined by a wall at the right and center of the painting survive as do some of those grouped at the left. Today, a large building stands at what would be the left foreground and the trees on the hill are, of course, larger (correspondence with E. Maillet, Musée de Pontoise, Nov. 1976). Pontoise is situated twenty-seven miles northwest of Paris on the right bank of the Oise River.

The catalogue of the Salon of 1866 listed Pissarro's address as "à Pontoise, rue du Fond-de-l'Ermitage; et à Paris, chez M. Guillemet, Grande-Rue, 20 (Batignolles)" (*Explication des ouvrages de peinture, sculpture, architecture, gravure, et lithographie des artistes vivants*, Paris, 1866, p. 199). The specific house where Pissarro lived between 1866 and 1868 remains unknown. No trace of documentation has

been found at the mayor's office or elsewhere by the Musée de Pontoise. The exact dates when Pissarro lived in the Maison de la Sente de Cheminées, which dominates the hill, cannot be determined. The house has survived and has recently undergone renovations (correspondence with Maillet, Nov. 1976).

There are two paintings of Pontoise that Pissarro dated 1867: *Jallais Hill, Pontoise* (Pissarro-Venturi 55; 87 x 144.9 cm {34 ¼ x 45 ¼ inches}, The Metropolitan Museum of Art, New York; J. Rewald, *Camille Pissarro*, New York, 1963, p. 71, color repr.) and *Hermitage at Pontoise* (Pissarro-Venturi 56; 91 x 150.5 cm {35 ⅞ x 59 ¼ inches}, Wallraf-Richartz Museum, Cologne; Champa, color pl. 21). The Thannhauser painting is closely related to both in style and subject matter; Christopher Lloyd and Anne Distel find the Thannhauser painting more closely related compositionally to the former (1981, Boston, Museum of Fine Arts, exh. cat., p. 77). Another undated painting of the Hermitage that can be placed in the year 1867 is *View of the Hermitage* (Pissarro-Venturi 57; 70 x 100 cm {27 ½ x 39 ⅜ inches}, present whereabouts unknown; Champa, fig. 108). Lloyd and Distel (p. 77) present the hypothesis that the Thannhauser painting is "an amalgam of the compositional motifs explored in these important canvases" (Pissarro-Venturi 55, 56, and 57).

Champa views Charles-François Daubigny's *Hermitage at Pontoise* (112 x 161.5 cm {44 ⅛ x 63 ½ inches} dated 1866, Kunsthalle, Bremen; Champa, fig. 106) as the picture that "provided a schema for Pissarro's series of pictures of the same subject done between mid-1867 and the spring of 1868" (p. 75). He places the more traditional Thannhauser version latest in date, 1867 into 1868, so that it was completed in time for the Salon (conversation, Jan. 1977).

It would appear then more than a coincidence that in 1868 Daubigny interceded on Pissarro's behalf at the Salon so that two of his Pontoise landscapes were accepted. *"La Côte de Jallais"* (no. 2015) is the painting now in the Metropolitan Museum of Art. "L'Ermitage" (no. 2016) has never been identified with certainty although Pissarro and Venturi (vol. I, p. 86) stated that it was probably the Thannhauser picture. Without providing proof, Champa says that it was in the Salon (p. 76). John

Rewald thinks that Pissarro may have sent it to the Salon since it is a large painting. However, the fact that two works were accepted could indicate that both were smaller in size (correspondence, Nov. 1973). According to Lloyd and Distel it is "highly probable that the painting was shown in the Salon," either in the Salon of 1868 as no. 2016 or in that of 1869 as no. 1950 (p. 77).

Both Emile Zola and Jules Antoine Castagnary complained that Pissarro's paintings were hung too high (Castagnary, *Salons {1857–1870}*, Paris, 1892, vol. I, p. 278). Zola described the painting of the Hermitage hill in considerable detail. "Dans *l'Hermitage* au premier plan, est un terrain qui s'élargit et s'enfonce; au bout de ce terrain, se trouve un corps de bâtiment dans un bouquet de grands arbres. Rien de plus. Mais quelle terre vivante, quelle verdure pleine de sève, quel horizon vaste! Après quelques minutes d'examen, j'ai cru voir la campagne s'ouvrir devant moi" (F. W. J. Hemmings and R. J. Niess, eds., *Salons*, Geneva and Paris, 1959, p. 128). ("In *The Hermitage* in the foreground is a terrain which becomes larger and deeper: at the end of this terrain is a group of buildings within a grove of large trees. Nothing more. But what vibrant earth, what greenery full of vitality, what a vast horizon! After studying it for several minutes, I thought I saw the very countryside open up before me.") Zola went on to state his preference for *La Côte de Jallais*, referring to specific details found in the painting in the Metropolitan Museum. Zola's description of *The Hermitage* appears to fit the picture in the Wallraf-Richartz Museum rather than that in the Thannhauser Collection. It is also quite possible that the painting exhibited as no. 2016 no longer exists since a large proportion of the paintings Pissarro stored at his house at Louveciennes were destroyed during the Franco-Prussian War.

The Thannhauser painting was admired by Cézanne, who wrote to Pissarro from L'Estaque on July 2, 1876: "Dès que je le pourrai je passerai au moins un mois en ces lieux, car il faut faire des toiles de deux mètres au moins, comme celle par vous vendue à Faure" (Rewald, ed., *Cézanne Correspondence*, Paris, 1937, p. 127). ("As soon as I am able I shall spend at least a month in these parts for I must do some canvases of at least two metres in size like the one by you which was sold to Faure.")

Provenance:
Acquired probably from Durand-Ruel or from the artist by J.-B. Faure by 1876;[1] purchased from Faure by Durand-Ruel, Paris, June 1901; sold to Cassirer, June 1901;[2] acquired by Moderne Galerie (Heinrich Thannhauser) by 1918.

Condition:
The painting is unlined and is on the original stretcher. There is a horizontal seam across the entire width, thirteen and one-half inches up from the bottom, where two pieces of canvas were joined. The painting was cleaned and revarnished in 1990. Very minor filling and inpainting were done along the top edge.

Exhibitions:
1868. Paris, Salon of 1868. No. 2016 (?).[3]

1927. Berlin, Künstlerhaus (organized by the Galerien Thannhauser). *Erste Sonderausstellung in Berlin.* Jan. 9–Feb. 15. No. 189, repr. (*Pontoise*).

1930. Paris, Musée de l'Orangerie. *Centenaire de la naissance de Camille Pissarro.* Feb.–March. No. 10 (*Pontoise*).

1939–40. Buenos Aires, Museo Nacional de Bellas Artes. *La pintura francesa de David a nuestros días.* July–Aug. 1939. No. 106 (*Vista de Pontoise*). Traveled to Montevideo, Ministerio de Instrucción Pública, April–May 1940 (label on reverse), and Rio de Janeiro, Museu Nacional de Belas Artes, June 29–Aug. 15 (label on reverse of frame).

1940–41. San Francisco, M. H. De Young Memorial Museum. *The Painting of France Since the French Revolution.* Dec. 1940–Jan. 1941. No. 82, repr.

1941. The Art Institute of Chicago. *Masterpieces of French Art.* April 10–May 20. No. 123, repr.

1941. Los Angeles County Museum. *The Painting of France Since the French Revolution.* June–July. No. 104.

1941. The Portland Art Museum. *Masterpieces of French Painting.* Sept. 3–Oct. 5. No. 86.

1942–45. Washington, D.C., The National Gallery of Art. On loan from Feb. 1942–June 1945 (correspondence with P. Davidock, Nov. 1973).

1945–46. New York, The Museum of Modern Art. On loan from Aug. 1945–July 1946 (conversation with B. Winiker, Oct. 1976).

1946. Pittsfield (Mass.), The Berkshire Museum. *French Impressionist Painting.* Aug. 2–31. No. 13.

1981. Boston, Museum of Fine Arts. *Camille Pissarro: The Unexplored Impressionist.* May 19–Aug. 9. Exh cat., *Pissarro: Camille Pissarro: 1830–1903,* p. 77, no. 11, repr. (Also reproduced in French edition.)

References:
Champa, K. S. *Studies in Early Impressionism.* New Haven and London, 1973, pp. 75–77 and fig. 109 (incorrectly states that the painting was dated 1868).

Duret, T. *Die Impressionisten.* Berlin, 1923, p. 91, repr. (*Landschaft*).

Solomon R. Guggenheim Museum. *Masterpieces.* 1972, p. 10, repr.

Holl, J.-C. *Camille Pissarro.* Paris [1911], p. 41, repr. (*Les Côteaux de L'Ermitage, Pontoise*).

Kirchbach, W. "Pissarro und Raffaëli." *Die Kunst unserer Zeit,* Jg. 15, 1904, p. 124, repr. (*Die Ermitage in Pontoise*).

Kunstler, C. *Pissarro Cities and Landscapes.* Trans. E. Kramer. Lausanne, 1967, pl. 1 (*Slopes at the Hermitage, Pontoise*).

Lloyd, C. *Camille Pissarro.* Geneva and New York, 1981, pp. 30, repr., and 31–32 (*The Hillsides of L'Hermitage, Pontoise, ca. 1867*).

Meier-Graefe, J. "Camille Pissarro." *Kunst und Künstler,* Jg. 2, 1904, p. 483, repr. (*Hügellandschaft*).

Moderne Galerie (Heinrich Thannhauser), Munich. *Nachtragswerk III.* 1918, pp. 19, repr., and 119 (*Landschaft,* 150 x 200 cm).

Moffett, C. S. *Impressionist and Post-Impressionist Paintings in the Metropolitan Museum of Art.* New York, 1985, p. 85 (*Hillsides of l'Hermitage, Pontoise*).

Osborn, H. "Klassiker der Französischen Moderne." *Deutsche Kunst und Dekoration,* vol. 59, March 1927, p. 341, repr.

Pissarro, L. R., and L. Venturi. *Camille Pissarro: son art-son oeuvre.* Paris, 1939, vol. I, pp. 20, 86, no. 58, and vol. II, pl. 11 (*Les Côteaux de l'Hermitage, Pontoise*).

Reidemeister, L. *Auf den Spuren der Maler der Ile de France.* Berlin, 1963, p. 39, repr.

Rewald, J. *The History of Impressionism.* New York, 1946, repr. opp. p. 148 (*Hermitage at Pontoise, ca. 1867*).

———. *The History of Impressionism.* 4th ed. rev. New York, 1973, p. 159, repr. (*The Hermitage at Pontoise, ca. 1867*).

———. "The Impressionist Brush." *The Metropolitan Museum of Art Bulletin,* vol. 32, no. 3, 1973–74, pp. 12–13, repr. and color detail.

Shikes, R. E., and P. Harper. *Pissarro: His Life and Work.* New York, 1980, pp. 73–74, repr. (*Hills of the Hermitage*).

Werner, B. E. "Französische Malerei in Berlin." *Die Kunst für Alle,* Jg. 42, April 1927, p. 224.

1. Cézanne's letter of July 2, 1876 (quoted in the text), gives the terminal date. J. Rewald kindly informed D. C. Rich that he found in L. R. Pissarro's files the following information: "Extrait d'un carnet de notes de l'artiste: 1873-en dépôt chez Durand-Ruel—I) Grande T de 2m sur 1m50—'l'Hermitage' 2500 frs. vendu à Faure" (correspondence, Feb. 1975). The dimensions and title clearly indicate the Thannhauser painting as does the fact that it was on consignment. According to the archives of Durand-Ruel, Jean-Baptiste Faure, the baritone (1830–1914), purchased two paintings by Pissarro in 1873. One entitled *Le Palais Royal à l'Ermitage, Pontoise* (Durand-Ruel Stock No. 2726, no date or measurements given) was sold for 2,500 francs, having been purchased from the artist the same year (correspondence with C. Durand-Ruel, Nov. 1976). Pissarro-Venturi contains no reference to a painting of that title. Undoubtedly, the references in the Durand-Ruel archives are to the present picture.

2. Durand-Ruel Stock No. 6430 (correspondence with C. Durand-Ruel, Nov 1976).

3. See discussion above in text. The issue is complicated somewhat by the presence of two railway labels on the reverse of the stretcher, indicating that the picture was shipped from the Chemin de fer du Nord in Paris to Pontoise. Rewald thinks that the shipping label refers not to the stretcher alone but to the completed painting, which must have been sent to Paris sometime after it was painted—ca. 1867 and before 1873 (correspondence, Feb. 1975).

Pierre Auguste Renoir
Born February 1841, Limoges
Died December 1919, Cagnes

Woman with Parrot. *1871*
(La Femme à la perruche; Femme au perroquet; Dame mit
Papagei; Girl Feeding a Bird [Lise])
78.2514 T68

Oil on canvas, 92.1 x 65.1 cm (36 ⅛ x 25 ⅝ inches)
Signed lower right: A. Renoir.
Not dated.

Detail. Full image on page 33.

The woman is Lise Tréhot, who appears in many paintings by Renoir (see Cooper, 1959, p. 169, and Daulte, 1971, p. 419). She was born at Ecquevilly (Seine-et-Oise) on March 14, 1848, and her family moved to Paris sometime after 1855. It is not known when Renoir and Lise met. Douglas Cooper proposes that it was in 1865 or early 1866 when Lise's older sister Clémence became the mistress of Renoir's friend, Jules Le Coeur (see p. 164 of Cooper for additional biographical information). Lise's association with Renoir ended before April 24, 1872, when she married Georges Brière de l'Isle (1847–1902), an architect and friend of Le Coeur. It is said that she never saw Renoir again. Lise kept two of her portraits by Renoir, but destroyed all her papers at some time before her death on March 12, 1922 (p. 171). A photograph of Lise Tréhot taken in 1864 is published in *The Burlington Magazine*, vol. CI, May 1959, p. 165, fig. 2.

In *Woman with Parrot*, Lise wears the same black silk dress with white cuffs and buttons and even the same earrings as in *Lise with a White Shawl*, which Cooper dates 1872 (55 x 45 cm [21 ⅝ x 17 ¾

inches], Collection Mr. Emery Reves; F. Fosca, *Renoir: His Life and Work*, trans. M. I. Martin, Englewood Cliffs, 1962, p. 25, color repr.).

Woman with Parrot would have to date from before Lise's marriage in April 1872 and after Renoir's return to Paris from service in the Franco-Prussian War (July 1870–March 1871). Upon his return in mid-March, Renoir rented a room in rue Dragon not far from the apartment of his friend Edmond Maître (1840–1898) in rue Taranne (Daulte, p. 36).

As Cooper has pointed out (p. 168), *Woman with Parrot* is "so close in handling and conception" to Renoir's *Portrait of Mme Maître*, which bears a date of April 1871, that a coeval date can be safely assumed (130 x 83 cm [51 ⅛ x 32 ⅝ inches], Collection Mme René Lecomte, Paris). François Daulte dates both paintings April 1871 (p. 36).

Renoir chose the theme of a woman holding a parrot for the portrait of Lise, who was his mistress, and for the portrait of Rapha, then the mistress and later the wife of his friend, Edmond Maître. The subject had been depicted in the 1860s by Courbet, Manet, and Degas. In Manet's *Woman with a Parrot* (185.1 x 128.6 cm [72 ⅞ x 50 ⅝ inches], 1866, The Metropolitan Museum of Art, New York), the woman stands beside the bird. In a drawing by Degas (23.5 x 18.7 cm [9 ¼ x 7 ⅜ inches], ca. 1866, BN Carnet 8, p. 27, Bibliothèque Nationale, Paris; J. S. Boggs, *Portraits by Degas*, Berkeley and Los Angeles, 1962, no. 48, repr.), the parrot perches on the woman's finger, as it does in the Thannhauser painting.

The relationship between women and parrots can be traced back for centuries. Women were thought to share their secrets with parrots. In turn, parrots were believed to speak more readily to women and children than to men (P. Larousse, *Grand Dictionnaire universel du XIX⁵ siècle*, Paris, 1867, vol. XII, p. 657). In nineteenth-century France, these birds were common pets (see M. Hadler, "Manet's Woman with a Parrot of 1866," *Metropolitan Museum of Art Journal*, vol. 7, 1973, pp. 115–22).

Provenance:
C. Hoogendijk,[1] The Hague, until 1912 (Amsterdam, Frederik Muller & Cie, *Catalogue des tableaux modernes*, May 21–22, 1912, no. 57);

purchased at sale by Cassirer and Bernheim-Jeune;[2] acquired by C. Tetzen Lund, Copenhagen, before 1921; Galerie Barbazanges, Paris, 1922;[3] J. K. Thannhauser by 1927.

Condition:
Lined at an unknown date before 1965. Moderate impasto in some areas (the sitter's head and hands and the parrot), whereas the skirt of the woman's dress is thinly painted. All edges show signs of considerable wear. Old repair at lower right. Scattered areas of cleavage in background (Jan. 1975).

Exhibitions:
1912. Berlin, Paul Cassirer. *XV. Jahrgang I. Ausstellung.* Oct.–Nov. No. 39 (according to Gordon, 1974, vol. II, p. 619).

1913. Paris, Bernheim-Jeune. *Renoir.* March 10–29. No. 2.

1914. Dresden, Galerie Arnold. *Ausstellung Französischer Malerei des XIX Jahrhunderts.* April–May. No. 99.

1921. Oslo, Nasjonalgalleriet (arranged by Foreningen Fransk Kunst). *Renoir.* Feb. 12–March 6. No. 4 (lent by Chr. Tetzen-Lund and ex. coll. H. Cassirer). Traveled to Copenhagen, Ny Carlsberg Glyptotek, March 17–April 10, 1921, and Stockholm, Nationalmuseum, April 31–June 1.[4]

1. Cornelis Hoogendijk (1866–1911) acquired the pictures in his collection in Paris and other European cities before 1900. He also owned another of Renoir's paintings of Lise, *Baigneuse au griffon* (184 x 115 cm [73 ½ x 46 ⅛ inches], 1870, Museu de Arte Moderna, São Paulo; Daulte, no. 54). It is not known from whom Hoogendijk purchased either picture.

2. The painting remained with Cassirer, who sold it (correspondence with G. Gruet of Bernheim-Jeune, Nov. 1976). The fact that the painting was included in a catalogue of the Moderne Galerie (Heinrich Thannhauser) in Munich in 1916 indicates that it was with the gallery but it does not prove that Thannhauser owned the picture. J. K. Thannhauser's notes (Dec. 1972) do not add any information as to whether the Moderne Galerie owned the picture before 1927.

3. The Galerie Barbazanges lent the picture to an exhibition at the Louvre in 1922. According to the provenance in Daulte, the picture belonged to the Galerie Barbazanges after Tetzen Lund and before Thannhauser.

4. Information from correspondence with L. Østby, Oslo, Oct. 1976, L. Vestergaard of Statens Museum for Kunst, Copenhagen, Sept. 1976, and N. Weibull of Nationalmuseum, Stockholm, Feb. 1977.

1922. Paris, Palais du Louvre, Pavillon de Marsan. *Le Décor de la vie sous le Second Empire*. May 27–July 10. No. 149 (*Femme au Perroquet*, 1869, Galerie Barbazanges).

1927. Berlin, Künstlerhaus (organized by the Galerien Thannhauser). *Erste Sonderausstellung in Berlin*. Jan. 9–Feb. 15. No. 196, repr.

1938. Amsterdam, Stedelijk Museum. *Honderd Jaar Fransche Kunst*. July 2–Sept. 25. No. 200.

1939. Buenos Aires, Museo Nacional de Bellas Artes. *La pintura francesa de David a nuestros días*. July–Aug. No. 113. Traveled to Montevideo, Ministerio de Instrucción Pública, April–May 1940, and Rio de Janeiro, Museu Nacional de Belas Artes, June 29–Aug. 15.

1940–41. San Francisco, M. H. de Young Memorial Museum. *The Painting of France Since the French Revolution*. Dec. 1940–Jan. 1941. No. 88, repr.

1941. The Art Institute of Chicago. *Masterpieces of French Art*. April 10–May 20. No. 130, repr.

1941. Los Angeles County Museum. *The Painting of France Since the French Revolution*. June–July. No. 110.

1941. The Portland Art Museum. *Masterpieces of French Painting*. Sept. 3–Oct. 5. No. 91.

1942–46. Washington, D.C., The National Gallery of Art. On loan from Feb. 1942–July 1946 (correspondence with P. Davidock, Nov. 1973).

1946. Pittsfield (Mass.), The Berkshire Museum. *French Impressionist Painting*. Aug. 2–31. No. 20.

1955. Los Angeles County Museum. *Pierre Auguste Renoir*. July 14–Aug. 21. No. 9, repr. Traveled to San Francisco Museum of Art, Sept. 1–Oct. 2.

1990. Venice, Palazzo Grassi. Pp. 116–17, no. A31, color repr.

1992. The Montreal Museum of Fine Arts. Pp. 56–57, no. 1, color repr.

References:
Alazard, J. *Auguste Renoir*. Milan and Florence, 1953, no. 7, repr. (incorrectly states Hamburg Museum).

Basler, A. *Pierre-Auguste Renoir*. Paris, 1928, p. 15, repr. (1871).

Cooper, D. "Renoir, Lise and the Le Coeur Family: A Study of Renoir's Early Development—I. Lise." *The Burlington Magazine*, vol. CI, May 1959, pp. 168–69, and 171, and fig. 12 (*Girl Feeding a Bird {Lise}*, 1871).

Daulte. 1971, p. 36 and no. 65 (*La Femme à la perruche*, 1871).

Daulte, F. "Une Donation sans précédent: la collection Thannhauser." *Connaissance des Arts*, no. 171, May 1966, p. 62, repr.

Solomon R. Guggenheim Museum. *Masterpieces*. 1972, p. 22, repr. (ca. 1872).

Hausenstein, W. *Katalog der Modernen Galerie, Heinrich Thannhauser München*. Munich, 1916, repr. betw. pp. 20–21 (*Dame mit Papagei*).

"La Jeunesse de Renoir." *Connaissance des Arts*, no. 34, Dec. 15, 1954, p. 70, repr.

Meier-Graefe, J. *Renoir*. Leipzig, 1929, pp. 44, repr., and 437, no. 28 (1871–72).

Mirbeau, O. *Renoir*. Paris, Bernheim-Jeune, 1913, p. 55 and repr. opp. p. ii (*La Femme à la perruche*, 1868).

Osborn, M. "Klassiker der Französischen Moderne." *Deutsche Kunst und Dekoration*, vol. 59, March 1927, p. 347, repr.

Roger-Marx, C. *Renoir*. Paris, 1933 and 1937, p. 31, repr. (*La Femme à la perruche*, 1871, incorrectly states Musée de Hambourg).

Thiis, J. *Renoir*. Stockholm, 1944, p. 197, repr. (photo of 1921 exhibition of French art in Oslo).

Thomsen, O. *Chr. Tetzen-Lunds Samling af moderne fransk Malerkunst*. Copenhagen, 1934, no. 97 (*Dame avec un papegai*).

Vollard, A. "La Jeunesse de Renoir." *La Renaissance de l'art français et des industries de luxe*. Vol. I, May 1918, p. 17, repr. (*La Femme au Perroquet*, 1865).

Still Life: Flowers. *1885*
*(Nature morte: fleurs: Blumenstilleben: Still Life with
Flowers and Pot)*
78.2514 T70

Oil on canvas. 81.9 x 65.8 cm (32 ¹/₁ x 25 ⁷/ₐ inches)
Signed and dated lower right: Renoir. 85.

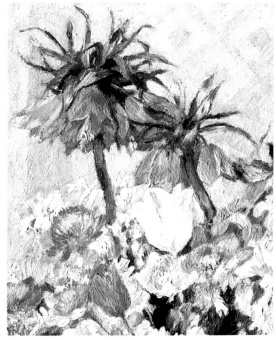

Detail. Full image on page 51.

The year 1885 belongs within the period that
Renoir's style became more severe and solid. From
1884 through 1887 he worked at resolving
questions of line and color. In September and
October 1885 Renoir wrote to Paul Durand-Ruel:
"J'ai beaucoup perdu de temps à trouver une
manière dont je sois satisfait. Je pense avoir fini de
trouver, et tout marchera bien" (L. Venturi, *Les
Archives de l'Impressionisme*, Paris, 1939, vol. I, p.
132). ("I've lost a great deal of time trying to find a
style with which I could be satisfied. I think I have
finally found it, and everything will go well.")

Although Renoir maintained a studio in Paris,
he traveled considerably. In 1885 he was in Paris at
the time of the birth of his son, Pierre, on March
21; at La Roche-Guyon from June 15 to July 11
(where Cézanne came to join him); in Wargemont
for July; back at La Roche-Guyon during August;
at Essoyes during September–October; early
November at Wargemont; and from November
20–30 in Paris, where his home was at 18, rue
Houdon and his studio at 37, rue de Laval.

Still Life: Flowers is closest to *Still Life: Flowers*

and Prickly Pears (73 x 56.5 cm [28 ¹/₄ x 23 ¹/₄
inches], usually dated 1884, present whereabouts
unknown; New York, Sotheby Parke Bernet, *Highly
Important Impressionist . . . Paintings . . . from the
Estate of the late W. W. Crocker*, Feb. 25, 1970, no. 8,
color repr.), which depicts the same vase and a
similar background and table. In the Thannhauser
painting, Renoir omitted the fruit and cloth on the
table and subdued the color and pattern of the
background. The present picture is distinguished
by restrained colors and firmly delineated contours.
Daniel Catton Rich thought that the Thannhauser
Still Life reflected Renoir's contact with Cézanne.

The present picture is actually dated 1885;
Gladioli, a similar work, bears the date 1884 (66 x
54 cm [26 x 21 ¹/₄ inches], ex. coll. Sam Salz, now
Collection Mr. George L. Simmonds, Chicago; New
York, Duveen Galleries, *Renoir Centennial Loan
Exhibition*, exh. cat., 1941, pl. 51). Another related
version is *Roses and Gladioli* (74.3 x 54 cm [29 ¹/₄ x
21 ¹/₄ inches] present whereabouts unknown; New
York, Bignou Gallery, *Renoir*, exh. cat., 1935, pl.
4), which is inscribed "au docteur Latty, souvenir
d'amitié." Since Dr. Latty is the one who delivered
Pierre in March 1885, it can be assumed that the
picture was probably executed in 1885.

Provenance:
Acquired by J. E. Blanche, probably from the art-
ist; Walther Halvorsen, Oslo;[2] Leicester Galleries,
London, by 1926?;[3] J. K. Thannhauser by 1927.

Condition:
There is a thick, glossy, natural resin varnish on the
surface that may be original. Scattered areas of
lifting paint have been consolidated in the past. In
1986, the painting was cleaned of grime and the
discolored varnish thinned very slightly in the area
of the vase. In 1990, a linen loose-lining or dry
backing was placed on the stretcher to provide
support for the heavy paint layer and fine original
linen (March 1992).

1. Jacques-Emile Blanche (1861–1942), once the pupil of
Renoir, purchased Renoir's *Bathers* in 1889 from the artist
(White, 1969, p. 344, fn. 98) and sold it in 1928.
2. According to notes made by J. K. Thannhauser,
Dec. 1972. See also p. 184, fn. 4.
3. See Exhibitions. However, it is not known whether the
painting belonged to the Leicester Galleries.

Exhibitions:
1926. London, Leicester Galleries. *Catalogue of the
Renoir Exhibition*. July–Aug. No. 3, repr. (*Fleurs*,
dated 1885).

1927. Berlin, Künstlerhaus (organized by the
Galerien Thannhauser). *Erste Sonderausstellung in
Berlin*. Jan. 9–Feb. 25. No. 198, repr. (*Blumen-
stilleben*).

1955. Los Angeles County Museum. *Pierre Auguste
Renoir*. July 14–Aug. 21. No. 33. Traveled to San
Francisco Museum of Art, Sept. 1–Oct. 2.

1958. Santa Barbara Museum of Art. *Fruits and
Flowers in Painting*. Aug. 12–Sept. 14. No. 50, repr.

1990. Venice, Palazzo Grassi. Pp. 118–19, no. A32,
color repr.

References:
Solomon R. Guggenheim Museum. *Masterpieces*,
1972, p. 26, repr.

Meier-Graefe, J. *Renoir*. Leipzig, 1929, pp. 177,
repr., and 441, no. 171 (*Blumen*, 1885).

White, B. E. "The Bathers of 1887 and Renoir's
Anti-Impressionism." *The Art Bulletin*, vol. LV,
March 1973, p. 107, fn. 8.

————. *Renoir: His Life, Art, and Letters*. New
York, 1984, p. 155, repr.

————. "Renoir's Trip to Italy." *The Art Bulletin*,
vol. LI, Dec. 1969, pp. 344–45, fn. 99.

Henri-Marie-Raymond de Toulouse-Lautrec-Monfa

Born November 1864. Albi (Tarn)
Died September 1901. Château of Malromé (Gironde)

Au Salon. 1893
(Intérieur: Im Salon)
78.2514 T73

Pastel. gouache. and pencil on cardboard. 53 x 79.7 cm
(20 ⁷/₈ x 31 ⅛ inches)
Signed lower right: H. T. Lautrec.
Not dated.

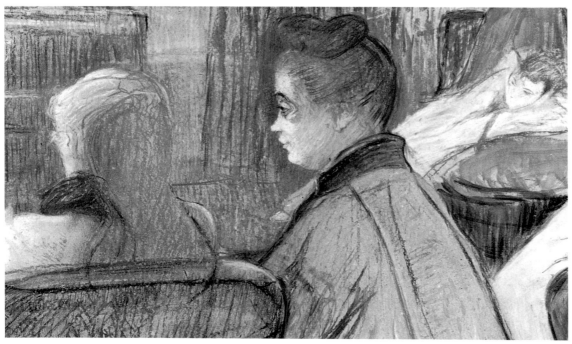

Detail. Full image on page 52.

The salon depicted is that of a brothel in Paris, probably the one at 24, rue des Moulins (see D. Cooper, *Henri de Toulouse-Lautrec*, New York, 1956, p. 118, and J. Bouret, *Toulouse-Lautrec*, Paris, 1963, p. 137 and 140). From 1892 through 1895 Lautrec frequently represented scenes from the brothels and even lived in one for a time.

The red circular divan appears also in *In the Salon* (Dortu P.502; 60 x 80 cm [23 ⁵/₈ x 31 ½ inches] Museu de Arte, São Paulo, Brazil) and in *Women Playing Cards* (Dortu P.505; 57.5 x 46 cm [22 ³/₄ x 18 ⅛ inches], Collection Dr. Hahnloser, Bern). The woman in the middle of the Thannhauser picture is seen frontally in the center of the São Paulo version. This model (with her hair pulled up in a bun on top of her head) can be found again at the far right in *Ces dames au réfectoire* (Dortu P.499; 61 x 81 cm [24 ⅛ x 32 inches], The Museum of Fine Arts, Budapest; F. Novotny, *Toulouse-Lautrec*, London, 1969, color pl. 76). In the present picture and in the related works, all generally dated 1893, Lautrec conveys the boredom experienced by the prostitutes.

There are drawings for the women in the foreground of the Thannhauser pastel. The woman at the left appears in the same pose in a blue-pencil drawing in a private collection (14.7 x 23.2 cm [5 ⅞ x 9 ¼ inches]; Dortu, vol. VI, D.4.046, where it is incorrectly identified as *Femme assise de dos, au theatre* and dated ca. 1895). Likewise, three drawings for the woman seen in profile in the center should be related to the present picture (D.4.045, 4.047, and 4.048 in Dortu, vol. VI, pp. 692–93, where they are dated ca. 1895 rather than 1893).

Provenance:
Heim, Munich,[1] until 1913 (Paris, Hôtel Drouot, *Catalogue de tableaux . . . par H. de Toulouse-Lautrec*, April 30, 1913, no. 3, repr. [*Au Salon*]); acquired at sale by Georges Bernheim, Paris; S. Sévadjian until 1920 (Paris, Hôtel Drouot, *Catalogue des tableaux modernes . . . formant la collection de M.S. . . . S. . . ,* March 22, 1920, no. 22, repr. [*Intérieur*, 52 x 80 cm]); Baron Lafaurie by 1926; Mlle Lucie Callot (acc. to Dortu); J. K. Thannhauser.

Exhibitions:
1943. Kunsthaus Zürich. *Ausländische Kunst in Zürich.* July 25–Sept. 26. No. 694[2] (*Au Salon*, 80 x 52.7 cm).

1956. New York, The Museum of Modern Art. *Toulouse-Lautrec.* March 20–May 6. No. 27 (*The Salon*, 1893).

References:
Camesasca, E. *Trésors du Musée d'Art de São Paulo: De Manet à Picasso.* Exh. cat., Fondation Pierre Gianadda. Martigny, 1988, pp. 226 and 228, repr. (ca. 1893, 78 x 51 cm). Italian edition, Milan, 1988.

Daulte, F. "Une Donation sans précédent: la collection Thannhauser." *Connaissance des Arts*, no. 171, May 1966, p. 67, repr.

Dortu, M. G. *Toulouse-Lautrec et son oeuvre.* New York, 1971, vol. II, P.500, pp. 306–07, repr. (*Au Salon*, 1893).

Fougerat, E. *Toulouse-Lautrec.* Paris [1955], pl. vii.

Solomon R. Guggenheim Museum. *Masterpieces.* 1972, p. 37, repr.

Jedlicka, G. *Henri de Toulouse-Lautrec.* Zurich, 1943, repr. opp. p. 207 (*Im Salon*, 1893).

Joyant, T. *Henri de Toulouse-Lautrec.* Paris, 1926, p. 283 (*Au Salon*, 1893).

Sugana, G. M. *The Complete Paintings of Toulouse-Lautrec.* London, 1973, p. 108, no. 351 (1893).

1. Among twenty works by Toulouse-Lautrec, Heim owned two works related to the present picture (Dortu P.499 and P.505). How and when Heim obtained them is not known but they were all sold in Paris in 1913.

2. No records exist at the Kunsthaus indicating who owned the picture in 1943 (notes by E. Billeter, Feb. 1977). However, the exhibition title suggests a previous owner rather than J. K. Thannhauser.

Vincent van Gogh
Born March 1853, Groot-Zundert, the Netherlands
Died July 1890, Auvers-sur-Oise

Roadway with Underpass. 1887
(Le Viaduc; The Viaduct; Viaduct at Asnières; Tunnel)
78.2514 T17

Oil on cardboard, mounted on panel. 32.7 x 41 cm
(12⅞ x 16⅛ inches)
Not signed or dated.

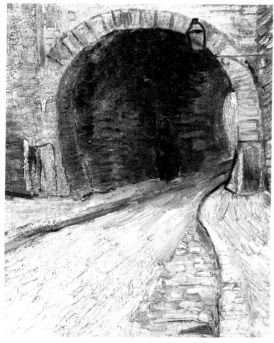

Detail. Full image on page 59.

Van Gogh must have painted *Roadway with Underpass*, formerly titled *The Viaduct*, in the early autumn of 1887. Although J.-B. de la Faille (1928, vol. I, p. 71) recognized the foliage as autumnal, the recent edition of de la Faille (1970, p. 122) places the picture in the early summer. According to Bogomila Welsh-Ovcharov (correspondence, Oct. 1977), the systematic dotting and parallel brushwork found in the Thannhauser painting cannot predate 1887. The dots of red and green pigment in the foliage at the upper left imply van Gogh's knowledge of Divisionist technique.

Welsch-Ovcharov has identified the subject of the picture as the fortifications between Montmartre and Asnières, where Vincent painted several watercolors in the summer of 1887 (de la Faille 1401, 1402, 1403, and 1410). More specifically it represents a *poterne*, or covered masonry underpass. Originally there were approximately ninety underpasses allowing entrance to or exit from Paris through these fortifications. Frequently a tollhouse or guardhouse structure, complete with chimneys for heating, was located on

the city side of the underpass. The presence of two chimneys in the Thannhauser oil would confirm Welsh-Ovcharov's identification of the site. Although the *poternes* no longer exist, a photograph of a *poterne* from the turn of the century displays two chimneys, a lantern, and lateral embankments similar to those in the present work. In the Thannhauser painting the view is toward Paris. (I am indebted to Bogomila Welsh-Ovcharov for providing all of the above information.)

The present picture brings to mind *The Railway Bridge over Avenue Montmajour* (de la Faille 480; Arles, Oct. 1888) or *The Iron Bridge at Trinquetaille* (de la Faille 481; Oct. 1888) and even foreshadows *A Passage at Saint Paul's Hospital* (de la Faille 1529; May–early June 1889, The Museum of Modern Art, New York).

Provenance:
Unknown Russian collector acting for Galerie Charpentier, Paris;[1] Galerie Hans Bamman, Düsseldorf, by 1927; J. K. Thannhauser, Berlin, by 1937.

Condition:
At an unrecorded date before 1965 the cardboard was mounted with glue onto a paper-veneered panel with wood center. Panel has a double warp. Cracks in pigment and some abrasion (Jan. 1975).

Exhibitions:
1955. New York, Wildenstein and Co. *Van Gogh*. March 24–April 30. No. 21, repr.

1956. The Art Center in La Jolla (Calif.). *Great French Paintings 1870–1910*. June 15–July 26. No. 24, repr.

1961. San Antonio, The Marion Koogler McNay Art Institute. *A Summer Exhibition*. June–Aug. No. iv, repr.

1964. New York, Solomon R. Guggenheim Museum. *Van Gogh and Expressionism*. July 1–Sept. 13. [P. 3.]

1990. Venice, Palazzo Grassi. Pp. 76–77, no. A11, color repr.

References:
de la Faille. 1928, vol. I, p. 71, no. 239, and vol. II, pl. lxiv (*Le viaduc*, coll. Hans Bamman, Düsseldorf).

de la Faille, J.-B. "Unbekannte Bilder von Vincent van Gogh." *Der Cicerone*, Jg. XIX, Feb. 1927, pp. 102 and 104, repr. (*Tunnel*, ca. 1887, coll. Hans Bamman, Düsseldorf).

de la Faille. 1939, p. 280, no. 385, repr. (Galerie Thannhauser, Berlin).

_____. 1970, pp. 122–23, repr., and 620, no. 239 (*The Viaduct*).

Solomon R. Guggenheim Museum. *Masterpieces*, 1972, p. 27 (*The Viaduct*).

Hulsker. 1980, pp. 278 and 283, no. 1267, repr. (*Viaduct*, assigned to spring 1887).

Lecaldano, P. *L'opera pittorica completa di Van Gogh*. Milan, 1971, vol. I, pp. 114–15, no. 385, repr.

Testori, G., and L. Arrigoni. *Van Gogh: Catalogo completo dei dipinti*. Florence, 1990, p. 186, no. 427, repr. (*Viadotto*).

Walther, I. F., and R. Metzger. *Vincent van Gogh: Sämtliche Gemälde*. Cologne, 1989, p. 249, color repr. (*Viadukt in Paris*).

Welsh-Ovcharov, B. *Vincent van Gogh: His Paris Period 1886–1888*. Utrecht and the Hague, 1976, p. 234 (*The Viaduct*: colors of the painting suggest an autumn date).

1. According to de la Faille (1970, p. 616), the unknown Russian collector mentioned as the first owner acted in fact for the Galerie Charpentier. However, according to R. Nacenta (correspondence, May 1975) it was never at the Galerie Charpentier.

Vincent van Gogh

Landscape with Snow, *late February 1888*
(*Paysage enneigé; Paysage de banlieue; Le pays d'Arles
sous la neige; Helle Landschaft; Landschaft*)
84.3239

Oil on canvas, 38.2 x 46.2 cm (15 1/16 x 18 3/16 inches)
Not signed or dated.

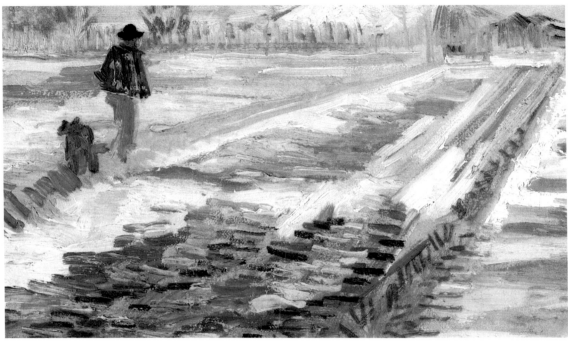

Detail. Full image on page 58.

Landscape with Snow and *Roadway With Underpass* (see p. 169) first came to light in 1927, when they were exhibited at the Galerie Hans Bamman in Düsseldorf and then published with four other van Gogh paintings by J.-B. de la Faille in *Der Cicerone*. Although de la Faille had not been aware of the six works when he prepared the manuscript for his catalogue raisonné, he included them in later editions. When the present picture was exhibited in Düsseldorf, it was titled *Helle Landschaft*. Likewise, de la Faille (1927, p. 102) referred to its bright hues, which he attributed to the influence of French art and related to the high-keyed colors of van Gogh's Arles pictures from 1888–89. De la Faille considered this landscape with snow to have been painted in the outskirts of Paris and dated it ca. 1888. By the 1950s, the Thannhauser work was considered to have been done in Arles. Only in the 1970 edition of de la Faille, however, was *Landscape with Snow* assigned a revised date of February 1888 and catalogued with the works painted in Arles.

On February 21, 1888, the day after he arrived in Arles, the artist wrote to his brother, Theo, "...

there's about two feet of snow everywhere, and more is still falling. . . . But here in Arles the country seems flat" (*CLVG*, II, p. 525, Letter 463). In Letter 464 (dated ca. February 25 by Hulsker in "Van Gogh's Extatische Maanden in Arles," *Maatstaf*, Jg. 8, Aug.–Sept. 1960, pp. 354) van Gogh states: "... I have finished three studies ..." and identifies them in a postscript as "an old Arlésienne, a landscape in the snow, a view of a bit of a pavement with a pork-butcher's shop" (*CLVG*, II, pp. 525–27). He refers again to the cold in Letter 466 (dated ca. March 3 by Hulsker): "Down here it is freezing hard and there is still some snow left in the country. I have a study of a landscape in white with the town in the background. Then two little studies of an almond branch already in flower in spite of it" (*CLVG*, II, p. 529). Only in Letter 467 (dated ca. March 4–9 by Hulsker) did he write to Theo, "This morning, at long last, the weather changed and turned milder. . . . The sky is a hard blue with a great bright sun which has melted almost all the snow. . ." (*CLVG*, II, p. 529).

Jan Hulsker (1980, p. 306) assumes that in

Letters 464 and 466 the artist was referring to another landscape with snow, *Snowy Landscape with Arles in the Background* (de la Faille 391; 50 x 60 cm [19 5/8 x 23 5/8 inches], private collection), and that the present painting was made when the snow was melting during the week of March 4–10. However, in comparing the Thannhauser landscape with the larger canvas titled *Snowy Landscape with Arles in the Background*, a town appears only in the background of the latter work. They are the two known snowy landscapes identified with Arles.

Ronald Pickvance (conversation, Feb. 1985) believes that the Thannhauser picture is the earlier of the two and that it was probably painted *sur le motif*. He proposes that the present work was painted by February 24 and that *Snowy Landscape with Arles in the Background* was probably made on Sunday, February 26 (Pickvance, *Van Gogh in Arles*, 1984, p. 43). Although neither canvas bears a date, the picture in the private collection is signed. In *Landscape with Snow* the grass in the foreground is difficult to read in relation to the figures in the field (a man and dog) and the white houses in the background. The sketchiness and tentativeness of the present picture have been resolved in the bold foreground and more stylized composition of the larger *Snowy Landscape with Arles in the Background*. (I am grateful to Ronald Pickvance and Susan Alyson Stein for their assistance.)

Provenance:
Unknown Russian collector acting for Galerie Charpentier, Paris;[1] Galerie Hans Bamman, Düsseldorf, by 1927; J. K. Thannhauser, Berlin, probably by 1937–until 1976; Mrs. Justin K. Thannhauser, Bern, 1976–84.

Condition:
The painting was lined with an aqueous-type adhesive onto a primed linen canvas at an unknown date. There are a number of damages in the sky, notably a diagonal one in the sky above the trees at the top left. The painting was cleaned in 1985 (March 1992).

1. According to de la Faille (1970, p. 616). See Provenance for preceding catalogue entry.

Exhibitions:
1927. Düsseldorf, Galerie Hans Bamman. *Alte Meister: Deutsche und französische Kunst des 19. Jahrhunderts*. Autumn. N.p., repr. (*Helle Landschaft*).

1956. Raleigh, The North Carolina Museum of Art. *French Painting of the Last Half of the Nineteenth Century*. June 15–July 29. N.p. (*Paysage près d'Arles*).

1978. Kunstmuseum Bern. *Sammlung Justin Thannhauser*. June 8–Sept. 16. Exh. cat., pp. 51, no. 14, color repr., and 108 (*Paysage enneigé*).

1990. Venice, Palazzo Grassi. Pp. 78–79, no. A12, color repr.

References:
Aletrino, P. *Tout Van Gogh*. Paris, 1981, p. 12, no. 377, repr.

de la Faille. 1928, vol. I, p. 84, no. 290, and vol. II, pl. lxxix (Paris: *Paysage de banlieue*).

de la Faille, J.-B. "Unbekannte Bilder von Vincent van Gogh." *Der Cicerone*, Jg. XIX, Heft 3, Feb. 1927, pp. 102 and 105, repr. (*Landschaft*, ca. 1888).

de la Faille. 1939, p. 272, no. 371, repr. (Paris: *Paysage de Banlieue*).

————. 1970, pp. 245, no. 290, repr., and 622 (*Landscape with Snow*).

Elgar, F. *Van Gogh*. Paris, 1958, pp. 77, color repr., 100, and 306 (*Le pays d'Arles sous la neige*).

Hulsker. 1980, pp. 306–07, no. 1360, repr.

————. *Vincent and Theo Van Gogh: A Dual Biography*. Ed. J. M. Miller. Ann Arbor, 1990, p. 263.

Lecaldano, P. *L'opera pittorica completa di Van Gogh*. Milan, new series 1977, vol. II, pp. 204–05, no. 465, repr.

Pickvance, R. *Van Gogh in Arles*. Exh. cat., The Metropolitan Museum of Art, New York, 1984, pp. 41 and 43.

Walther, I. F., and R. Metzger. *Vincent Van Gogh: Sämtliche Gemälde*. Cologne, 1989, pp. 310–11, repr.

2. Although the catalogue identifies the picture as de la Faille 371 (which must refer to the 1939 edition) and provides incorrect dimensions, there is evidence that this canvas was the one exhibited in Raleigh. The work itself bears a label from the North Carolina Museum of Art and the title *Winter Landscape* appears in the museum's files for this exhibition (correspondence with C. H. Hedrick, Oct. 1990).

Vincent van Gogh Letter to John Peter Russell. *April 1888*
78.2514 T18 *Ink on laid paper. 20.3 x 26 cm (8 x 10 ¼ inches)*
No watermark.
Not dated.

My dear Russell,[1] I ought to have answered your letter ever so long ago[2] but working pretty hard every day at night I feel so often too weary to write. As it rains to day I avail myself of the opportunity. Last Sunday I have met MacKnight[3] and a Danish painter[4] and I intend to go to see him at Fonvieille[5] next Monday. I feel sure I shall prefer him as an artist to what he is as an art critic his vieuws as such being so narrow that they make me smile.

I heartily hope for you that you will be able to leave Paris for good soon and no doubt leaving Paris will do you *a world of good* in all respects.[6] As for me I remain enraptured with the scenery here am working at a series of blooming orchards.[7] And unvoluntarily I thought often of you because you did the same in Sicily.[8] I wished you would one day or another when I shall send over some work to Paris exchange a Sicilian study with me—in case you should have one to spare—

You know I thought and think such a deal of

1. The letter is transcribed as van Gogh wrote it. H. Thannhauser (*L'Amour de l'Art*, p. 285, fn. 2) states that Russell's name was crossed out by his son-in-law.

2. See letter 466 (*CLVG*, II, pp. 528–29). In Letter 473 (dated ca. April 1, by Hulsker, 1960, p. 334), van Gogh tells Theo: "I think that Russell is trying to reconcile me with [Alexander] Reid, and that he wrote the letter expressly for that purpose. I shall certainly write Russell and tell him that I have told Reid frankly that he made a foolish mistake in loving dead pictures and completely neglecting living artists, and that moreover I hoped to see him change, at least in that respect" (*CLVG*, II, p. 540).

3. Hulsker (p. 332) thinks that "last Sunday" must be April 22, 1888. The American painter, Dodge MacKnight (1860–1950), arrived in Paris at the end of 1883 and studied at Cormon's studio in 1884. According to D. Adlow (Boston, Museum of Fine Arts, *Dodge MacKnight*, exh. cat., 1950, pp. 9–11), MacKnight first met van Gogh at Cormon's. Van Gogh mentions the American painter in Letters 479–82, 485, 498, 502, 505, 506, 514, 516, and 528 and frequently refers to him as Russell's friend.

4. Christian Vilhelm Mourier-Petersen (1858–1945). Van Gogh made his acquaintance in March, and Mourier-Petersen left late in May for Paris, where he stayed with Theo. He is mentioned in Letters 468, 469, 474, 476, 482, 488–90, 496, 498, 502, 507, and 515.

5. Fontvieille, where MacKnight stayed, is 9 km from Arles.

6. Russell left Paris in the summer of 1888 to live at Belle-Ile (correspondence with Galbally, Oct. 1976).

7. For example, de la Faille 404, 405, and 552–56. Compare with Letter IV to Bernard (D. Lord, pseud. for D. Cooper, ed., *Vincent van Gogh: Letters to Emile Bernard*, London, 1938, p. 29, fn. 8).

8. Russell was in Sicily in the autumn of 1886.

those of yours I don't gainsay that your portraits are more serious and higher art but I think it meritory in you and a rare quality that together with a perfection as appeared to me the Fabian and McKnight portraits[9] you are at the same time able to give a Scherzo the adagio con expressione the gay note in one word together with more manly conceptions of a higher order. And I so heartily hope that you will continue to give us simultanément both the grave and elaborate works and those aforesaid scherzos.—Then let them say if they like that you are *not always* serious or that you *have* done work *of a lighter sort*—So much the worse for the citics [critics] & the better for you.

I have heard nothing of our friend Mr. Reid.[10] I felt rather anxious on his account because I feel sure that he was on a false track. My brother has received a letter of him but pretty unsatisfactory.

I was very much taken in by him during the first 6 weeks or 2 months but after that period he was in pecuniary difficulties and in the same acted in a way that made on me the impression that he had lost his wits.[11]

Which I still think was the case and consequently he not responsable even if his doings then were pretty unfair. He is very nervous—as we all are—and can't help being so—He is prompted to act in his crisis of nerves to make money . . . whilst painters would make pictures . . .

So much to say that I consider *the dealer stronger* in him than *the artist* though there be a battle in his conscience concerning this—of the which battle I do not yet know the result. So much—pour votre

gouverne—as I had the pleasure of introducing him to you feel bound to warn you with the same sympathy however for him because I found him artistic in pleading the monticelli cause.[12]

In the which I took and take my part Witnessing the very scenery which inspired Monticelli I maintain this artists rights to public though too late appreciation.[13]

Surely Monticelli gives us not neither pretends to give us local colour or even local truth. But gives as something passionate and eternal—the rich colour and rich sun of the glorious South in a true colourists way parallel with Delacroix conception of the South Viz that the South be represented now by contraste simultané of colours and their derivations and harmonies and not by forms or lines in themselves as the ancient artists did formerly by pure *form* greeks & Michel Ange or by pure line or delineation Rafael Mantegna Venetian *primitifs* (Botticelli Cimabue Giotto Bellini.)

Contrariwise the thing undertaken by P. Veronese & Titian—Colour. The thing undertaken by Velasquez and Goya to be continued and—more fully or rather more universally done by the more universal knowledge we have & possess of the colours of the prism and their properties.

Hoping to write to you again and to hear of you pretty soon!

Yours very truly,
Vincent

The painter John Peter Russell was born in Sydney in 1858 of wealthy Australian parents. He went to Paris in 1885 following three years of study in London. It is most likely that Russell and van Gogh first met at the atelier of Fernand-Anne Piestre, called Cormon, at 104, boulevard de Clichy (Galbally, p. 29). Russell had been at Cormon's atelier since the beginning of 1885, and van Gogh was there in the spring and/or autumn of 1886 (see B. Welsh-Ovcharov, *Vincent van Gogh: His Paris Period 1886–1888*, Utrecht and the Hague, 1976, pp. 12–13 and 209–12). Vincent lived with his brother Theo at 54, rue Lepic, which was near Russell's home at 73, boulevard de Clichy and his studio at 15, impasse Hélène, which was part of the Villa des Arts (correspondence with Galbally, Oct. 1976). Russell knew Anne Marie Mattiocco from ca. 1885 and decided in 1886 to have a house built on Belle-Ile off the coast of Brittany. He actually left Paris to live on Belle-Ile in 1888. Russell invited several painters to visit him there: Monet and Matisse as well as van Gogh (who never went). Russell returned to Australia in 1921 with his second wife, and he died there in 1931 (information from Galbally, 1976, and D. Finley in *John Peter Russell*, exh. cat., Wildenstein and Co., Ltd., London, 1965 [pp. 2–6]).

Russell's *Portrait of van Gogh* (60 x 45 cm [23 5/8 x 17 3/4 inches], Rijksmuseum Vincent van Gogh, Amsterdam; *CLVG*, II, p. 548, color repr.) probably dates from 1886, after van Gogh arrived in Paris (by early March) and became acquainted with Russell but before Russell's departure for Italy

9. Russell's *Portrait of Fabian* (64.8 x 63.2 cm [25 1/2 x 24 7/8 inches]) was given to the Fogg Art Museum, Harvard University, Cambridge, Mass., in 1956 by Mr. and Mrs. Justin K. Thannhauser in memory of their son Heinz H. Thannhauser. According to MacKnight's letters to Russell, Fabian was a Spanish painter (*L'Amour de l'Art*, p. 285, fn. 6). He appears in a photograph taken at Cormon's atelier ca. 1883–85, where he probably met Russell (see B. Welsh-Ovcharov, *Vincent van Gogh: His Paris Period 1886–1888*, Utrecht and the Hague, 1976, pp. 22, 56 fn. 26, and fig. 1b, and M. Joyant, *Henri de Toulouse-Lautrec 1864–1901*, Paris, 1926, p. 58). Van Gogh and Fabian may have exchanged paintings since a landscape, *Roadway with Fence*, bearing Fabian's signature belonged to Theo (Welsh-Ovcharov, fig. 1c, and Amsterdam, Stedelijk Museum, *Collectie Theo van Gogh*, exh. cat., 1960, no. 34).

Russell's *Portrait of Dodge MacKnight* 55.9 x 48.2 cm (22 x 19 inches) belongs to the latter's niece, Mrs. George W. Bruce, West Barnstable, Mass. (correspondence, Sept. 1976).

10. Alexander Reid (1854–1928) went to Paris in 1887 and joined the firm of Boussod et Valadon with which Theo van Gogh was associated. Vincent undoubtedly met Reid through his brother, and he painted the Scot's portrait twice in 1887 (de la Faille 270 and 343). After returning to Glasgow in 1889, Reid opened a gallery, La Société des Beaux-Arts. Van Gogh refers to Reid in Letters 464, 465, 472, 473, 482, 506, 511, 512, and 597.

11. See also Letter 464 in which van Gogh mentions that Reid has been "right good company for the first few months" (*CLVG*, II, p. 526).

It is said that Vincent and Reid shared rooms together for a time until one evening Vincent proposed a suicide pact and Reid left soon thereafter (see T. J. Honeyman, "Van Gogh: A Link with Glasgow," *The Scottish Art Review*, vol. II, no. 2, 1948, p. 17, and R. Pickvance, "A Man of Influence: Alex Reid," *The Scottish Art Review*, vol. XI, no. 3, 1968, p. 6).

12. Van Gogh refers frequently to Adolphe Monticelli

(1824–1886). A letter written to Theo from Arles makes it clear that both he and Reid were interested in purchasing works by Monticelli and that they were competitors rather than partners in their efforts to obtain works by Monticelli (*CLVG*, II, Letter 464, p. 526). For references to Monticelli, see Letters 463, 464, 471, 478, 496, 507, 508, 541, 542, 550, 558a, and 574. Van Gogh had seen Monticelli's paintings first at the gallery of Joseph Delarebeyrette at 43, rue de Provence and then at Boussod et Valadon. Theo owned five pictures by Monticelli in addition to the one given to him by Reid. See A. M. Alauzen and P. Ripert, *Monticelli: sa vie et son oeuvre*, Paris, 1969, pp. 441–48.

13. Monticelli lived in Marseilles; thus, the south of France is intended. In Letters 541 and 558a Vincent expresses his own sense of continuing Monticelli's work. In Letter 558a he asks Theo: "What do De Haan and Isaäcson say about Monticelli? Have they seen other pictures of his than those in your house? You know that I myself still have the pretension to continuing the job that Monticelli started here" (*CLVG*, III, p. 97).

that autumn. The following year the two artists were both in Paris in the late spring–early summer and the rest of 1887 until van Gogh left for Arles in February 1888 (Galbally, p. 32).

From Vincent's letters to Theo it is evident that he wrote many letters to Russell. Justin Thannhauser's son Henry estimated that Russell must have destroyed at least a dozen letters from van Gogh (*The Burlington Magazine*, p. 96). There are no letters from van Gogh among the surviving Russell papers (correspondence with Galbally, Aug. 1976).

Henry Thannhauser, who was the first to write about van Gogh's letters to the Australian, pointed out that "though one of his [van Gogh's] motives was the desire to help Gauguin by persuading Russell to buy one of the latter's paintings, the correspondence in general shows a continuity of friendship which is a moving trait in the lonely Van Gogh: a trait well known to us already through the letters to Van Rappard and Emile Bernard" (*The Burlington Magazine*, p. 96). Letters 466, 467, 494a, 496, 506, 514–16, and 536 all refer to persuading Russell to purchase a painting by Gauguin.

Two of the letters in the Thannhauser Collection are written in English. Van Gogh's correspondence in English is otherwise extremely rare and limited to two postcards (Letters 196 and 203), a letter to the English painter Levens (Letter 459a), a letter to Van Rappard (R5), and his sermon (*CLVG*, I, pp. 87–91). Scattered phrases and sentences in English appear in letters primarily written in French or Dutch. Van Gogh lived in England for periods of time between 1873 and 1876 but he knew English even before the trips (*CLVG*, I, p. 3).

The present letter dates from April 1888 not long after van Gogh went to Arles. Hulsker places it after Letter 479, that is, about April 24–28. Henry Thannhauser dated it early in April (*The Burlington Magazine*, p. 97, fn. 24). MacKnight's letters, which might validate a more precise date, were known to Thannhauser in 1938 but probably no longer exist.

Provenance:
Received from the artist by John Peter Russell (d. 1931), 1888; inherited from Russell by his daughter, Jeanne Jouve, Paris, probably 1931–32;

acquired from Jouve by J. K. Thannhauser, Paris, probably 1938–39 (notes Dec. 1972).

Exhibitions:
1955. New York, Wildenstein and Co. *Van Gogh*. March 24–April 30. No. 110.

1984. New York, The Metropolitan Museum of Art. *Van Gogh in Arles*. Oct. 18–Dec. 30. Exh. cat. by R. Pickvance, p. 252, no. 150, color repr.

References:
CLVG. 1958, vol. II, Letter 477a, pp. 546–48.

Galbally, A. "Amitie: Russell and Van Gogh." *Art Bulletin of Victoria*, 1976, p. 32.

Graber, H., ed. *Vincent Van Gogh: Briefe an Emile Bernard, Paul Gauguin, John Russell, Paul Signac und Andere*. Basel, 1941, pp. 119–22 (German trans.).

Solomon R. Guggenheim Museum. *Masterpieces*. 1972, p. 28, repr.

Hulsker, J. "Van Gogh's Extatische Maanden in Arles." *Maatstaf*, Jg. 8, Aug.–Sept. 1960, pp. 332 and 334 (ca. April 24–28, 1888).

Lubin, A. J. *Stranger on the earth: A Psychological Biography of Vincent van Gogh*. 1972. Reprint, New York, 1987, p. 150.

Thannhauser, H. "Documents inédits: Vincent van Gogh et John Russell." *L'Amour de l'Art*, XIXᵉ année, Sept. 1938, pp. 285–86 (early April).

———. "Van Gogh and John Russell: Some Unknown Letters and Drawings." *The Burlington Magazine*, vol. LXXIII, Sept. 1938, pp. 96–97 (early April).

Wheldon, K. *Van Gogh*. London, 1989, p. 90.

Vincent van Gogh

Letter to John Peter Russell, *late June 1888*
78.2514 T19

Ink on wove paper, 20.3 x 26.3 cm (8 x 10 ⅜ inches)
Watermark: L-J D L&C
Not dated.

My dear Russell[1] for ever so long I have been wanting to write to you—but then the work has so taken me up. We have harvest time here at present and I am always in the fields.[2]

And when I sit down to write I am so abstracted by recollections of what I have seen that I leave the letter.[3] For instance at the present occasion I was writing to you and going to say something about Arles as it is—and as it was in the old days of Boccaccio.—

Well instead of continuing the letter I began to draw on the very paper the head of a dirty little girl[4] I saw this afternoon whilst I was painting a view of the river with a greenish yellow sky.[5]

This dirty "mudlark" I thought yet had a vague florentine sort of figure like the heads in the monticelli pictures,[6] and reasoning and drawing this wise I worked on the letter I was writing to you. I enclose the slip of scribbling. that you may judge of my abstractions and forgive my not writing before as such.

1. The letter is printed as van Gogh wrote it and differs slightly from the transcription in *CLVG*, II, pp. 592–94. Russell's name has been crossed out in ink in the same manner as in the earlier letter (see p. 172, fn. 1).

2. Van Gogh mentions working in the fields in Letters 496 and 498 as well as in Letter 501 (dated June 29 or 30 by Hulsker). For drawings of the harvest, see M. Roskill, "Van Gogh's Blue Cart," *Oud Holland*, Jg. LXXXI, no. 1, 1966, pp. 3–19. In Letter 507 (dated ca. July 7 by Hulsker), van Gogh wrote that "during the harvest my work was not any easier than what the peasants who were actually harvesting were doing" (*CLVG*, II, p. 607).

3. The meaning becomes clear if "distracted" is substituted for "abstracted." See also fn. 16. H. Thannhauser (*The Burlington Magazine*, p. 98) discusses possible meanings of "abstractions" and suggests that van Gogh may have been making an excuse for his delay in writing to Russell.

4. This refers to *Head of a Girl*, p. 178. R. Pickvance ("The new De La Faille," *The Burlington Magazine*, vol. CXV, March 1973, p. 178) points out that it is "a" dirty little girl rather than "the" as given in *CLVG*, II, p. 592 and de la Faille, 1970, p. 523.

5. The painting referred to is probably *The Bridge at Trinquetaille* (de la Faille 426; 65 x 81 cm (25 ½ x 32 inches), June–July 1888, Collection André Meyer, New York). A drawing of the same subject exists (de la Faille 1507; 24 x 31 cm [9 ½ x 12 ¼ inches], The Metropolitan Museum of Art, New York, The Robert Lehman Collection).

6. See p. 173, fn. 12 for Monticelli. Theo owned several paintings by Monticelli including *L'Italienne* (A. M. Alauzen and P. Ripert, *Monticelli: sa vie et son oeuvre*, Paris, 1969, fig. 476). However, faces like those described in the letter appear in many paintings by Monticelli.

Do not however imagine I am painting old florentine scenery—no I may dream of such—but I spend my time in painting and drawing landscapes or rather studies of colour.

The actual inhabitants of this country often remind me of the figures we see in Zola's work.[7]

And Manet would like them as they are and the city as it is.

Bernard is still in Brittany and I believe he is working hard and doing well.[8]

Gauguin is in Brittany too but has again suffered of an attack of his liver complaint.[9] I wished I were in the same place with him or he here with me.[10]

My brother has an exhibition of 10 new pictures by Claude Monet—his latest works.[11] for instance a landscape with red sun set and a group of dark firtrees by the seaside. The red sun casts an orange or blood red reflection on the blue green trees and the ground. I wished I could seé them.

How is your house in Brittany getting on[12]— and have you been working in the country.

I believe my brother has also another picture by Gauguin which is as I heard say very fine two negro women talking. it is one of those he did at Martinique.[13]

McKnight told me he had seen at Marseilles a picture by Monticelli, flowerpiece.[14]

Very soon I intend sending over some studies to Paris and then you can, if you like, choose one for our exchange.[15]

I must hurry off this letter for I feel some more abstractions coming on[16] and if I did not quickly fill up my paper I would again set to drawing and you would not have your letter.

I hear Rodin had a beautiful head at the salon.[17]

I have been to the seaside for a week and very likely am going thither again soon.[18] Flat shore sands—fine figures there like Cimabue—straight stylish.[19]

Am working at a Sower:[20] the great field *all violet* the sky & sun very yellow. it is a hard subject to treat.[21]

Please remember me very kindly to Mrs. Russell—and in thougt I heartily shake hands.

Yours very truly
Vincent

7. Zola (1840–1902) is mentioned in Letters 497, 498, 514, 519, 524, 525, and 543.

8. Bernard stayed at Saint-Briac on the northern coast of Brittany until early Aug., when he went to Pont-Aven, where Gauguin was staying. See D. Lord, pseud. for D. Cooper, ed., *Vincent van Gogh: Letters to Emile Bernard*, New York, 1938, Letter XIV, p. 72, fn. 1.

9. Gauguin was at Pont-Aven from Feb.–Oct. 1888.

10. On Oct. 23, 1888, Gauguin joined van Gogh at Arles.

11. Theo was manager of Boussod et Valadon, 19, boulevard Montmartre in Paris. According to J. Rewald, Theo bought the ten Monets on June 4, 1888, and immediately arranged for a small exhibition ("Theo van Gogh, Goupil, and the Impressionists," *Gazette des Beaux-Arts*, vol. LXXXI, Jan. 1973, p. 23). The exhibition is listed as being open in *Journal des Arts*, June 15, 1888, p. 2, but the exact date that it began is not known (correspondence with F. Daguet, Fondation Wildenstein, Paris, July 1976).

12. Russell was having a house built on Belle-Ile-en-Mer, off the coast from Quiberon in Brittany. The house, "Le Château de l'Anglais," was begun in 1887 and completed by the summer of 1888 (correspondence with A. Galbally, Oct. 1976).

13. Rewald (*Gazette des Beaux-Arts*, Jan. 1973, p. 61, fn. 33) points out that van Gogh had not seen the Gauguin in question, *Négresses causant à la Martinique* (Wildenstein 227; 61 x 76 cm [24 x 29 ¹⁵/₁₆ inches], dated 1887, private collection, Switzerland). Boussod et Valadon had the painting on consignment at that time; they purchased the work from Gauguin on June 22, 1889, having actually sold it four days earlier (Rewald, *Gazette des Beaux-Arts*, Jan. 1973, p. 21, and Feb. 1973, p. 91). Van Gogh states in Letter 514, which is dated July 29, that Russell did not have time to see the painting.

14. A Monticelli flower piece that Dodge MacKnight had seen is also referred to in Letter 496.

15. It is very doubtful that an exchange of pictures took place since Russell's name is not mentioned in the provenance of paintings in de la Faille, 1970. However, van Gogh did send twelve drawings after paintings to Russell (see p. 179).

16. Although H. Thannhauser (*The Burlington Magazine*, p. 98) states that "abstractions" in this form were not alluded to elsewhere, Letter 507, which describes the artist's method of working rapidly in a single long sitting, reports: "But when I come home after a spell like that, I assure you my head is so tired that if that kind of work keeps recurring, as it has done since the harvest began, I become hopelessly absent-minded and incapable of heaps of ordinary things" (*CLVG*, II, p. 606). Significantly, in the original, the last phrase reads: ". . . je deviens absolument abstrait et incapable d'un tas de choses ordinaires" (*Lettres de Vincent van Gogh à son frère*, Paris, 1937, pp. 203–04). Van Gogh's use of the word "abstraction" derives from his translation of the French "*abstrait*."

Later in 1889, in a letter to Bernard, van Gogh discusses "abstractions" as opposed to paintings based upon a study of nature (*CLVG*, III, pp. 522–25; *Lettres de Vincent van Gogh à Emile Bernard*, Paris, 1911, p. 133).

17. "No. 4592 *Portrait de Mme. M.V. . . .*; buste, marbre" was Rodin's only piece in the Salon, which opened May 1, 1888 (Paris, Société des artistes français, *Salon de 1888*, 2nd ed., p. 365). The 1884 portrait of Mme Luisa Lynch de Morla Vicuña was purchased by the French government at the Salon of 1888 (J. L. Tancock, *The Sculpture of Auguste Rodin*, Philadelphia, 1976, no. 89).

18. The visit to Saintes-Maries-de-la-Mer took place during the week of June 17–24, 1888 (C. W. Millard, "A Chronology for Van Gogh's Drawings of 1888," *Master Drawings*, vol. 12, summer 1974, pp. 159, 163, fn. 33). It appears to have been Vincent's only trip to Saintes-Maries.

19. Van Gogh wrote to Bernard: "There, at Saintes-Maries, were girls who reminded one of Cimabue and Giotto—thin, straight, somewhat sad and mystic" (*CLVG*, III, Letter B6, p. 490).

20. The painting referred to is *The Sower* (de la Faille 422; 64 x 80.5 cm [25 ¹/₄ x 31 ¹/₄ inches], Rijksmuseum Kröller-Müller, Otterlo; de la Faille, 1970, p. 234, color repr.). Drawings related to the sower in the present letter are: a sketch in Letter VII to Emile Bernard (B7; dated ca. June 28 in de la Faille), de la Faille 1441 (24.5 x 32 cm [9 ⁵/₈ x 12 ⁵/₈ inches], Rijksmuseum Vincent van Gogh, Amsterdam), and de la Faille 1442 (25 x 31 cm [9 ⁷/₈ x 12 ⁵/₁₆ inches], present whereabouts unknown, ex. coll. Thannhauser, Berlin).

Van Gogh first treated the subject of the sower in 1880 (Letter 134) and did approximately thirty versions of it during his lifetime. According to R. L. Herbert, Millet's *Sower* had been popularized with the engraving executed by Paul LeRat (or Lerat, 1849–92) for Durand-Ruel in 1873 (Paris, Grand Palais, *Jean-François Millet*, exh. cat., 1975, p. 92). LeRat's engraving was the source for van Gogh's drawing of 1881 (de la Faille 830) and painting of Oct. 1889 (de la Faille 689).

21. Van Gogh sketched the sower in Letter VII to Bernard and wrote: "Here is a sketch of a sower: large plowed field with clods of earth, for the most part frankly violet. A field of ripe wheat, yellow ocher in tone with a little carmine. The sky, chrome yellow, almost as bright as the sun itself, which is chrome yellow No. 1 with a little white, whereas the rest of the sky is chrome yellow Nos. 1 and 2 mixed. So very yellow. The Sower's shirt is blue and his trousers white. Size 25 canvas, square" (*CLVG*, III, pp. 491–92).

Letter 501, which parallels the present letter and is placed a few days later than it by Hulsker (June 29 or 30), states: "A plowed field, a big field with clods of violet earth—climbing toward the horizon, a sower in blue and white. On the horizon a field of short ripe corn. Over it all a yellow sky with a yellow sun. . . . And the sketch, such as it is—a size 25 canvas—torments me, making me wonder if I shouldn't attack it seriously and make a tremendous picture of it" (*CLVG*, II, p. 591).

When the artist wrote Letter 503 (dated ca. July 6 by Hulsker), the picture had been altered so that the sky was yellow and green and the ground violet and orange.

Provenance:
Received from the artist by John Peter Russell (d. 1931), 1888; inherited from Russell by his daughter, Jeanne Jouve, Paris, probably 1931–32; acquired from Jouve by J. K. Thannhauser, Paris, probably 1938–39 (notes Dec. 1972).

Exhibitions:
1955. New York, Wildenstein and Co. *Van Gogh.* March 24–April 30. No. 110.

1984. New York, The Metropolitan Museum of Art. *Van Gogh in Arles.* Oct. 18–Dec. 30. Exh. cat. by R. Pickvance, pp. 254, no. 151, color repr., and 255.

References:
Bremer, J., and T. van Kooten, eds. *Vincent van Gogh: Catalogus van 278 werken in de verzameling van het Rijksmuseum Kröller-Müller, Otterlo.* Otterlo, 1983, p. 85.

CLVG. 1958, vol. II, Letter 501a, pp. 592–94 (*Sower,* repr.).

Elgar, F. *Van Gogh.* Trans. J. Cleugh. New York, 1958, p. 191.

Formaggio, D. *Van Gogh in cammino.* Milan, 1986, p. 71, repr. (*Lettera a John Russel* [sic]).

Graber, H., ed. *Vincent Van Gogh: Briefe an Emile Bernard, Paul Gauguin, John Russell, Paul Signac und Andere.* Basel, 1941, pp. 122–24 (German trans.).

Graetz, H. R. *The Symbolic Language of Vincent Van Gogh.* New York, 1963, pp. 96–97, repr.

Solomon R. Guggenheim Museum. *Masterpieces.* 1972, p. 29, repr.

Hulsker. 1980, pp. 331–32.

Hulsker, J. *Lotgenoten: Het leven van Vincent en Theo van Gogh.* Weesp, 1985, pp. 413 and 419.

————. "Van Gogh's Extatische Maanden in Arles." *Maatstaf,* Jg. 8, Aug.–Sept. 1960, pp. 332 and 334 (ca. June 27 and before Letter 501).

————. *Vincent and Theo van Gogh: A Dual Biography.* Ed. J. M. Miller. Ann Arbor, 1990, p. 282.

Lubin, A. J. *Stranger on the earth: A Psychological Biography of Vincent van Gogh.* 1972. Reprint, New York, 1987, pp. 215 and 219.

The National Museum of Art, Osaka. *Vincent van Gogh from Dutch Collections.* Exh. cat., 1986, p. 142.

Pickvance, R. "Synthesis." In *Vincent van Gogh Exhibition.* Exh. cat., The National Museum of Western Art, Tokyo, 1985, p. 201.

Testori, G., and L. Arrigoni. *Van Gogh: Catalogo completo dei dipinti.* Florence, 1990, pp. 226–27.

Thannhauser, H. "Documents inédits: Vincent van Gogh et John Russell." *L'Amour de l'Art,* XIXe année, Sept. 1938, p. 286.

————. "Van Gogh and John Russell: Some Unknown Letters and Drawings." *The Burlington Magazine,* vol. LXXIII, Sept. 1938, pp. 97–98 and 102, pl. IIIc (end of June or early July).

van Uitert, E. "Van Gogh's Concept of his Oeuvre." *Simiolus,* vol. 12, no. 4, 1981–82, p. 238, fns. 66 and 67. Reprinted in van Uitert's *Vincent van Gogh in creative competition: four essays from Simiolus,* Amsterdam, 1983.

Zurcher, B. *Vincent van Gogh: art, life & letters.* Trans. H. Harrison. New York, 1985, p. 161.

Vincent van Gogh

Head of a Girl, late June 1888
78.2514 T20

Ink on wove paper (lozenge), 18 x 19.5 cm (7 ¹/₈ x
7 ¹¹/₁₆ inches)
Watermark: L-JD
Not signed or dated.

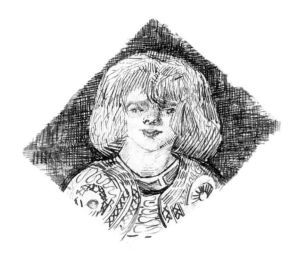

Inscribed by the artist on reverse:
Have you been working in the country lately and is
the house you are building getting on. It appears
that Claude Monet has done fine things my brother
writes to say that he has at present an exhibition of
10 new pictures. One representing pine trees at the
seaside with a red sunset casting a red glow over
some branches foliage and the ground. It is a marvel
I hear. Bernard is doing good things I believe he is
taking a lot of trouble. Gauguin is still at Pont-
Aven and suffering of his liver complaint [bu]t
working nevertheless.

This drawing was enclosed with the letter van
Gogh sent to John Russell late in June 1888 (see
pp. 175–77). Vincent identifies the subject as "a
dirty little girl I saw this afternoon whilst I was
painting a view of the river." He refers to her as
"this dirty 'mudlark'" and makes it clear that the
present drawing was done from memory.

 The same model appears in a painting, *The Girl
with the Ruffled Hair* (de la Faille 535; 35.5 x 24.5
cm [14 x 9 ³/₄ inches], private collection,
Switzerland; de la Faille, 1970, p. 229, repr. [June
1888]). Henry Thannhauser (*The Burlington
Magazine*, p. 98) was the first to point out that the
female model in *The Girl* had been incorrectly
identified as *L'Homme aux cheveux ébouriffés* (de la
Faille, 1928, vol. I, p. 153).

 The foreground figure in *The Bridge at
Trinquetaille* (de la Faille 426) and in a drawing of

the same subject (de la Faille 1507) resembles the
Head of a Girl (see p. 175, fn. 5).

Provenance:
Received from the artist by John Peter Russell
(d. 1931), 1888; inherited from Russell by his
daughter, Jeanne Jouve, Paris, probably 1931–32;
acquired from Jouve by J. K. Thannhauser, Paris,
probably 1938–39 (notes Dec. 1972).

Condition:
Small loss of support at upper right. Old repair of
five and one-half inch cut in support on right side
from top to bottom through figure's hair and left
shoulder. Work deacidified and rehinged by C.
Gaehde (June 1973). Horizontal and vertical grid
of graph paper visible only on reverse.

Exhibitions:
1984. New York, The Metropolitan Museum of
Art. *Van Gogh in Arles*. Oct. 18–Dec. 30. Exh. cat.
by R. Pickvance, p. 105, no. 51, color repr. recto,
repr. verso (*Head of a Girl: The Mudlark*).

1990. Venice, Palazzo Grassi. Pp. 80–81, no. A13,
color repr.

References:
CLVG. 1958, vol. II, pp. 593, repr., and 665 (June
1888).

de la Faille. 1970, p. 523, no. 1507a, repr.

Erpel, F. *Vincent van Gogh: Lebensbilder, Lebenszeichen*.
Berlin, 1989, pp. 184, repr., 185, and 300, no. 362
(*Kleiner "Schmutzfink" aus Arles*).

Solomon R. Guggenheim Museum. *Masterpieces*.
1972, p. 32, repr.

Hulsker. 1980, pp. 328 and 335, no. 1466, repr.
(*Girl's Head*).

Johnson, R. "Vincent van Gogh and the Vernacular:
The Poet's Garden." *Arts*, vol. 53, no. 6, Feb. 1979,
p. 101, repr., and 102, fig. 10 (*Head of a Girl
[The Mudlark]*, 1888).

Pickvance, R. "The new De La Faille." *The
Burlington Magazine*, vol. CXV, March 1973, p.
178.

Roskill, M. "Van Gogh's Exchanges of Work with
Emile Bernard in 1888: Appendix A." *Oud Holland*,
Jg. LXXXVI, no. 2–3, 1971, p. 169 (late June).

Thannhauser, H. "Documents inédits: Vincent van
Gogh et John Russell." *L'Amour de l'Art*, XIXᵉ
année, Sept. 1938, p. 284, repr.

———. "Van Gogh and John Russell: Some
Unknown Letters and Drawings." *The Burlington
Magazine*, vol. LXXIII, Sept. 1938, pp. 98 and 102,
pl. 11a.

Vincent van Gogh Boats at Saintes-Maries, *late July–early August 1888* *Pencil and ink on wove paper. 24.3 x 31.9 cm (9 ⁹/₁₆ x*
78.2514 T21 *12 ⁹/₁₆ inches)*
No watermark.
Not signed or dated.

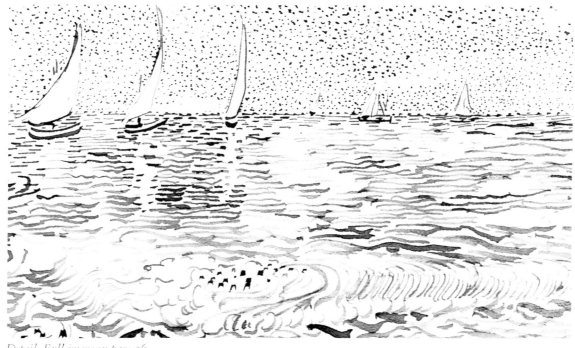

Detail. Full image on page 56.

During July and early August of 1888, van Gogh made many drawings after recent paintings and then sent the sketches to his brother Theo and to his friends, John Peter Russell and Emile Bernard, both painters.

In Letter 516 (dated ca. July 31 by Jan Hulsker, "Van Gogh's Extatische Maanden in Arles," *Maatstaf*, Jg. 8, Aug.–Sept. 1960, p. 335), van Gogh writes: "I am working hard for Russell, I thought that I would do him a series of drawings after my painted series; I believe that he will look upon them kindly, and that, at least I hope so, will help him to make a deal" (*CLVG*, II, p. 623). He had mentioned Russell in Letters 514 and 515 (placed July 29–30 by Hulsker) but without reference to the drawings. In Letter 517 (dated ca. August 3 by Hulsker) van Gogh informs his brother that he had "sent Russell 12 drawings after painted studies" (*CLVG*, II, p. 625). Thus all these drawings were completed before August 3.

Since the paintings from which *Boats at Saintes-Maries* and *The Zouave* (see pp. 182–83) were copied date from June, it it possible that the drawings

were done before the period of late July to early August. However, the letters cited above and the rapidity with which van Gogh worked at the time suggest a date of very late July into the first days of August. Ronald Pickvance specifies July 31–August 3, 1888 ("The new De La Faille," *The Burlington Magazine*, vol. CXV, March 1973, p. 180). The twelve drawings in question are: *Hayricks* (de la Faille 1427), *Sea with Sailing Boats* (de la Faille 1433), *View in the Park* (de la Faille 1449), *A Garden* (de la Faille 1454), *The Postman Roulin* (de la Faille 1458), *Harvest in Provence* (de la Faille 1486), *Sheaves* (de la Faille 1489), *Arles: View from the Wheatfields* (de la Faille 1490), *Mousmé* (de la Faille 1503), *Sailing Boats Coming Ashore* (this drawing; de la Faille 1430a); *The Zouave* (see pp. 182–83; de la Faille 1482a), and *The Road to Tarascon* (see p. 181; de la Faille 1502a). The last three drawings are in the Thannhauser Collection at the Guggenheim.

Boats at Saintes-Maries was done after the painting *Seascape at Saintes-Maries* (de la Faille 417; 44 x 53 cm [17 ¹/₄ x 20 ³/₄ inches], Pushkin Museum, Moscow; P. Cabanne, *Van Gogh*, trans. M.

Martin, Englewood Cliffs, 1963, p. 88, color repr.). Mark Roskill emphasizes that van Gogh's drawings were made after paintings and not from other drawings ("Van Gogh's Blue Cart," *Oud Holland*, Jg. LXXXI, no. 1, 1966, p. 13, fn. 32). In addition, there are two very similar reed pen drawings: *Sailing Boats Coming Ashore* (de la Faille 1430b; 24 x 31.5 cm [9 ¹/₂ x 12 ¹/₂ inches], Musée d'Art Moderne, Brussels), which van Gogh sent to Theo, and *Sailing Boats Coming Ashore* (de la Faille 1430; 24 x 32 cm [9 ¹/₂ x 12 ¹/₂ inches], Nationalgalerie, East Berlin), which he sent to Bernard. A related drawing with color notes was enclosed in a letter that van Gogh wrote Bernard after his return from Saintes-Maries (*CLVG*, III, p. 489, repr.).

Van Gogh had written earlier about his intention and eagerness to go to Saintes-Maries (Letters 492, 494, and 495) but it appears that the trip took place only during the third week in June (C. W. Millard, "A Chronology of Van Gogh's Drawings of 1888," *Master Drawings*, vol. 12, summer 1974, pp. 159 and 163, fn. 33). Letter 499, written to Theo from Saintes-Maries, is dated ca. June 22 by Hulsker (p. 334). Saintes-Maries-de-la-Mer is a fishing village on the Mediterranean. A stagecoach left daily to travel the twenty-four miles from Arles to Saintes-Maries across the Camargue, the peninsula at the delta of the Rhône River (*CLVG*, II, Letter 498, p. 584, and *CLVG*, III, Letter B6, p. 490).

The strokes made with reed pens of varying widths in the Saintes-Maries drawings closely resemble the corresponding brushstrokes in the painting. However, in the Thannhauser drawing, the sky is indicated by dotting. Van Gogh first used reed pens at Arles, apparently because of his wish to produce works close to Japanese art. The combination of dots, commas, short lines, and hatching is used consistently in the drawings sent to John Russell.

Provenance:
Received from the artist by John Peter Russell (d. 1931), 1888; inherited from Russell by his daughter, Jeanne Jouve, Paris, probably 1931–32; acquired from Jouve by J. K. Thannhauser, Paris, probably 1938–39 (notes Dec. 1972).

Condition:
Deacidified, flattened, and rehinged by C. Gaehde
(June 1973).

Exhibitions:
1939. Adelaide, The National Art Gallery.
Exhibition of French and British Contemporary Art.
Opened Aug. 21. No. 138. Traveled to Melbourne,
Town Hall, opened Oct. 16, and Sydney, David
Jones, opened Nov. 20 (correspondence with R.
Appleyard, Nov. 1973 and June 1975, and A.
Dixon, Nov. 1973).

1984. New York, The Metropolitan Museum of
Art. *Van Gogh in Arles.* Oct. 18–Dec. 30. Exh. cat.
by R. Pickvance, no. 73, pp. 138 and 139, color
repr. (*Fishing Boats at Saintes-Maries-de-la-Mer*).

1990. Venice, Palazzo Grassi. Pp. 84–85, no. A15,
color repr.

References:
Bernard, B., ed. *Vincent by Himself: A selection of his
paintings and drawings together with extracts from his
letters.* London, 1985, pp. 226, color repr., and 324
(*Fishing Boats at Sea*). American edition, New York,
1985.

de la Faille. 1970, pp. 503, repr., and 662, no.
1430a (*Sailing Boats Coming Ashore*, June 1888).

Erpel, F. *Vincent van Gogh: Die Rohrfederzeichnungen.*
Munich, 1990, pp. 168–69, repr. (*Fischerboote vor
Les Saintes-Maries-de-la-Mer*).

Solomon R. Guggenheim Museum. *Masterpieces.*
1972, p. 31, repr.

Hulsker. 1980, pp. 344, 346, and 350, no. 1526,
repr. (*Fishing Boats at Sea*).

Keller, H. *Vincent van Gogh: The Final Years.* New
York, 1969, p. 26, repr.

Leymarie, J. *Who Was van Gogh?* Trans. J.
Emmons. Geneva, 1968, p. 95, repr.

Rewald. 1962, p. 227, repr. (June 1888).

Thannhauser, H. "Documents inédits: Vincent van
Gogh et John Russell." *L'Amour de l'Art,* XIXe
année, Sept. 1938, pp. 283, repr., and 284 (ex. coll.
J. Russell).

————. "Van Gogh and John Russell: Some
Unknown Letters and Drawings." *The Burlington
Magazine,* vol. LXXIII, Sept. 1938, pp. 99, pl. 11A,
and 104 (private coll., France).

van Uitert, E. *Van Gogh Drawings.* Trans. E.
Williams-Truman. Woodstock, N.Y. 1978, p. 27
and no. 66 (*Sail-boats Coming Ashore*, June 1888,
Saintes-Maries).

Welsh-Ovcharov, B. *Vincent van Gogh and the Birth
of Cloisonism.* Exh. cat., Toronto, Art Gallery of
Ontario, 1981, p. 124.

Vincent van Gogh The Road to Tarascon, *late July–early August 1888* *Pencil and ink on wove paper. 23.2 x 31.9 cm (9 ¹/₈ x*
78.2514 *T22* *12 ⁹/₁₆ inches)*

No watermark.
Signed lower right: Vincent.
Not dated.

Detail. Full image on page 57.

Tarascon is on the left bank of the Rhône river not far north of Arles. Vincent reports to Theo in Letter 496 (dated July 12 by Jan Hulsker, "Van Gogh's Extatische Maanden in Arles," *Maatstaf*, Jg. 8, Aug.–Sept. 1960, p. 334) that "one day I went to Tarascon, but unfortunately there was such a blazing sun and so much dust that day that I came back with an empty bag" (*CLVG*, II, p. 582). In letter 499 he expresses a wish to go there again. However, no evidence indicates that he did.

In Letter 524 (dated ca. August 14 by Hulsker) van Gogh describes "a rough sketch I made of myself laden with boxes, props, and canvas on the sunny road to Tarascon" (*CLVG*, III, p. 14). By this time the painting, *The Painter on the Road to Tarascon* (de la Faille 448; 48 x 44 cm [19 x 17 ¹/₄ inches], now destroyed, formerly Kaiser Museum, Magdeburg; L. Goldscheider and W. Uhde, *Vincent van Gogh*, Oxford, 1941, color pl. 69), was completed and was included in a roll of thirty-five works that Second Lieutenant Milliet was soon to deliver to Theo in Paris (*CLVG*, III, Letter 524, p. 14).

The present drawing closely resembles the painting in the general disposition of road, trees, and field. However, the figure is omitted and the blazing sun is made explicit by the circle in the sky in the drawing. Sunlight is represented in the painting by golds and yellows and by the prominent foreground shadow. These differences between the painting and the present drawing, which was sent to Russell by August 3 (Letter 517), suggest that van Gogh may have worked more on the canvas and completed it after August 3 but before August 14. (See also p. 179).

Drawings of the road to Tarascon include *The Road to Tarascon with Figure* (de la Faille 1502; 25 x 34 cm [9 ³/₄ x 13 ¹/₂ inches], dated August 1888 in

de la Faille, Kunsthaus Zürich) and *Three Trees, Route de Tarascon* (de la Faille 1518; 25.5 x 35 cm [10 x 13 ³/₄ inches], dated summer 1888 in de la Faille, present whereabouts unknown). Both drawings as well as others that refer to the Tarascon road are placed in July 1888 by Charles W. Millard ("A Chronology for Van Gogh's Drawings of 1888," *Master Drawings*, vol. 12, summer 1974, p. 159).

Van Gogh represented the sun as a circle prominent in the sky in several drawings of the period (de la Faille 1439, 1441, 1442, 1472a, 1506, and 1514).

Provenance:
Received from the artist by John Peter Russell (d. 1931), 1888; inherited from Russell by his daughter, Jeanne Jouve, Paris, probably 1931–32; acquired from Jouve by J. K. Thannhauser, Paris, probably 1938–39 (notes Dec. 1972).

Condition:
Small tears at bottom margin and top center margin. Deacidified and rehinged by C. Gaehde (June 1973).

Exhibitions:
1939. Adelaide, The National Art Gallery. *Exhibition of French and British Contemporary Art.* Opened Aug. 21. No. 139. Traveled to Melbourne, Town Hall, opened Oct. 16, and Sydney, David Jones, opened Nov. 20 (correspondence with R. Appleyard, Nov. 1973 and June 1975, and A. Dixon, Nov. 1973).

1984. New York, The Metropolitan Museum of Art. *Van Gogh in Arles.* Oct. 18–Dec. 30. Exh. cat. by R. Pickvance, pp. 142–43, no. 78, color repr. (also reproduced on pp. 2–3).

1990. Venice, Palazzo Grassi. Pp. 86–87, no. A16, color repr.

References:
Bernard, B., ed. *Vincent by Himself: A selection of his paintings and drawings together with extracts from his letters.* London, 1985, pp. 232, color repr., and 324.

de la Faille. 1970, pp. 522–23, repr., and 665, no. 1502a (*The Road to Tarascon: Sky with Sun*, Arles, Aug. 1888).

Elgar, F. *Van Gogh.* Trans. J. Cleugh. New York, 1958, p. 167, repr.

Erpel, F. *Vincent van Gogh: Lebensbilder, Lebenszeichen.* Berlin, 1989, pp. 179–81, repr., and 300, no. 355 (*Straße nach Tarascon*).

———. *Vincent van Gogh: Die Rohrfederzeichnungen.* Munich, 1990, color pl. 36, pp. 15, 21, 23, and 168–69, repr. (*Straße nach Tarascon*, also reproduced in color on dust jacket).

Graber, H., ed. *Vincent Van Gogh: Briefe an Emile Bernard, Paul Gauguin, John Russell, Paul Signac und Andere.* Basel, 1941, repr. opp. p. 68 (*Landschaft bei Arles*).

Solomon R. Guggenheim Museum. *Masterpieces.* 1972, p. 33, repr. (*The Road from Tarascon*).

Hammacher, A. M., and R. Hammacher. *Van Gogh: A Documentary Biography.* New York, 1982, pp. 180, repr., 181, and 237, no. 146 (*The Road to Tarascon: Sky with Sun*).

Hulsker, J. 1980, pp. 344, 346, and 351, repr., no. 1531.

———. *Lotgenoten: Het leven van Vincent en Theo van Gogh.* Weesp, 1985, p. 423.

———. *Vincent and Theo van Gogh: A Dual Biography.* Ed. J. M. Miller. Ann Arbor, 1990, p. 284.

Petrie, B. *Van Gogh.* London, 1974, pl. 77.

Pickvance, R. "The new De La Faille." *The Burlington Magazine*, vol. CXV, March 1973, p. 179 (corrects omission of signature).

Rijksmuseum Kröller-Müller. *Vincent van Gogh: Drawings.* Exh. cat. by J. van der Wolk, R. Pickvance, and E. B. F. Pey. Milan, Rome, Otterlo, and Amsterdam, 1990, p. 232.

Thannhauser, H. "Documents inédits: Vincent van Gogh et John Russell." *L'Amour de l'Art*, XIXᵉ année, Sept. 1938, pp. 284–85, repr.

———. "Van Gogh and John Russell: Some Unknown Letters and Drawings." *The Burlington Magazine*, vol. LXXIII, Sept. 1938, pp. 99, pl. 11c, and 104 (private coll., France).

Vincent van Gogh The Zouave, *end of July–early August 1888* *Ink on wove paper, 31.9 x 24.3 cm (12 ⁹/₁₆ x*
 78.2514 T23 *9 ⁹/₁₆ inches)*
 No watermark.
 Signed lower left: Vincent.
 Not dated.

Detail. Full image on page 18.

Vincent wrote to his brother Theo (*CLVG*, II, Letter 501, p. 591; dated June 29–30 by Jan Hulsker, "Van Gogh's Extatische Maanden in Arles," *Maatstaf*, Jg. 8, Aug–Sept. 1960, p. 334): "I have a model at last—a Zouave—a boy with a small face, a bull neck, and the eye of a tiger, and I began with one portrait, and began again with another, the half-length I did of him was horribly harsh, in a blue uniform, the blue of enamel saucepans, with braids of a faded reddish-orange, and two stars on his breast, an ordinary blue, and very hard to do. That bronzed, feline head of his with the reddish cap, against a green door and the orange bricks of a wall." The painting referred to is *A Bugler of the Zouave Regiment* (de la Faille 423; 65 x 54 cm [25 ¹/₂ x 21 ¹/₄ inches], Rijksmuseum, Amsterdam; *Vincent van Gogh Paintings and Drawings: A Choice from the Collection of the Vincent van Gogh Foundation*, Amsterdam, 1968, p. 74, color repr.). The present drawing is a copy of the painting (see p. 179).

A Zouave is a member of "a body of light infantry in the French army, originally recruited from the Algerian Kabyle tribe of Zouaoua, but

afterwards composed of French soldiers distinguished for their physique and dash, and formerly retaining the original Oriental uniform" (*Oxford English Dictionary*, Oxford, 1933, vol. XII, p. 103).

The Zouave described in Letters 501, 502, B8, and W5 has been confused with the Second Lieutenant of the Zouave Regiment named Milliet, who was a friend of van Gogh (Letters 506, 541, 541a, 553b, and B16). Douglas Cooper (*The Burlington Magazine*, 1938, p. 227) was the first to distinguish between the two people and identify van Gogh's representations of each. The physiognomies and uniforms in *A Bugler of the Zouave Regiment* and *The Zouave* (de la Faille 424) differ from those in *Portrait of Milliet* (de la Faille 473).

In addition to the present drawing, which was sent to Russell, van Gogh executed a drawing in pen, brown ink, blue crayon, and watercolor and inscribed it "A mon cher copain Emile Bernard" (de la Faille 1482; 30.5 x 22.9 cm [12 x 9 inches], The Metropolitan Museum of Art, New York). The copy sent to Bernard follows the painting less closely than the present drawing since the distinction between the background areas and any indication of the bricks have been omitted and slightly more of the figure's sash and jacket is visible. In the Thannhauser drawing, the stocky figure with bull neck and intense eyes is described with attention to such details as the roughness of his beard and complexion.

In Letter 502, van Gogh wrote to Theo: "Anyway, I shall send you a drawing of the Zouave today" (*CLVG*, II, p. 595). This probably refers to the full-length view, *The Zouave Seated* (de la Faille 1443; 52 x 66 cm [20 ¹/₂ x 26 inches], Collection Rijksmuseum Vincent van Gogh, Amsterdam).

Provenance:
Received from the artist by John Peter Russell (d. 1931), 1888; inherited from Russell by his daughter, Jeanne Jouve, Paris, probably 1931–32; acquired from Jouve by J. K. Thannhauser, Paris, probably 1938–39 (notes Dec. 1972).

Condition:
Deacidified and rehinged by C. Gaehde (June 1973).

Exhibitions:
1939. Adelaide, The National Art Gallery. *Exhibition of French and British Contemporary Art.* Opened Aug 21. No. 137. Traveled to Melbourne, Town Hall, opened Oct. 16, and Sydney, David Jones, opened Nov. 20.

1962. Minneapolis, University Gallery, University of Minnesota. *The Nineteenth Century: One Hundred Twenty-five Master Drawings.* March 26–April 23. No. 119. Traveled to the Solomon R. Guggenheim Museum, May 15–June 28.

1984. New York, The Metropolitan Museum of Art. *Van Gogh in Arles.* Oct. 18–Dec. 30. Exh. cat. by R. Pickvance, p. 142, no. 77, color repr.

1990. Venice, Palazzo Grassi. Pp. 82–83, no. A14, color repr.

References:
Berger, K. *Französische Meisterzeichnungen des Neunzehnten Jahrhunderts.* Basel, 1949, pp. 30 and 88, no. 54, repr.

de la Faille. 1970, pp. 516, repr., and 665, no. 1482a (*The Zouave: Head and Shoulders*, June 1888).

Elgar, F. *Van Gogh.* Trans. J. Cleugh. New York, 1958, pp. 154, repr., and 183.

Erpel, F. *Vincent van Gogh: Die Rohrfederzeichnungen.* Munich, 1990, color pl. 37, pp. 23 and 170–71, no. 79, repr. (*Ein Zuave, Kopfstudie*).

——————. *Vincent van Gogh: Lebensbilder, Lebenszeichen.* Berlin, 1985, pp. 158, repr., 159, and 300, no. 324 (*Der Zuave*).

Galleria Nazionale d'Arte Moderna, Rome. *Vincent van Gogh.* Milan, 1988, p. 204.

Graber, H., ed. *Vincent Van Gogh: Briefe an Emile Bernard, Paul Gauguin, John Russell, Paul Signac und Andere.* Basel, 1941, repr. opp. p. 44.

Solomon R. Guggenheim Museum. *Masterpieces.* 1972, p. 34, repr.

Hulsker. 1980, pp. 344, 346, and 352, no. 1535, repr.

Hulsker, J., ed. *Van Gogh's "Diary": The Artist's Life in His Own Words and Art.* New York, 1971, pp. 112, repr., and 168 (*The Zouave*).

Leymarie, J. *Who Was van Gogh?* Trans. J. Emmons. Geneva, 1968, p. 107, repr.

Lord, D. (pseud. for D. Cooper). "Letter: Van Gogh and John Russell." *The Burlington Magazine*, vol. LXXIII, Nov. 1938, p. 227 (correcting identification of the Zouave).

Rewald. 1962, p. 262, repr. (*Portrait of a Zouave Bugler*).

Rijksmuseum Kröller-Müller. *Vincent van Gogh: Drawings*. Exh. cat. by J. van der Wolk, R. Pickvance, and E. B. F. Pey. Milan, Rome, Otterlo, and Amsterdam, 1990, pp. 232–33.

Sachs, P. J. *Modern Prints and Drawings*. New York, 1954, p. 50, pl. 41.

Thannhauser, H. "Documents inédits: Vincent van Gogh et John Russell." *L'Amour de l'Art*, XIX^e année, Sept. 1938, pp. 281, repr., and 284 (*Le Zouave Milliet*, ex. coll. John Russell).

———. "Van Gogh and John Russell: Some Unknown Letters and Drawings." *The Burlington Magazine*, vol. LXXIII, Sept. 1938, pp. 94, repr., and 104 (private coll., France).

Wadley, N. *The Drawings of van Gogh*. London, 1969, p. 37 and pl. 92 (*The Zouave Milliet*).

Mountains at Saint-Rémy. *July 1889*
(Montagnes à Saint-Rémy: The Alpilles with Dark Hut:
Hills at Saint-Rémy: Collines à Arles: Berglandschaft)
78.2514 T24

Oil on canvas. 71.8 x 90.8 cm (28 ¹/₄ x 35 ³/₄ inches)
Not signed or dated.

Detail. Full image on page 22.

References in the artist's letters to the present painting provide information about its provenance, date, and subject matter. It is first mentioned in Letter 600 (dated ca. July 9, 1889, by Jan Hulsker, "Van Gogh's Bedreigde Leven in St. Rémy en Auvers," *Maatstaf*, Jg. 8, Jan. 1961, p. 663): "The last canvas I have done is a view of mountains with a dark hut at the bottom along some olive trees" (*CLVG*, III, p. 193). Van Gogh painted it at Saint-Rémy while a patient at the Hospital of Saint-Paul-de-Mausole. He used an empty cell on the ground floor as a studio and was allowed freedom to paint outside the hospital. The Alpilles range is visible from the hospital, and the view from in front bears a striking resemblance to the present picture (fig. a).

After receiving news from his brother that he and his wife were expecting a child and shortly after writing Letter 600, van Gogh had another mental seizure while painting in the fields, and he remained in his room for the next six weeks (Rewald, 1962, p. 545). When his correspondence with Theo was resumed in August, van Gogh refers

again to the present picture (Letters 601, 602, and 607), and he now associates it with a passage in a book by Edouard Rod. The book in question, *Le Sens de la vie*, had been sent to him late in June by his sister, Wil (see Letters 596 and W13).

In Letter 607 (dated Sept. 20 by Hulsker), the artist writes about the "Mountain": "But after all it seemed to me it expressed the passage in Rod's book—one of the very rare passages of his in which I found something good—about a desolate country of somber mountains, among which are some dark goatherds' huts where sunflowers are blooming" (*CLVG*, III, p. 217). In Book III of *Le Sens de la vie*, which is entitled "Altruisme," chapters IV and V are about a mountain. Rod writes of the *montagnards:* "Ils semblent indifférent au bien-être: leurs chalets de bois sont petits et noirs, . . . ils mangent les légumes qu'ils ont fait pousser dans leurs jardinets où se balancent de rares tournesols, . . ." (p. 223). ("They seem indifferent to life's comforts: their wooden huts are small and black, . . . they eat the vegetables which they have grown in their little gardens where an occasional

sunflower sways, . . .") Rod also refers to goats. (The passage was brought to my attention by Audrey Helfand.)

It must be kept in mind that the association with Rod's book arises at least a month after van Gogh first mentioned the painting and probably after he completed work on the canvas.

There are other compositions close in subject and in date to the Thannhauser painting (de la Faille 611, 615, 618, 619, and 635).

Provenance:
Sent by the artist to Theo van Gogh, Sept. 1889 (Letter 607); acquired in exchange by Eugène Boch,[1] Monthyon (Seine-et-Marne), June 1890 and still in his possession in 1908; Galerie E. Druet, Paris, by 1912;[2] Walther Halvorsen,[3] Paris, from 1918; Trygve Sagen, Oslo;[4] Galerien Thannhauser, Berlin, by 1927.

Condition:
Lined with aqueous adhesive at an unrecorded date before 1965. some flattening of the impasto resulted, and two tears in the lower right were repaired. In 1986 some local cleavage was set down. Old glue residues were cleaned out of the deep

1. Theo arranged the exchange with Boch, a Belgian painter (1885–1944), and told Vincent about it in a letter dated June 23, 1890 (*CLVG*, III, Letter T38, p. 573). In exchange Vincent received Boch's *La Mine de l'Agrappe* (Amsterdam, Stedelijk Museum, *Collectie Theo van Gogh*, exh. cat., 1960, no. 16). In Sept. 1888 Vincent met Boch, who was staying with Dodge MacKnight at Fontvieille (Letter 531). At that time Boch was thirty-three years old and had already been working in Paris for ten years (M. E. Tralbaut, *Vincent van Gogh*, New York, 1969, p. 253). Van Gogh's *Portrait of Eugène Boch* dates from Sept. 1888 (de la Faille 462; 60 x 45 cm [23 ⁵/₈ x 17 ³/₄ inches], Musée du Louvre, Galerie du Jeu de Paume, Paris; de la Faille, 1970, p. 287, color repr.). His sister, the painter Anna Boch, purchased van Gogh's painting *The Red Vineyard* (de la Faille 495; Nov. 1888) at the exhibition of Les XX in Brussels in Feb. 1890 (Rewald, 1962, p. 374).
2. De la Faille, 1928, vol. I, p. 175. According to de la Faille the present picture is Druet photo nos. 2896 and 61103.
3. According to his widow, Halvorsen destroyed all his correspondence before his death in 1972. She remembers that her husband sold the remainder of his collection to Flechtheim in Berlin before leaving Paris in 1920 (correspondence with Anita Halvorsen, Nov. 1976).
4. Notes made by J. K. Thannhauser in Dec. 1972 and by D. C. Rich in March 1975 indicate that it belonged to Sagen after Halvorsen and before Thannhauser.

impasto. Some old, unfilled losses were filled and inpainted. Some thicker areas of the uneven, somewhat-yellowed varnish were thinned, and old discolored retouching was adjusted to better match the surrounding paint.

Exhibitions:[5]
1908. Paris, Galerie E. Druet. *Vincent van Gogh*. Jan. 6–18. No. 3 (*Collines à Arles*, lent by E. Boch).[6]

1913. New York, Armory of the Sixty-ninth Infantry. *International Exhibition of Modern Art*. Feb. 15–March 15. No. 424 (*Collines à Arles*, lent by E. Druet). Traveled to the Art Institute of Chicago, March 24–April 16, no. 408, repr.; and Boston, Copley Hall, April 28–May 19, no. 213, repr.

1923–24. Prague, Spolku Vytvarnych Umelcu Mánes. *Exhibition of French Art*. Dec. 1923–Jan. 1924(?).[7] No. 55 (*Landscape of Arles*, oil, 93 x 73 cm).

1927. Berlin, Künstlerhaus (organized by the Galerien Thannhauser). *Erste Sonderausstellung in Berlin*. Jan. 9–Feb. 15. No. 117, repr. (*Berglandschaft*).

1939. New York, The Museum of Modern Art. *Art in Our Time*. May 10–Sept. 30. No. 70, repr. (*Hills at Saint-Rémy*). On loan to the Museum of Modern Art until April 1941 (MoMA Registrar's Files 39.351).

1940. Cincinnati Modern Art Society. *Paintings of School of Paris*. April 12–May 12. (No cat.; correspondence with S. C. Johnson, Jan. 1974.)

1940. San Francisco, Palace of Fine Arts. *Golden Gate International Exposition*. May 25–Sept. 29. No. 272, repr.

1941. The Detroit Institute of Arts. *Modern Paintings from the Museum of Modern Art*. Jan. 3–Feb. 2. (No cat.; correspondence with C. Elam, Sept. 1976.)

1942. The Baltimore Museum of Art. *Paintings by van Gogh*. Sept. 18–Oct. 18. No. 18. Traveled to Worcester Art Museum, Oct. 28–Nov. 28.

1943. Pittsburgh, Carnegie Institute Museum of Art. *Modern Dutch Art*. Feb. 5–March 1.[8] No. 24G (*Hills at Saint-Rémy*).

1948. The Cleveland Museum of Art. *Work by Vincent van Gogh*. Nov. 3–Dec. 12. No. 20, repr.

1955. The Art Institute of Chicago. May–Aug. (correspondence with W. D. Bradway, Dec. 1973).

1964. New York, Solomon R. Guggenheim Museum. *Van Gogh and Expressionism*. July 1–Sept. 13. (*Mountains at Saint-Rémy*).

1986–87. New York, The Metropolitan Museum of Art. *Van Gogh in Saint-Rémy and Auvers*. Nov. 25, 1986–March 22, 1987. Exh. cat. by R. Pickvance, pp. 117, color repr., 118–19, and 297, no. 20, repr.

1990. Venice, Palazzo Grassi. Pp. 88–89, no. A17, color repr.

1992. The Montreal Museum of Fine Arts. Pp. 64–65, no. 5, color repr.

References:
Brown, M. W. *The Story of the Armory Show*. Greenwich, 1963, p. 246, no. 424.

CLVG. 1958, vol. III, pp. 193, 195–96, 216–17, and 573.

Fig. a. The Alpilles from the Hospital of Saint-Paul-de-Mausole. Saint-Rémy.

Coquiot, G. *Vincent van Gogh*. Paris, 1923, p. 317 (*Vue de montagnes, avec une cabane noirâtre, dans les oliviers*).

Daulte, F. "Une Donation sans précédent: la collection Thannhauser." *Connaissance des Arts*, no. 171, May 1966, p. 64, repr. (erroneously states that it was the only painting van Gogh sold during his life).

de la Faille. 1928, vol. I, p. 175 and vol. II, pl. clxxii (*Collines à Saint-Rémy*, July 1889).

――――. 1939, p. 427, no. 619, repr. (*Collines à St.-Rémy*).

――――. 1970, pp. 248, repr., 249, and 635, no. 622 (*The Alpilles with Dark Hut*, July 1889).

Elgar, F. *Van Gogh*. Trans. J. Cleugh. New York, 1958, pp. 168–69, repr., and 222.

Solomon R. Guggenheim Museum. *Masterpieces*. 1972, p. 35, repr.

Hildebrandt, H. *Die Kunst des 19. und 20. Jahrhunderts*. Potsdam, 1924, pl. xiv (*Arlesische Landschaft*, Galerie Thannhauser).

Hulsker. 1980, pp. 403 and 408, no. 1766, repr. (*Mountains with Dark Hut*, dated first half of July).

――――. *Lotgenoten: Het leven van Vincent en Theo van Gogh*. Weesp, 1985, p. 537.

――――. *Vincent and Theo van Gogh: A Dual Biography*. Ed. J. M. Miller. Ann Arbor, 1990, p. 365.

5. Since J. K. Thannhauser (notes, Dec. 1972) remembered that the painting was exhibited by Heinrich Thannhauser in 1908 and since his father was an associate of F. J. Brakl in Munich, it is possible that the present picture was included in the van Gogh exhibition held in March 1908 (listed in de la Faille, 1970, p. 691) or in Oct.–Dec. 1909 at the Moderne Kunsthandlung (F. J. Brakl), perhaps as nos. 39 or 45 (Gordon, 1974, vol. II, pp. 343–44). There were also paintings by van Gogh exhibited in March–April 1909 in Munich at the Kunstsalon W. Zimmerman (Gordon, 1974, vol. II, p. 249).

6. Information from Gordon, 1974, vol. II, pp. 244–45.

7. The present picture corresponds with no. 55 (*Landscape of

Arles, oil, 93 x 73 cm) in the Dec. 1923 exhibition of French art although it is not reproduced in the catalogue nor is the lender's name given (correspondence with J. Kotalík, Jan. 1974). De la Faille (1928 and 1970) identifies the present picture as the single work exhibited at an unspecified location in Prague in Jan. 1924. J. K. Thannhauser also stated that it was exhibited in Prague in Jan. 1924 (notes made by D. C. Rich, March 1975). Kotalík concurs that the picture probably remained in Prague in the first month of 1924 (correspondence, Jan. 1974).

8. The painting was not included in the exhibition when it opened in Albany in Jan. 1943 and it did not travel (correspondence with L. A. Arkus, Feb. 1974).

Kuhn-Foelix, A. *Vincent van Gogh*. Bergen, 1958, p. 200 and pl. 46 (*Hügellandschaft bei St. Rémy*).

Lamberto, V. *Vincent van Gogh*. Milan, 1936, pl. xx.

Mathews, P. "Aurier and Van Gogh: Criticism and Response." *Art Bulletin*, vol. 68, no. 1, March 1986, pp. 95 and 97, repr.

The National Museum of Art, Osaka. *Vincent van Gogh from Dutch Collections*. Exh. cat., 1986, p. 138.

Nordenfalk, C. "Van Gogh and Literature." *Journal of the Warburg and Courtauld Institutes*, vol. X, 1947, p. 145 and pl. 38e.

Osborn, M. "Klassiker der Französischen Moderne." *Deutsche Kunst und Dekoration*, vol. 59, March 1927, p. 338, repr.

Rewald. 1962, p. 359, color repr. (*Mountains at Saint-Rémy*).

Scherjon, W. *Catalogue des tableaux par Vincent van Gogh décrits dans ses lettres*. Utrecht, 1932, p. 25, no. 14, repr. (*La Montagne* [Livre de Rod *Le Sens de la vie*]).

Scherjon, W., and J. de Gruyter. *Vincent van Gogh's Great Period: Arles, St. Rémy and Auvers sur Oise*. Amsterdam, 1937, pp. 215, repr., and 217, no. 14.

Seznec, J. "Literary Inspiration in Van Gogh." *Magazine of Art*, vol. 43, Dec. 1950, p. 286.

Stein, S. A., ed. *Van Gogh: A Retrospective*. New York, 1986, p. 19, repr. (*Mountains with Dark Hut*).

Testori, G., and L. Arrigoni. *Van Gogh: Catalogo completo dei dipinti*. Florence, 1990, pp. 301, color repr., and 302, no. 675 (*Veduta delle Alpilles*).

Treble, R. *Van Gogh and His Art*. London, 1975, p. 104, pl. 84.

Walther, I. F., and R. Metzger. *Vincent van Gogh: Sämtliche Gemälde*. Cologne, 1989, p. 529, color repr. (*Berglandschaft in Saint-Rémy*).

Zurcher, B. *Vincent van Gogh: art, life & letters*. Trans. H. Harrison. Fribourg, Switzerland, 1985, pp. 239, 243, color pl. 165, and 300, repr. detail (*Mountains*).

Vincent van Gogh Letter to John Peter Russell, *late January 1890* *Ink on laid paper. 17.8 x 22.5 cm (7 x 8⅞ inches)*
78.2514 T25 *Watermark of a shield (2⅛ x 1⅜ inches) with the*
*word "*UNIVERSAL*" below*
Not dated.

My dear friend Russell,[1]

Today I am sending you a little roll of photographs of pictures by Millet, which you may not know.[2]

However this may be, the purpose is to remind you of myself and my brother.

Do you know that my brother has got married in the meantime, and that he is now expecting his first child?[3] Let's hope all goes well—he has a very nice Dutch wife.

How much it pleases me to write you after such a long silence! Do you remember when we met our friend Gauguin[4] almost at the same time—I think you were the first, and I the second?

He is still struggling on—alone, or nearly alone, like the brave fellow he is. I feel sure you

1. The translation is from *The Complete Letters of Vincent van Gogh*, III, pp. 249–50, courtesy of the New York Graphic Society. The letter (623a) was translated by C. de Dood, who completed the work of J. van Gogh-Bonger who, at the time of her death in 1925, had reached Letter 526 (*CLVG*, I, pp. xii and lxvii).

2. Vincent had just received the photographs in question from Theo (*CLVG*, III, Letter 625, p. 252, where it is dated Feb. 1). Van Gogh was interested in "translating" works by Millet. However, as he wrote in Letter 625 (dated Feb. 2 by J. Hulsker, "Van Gogh's Bedreigde Leven in St. Rémy en Auvers," *Maatstaf*, Jg. 8, Jan. 1961, p. 664): "I have scruples of conscience about doing the things by Millet which you sent me, for instance, and which seemed to me perfectly chosen, and I took the pile of photographs and unhesitantly sent them to Russell, so that I shall not see them again until I have made up my mind" (p. 252).

According to R. L. Herbert, there were many Millet photographs available at that time so that it is difficult to know which ones Theo sent. Adolphe Braun was the most important early source for photographs of Millet's work: the appendix to A. Sensier, *La Vie et l'oeuvre de J.-F. Millet*, Paris, 1881 [pp. 403–04], includes a list of photographic reproductions of forty-seven paintings, pastels, and drawings that could be purchased from Braun. In addition, several dealers had Millet photographs including Durand-Ruel and, significantly, Boussod et Valadon. Since Theo worked for the latter, their photographs would have been readily accessible to him (correspondence with R. L. Herbert, Aug. 1976).

3. His nephew and namesake, Vincent W. van Gogh, was born on Jan. 31, 1890.

4. According to Rewald (1962, pp. 41, 540–41), van Gogh met Gauguin in Nov. 1886 after Gauguin's return from Pont-Aven to Paris. B. Welsh-Ovcharov points out that there is actually no concrete evidence for a close personal relationship between the two artists until very late 1887 (pp. 24–25). Citing the reference in the present letter she finds it posssible that van Gogh and Gauguin met through an intermediary such as A. S. Hartrick (1864–1950; p. 56, fn. 28).

have not forgotten him.

I assure you that he and I are still friends, but perhaps you are not unaware that I am ill, and that I have had serious nervous crises and delirium more than once. This was the cause of our parting company, he and I, for I had to go into a lunatic asylum.[5] But, before that, how many times we spoke of you!

At the moment Gauguin is still with one of my fellow countrymen by the name of De Haan,[6] and De Haan praises him highly, and does not think it at all bad to be with him.

You will find [an] article about some canvases I have at the exhibition of the *Vingtistes*.[7] I assure you that I owe much to the things Gauguin told me on the subject of drawing, and I have the highest respect for the way he loves nature.[8] For in my opinion he is worth even more as a man than as an artist.

And is everything going well with you? And are you still working hard?

Though it is not pleasant to be ill, yet I have no right to complain, for it seems to me that nature sees to it that disease is a means of putting us on our legs again and of healing us, rather than an absolute evil.

If you should go to Paris, please go and take a canvas of mine at my brother's, if you still stick to the idea of someday getting together a collection for you native country.[9]

You will remember that I have already told you it is my great desire to give you one for this purpose. How is our friend MacKnight? If he is still with you, and if there are others with you whom I have had the pleasure of meeting, please remember me to them.

Above all give my kind regards to Mrs. Russell, and believe me, with a handshake in thought,
Sincerely yours, Vincent van Gogh

This letter was written late in January 1890, before van Gogh learned of the birth of his nephew (which occured on Jan. 31) and after Theo had sent him Aurier's article, which appeared in the first issue of *Mercure de France*.

Unlike the earlier letters in English, van Gogh wrote to Russell in French. The existing correspondence contains no mention of Russell for a considerable period of time before January 1890. However, Letter 625 (dated February 2 by Jan Hulsker), which sheds light on several aspects of the present letter, does mention Russell's name several times. Vincent writes of having "written a note to Russell once more, to remind him a little of Gauguin, for I know that Russell as a man has much gravity and strength" (*CLVG*, III, p. 252). In addition, van Gogh thought of Russell with regard to Millet: "If for my part I wanted to go on—let's call it *translating* certain pages of Millett, then, to prevent anyone from being able, not to criticize me, which wouldn't matter, but to make it awkward for me or hinder me by pretending that it is just copying—then I need someone among the artists like Russell or Gauguin to carry this thing through and make a serious job of it And not now, but in a few months' time, I shall try to get a candid opinion from Russell himself on the usefulness of the thing" (Letter 625, pp. 252–53).

Russell's reply to the present letter is mentioned in Letter 628 (*CLVG*, III, p. 260).

Provenance:
Received from the artist by John Peter Russell (d. 1931), 1890; inherited from Russell by his daughter, Jeanne Jouve, Paris, probably 1931–32; acquired from Jouve by J. K. Thannhauser, Paris, probably 1938–39 (notes Dec. 1972).

Exhibition:
1955. New York, Wildenstein and Co. *Van Gogh*. March 24–April 30. No. 110.

References:
Bernard, B. *Vincent by Himself: A selection of his paintings and drawings together with extracts from his letters*. London, 1985, p. 208.

CLVG. 1958, vol. III, Letter 623a, pp. 249–50 (end of Jan. 1890).

Galbally, A. "Amitie: Russell and Van Gogh." *Art Bulletin of Victoria*, 1976, pp. 36–37.

Graber, H., ed. *Vincent Van Gogh: Briefe an Emile Bernard, Paul Gauguin, John Russell, Paul Signac und Andere*. Basel, 1941, pp. 124–26 (German trans.).

Solomon R. Guggenheim Museum. *Masterpieces*. 1972, p. 30, repr.

Hulsker, J. "Van Gogh's Bedreigde Leven in St. Rémy en Auvers." *Maatstaf*, Jg. 8, Jan. 1961, p. 664 (end of Jan.).

Pickvance, R. *Van Gogh in Saint-Rémy and Auvers*. Exh. cat., The Metropolitan Museum of Art, New York, 1986, p. 62 (ca. Feb. 1).

Thannhauser, H. "Documents inédits: Vincent van Gogh et John Russell." *L'Amour de l'Art*, XIXᵉ année, Sept. 1938, p. 286 (end of Jan. 1890).

———. "Van Gogh and John Russell: Some Unknown Letters and Drawings." *The Burlington Magazine*, vol. LXXIII, Sept. 1938, p. 103.

Welsh-Ovcharov, B. *Vincent van Gogh: His Paris Period 1886–88*. Utrecht and the Hague, 1976, p. 56, fn. 28.

5. Vincent's breakdown occurred on Dec. 23, 1888, and Gauguin left Arles a day or two after Christmas (M. Roskill, *Van Gogh, Gauguin and the Impressionist Circle*, Greenwich, 1970, p. 270).

6. The Dutchman is Jacob Meyer de Haan (1852–95). In 1888 he went to Paris, met Gauguin, and stayed with Theo, who sent de Haan's drawings to Vincent (*CLVG*, III, Letters T1 and T2, pp. 530–31). (See W. Jaworska, *Gauguin and the Pont-Aven School*, trans. P. Evans, Greenwich, ca. 1972, pp. 95–106.) During the winter of 1889–90, Gauguin stayed with de Haan at Le Pouldu in Brittany. On Jan. 3, 1890, Theo wrote to Vincent: "I have had no news from Gauguin. He is very happy because De Haan is with him, for the latter pays for his whole maintenance and for his paints" (*CLVG*, III Letter T23, p. 560).

On Feb. 9, 1890, Theo wrote that "Gauguin arrived in Paris yesterday" (*CLVG*, III, Letter T28, p. 564).

7. The article is G.-Albert Aurier's "Les Isolés: Vincent van Gogh," *Mercure de France*, vol. I, no. 1, Jan. 1890, pp. 24–29. The exhibition of Les XX opened in Brussels on Jan. 18, 1890 (Rewald, 1962, pp. 367–73). Like the Millet photographs mentioned above, Theo had recently sent the article to his brother (*CLVG*, III, Letter 625, p. 251).

8. Likewise, in his letter to Aurier, van Gogh states: "I owe much to Paul Gauguin" (*CLVG*, III, Letter 626a, p. 256).

9. Russell's plan was never realized. Before returning to Australia in 1921, he sold his collection in Paris at the Hôtel Drouot, March 31, 1920.

Edouard Vuillard
Born November 1868, Cuiseaux
Died June 1940, La Baule

Place Vintimille. 1908–10
78.2514 T74

Distemper on cardboard, mounted on canvas: two panels:
200 x 69.5 cm (78 ¾ x 27 ⅜ inches) and
200 x 69.9 cm (78 ¾ x 27 ½ inches)
Not signed or dated.

Detail. Full image on page 54.

The panels of *Place Vintimille* were part of a series of eight that Vuillard painted for the playwright Henry Bernstein. First installed (probably in the dining room and salon) in his bachelor apartment at 157, boulevard Haussmann, they were united in 1919 in Bernstein's dining room at 110, rue de l'Université in Paris. (We are indebted to Georges Bernstein Gruber, daughter of H. Bernstein, for this information. She remembers that her mother said they were installed as doors.) It has not been possible to locate photographs (if any existed) of the panels in either apartment or to reconstruct their installation.

Bernstein (1876–1953) was the son of Marcel Bernstein, a French financier. His mother was the daughter of William Seligman of the New York banking family. By 1905, he was a successful playwright and, in 1908, his play *Israel*, which attacked anti-Semitism in France, increased his fame while causing a furor that led to a three-year period of retirement (obituary, *The New York Times*, Nov. 28, 1953, p. 15).

Vuillard moved to 26, rue de Calais in 1907,

and his apartment on the fourth floor looked down on the square (now called place Adolphe-Max). The left panel shows the side of rue de Bruxelles and the right, rue de Douai.

Understandably, the artist favored the subject. Similar views of the square include: sketches for the two Thannhauser panels (each 195 x 68 cm [76 ½ x 26 ¾ inches]; Paris, Durand-Ruel, *K. X. Roussel— Vuillard*, exh. cat., 1974, pls. 19 and 20, and Munich-Paris, *Vuillard—K.-X. Roussel*, exh. cat., 1968, nos. 137 and 138); a three-panel pastel (left and right panels each 183 x 66.5 cm [72 ¹/₁₆ x 26 ⁵/₁₆ inches]; and center panel 188 x 48 cm [74 x 18 ⅞ inches]; Paris, Galerie l'Oeil, *Vuillard et son kodak*, exh. cat., 1963, p. 10, color repr.); a five-panel screen (distemper on paper, each section 250 x 60 cm [98 ½ x 23 ⅝ inches]; ex. colls. Princess Bassiano and A. S. Henraux, Paris, now in a private American collection); and a painting in distemper (161 x 228 cm [63 ½ x 90 inches], ex. colls. M. Kapferer, Paris, and Mrs. D. Wildenstein, New York, now in the collection of Mrs. Joseph Hazen; Preston, p. 135, color repr.). (All related works are known only through photographs.)

The other six panels that belonged to Bernstein (private collection) include a panel representing the middle part of place Vintimille (1908–10, distemper on cardboard, mounted on canvas, 200 x 49.8 cm [78 ¾ x 19 ⅝ inches]; fig. a). When a photograph of this middle part is placed between photographs of the Thannhauser panels, not only do the three have the same composition as the pastel mentioned above but their proportions are similar. The only difference is the repetition of a tree in the left and center panels that appears once in the pastel. A photograph of place Vintimille taken by the artist confirms the arrangement of the three panels (Galerie l'Oeil, 1963, p. 11, repr., and Preston, p. 38, repr., dated 1911).

There are, however, differences between the Thannhauser panels and the central one of place Vintimille in handling and in the greater degree to which the present pictures are elaborated. The central panel remains less heavily painted and freer in execution although not as boldly sketchy as the five street scenes that complete the Bernstein panels. (I am indebted to Margaret Potter and Olive Bragazzi for these observations and to Potter for her advice throughout.) There is no evidence of a

Fig. a. Vuillard. Place Vintimille.

sketch for the central panel to correspond with the sketches for the lateral ones, which the Thannhauser paintings follow closely. It is possible to speculate that the Thannhauser panels are more heavily painted and precisely detailed because Vuillard had made sketches specifically for them and not for the others. Furthermore, Vuillard's technique would allow for reworking (see Russell, pp. 137–40, and M. Davies, *French School*, rev. ed., London, 1970, pp. 142–44).

The Bernstein pictures are first documented in A. Segard, *Peintres d'aujourd'hui: les décorateurs*, Paris, 1914, vol. II, p. 321, in a list under the year 1910: "Six panneaux décoratifs exécutés à la colle, sur carton, sur le thème des rues de Paris, pour M. Henry Bernstein, 157 boulevard Haussmann." Since Achille Segard's list has proved reliable, the fact that it mentions only six panels can perhaps be explained as referring to the number of street scenes rather than to the number of panels: *La Rue, La Voiture d'arrosage, La Tour Eiffel, L'Enfant au ruisseau, Rue Lepic,* and *Place Vintimille.*

Of this list the first four titles appear as nos. 1–4 in the *Exposition Vuillard* held at Bernheim-Jeune, Paris, from November 11–24, 1908, where they are dated 1908. No mention is made of Henry Bernstein (Gordon, 1974, vol. II, p. 285). Thus, a *terminus ante quem* is established for four of the eight panels. The place Vintimille panels could not have been painted before 1907 since only then did Vuillard move to the square. Segard's date of 1910 is probably correct for the completion of the whole project. Inconsistencies in the handling of the panels reinforce the hypothesis that all were not executed at the same time.

Later in date is the five-panel screen (dated 1911 by Segard), which had to have been completed by April 1912, when it was exhibited at Bernheim-Jeune, *Edouard Vuillard*, as no. 29. The unity of the composition with its emphasis on the dense summer foliage and the activity in the street implies a knowledge of the Bernstein panels. In the painting in the Hazen collection, differences in style and alterations in the street confirm a date later than all other representations of place Vintimille mentioned.

Provenance:
Acquired from the artist by Henry Bernstein, Paris (Georges Bernstein Gruber in conversation with D. C. Rich, March 1975); purchased from the family of Bernstein by J. K. Thannhauser, New York, 1948.

Condition:
The canvas mounts are not identical: the canvas on the left panel has a fine texture whereas that of the right panel is relatively coarse. Tack holes at corners and along vertical edges of both panels penetrate the cardboard and canvas. There are scattered losses in each panel. The condition of the left panel is good and generally stable. The right panel is fragile. Local consolidation of recurring active cleavage in the green area of lawn and adjacent yellow tree was carried out in 1987 (March 1992).

Exhibition:
1944–45. Paris, Galerie Charpentier, *Paris*. Dec. 1, 1944–March 1, 1945. Nos. 214 and 215, repr. left panel (correspondence with R. Nacenta, May 1975).

References:
Arnason, H. H. *History of Modern Art.* New York, 1968, pp. 97–98, fig. 141.

Daulte, F. "Une Donation sans précédent: la collection Thannhauser." *Connaissance des Arts,* no. 171, May 1966, pp. 68–69, color repr. both panels (ca. 1910).

Dugdale, J. "Vuillard the Decorator; The Last Phase: The Third Claude Anet Panel and the Public Commissions." *Apollo,* vol. LXXXVI, Oct. 1967, pp. 272 and 274, figs. 5 and 6 (1908–10).

Dumas, A., G. Cogeval, A. Chastel, et al. *Vuillard.* Exh. cat., Musée des Beaux-Arts, Lyon, Fondation Caixa de Pensions, Barcelona, and Musée des Beaux-Arts, Nantes. Paris, 1990, pp. 223 and 232.

Solomon R. Guggenheim Museum. *Masterpieces,* 1972, pp. 38–39, repr. (ca. 1908).

Haus der Kunst, Munich, and Musée de l'Orangerie, Paris. *Edouard Vuillard—K.-X. Roussel.* Exh. cat., 1968, pp. 110–11 (after 1907).

L'Oeil, no. 36, Dec. 1957, p. 78, repr. right panel.

Preston, S. *Edouard Vuillard.* New York, 1985, p. 35, repr. both panels (ca. 1908, each panel 76 x 25 ½ inches, Collection J. K. Thannhauser, New York City).

———. *Vuillard.* New York, 1971, p. 39, fig. 54, repr. both panels (ca. 1908).

Roger-Marx, C. *Vuillard.* Paris, 1948, p. 55, figs. 42 and 43 (1908).

———. *Vuillard et son temps.* Paris, 1945, pp. 140, 149, repr. both panels, and 155–57 (1908).

Russell, J. *Vuillard.* Greenwich, 1971, pp. 48, repr. both panels, and 226 (1907–08).

Salomon, J. "Edouard Vuillard als Chronist seiner Epoch." *Du,* Jg. 22, Dec. 1962, pp. 30 and 36, color repr. both panels (ca. 1910).

———. *Vuillard.* Paris, 1968, pp. 25, 108, 111, color repr. both panels, and 218 (ca. 1910).

———. *Vuillard admiré.* Paris, 1961, pp. 98 and 101, repr. both panels (ca. 1910).

———. *Vuillard, témoignage.* Paris, 1945, p. 57, repr. right panel (ca. 1910).

Schweicher, C. *Die Bildraumgestaltung, das Dekorative und das Ornamentale im Werke von Edouard Vuillard.* Zurich, 1949, pp. 83–84 (1908).

———. *Vuillard.* Bern, 1955, p. 13.

Thomson, B. *Vuillard.* Oxford, 1988, pp. 86–87, nos. 72 and 73, color repr. both panels, and 96 (1909–10).

Wilson-Bareau, J. "Edouard Vuillard et les princes Bibesco." *Revue de l'Art,* no. 74, 1986, pp. 39, 45, fns. 8 and 11, and 46.

Paul Cézanne

Environs du Jas de Bouffan, *1885–87*
Oil on canvas, 65 x 81 cm (25 ⁹/₁₆ x 31 ⁷/₈ inches)
Not signed or dated

Exhibition:
1978. Kunstmuseum Bern. No. 3, color repr.

Reference:
Venturi. 1936, vol. I, p. 167, no. 473, and vol. II,
pl. 142.

Paul Klee

Hampelmann, *1919*
*Pencil, oil transfer drawing, and watercolor on paper,
mounted on cardboard, 28.4 x 22 cm (11 ³/₁₆ x
8 ¹¹/₁₆ inches)*
Signed within image: Klee; *dated and numbered lower
left:* 1919.214.

Exhibition:
1978. Kunstmuseum Bern. No. 18, repr.

Edouard Manet

Portrait de la comtesse Albazzi, *1880*
*Pastel on primed canvas, 56.5 x 46.5 cm (22 ¹/₂ x
18 ¹/₂ inches)*
Signed bottom center: M; *inscribed on reverse, not by the
artist:* fait a Trouville en Bretagne / Comtesse Iza
Albazzi / née de Kwiatowska

Exhibition:
1978. Kunstmuseum Bern. No. 21, color repr.

Reference:
Rouart, D., and D. Wildenstein. *Edouard Manet.*
Lausanne and Paris, 1975, vol. II, pp. 14–15,
repr., no. 35.

Claude Monet

Le Palais Ducal vu de Saint-Georges Majeur, *1908*
*Oil on canvas, 65 x 100.5 cm (25 ⁹/₁₆ x
39 ⁹/₁₆ inches)*
Signed and dated lower right: Claude Monet 1908

Exhibition:
1978. Kunstmuseum Bern. No. 24, color repr.

Reference:
D. Wildenstein. *Claude Monet.* Lausanne and Paris,
1985, vol. IV, pp. 240–41, no. 1756, repr.

Jules Pascin

Justin K. Thannhauser et Rudolf Levy jouant aux
cartes, *December 1911*
*India ink and colored pencil on paper, 23 x 29 cm
(9 ¹/₁₆ x 11 ⁷/₁₆ inches)*
*Signed, dated, and inscribed upper right, possibly by the
artist:* Justin Thanhauser {sic} vor Ankunft / des
Christkindls 1911 / Pascin / Café du Dôme.
A sketch with figures on the reverse.

Exhibition:
1978. Kunstmuseum Bern. No. 26, repr.

Pablo Picasso

The Picador, *1900/01?*
Pastel on paper, 19 x 27 cm (7 ¹/₂ x 10 ⁵/₈ inches)
Signed lower left: - P Ruiz Picasso -

Exhibition:
1978. Kunstmuseum Bern. No. 28, color repr.
(1901).

References:
Daix and Boudaille. 1967, no. II. 1, p. 119, repr.
(Barcelona, 1900).
Palau i Fabre, J. *Picasso: The Early Years
1881–1907.* Trans. K. Lyons. New York, 1981,
p. 194, repr., p. 530, no. 449 (Barcelona, 1900).
Catalan edition: *Picasso Vivent 1881–1907. Infantesa
i primera joventut d'un demiürg*, 1980.
Zervos. 1954, vol. VI, no. 379, pl. 47 (1901).

Pablo Picasso

Profile of Woman with a Chignon, *1904*
*Pencil, india ink, charcoal, and blue wash on paper,
37 x 26.7 cm (14 ⁹/₁₆ x 10 ¹/₂ inches)*
Signed lower left: Picasso

Exhibition:
1978. Kunstmuseum Bern. No. 30, repr.

References:
Daix and Boudaille. 1967, no. D. XI. 12,
p. 249, repr.
Zervos. 1932, vol. I, no. 221, pl. 98.

Pablo Picasso

Fernande with a Black Mantilla, *1905/6?*
Oil on canvas, 100 x 81 cm (39 ³/₈ x 31 ⁷/₈ inches)
Signed on reverse at upper left: Picasso

References:
Daix and Boudaille. 1967, no. XV. 43, p. 304
(summer 1906).
Palau i Fabre, J. *Picasso: The Early Years
1881–1907.* Trans. K. Lyons. New York, 1981,
pp. 424–25, repr., p. 548, no. 1154 (Paris, 1905).
Catalan edition: *Picasso Vivent 1881–1907. Infantesa
i primera joventut d'un demiürg*, 1980.
Zervos. 1932, vol. I, no. 253, pl. 112 (Paris, 1905).
Zervos, C. *Pablo Picasso.* 3rd edition. Paris, 1957,
vol. I, no. 253, pl. 112 (Paris, 1906).

Pablo Picasso

Femme dans un fauteuil, *1922*
Oil on canvas, 91.5 x 62.5 cm (36 x 24 ⁵/₈ inches)
Signed upper right: Picasso

Exhibition:
1978. Kunstmuseum Bern. No. 41, repr.

Reference:
Zervos. 1951, vol. IV, no. 391, pl. 162.

Pablo Picasso

Le Homard et le chat, *January 11, 1965*
Oil on canvas, 73 x 92 cm (28 ³/₄ x 36 ¹/₄ inches)
Signed and inscribed upper left: Pour Justin /
Thannhauser / so {sic} ami / Picasso; *dated on reverse:*
11.1.65./ III

Exhibition:
1978. Kunstmuseum Bern. No. 55, color repr.

Reference:
Zervos. 1972, vol. XXV, no. 10, pl. 6.